ART
■ UNDER ■
STALIN

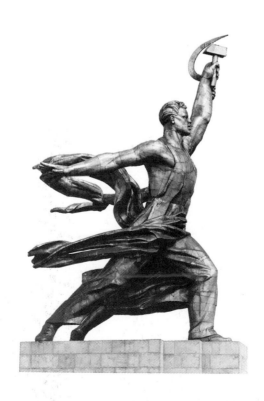

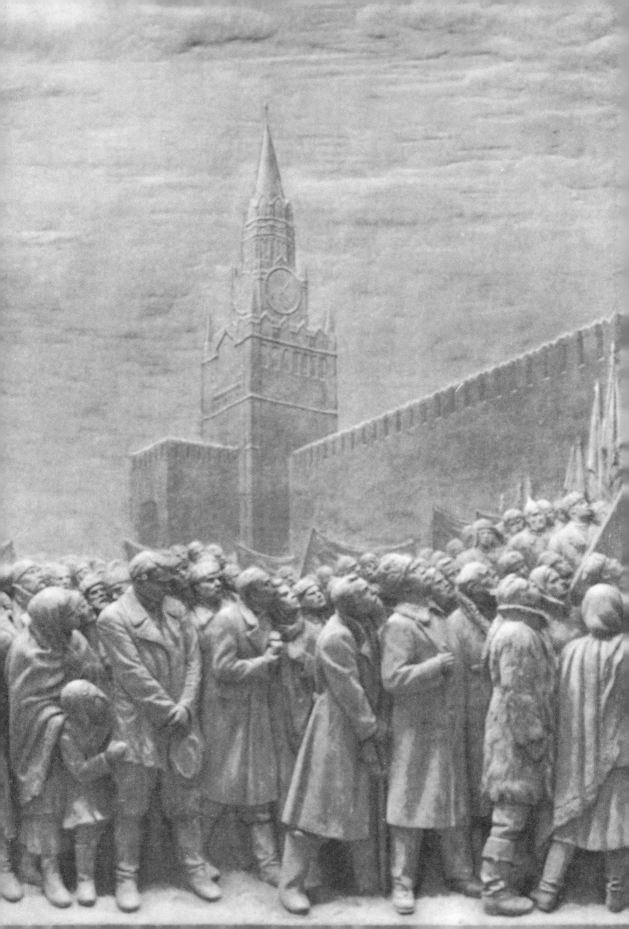

ART
UNDER
STALIN

MATTHEW CULLERNE BOWN

Holmes & Meier · New York

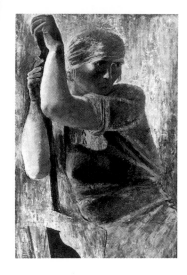

Посвящается Натусеньке

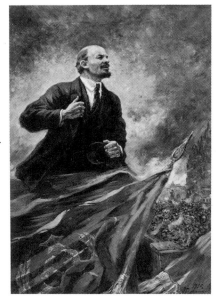

Published in the USA 1991 by
Holmes & Meier Publishers, Inc.
30 Irving Place
New York, NY 10003

First published 1991
© Phaidon Press, Oxford 1991
Text © Matthew Cullerne Bown
1991
Foreword © A Sidorov 1991

**Library of Congress Cataloging-
in-Publication Data**

Bown, Matthew Cullerne.
 Art under Stalin / Matthew
 Cullerne Bown.
 p. cm.
 Includes bibliographical
 references and index.
 ISBN 0-8419-1299-8
 1. Art. Soviet. 2. Socialist
 realism in art—Soviet Union.
 3. Art. Modern—20th century-
 Soviet Union. I. Title.
 N6988.B67 1991
 709'.47'0904—dc20 91-11281
 CIP

Printed in Hong Kong

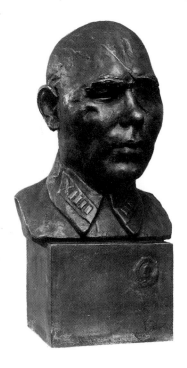

Half-title page: Vera Mukhina,
Worker and Collective Farm Girl,
1937. Stainless steel, 2,400 cm
(960 in) high. Moscow, Park of the
People's Economic Achievements.

Frontispiece: Evgeni Vuchetich,
Pavel Fridman, Grigori Postnikov,
Pyotr Yatsyno, *We Swear to You,
Comrade Lenin . . .*, 1949. Plaster,
300 × 500 × 25 cm (120 × 200
× 10 in). Location unknown.

This page: see plates 24, 39, 111.

Contents

Acknowledgements

I am grateful to *VAAP* (the All-Union Agency for Authors' Rights) and the publishers, Sovetski Khudozhnik, for supplying the bulk of the illustrations. Thanks also to the Society for Cultural Relations with the USSR (Pl. 3); Irina Evstafeva (Pl. 18); Vladilen Shabelnikov (Pls. 31, 57, 134), Iosif Gurvich (Pl. 35); Roy Miles (Pl. 37); Roshal Natapova (Pl. 41); the late Sergei Luchishkin (Pl. 48); Igor Rublyov (Pls. 49, 55, 94, 127); Olga Yanovskaya (Pl. 74); Vladimir Kostin (Pl. 79); Mai Miturich (Pl. 95); Elena Tsaplina (Pl. 97); Maks Birshtein (Pl. 119); Nikogos Nikogasyan (Pl. 123); Evgeniya Belousova (Pl. 172); Zigurds Constants (Pl. 180); Connaught Brown Gallery (Pl. 185).

I have received a enormous amount of assistance with this book. I would like to thank Natasha; my family; Olga Filonovskaya; Vladimir Kostin for fascinating talks and the use of his archive; Aleksandr Sidorov for his valuable foreword and other help; the British Council for giving me a six-month scholarship in Moscow; Vladimir Goryainov, Edvard Rikhter and the staff at Sovetski Khudozhnik for the supply of most of the illustrations; Elena Gryaznova and Lyudmilla Smirnova at VAAP; Michael Bird, Steven McEnally and the staff of the cultural section at the British embassy in Moscow; the foreign department at Moscow State University; the staff at TsGALI; Lyudmilla Marts, Stanislav Ivanitski and the staff of the Tretyakov Gallery; the staff of the MOSKh library; Tair Salakhov, Mikhail Mikheev and the USSR Union of Artists; Roger Sears, Mark Fletcher and Bernard Dod at Phaidon Press; Anatoli Popov and Gosobrazovanie, the State Education Committee that deals with foreign scholars; Mariam Aslamazyan; Lavinia Bazhbeuk-Melikyan; Evgeniya Belousova; Eli Belyutin and Nina Moleva; Maks Birshtein; Svetlana Bobrova and the staff of the Konyonkov museum; Sofiya Razumovskaya and Mitya Bogorodski; Lyudmilla Bubnova; Ivan and Vasili Chuikov; Igor Dolgopolov; Ekaterina Drevina; Stepan Dudnik; Viktor Elkonin; Irina Evstafeva; Angelina Falk; Taras Gaponenko; Lyudmilla Gerasimova; Aleksei Gritsai; Iosif Gurvich; Mikhail Konchalovski; Nina Korotkova; Elizaveta Kovalevskaya; Leona Labas; Aleksandr Lavrentev; the late Sergei Luchishkin; Sergei Lyubimtsev and the staff of the Russian Museum; Konstantin Maksimov and Galina Maksimova; Lev Melikhov; Roy Miles; Sergei Miroshnechenko; Mai Miturich; Aleksandr Morozov; Nataliya Motovilova; Dmitri Nalbandyan; Roshal Natapova; Nikolai and Mariam Nikogasyan; Nikolai Plastov; Viktor Puzyrkov; Nina Romadina and Mikhail Romadin; Igor Rublyov; Dmitri Sarabyanov; Vladilen Shabelnikov; Tatyana Shevchenko; Dementi Shmarinov; Savva Shurpin; Nikolai Tryaskin; Elena Tsaplina; Vladimir Tsigal; Flora Tsyrkin; Vera Vuchetich; Tatyana Yablonskaya; Valentina Yakovleva; Olga Yanovskaya; Marfa Zamkova; Ekaterina and Viktoria Zernova; and any others whose names I have here overlooked.

Preface

There has been no satisfactory account of the Stalin period in Soviet art. In the West, ideological antagonism and the impossibility of reconciling socialist realism with modernism have led to its being virtually ignored. Soviet surveys have been distorted in one or both of the following ways: first, by the assumption that socialist realism is the most advanced and important art of the twentieth century, placing it *hors combat* in critical terms and turning a history into a mere roll-call of artists and works; second, after Krushchev's denunciation of Stalin in 1956, by a shrinking from some of the art which was in fact most typical of the period – in particular, from images of Stalin himself. I have built my account on a study of the archives of the Committee for Art Affairs and the Moscow Artists' Union and of the art magazines and newspaper articles of the time. This raw material has been enriched by the recollections of artists and their relatives, gathered by me in the course of many interviews and conversations conducted in 1988–9.

1

Arkadi Plastov
Haymaking, 1945.
Oil on canvas,
193×232 cm (77×91 in).
State Tretyakov Gallery.

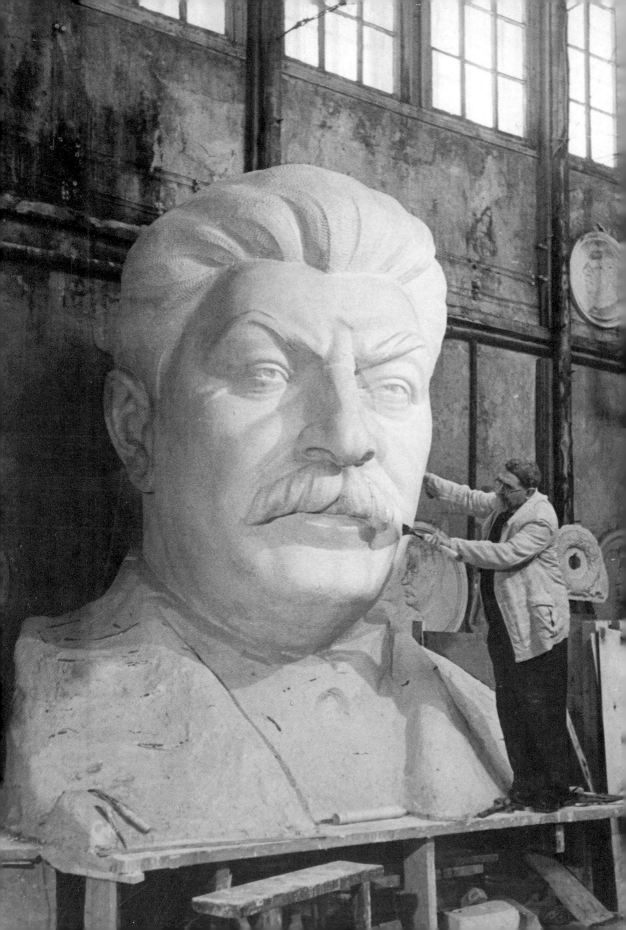

Foreword

by Aleksandr Sidorov, USSR Academy of Arts

Stalin's Art through Soviet Eyes

'When you are in the latrine, you get used to the smell whether you want to or not . . .' (Pushkin)

Once an art critic has decided to write an 'objective' history of Soviet art from the 1930s to the 1950s, he will find difficulties awaiting him similar to those confronting him were he to undertake to describe the artistic culture of Atlantis. Despite the extensive evidence recorded in numerous works, some of them consisting of many volumes (such as the nine-volume *Art History of the Peoples of the USSR*), the researcher not only comes up against a mass of quite different assessments of the very same artistic works and phenomena, but finds himself face to face with an iceberg only one-tenth of which is accessible to view – and even that only with difficulty.

As regards the works of art themselves – 'monuments' to the Stalinist era – what the art historian sees is not so much a forest, but rather a neglected piece of woodland where, instead of tall trees, the predominant feature is small tree stumps. The historian does not see a luxuriant head of hair, but rather a monk's tonsure. It is scarcely less sad to behold the 'golden fund' of socialist realist art in its undamaged state than it is to look at the Soviet avant-garde. Since Khrushchev denounced Stalin in 1956, many of its 'masterpieces' have been destroyed or have lain hidden and neglected in the depositories of museums and the Ministry of Culture.

'Nothing inspires the imagination as much as an absence of facts.' This observation by the Russian writer Saltykov-Shchedrin beautifully illustrates the process by which the art critic becomes aware of Stalinist art, beginning with the 'thaw' under Khrushchev and continuing right up to the present. This process is marked by a series of pitfalls. Some of these arise when the attempt is made to assess aesthetically the creative work of the artists and to divide the artists into righteous people and sinners. Not one of the criteria employed when carrying out this 'separation' can be acknowledged as being sufficiently reliable and irreproachable.

One such criterion, however much it appears to be the simplest

2

Sergei Merkurov working on the monument to Stalin destined for Yerevan, 1949.

and most indisputable of them, is the answer to the question: 'Did or did not any artist in fact depict Stalin?' – as if, at that time and under the circumstances then prevailing, the creation of an image of Lenin and other well-known personalities took on a basically different and unofficial character. Certain 'discoveries' made in the era of *perestroika* are related to this false premise. An example is the picture called *Opening Ceremony of the Second Comintern Congress* by Isaak Brodski, a well-known pioneer of official art. This picture is considered to belong to the category of outstanding clandestine works, the reason being merely that its painter 'apart from V. I. Lenin . . ., also depicted G. Zinovev and A. Rykov, N. Bukharin and K. Radek, B. Kun and Platten, and other distinguished people who were involved in the October Revolution and in the international workers' movement and who died in Stalin's prisons and camps', and was also able to 'capture the characteristic features of the future "leader of the nations"', namely 'the haughty, scornful gaze, and the caustic smile hiding in the moustache' (*Pravda*, 20 April 1989).

The modern process of re-evaluating history in the USSR does not, as a rule, admit even as much as the possibility of thinking of Stalin as someone who continued the cause of Lenin. The process is characterised by going to another extreme – that of an almost complete break between the Stalin and pre-Stalin periods. In fact, certain events which took place in the first years after the Revolution – the breaking-up of the Constituent Assembly, the execution of the Romanov tsarist family and of Nikolai Gumilev, the taking of hostages in areas where there were peasants' uprisings, and the creation of the first concentration camps for political prisoners (including Solovka) – ought under no circumstances to be reckoned among the category of exceptions which became the rule in the era of Stalinism.

The idea of political management was formulated very clearly and definitely in the works of Lenin which are known from selections of literature and are devotedly included in the collection entitled *V. I. Lenin on Literature and Art*. To the present day, this idea – art's subservience to politics – is included as a provision of primary significance in almost all the regulations, which are still valid today (in 1990), of those of the USSR's artistically and scientifically creative associations and institutions which were set up before 1983.

Many artists, especially leading members of the Soviet intelligentsia, contributed in no small degree to ensuring the complete vassalage of culture. The battle between artistic groupings in the 1920s was a squabble to obtain a monopoly in the determination and pursuit of cultural policy. This was typical of the 'dictatorship of the left-wingers' in the People's Commissariat for Education. This squabble tended to develop into an intrigue to obtain leading roles and top positions in the State's 'horn of plenty'. After all, that horn was fairly meagre in those years.

In the initial stage of its development, the system by which the

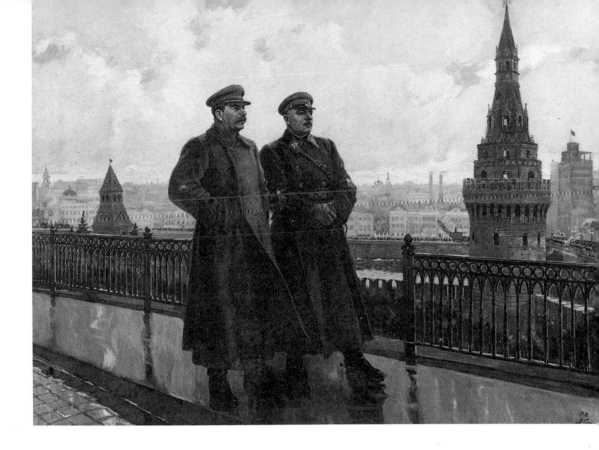

Party and the State administered the arts was only able to grow a tree of 'proletarian culture'. In the main, it was enthusiasts – the 'communist futurists', the members of 'proletarian culture' and the 'left-wing front', and other 'left-wingers' (such as the so-called 'productionists' and the 'life-builders') – who, by their own wish, climbed into this tree and watered and decorated it. In time, according to the measure of maturity achieved, a more powerful tree was successfully grown, the tree of 'socialist realism', whose trunk became the voluntary – or compulsory – 'testing ground' for all artists, recalling the well-known scene in which the ministers at court are tested in one of Gulliver's travels in the novel by Jonathan Swift.

There is scarcely any point in this short foreword in attempting to determine what socialist realism actually was: whether it was a totalitarian method used by a totalitarian culture as a practical way of managing the arts, so that art was transformed into the handmaiden of the State and Party bureaucracy; 'a style fixed within certain limits of society and time'; an artistic (or pseudo-artistic) phenomenon; or a terminological fiction. It is more important to point out that, in the Stalinist era and the period thereafter, there was a system consisting of certain fundamental characteristics of artistic awareness.

Perhaps most important of all from a present-day Soviet

3

Aleksandr Gerasimov
Stalin and Voroshilov in the Kremlin, 1938.
Oil on canvas,
300×390 cm
(118×153½ in).
State Tretyakov Gallery.

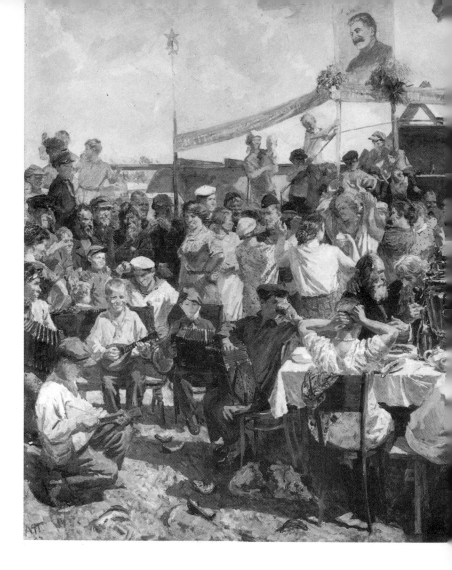

perspective, the 'respected public' had ceased to be an effective force and a participant enjoying equal rights in the artistic process. This was because – according to the vulgarised sociological opinion which had become established ever since the first years of Soviet power – the personal possession of objects of spiritual value came under the category of 'bourgeois relics'. Man, and especially 'simple' Soviet man, was thought of exclusively as a viewer, but by no means a consumer or possible possessor, of decorative art works, and at best he had to be content with a mere reproduction, copy or album of an artist's work. This circumstance is indissolubly linked to the following four processes. Firstly, public awareness was transformed into an object of demagogic manipulations and speculations. Secondly, aesthetic requirements were depersonalised, and the interests of the individual were completely dissolved in ideological and artistic programmes imposed by the State. Thirdly, leaders

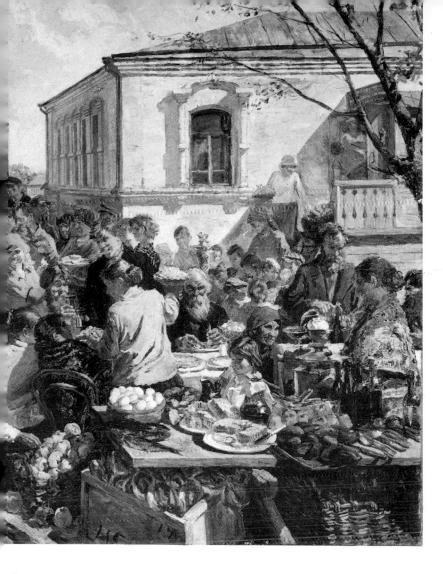

appeared who acted as mediators of culture and invariably took up a position above the viewer, reader or listener and knew better than others what to teach, how to educate, what the people must know and what they must not know, what the people needed and what was contrary to their needs, what was 'good' and what was 'bad'. And fourthly, art criticism was reduced to a concrete exposition of ideas sent down from on high; it played the role of a priest of a new belief who explained the postulates of that belief to the parishioners of the church of socialist realism.

Another chief characteristic of Stalinist art was the idea that, as a result of socio-economic progress, art itself continually makes progress. Consequent upon this is the axiom that Soviet art is in the vanguard and that socialist realism is the most forward-looking and progressive of all the artistic methods that have ever existed in the world. This is confirmed by the *Encyclopaedic Dictionary of Literature*

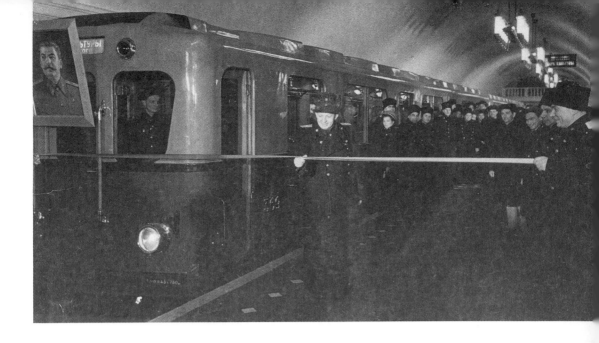

which was published in the USSR in 1987 (!) and describes socialist realism as 'the leading artistic method of the modern era'.

Domestic art and international art were accordingly divided up into Soviet art and Western (bourgeois) art. The former was destined to be constantly flourishing and heroically rising towards a bright future, whereas the latter was doomed to a fate of continuous decadence and decay. The only exception was made in the case of certain individual artists who, in the 1920s, were called 'the revolutionary artists of the West' (in this we see a reflection of hopes for a world revolution). In the 1930s they were known as 'friends of the Soviet Union', and up until recent times they were termed 'the progressive artists of the West', as if they were striving to attain the level of Soviet art.

The essence of the changes which had taken place is set forth as follows in one of the works of art criticism which appeared in the Stalinist period: 'The bosses of foreign capital, who were the managers of political and economic life in tsarist Russia, tried in every possible way to ensure that our country remained backward and ignorant. The Russian capitalists and landowners helped the foreign bourgeoisie to take possession of the minds of the Russian intelligentsia, and drilled into the heads of that intelligentsia the idea that the Russian people were culturally and spiritually inferior. The October Revolution did away with our country's shameful economic and spiritual dependence on the bourgeois West, rescued the independence of our State and our nation, and created all the necessary conditions for the establishment of a new science, a new culture, a new art.'

A barbaric attitude towards the artistic heritage of the pre-revolutionary period was a typical trait of post-revolutionary socialist

'cultural' awareness, not merely in the period of military communism, in which there was a popular appeal to burn 'the works of Raphael, destroy the museums, and trample upon the very cream of art – all this in the name of our tomorrow'. This attitude continued in the 1930s and 1940s, and even the following decades were not free of it.

There are certain phenomena which ought to be regarded as propaganda campaigns rather than as serious attempts to assimilate the spiritual experience of the past. Such phenomena are the switch, in the first half of the 1930s, towards Ilya Repin, Vasili Surikov and the other pillars of the Itinerants school of nineteenth-century Russian painters. There was also the sensational celebration in 1937 of the centenary of Pushkin's death. Other examples are Stalinist neo-classicism and the neo-baroque. If one were to regard these as a real attempt to assimilate the past, it would be almost impossible to explain how such apparently mutually exclusive facts as the following could exist within one and the same culture: firstly, there was the manner in which propaganda, including the tools of art, the cinema, literature and music, was actively used to illustrate the historic victories achieved by Russian arms; secondly, certain decorations were instituted: these were the so-called Orders of Nakhimov, Suvorov and Kutuzov. On the other hand, sacred objects and monuments were destroyed on the Borodinski field. Museum treasures were sold for foreign currency. The temples of old art 'inexorably' fell into ruins and were blown up and defiled.

The new socialist culture merely selected individual parts, mere fragments, of the pre-revolutionary world which it had stripped almost to its foundations. It did this exclusively to serve its own needs which, with rare exceptions, had nothing in common with the goals of past culture, and were frequently opposed to those goals. Moscow was obliged to become the model capital, the socialist third Rome, of the first workers' and peasants' state in the world, and was destined to serve as a training ground for all possible kinds of experiments and ventures in the field of architectural politics, examples being the Palace of Soviets, the General Plan of Reconstruction and, even in my day, the Monument to Victory. These experiments were mainly carried out in such a way that pre-revolutionary architecture, the monuments of history and culture, and also other rarities and remnants of the past, such as old gardens, parks and memorable sites, all suffered as a result.

In this process, the uncompromising pursuit of the principle that anything new, particularly if it was anything new and Soviet, was always better than anything old led to certain consequences: it was not merely that the past was being abolished, but it also meant that monuments were hidden away (this was what happened to Pavel Trubetskoi's statue of Alexander III on a horse) or that one work was replaced by another which was obviously inferior, as when Nikolai Andreev's monument to Gogol was replaced in 1951 by a like-named

work by Nikolai Tomski.

As the basic principles of Stalinist cultural politics became more firmly established, real creative potential invariably became more limited and threatened to degenerate into an officially approved collection of 'vitally important' subjects, 'necessary' topics and 'correct' means of expression. By the time the 1950s began, the limits of socialist realism had become so narrow that the works of some of its recognised classic artists were already beyond those limits: examples are Yuri Pimenov and Arkadi Plastov, Aleksandr Matveev and Sergei Gerasimov, to say nothing of such works, which even in our day are regarded as strange, as *Battle of the Amazons* (1948) by Aleksandr Deineka.

In the post-Stalinist era, any attempt to reanimate the artistic mechanism that operated under Stalinism and to go back to the artists just mentioned invariably took on the nature of a reactionary activity. Two examples of such attempts are the crushing defeat of avant-gardism in 1962 at the exhibition called 'The Thirteenth Anniversary of the Moscow Section of the Artists' Union', and the establishment of a new cult such as the 'Brezhnevist' cult, with all the defects characteristic of efforts to revive former works of art. Such typical defects are the absence, firstly, of the former unity and integrity – albeit a subdued and simplified integrity – of the awareness felt by the Party, the State and the public, and secondly, of the slogans and ideals that used to be universally present – although they were the ideals and myths of an uncivilised society. But the chief factor was the absence of the total belief in that unity and integrity and in those slogans and ideals. That belief excluded the possibility that any double morality could exist – one morality for the individual

6

Aleksandr Bubnov
Morning on Kulikov Field, 1943–7.
Oil on canvas,
270×503 cm
(106×198 in).
State Tretyakov Gallery.

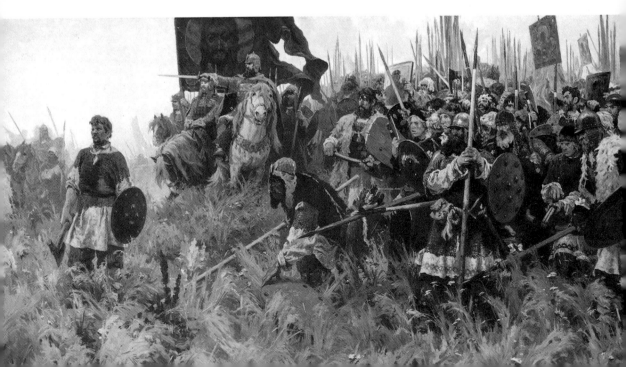

and his close circle of friends and relations, and another for the people as a whole.

As a rule, Stalinist culture did not admit the compromises which became typical of the later period, particularly the period of economic stagnation, the Brezhnev period, when art and art exhibitions took on Western features as regards artistic pluralism and creative variety but, in the main, addressed themselves to the Soviet viewer in terms of old-fashioned socialist realism. Particular values and authorities were being proclaimed from the rostrums, but a completely different 'aesthetic' currency was in circulation in the family circles of the top echelons of power and among official ideologists. That currency included pornographic videos and banned literature. The art of socialist realism was the official State-based art of Stalin, and at the same time it was also the art of his own home and of his closest surroundings, as well as being the art of the entire Soviet people. The classic works of Stalinist art were inferior to the official artistic practice of the Khrushchev and Brezhnev periods as regards certain details and 'lyrical digressions' (these include the film *The Cranes are Flying* and the novel *A Day in the Life of Ivan Denisovich* by Aleksandr Solzhenitsyn). But Stalinist classicism considerably surpassed those periods in its spirit of social purposefulness and rightness and in the exclusiveness of the path selected by that spirit. That spirit never doubted its superiority, and never recognised contradictions or introspections arising from artistic pathos. It was permeated by a feeling for a common cause useful to all and by the immutable, optimistic, triumphant basis on which it operated. Right up to the present day, this has had an almost irresistible effect upon us Soviets, the contemporaries of another era, and this is so despite our critical attitude towards the 'masterpieces' of Stalinism.

In my brief foreword I may have thrown somewhat too negative a light on the range of art in the Stalinist period, and perhaps I have paid too much attention to the 'extreme' manifestations of that art. But, as the Russian saying has it, things are seen more clearly when observed from one side.

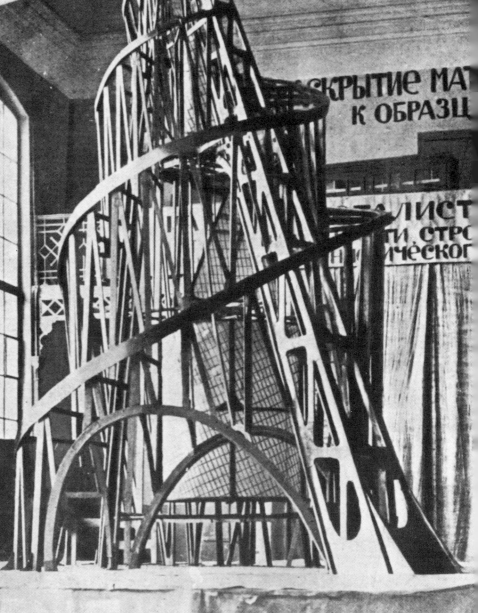

Introduction

Art under Lenin 1917–24

Prelude to revolution

Russia's lurch into revolution in 1917 was foreseen by her cultural avant-garde – those writers and artists who maintained a dialogue with the modern movement in Western Europe and created their own versions of its dynamic in the form of Russian futurism, constructivism and suprematism. The prospect was a challenge as intimidating and exciting as a newly primed canvas: to realise, out of a widening void of collapse, the indistinct but powerful vision of a radically new society. Kazimir Malevich (1878–1935) was the artist above all others whose paintings presage the coming spring clean. He had developed the iconoclastic method of suprematism by 1915. He attempted to expunge from painting everything materially inessential to it. In paintings such as *Red Square* [pl. 8] he rejected the anecdotal content of colour-contrast and composition and aspired to images which – for all their iconoclasm of form – had in common with Russian icon-painting a harsh spirituality, almost a spiritual dictat. Malevich's ambition was of a transcendental kind; he attempted to unite the viewer with the spirit of the new age.

7

Vladimir Tatlin
Model for a monument
to the Third
International, 1919.

The February revolution and the *proletkults*

When the revolution came it was in two stages. The first stage, the so-called bourgeois revolution, took place in February 1917 and led to the abdication of the Tsar and the formation of Kerenski's provisional government, reflecting a variety of political opinion. In the following months a novel form of art organisation appeared, that

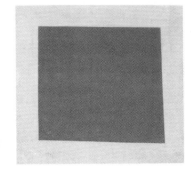

8

Kazimir Malevich
Red Square, 1914–15
Oil on canvas,
53×53 cm (21×21 in).
State Russian Museum.

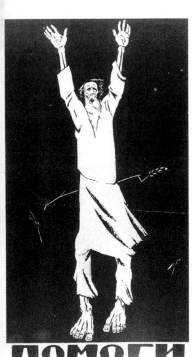

9

Dmitri Moor
Help! 1921–2.
Poster.

of the *proletkult* (acronym for proletarian culturo-educational organisation). The *proletkults* were the idea of the communist, Aleksandr Bogdanov (1873–1928), who wanted to make art responsive to the needs of the working class; theoretical support came from Georgi Plekhanov (1856–1918), a Marxist aesthetician, and in particular from his work "The Proletarian Movement and Bourgeois Art" (1905). The *proletkults* encouraged the masses to participate actively in making art. During 1917, *proletkults* sprang up in many cities, offering open access to the masses. By 1920 there were some 400,000 *proletkult* members, including 80,000 active in art studios and clubs, and about 20 *proletkult* journals.

The *proletkults* promoted the idea of *proizvodstvennoe iskusstvo*, production art – that is to say, the art of mass-production and factory technique – as a quintessentially proletarian art-form. They were thus in clear opposition to old institutions such as the élite Imperial Academy of Arts, established by the Empress Elizabeth in St. Petersburg in 1757; but, while rejecting the old regime, they were not tied to any particular political party. Bogdanov preached art's independence from direct political control; he believed that a proletarian art would take its own path towards communism.

The October revolution

The *proletkults* held their first conference in Petrograd (as St. Petersburg had been renamed in 1914) just days before the Bolsheviks seized complete political control of the country, accomplishing in October 1917 a second upheaval that was to prove far more decisive than the first. The Constituent Assembly was dissolved, Kerenski fled, and the possibility of a liberal consensus in government vanished.

Vladimir Ilich Ulyanov (1870–1924), better known by his revolutionary alias of Lenin, lived only a few more years to work at the revolution over which he had presided. He lived long enough to see a harvest of blood and debt – the blood spilt in the civil war with the White Army and its foreign allies, which lasted until 1921; and the debts run up by the fledgling Soviet state, to which almost every foreign government was hostile. The state of the nation during the period of so-called War Communism (1918–21) [pl. 9] and its aftermath, and Lenin's own poor health thereafter (he suffered his first stroke in May 1922), probably precluded any possibility of Lenin devising a comprehensive Bolshevik policy towards the arts. That was to come later. But Lenin's few interventions into cultural life are still very significant in that they foreshadowed much of what was to follow after his death. His utterances, even when temperately phrased, are often close in spirit to the rhetoric of the Stalin era. And even when Lenin himself was not directly involved, the cultural decrees and the artistic manifestos and debates of the Lenin period

are often, in embryo, those of ten or twenty-five years later. Official Stalinist art was a legitimate child of Lenin's revolution.

The new art world

A striking feature of the Bolshevik art world was that artists' lives gained a political dimension. This was in accordance with Marxist theories of culture, which viewed art, no less than other areas of social activity, as a political phenomenon. As part of a communist policy of worker self-government, artists were enjoined to administer and develop all aspects of the visual arts, such as exhibitions, purchasing and art education. In return they were given – at first – reasonable freedom to proselytise their own aesthetic beliefs. That this signalled the end of art as an autonomous activity seems to have been scarcely noticed by those artists, mainly avant-gardists, who first enjoyed the Bolshevik mandate. This is not to say that in the years preceding the revolution the avant-garde had practised *l'art pour l'art*; they had been well aware of the political metaphors – often the metaphor of revolution – present in their work; but they had adhered to the idea of revolution of their own free will, unbeholden to any political party. Now they forswore their independence for power, which, as communist sympathisers, they relished.

The organisation through which the new artistic bureaucracy worked was the art department of the People's Commissariat for Education, known as *Izo NarKomPros*. It was set up by Anatoli Lunacharski (1875–1933), Commissar for Education. He was a man of some broad culture, much of it gained while living in exile in Paris before the revolution. He was the brother-in-law of Bogdanov, and he shared some of his views on the necessary independence of art from overt political control. At the head of *Izo NarKomPros* he placed his friend, the painter David Shterenberg (1881–1948).

Shterenberg was a communist and a devotee of the modern movement in France [pl. 10]. His associates in the *Kollegiya*, or ruling body, of *Izo NarKomPros* included a broad cross-section of those Russian artists who were stylistically most progressive. They included Malevich; the constructivist Vladimir Tatlin (1885–1953); the abstract painter Vasili Kandinski (1866–1944); followers of Cézanne such as Robert Falk (1886–1958); primitivists such as Pavel Kuznetsov (1878–1968) and Aleksandr Shevchenko (1883–1948); and sculptors whose work showed the influence of archaic art, such as Sergei Konyonkov (1874–1971) and Aleksandr Matveev (1878–1960).

The rule of the avant-garde

These new structures and personnel represented a political victory for the avant-garde and its sympathisers – and a slap in the face for

10

David Shterenberg
Prostokvasha, 1919.
Oil on canvas,
89×71 cm
(35½×28½ in).
State Tretyakov Gallery.

academic and realist art – of which the *Kollegiya* was pleasantly conscious. The old Imperial Academy of Arts, dismissed by avant-gardists as a 'canonical ice-cream factory', was closed down in 1918. Indeed, avant-gardists urged the destruction of all the cultural baggage of the past, including razing the churches in the Kremlin. Shterenberg, responsible for the distribution of art materials, discriminated against realist artists, whom he saw as symbols of the old regime.

A famous expression of the avant-garde's ascendancy was Tatlin's projected *Monument to the Third International*, commissioned by *Izo NarKomPros* in 1919 [pl.7]. This gloriously impractical design, which looks like nothing so much as a fairground helter-skelter, was intended as the basis of a functioning headquarters building twice the height of the Empire State Building – a first inkling of the kind of *folie de grandeur* that was to become endemic in later, Stalinist architecture.

In the field of art education, too, *Izo NarKomPros* made its mark. The major art schools of Moscow and Petrograd, hitherto functioning along academic lines, were closed down in 1918 and reorganised into institutes with a liberal regime. At first they were known as Free Art Studios, because they offered open access to the populace. Later they were given more formal status and nomenclature as the *VKhuTeMas*, the State Artistic and Technical Studios; but, echoing the principles of the *proletkults*, they retained the principle of offering places first and foremost to the proletariat. The offspring of bourgeois families who wished to study art in the 1920s often had to take private lessons.

The avant-garde or 'leftist' artists, as the Soviets had it, also controlled state funding. The *Kollegiya* ran a museum bureau, headed for a while by the constructivist Aleksandr Rodchenko (1891–1956), another communist supporter. Its showpieces were the newly created Museums of Artistic Culture in Moscow and Petrograd, both filled with works of leftist art purchased with resources provided by the government. They benefited from Lunacharski's support – despite the reputation he now enjoys as a pluralist. Thus when as early as 1918 there was a complaint in the party newspaper, *Pravda*, about discrimination against realist art by the purchasing committee of *Izo NarKomPros*, Lunacharski explained (perhaps rather disingenuously when one considers that Shterenberg and other avantgardists were his friends) that the aim of his policy was to help those artists who had been most neglected during tsarist times.

The avant-garde expressed its views in the journal of *Izo NarKomPros*, *Art of the Commune*. It claimed to represent the true art of the revolution. 'Futurism – State Art' was the telling title of an article by the critic, Nikolai Punin (1888–1953). The artist Natan Altman (1889–1970) expressed the view that 'Only futurist art is at the present time the art of the proletariat.' Avant-gardists believed that a New Soviet Person would emerge from the revolution to

appreciate and make use of their discoveries. Although it is probably true that no good modernist was particularly tolerant of, or interested in, art less radical than his own, the utopian claims made on behalf of their work by the Russian avant-garde were unusually ambitious even when compared to the manifestos of their peers in Western Europe.

Lenin's views on art[1]

The belief of the avant-garde that an art of geometric shapes and industrial techniques could maintain itself as the one, exclusive art of the new Soviet state ignored a number of factors, not least of which was Lenin's own taste in art. Lenin did not like avant-gardism. He lacked the time, and probably any inclination, to be initiated into its logic; and more to the point, it did not offer him the evangelising power of realist art. He is said to have expressed the view that expressionism, futurism, cubism and other 'isms' (not including realism, presumably) were the least elevated manifestations of artistic genius – 'I feel no joy from them'. Of the poem *150,000,000* by the avant-garde poet and graphic artist Vladimir Mayakovski (1893–1930) [pl. 11], he said that Lunacharski should be 'thrashed for futurism' for publishing it. Lenin's disappointment may be pictured when, on a visit to the Moscow *VKhuTeMas* in February 1921, he asked a group of students whether they were fighting futurism. 'Of course not, Vladimir Ilich, we're all futurists ourselves' came the reply. Lenin did not question the ideological soundness of avant-garde activists so much as feel a genuine antipathy for their work; after the publication of Mayakovski's poem, he asked a colleague, 'Is it impossible to find any reliable anti-futurists?'

Lenin's taste in art was conventional; he understood only the traditional. He abhorred the vandal attitude of the avant-garde to the art of the past, stating: 'we must preserve the beautiful, take it as a model, use it as a starting point, even if it is old.' To this end, the state took control of the existing museums in Petrograd, the Russian Museum and the Hermitage, and of the Tretyakov Gallery, a museum of Russian realism donated to the city of Moscow in 1892. A Museum of New Western Art was created in Moscow to house the great collections of French impressionist and post-impressionist painting amassed by the merchants, Shchukin and Morozov, nationalised by Lenin in July 1918. In all, Lenin nationalised about 1,100 private art collections, comprising some 200,000 works; the idea of private art ownership and patronage on anything but a very modest scale was all but eradicated.

His views on the social role of art were largely derived from those of nineteenth-century Russian radicals. The most important influence in this respect was the revolutionary and critic, Nikolai Chernyshevski (1828–1889), whose aesthetic theories were expounded in his novel, *What Is To Be Done* (1863), and an essay,

11

Vladimir Mayakovski
Peasant, this is how to greet Vrangel, 1920.
Poster.

Vrangel was a general of the White Army during the civil war.
Mayakovski's advice to the peasant runs as follows:

1 Peasant, if you're waiting for Vrangel
2 As an angel from on high
3 Remember the tale of the rich benefactor
4 He'll take you in hand
5 Give you somewhere to live (JAIL)
6 Caress your head
7 Ask you to sing a little song
8 Give you a little plot of land
9 You make him happy: greet him like this

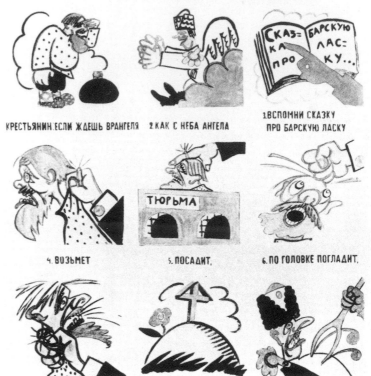

'The Aesthetic Relations of Art and Reality' (1853). Numbering a large number of artists among his acquaintance, Chernyshevski chose to promulgate the work of the Itinerants, a group of realist painters who took their name from their practice of arranging exhibitions which toured Russian towns. The Itinerants had come together in the second half of the nineteenth century. They were rebelling against the values of the Imperial Academy of Arts, which emphasised themes that had no connection with Russian life. The Itinerants espoused a high degree of social concern and, in many cases, a more robust, less finished manner of painting than academicism allowed. According to Ilya Repin (1844–1930), one of the leading Itinerants, their aim was to 'criticise mercilessly all the monstrosities of our vile society' – although Repin himself painted some notably patriotic, even jingoistic canvases (this paradox is perhaps typical of the Russian, painfully aware of his country's deficiencies yet fiercely in love with it). In 1893, the Itinerants accepted a rapprochement with the Academy; its leading members,

by now successful and rich, began to teach and exhibit under Academy auspices. This marked the end of the Itinerants as a real campaigning force in Russia, although the group itself continued to attract members and survived the 1917 revolution.

The art of the Itinerants in their heyday was one of social comment and social criticism, undemanding and popularly accessible in form – a perfect ally in the struggle to raise the consciousness of the mass. This commitment of a work of art to an idea or ideology of a social or political kind, vital to Chernyshevski and the Itinerants, came to be known as *ideinost*, which derives from the word *ideya*, idea.

It was a concept of art closely allied to that of Lenin's great mentors from Western Europe, Marx and Engels. Engels, for example, believed in the need for a 'socialist tendentious novel' as the antidote to the bourgeois nature of art in capitalist society. In other words, for Marx and Engels art had a class character, and a socialist art work was part of the struggle against the bourgeoisie. The essentially class-dictated nature of art has also been given a name in Soviet aesthetics, *klassovost*, although this word is not often met with.

Lenin's ideas on the proper role of art in society reflect these influences; they are trenchantly expressed in a conversation he held with his secretary, Klara Zetkin. He said: 'Art belongs to the people, it should extend with its deepest roots to the very heart of the great working masses. It should be understood and loved by these masses. It should bring together the feeling, the thought and the will of these masses and elevate them. It should stir the artists among them and develop them.'

This text was published only after Lenin's death, recalled by Zetkin from a conversation that was held in German, and thus the form in which these thoughts have reached us may well be that which was most congenial to the Stalinist regime. But there is no real reason to doubt that they were essentially Lenin's.

They express clearly the need for art to be not only popular, but also inspirational. This symbiosis is the basis of a most important concept in Soviet art, that of *narodnost*. The requirement for *narodnost* in art was first promulgated by the Russian critic, Vissarion Belinski (1811–1848), at a time when the Russian people were beginning to confront tsarist oppression. Derived from the word *narod*, meaning 'the people', *narodnost* is a slippery concept. It denotes a quality of popularity and accessibility, but it may also connote something arising from the people (e.g. in the form of folk or amateur art) or else something acting in the best interests of the people, educating and directing them.

But one idea above all characterised the Leninist view of art, and this was all his own: the principle of *partiinost*, submission to the decisions of the communist party. In his book *Party Organisation and Party Literature* (1905) Lenin had written: 'We want to establish, and shall establish, a free press, free not simply from the police but also from capital, careerism and, moreover, from bourgeois-anarchist

individualism.' From Lenin clearly stemmed the idea, so important to the development of Soviet art, that only by identifying his aims with those of the party might an artist claim to represent those ideas, of which freedom is one example, that European culture considers so valuable. *Partiinost* implied that all decisions, even ethical decisions, were a matter for the party and not the individual; the artist was encouraged to let the party look after his conscience.

Lenin's plan for monumental propaganda

Lenin had a vision of art that promised to unite those various qualities he valued in it: its public accessibility, its evangelical potential and its necessary *partiinost*. This vision was apparent in his *Plan for Monumental Propaganda*, published in 1918, requiring the urgent construction of more than fifty public monuments to famous figures. Their erection was accompanied by the destruction of many monumental works from tsarist times. This was the beginning of a wholesale dismemberment of Russia's cultural heritage by communists which continued apace for decades: the Leninist principle of the preservation of the achievements of the past proved to be selective in the extreme.

The list of those then intended to edify the Soviet populace is interesting for its catholic, pan-European perspective: it included Garibaldi and Robert Owen, Heine and Chopin, as well as Russian luminaries – a reflection of the internationalist ideals of the Bolsheviks at that time. The monuments were assembled in haste, often from poor-quality materials, and most were soon demolished. A number of portraits were said to have been execrated and vandalised by the public because they were executed in a cubist style which the public abominated; how far this is true, and how far an invention of Lenin's, and later Stalin's, cultural propagandists, it is today hard to judge.

However short-lived these first essays in monumental sculpture may have been, they were the seed-corn from which the whole Soviet tradition of monumental art was to grow. Although pre-revolutionary Russia boasted a fair sprinkling of monumental sculpture, Lenin's inspiration had its roots in an idea which he had come across in a book, *City of the Sun* (composed 1602, published 1623), by the Italian utopian, Tommaso Campanella (1568–1639), many of whose ideas were looked upon favourably by socialists. Campanella's book extols the idea of a communist state in opposition to the corrupt Italy of his day, in which the population is educated and edified by means of large public frescoes. Lenin recognised that fresco was an unsuitable medium for the Russian climate, and had the idea of using sculpture instead.

Thus Soviet monumental art issued from the conjunction of two

diverse urges: towards the utmost functionality on the one hand, and towards a mystic utopianism on the other. This is, in essence, the dialectic that was to assert itself most clearly in much art and architecture of the Stalin period.

Lenin acts against the *proletkults* and avant-garde

On 11 October 1920, Lenin sent a brief note to Nikolai Bukharin (1888–1938), a colleague in the ruling Council of People's Commissars. Bukharin was to speak on behalf of the party at the First All-Russian Congress of the *proletkults* a few days later. Bukharin's views on culture were liberal, and earlier in the day he had disagreed with Lenin. Now he was given guidance in a simple formula:

1 proletarian culture=communism
2 it is the responsibility of the RKP (the Russian Communist Party)
3 the proletariat class = the RKP = Soviet power. Are we all agreed on this?[2]

Under pressure from the party, the *proletkults* at the congress voted to relinquish the independence Bogdanov considered so important and to accept the control of *Izo NarKomPros*, thus bowing to the Leninist principle of *partiinost*.

Soon after, on 1 December 1920, an open letter was published from the Central Committee of the Party. It was an attack on the *proletkults*, and stated that in the guise of proletarian culture bourgeois views had been aired in philosophy ('Machism') and that in the arts workers were being offered 'absurd, perverted tastes (futurism)'. (Machism, as opposed to Marxism, was a philosophy derived from the writings of one Ernst Mach (1838–1916); Lenin opposed it as a form of idealism at odds with materialism.) This intervention was significant because of the party's decision to attack futurism, a catch-all name for all kinds of avant-garde art, under cover of further criticism of the *proletkults*. The inclusion of the term 'futurism' in brackets in the letter was a sleight of hand not entirely justified by the facts: the *proletkults* were not the only, or even the main, forum for the avant-garde. That Lenin chose to stretch a point here is indicative of his own antipathy to avant-gardism.

Further attacks on the *proletkults* by the party in 1921–2 led to the collapse of their network of art studios; during the 1920s their most interesting work was in the theatre (the film director, Sergei Eisenstein (1898–1948), worked in the *proletkults*' First Workers' Theatre for a time). As far as stylistically progressive artists were concerned, the open letter about the *proletkults* signalled the emergence of a party line in the arts that was fundamentally hostile to avant-gardism and in favour, implicitly, of realism.

The realists' challenge

Avant-gardists did not just have to contend with Vladimir Ilich and his slogan of 'art is for the people', or with a general public brought up on a diet of icons and realistic genre-painting. They also faced antagonism from a large body of artists. The avant-gardists' energy, aggression and belief in their mission were counterbalanced by the sheer weight of numbers of realist artists. These artists were products not only of the big pre-revolutionary institutes such as the Imperial Academy of Arts or the Moscow College of Painting, Sculpture and Architecture, but also of innumerable private studios, run by practising artists and scattered in towns the length and breadth of Russia.

Punin expressed the avant-gardists' distaste for, and wariness of, the 'realist-itinerants' in the journal, *Art of the Commune*, describing them as 'by and large of little intelligence, and although weak in their degree of artistic culture, nevertheless strong and constructive, crude and naïve. The proletariat, especially non-communists and those of little culture, are instinctively drawn to them, to their coarse tastes, even to their obvious lack of taste . . .'[3] These are the words, if not of an aesthete, then of a cultivated man who has discerned in the population at large an affinity for the unsophisticated, the vulgar, the prosaic in art, and who is acute enough, in his Soviet milieu, to feel threatened by it.[4]

It is understandable that realists should not have seized the initiative in October 1917. The Soviet realist usually had more of a stake in the old regime, having patrons among the bourgeoisie and aristocracy, and was unlikely to burn his boats while the civil war raged and the White Army had a chance of securing power. And – as a painter of portraits, maybe, or of religious devotional scenes – he had to watch his step: he might paint someone or something far more offensive to a new regime than a collection of triangles, circles and squares. Although one can find many realist painters who supported the revolution from the outset, there are many more who, for a time, discreetly hung fire.

Typical was the experience of Aleksandr Gerasimov (1881–1963) – a committed realist, painter of portraits and still-lifes, sitting out the civil war in the town of Kozlov. Gerasimov had painted portraits of tsarist military commanders during the First World War. In 1918, dismayed by the avant-garde predominance in Moscow, he returned to his home town. There he made paintings of Marx and Engels, which caused him to go into hiding when Kozlov fell temporarily into the hands of the White general, Mamontov.[5]

As Bolshevik power gradually became more secure, realist artists in Moscow and Petrograd began to reassert their claims in competition with those of the avant-garde. In July 1918 many avant-

gardists refused to participate in an exhibition in Moscow arranged by the new Moscow Trade Union of Artists, citing the presence of old-fashioned artists among the exhibitors as a reason. By the end of 1918 *Izo NarKomPros*, despite referring patronisingly to realism as the 'impressionist-naturalist tendency', was willy-nilly organising exhibitions of realist art. In 1919 a competition was held in Petrograd for works of art on the theme of The Great Russian Revolution. The painting section was won by Isaak Brodski (1884–1939), a meticulous, Academy-trained painter, with a picture of Lenin [pl.12].

The cult of Lenin

Thus the pictorial genre of the Leader, a genre which was to play such an important role in the Stalin era, was first sanctioned and rewarded under Lenin.

That Lenin actively encouraged a cult centred on himself is most unlikely: he valued power, not adulation. However, the groundwork for this cult, which was the prototype for the cult of Stalin, was laid during his lifetime. The first poster depicting Lenin was issued in 1918. In the same year, following the attempt on his life by Fania Kaplan, his fellow Bolsheviks seized the opportunity to laud him in print: 'He is really the chosen one of millions. He is leader by the grace of God. He is the authentic figure of a leader such as is born once in 500 years . . .' wrote Grigori Zinovev (1883–1936) in a

12

Isaak Brodski
V. I. Lenin and the Demonstrations, 1919.
Oil on canvas,
90×135 cm (35½×53 in).
Central Lenin Museum,
Moscow.

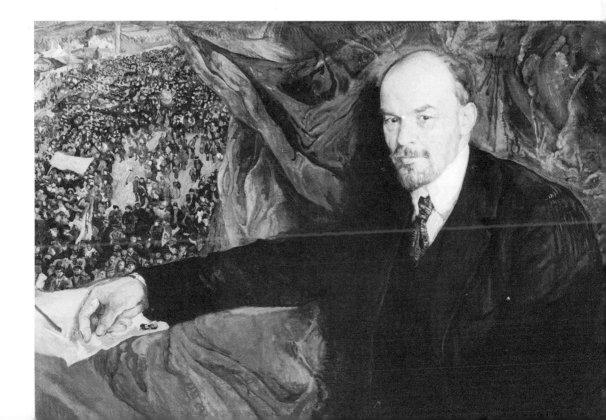

speech published in an edition of 200,000. Leon Trotski (1879–1940), too, enthused in a pamphlet. In 1920, Mayakovski recited his poem *Vladimir Ilich*: 'but who can restrain himself / and not sing / of the glory of Ilich?'

In August 1923, by which time Lenin was already a sick man, convalescing in Gorki, the All-Union Agricultural and Domestic-Industrial Exhibition opened in Moscow; on display was a giant portrait of Lenin woven from thousands of living plants. The exhibition also boasted a Lenin Corner (the name derived from the so-called Red Corner where icons traditionally hung in the Russian home) consisting of a number of rooms containing photographs and documentary material concerning Lenin. It is possible that Lenin would have prevented such an innovation had he been able to, but he was not. His party colleagues encouraged the cult, probably convinced that Lenin would not recover; it was a useful means of shaping the consciousness of the masses, one which depended, ironically, on the entrenched habit of tsar-worship which the Bolsheviks held in scorn.

Portraits of Lenin made during his lifetime are usually modest affairs. A number of artists drew him from life, including Brodski, Altman and most famously the sculptor, Nikolai Andreev (1873–1932), who devoted huge energies to the Lenin theme throughout the 1920s. He also made, in 1922, the first recorded portrait of Iosif Vissarionovich Dzhugashvili (1879–1953), known as Stalin.

Beginning of the end for the avant-garde

The leading avant-gardists were united in 1920 as members of the newly created Institute of Artistic Culture, *InKhuK*, in Moscow. *InKhuK* was under the auspices of *Izo NarKomPros*; its members hoped that it would provide a base from which they could control the development of Soviet art. *InKhuK* drew up, for example, the timetable of the new art schools, *VKhuTeMas*.

In May 1920 members of *InKhuK* debated the future role that their artistic principles might play in the Soviet state as a whole, and reached the majority decision that this role lay in the field of applied, as opposed to fine art. This decision, inspired by the widely held desire to make art accessible and useful to the masses, put the organisation in the hands of a group who called themselves productionists (not to be confused with those *proletkultists* who supported a similar idea of 'production art').

This majority decision was unpalatable to some members of *InKhuK*. It seemed to them to confirm and consolidate the way in which state policy in the fine arts was already evolving away from support for avant-garde ideas. In the prize given to Brodski's portrait of Lenin in 1919, and in Lenin's disapproval of futurism, they

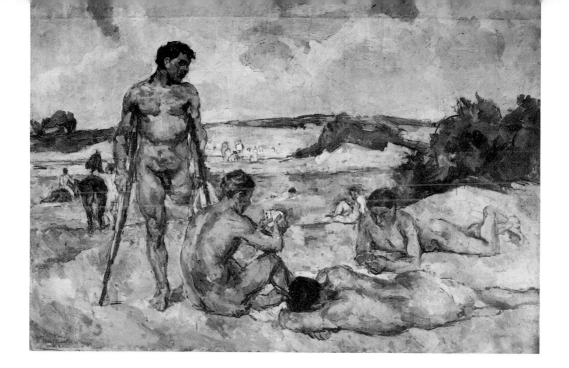

discerned the writing on the wall. A diaspora of avant-garde artists from Moscow now took place as the avant-garde carried its faith to distant parts. In 1921 Kandinski took up an invitation to teach at the Bauhaus in Germany: he never returned to Russia. The constructivist, Naum Gabo (1890–1977), left for Berlin in 1922 and his brother, Natan Pevsner (1886–1962), departed to Paris in 1923; Malevich quit Moscow for the art school in Vitebsk, where he set up his *UNovIs* group, the Affirmers of New Art; Mark Chagall emigrated to Berlin in 1922. Those avant-gardists who remained in Moscow – Tatlin, Rodchenko, El Lissitski (1890–1941) – pursued the application of avant-garde ideas in the field of design.

Some of the avant-garde, led by Malevich and abetted by Pavel Filonov (1883–1941), were to regroup at the Petrograd branch of *InKhuK*, where Malevich was director from 1923 to 1926. But here, too, he was constrained and sometimes reduced to designing teapots of awesome impracticality. Many other leftist artists also continued to teach; but in the capital they had abandoned for good the non-figurative heights of their brief supremacy in painting and sculpture.

Figurative art ascendant

Henceforth the salient and influential groupings of painters and sculptors were to be composed of figurative artists. They were helped by the institution in 1921 of the *NEP*, Lenin's New Economic Policy, which provided for a measure of free enterprise and led to the reappearance of private patrons.

13

Pyotr Konchalovski
Soldiers Bathing, 1922.
Oil on canvas,
130×180 cm
(52×72 in).
Private collection.

Many of these figurative artists were adapting to the new ground-rules of Soviet art and exploring socially concerned subject-matter. This did not necessarily impose strain: a social dimension was an important feature of Russian culture before the revolution. Painters working in the widely practised modes of primitivism and cezannism now created works of quite emphatic social engagement. In the hands of Pyotr Konchalovski (1876–1956), the leading figure among the Russian followers of Cézanne, the subject of bathers [pl.13] – in Cézanne's hands a pretext for the exploration of questions of pictorial form – was adapted to show the cruel consequences of the civil war.

The fundamental unit of the Soviet art world, to an even greater extent than in pre-revolutionary Russia, was not the individual, but the group. This reflected the bias against individual endeavour in communism. In the early 1920s many groups were formed, each emphasising a return to traditional values. Among the most important in Moscow were *NOZh*, the New Society of Painters, whose manifesto stated that painting should be 'objective and realistic'; and *Makovets*, whose members believed 'that a renaissance in art is possible only in a strict succession from the great masters of the past'.

The most popular group to emerge, in the size of its membership, and also the most influential, measured by its proximity to the ear of the leadership, was stylistically the most conservative. It was known as *AKhRR*, the Association of Artists of Revolutionary Russia. Formed in 1922, *AKhRR* espoused a traditional realism. Its first

chairman, Pavel Radimov (1887–1967), was a former member of the Itinerants. It spoke for the majority of Russian artists and also catered to the taste of Lenin and most of the party élite. No less than Lenin, *AKhRR* felt a positive antagonism towards the avant-garde, stating in its manifesto: 'We will provide a true picture of events and not abstract conceptions discrediting our Revolution in front of the international proletariat.'

Its conservatism in matters of artistic form, however, was countered by its seizure of the ideological initiative. *AKhRR*, like the avant-garde a few years before, tied its programme to that of the party. It asked party high-ups for guidance; in effect, it chose to adopt Lenin's principle of *partiinost*. It stressed the importance of revolutionary content, and its manifesto declared: 'We will depict the present day: the life of the Red Army, the workers, the peasants, the revolutionaries, and the heroes of labour.'

AKhRR artists dubbed their style 'heroic realism'. *Transport is being Laid* [pl.14] by Boris Yakovlev (1890–1972) was particularly well received in the press. It inspired a whole new genre devoted to Soviet industrial striving: the industrial landscape. The familiar genres of realist art – landscape, portrait, still life, history painting – were imbued with communist *ideinost*, ideological content. Pictures attuned to the current policies of the party were exhibited at thematic exhibitions devised to produce a contribution to social debate; for example, the first *AKhRR* exhibition in 1922 was called 'An Exhibition of Artists of a Realistic Orientation in Aid of the Starving'.

From the beginning, *AKhRR* established good relations with the Red Army and its chief, Trotski. The fourth exhibition of *AKhRR*, held in March 1923, was devoted to the army's fifth anniversary. Nearly every work at the exhibition was purchased for a new Museum of the Red Army and Navy. This close relationship between art and the military – the legitimisation of each by association with the other – was to be a striking feature of the Stalin period.

In effect, *AKhRR* artists were inheritors of the tradition of engaged art represented by the Itinerants, who held their last exhibition in 1923. Painters such as Radimov, Abram Arkhipov (1862–1930) and Nikolai Kasatkin (1859–1930) who joined *AKhRR* from the Itinerants provided a tangible link with the traditions of socially concerned nineteenth-century Russian realism. Like the Itinerants, the *akhrrovtsky* created exhibitions that travelled from city to city. The Soviet citizen, unsophisticated in his response to the visual arts, was now actively enjoined to educate himself in a culture which had been remote from him before the revolution. To such a viewer, the paintings of *AKhRR* artists, exhibited in plain wooden frames which eschewed the gilt that was considered bourgeois, offered a comprehensive and approachable reflection of everyday life. The formation of *AKhRR* ensured that, when Lenin died in January 1924, Soviet art was well on its way to becoming the evangelising tool of the party that he had envisaged.

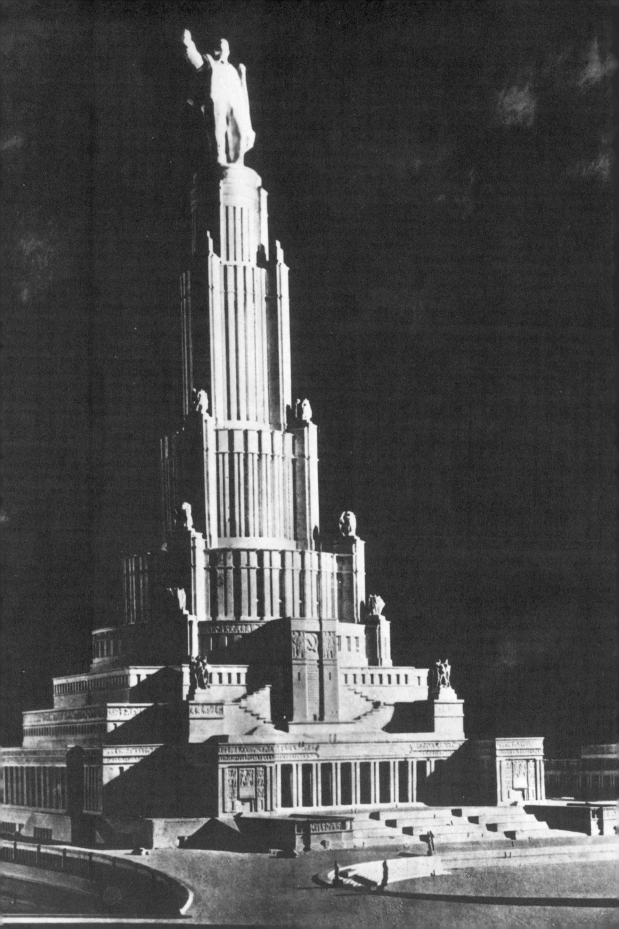

1 Communism in One Country

Reconstruction and Industrialisation 1924–32

The rise of Stalin

Stalin, General Secretary of the party since 1922, was only one of several contenders for supreme power after Lenin's death, but during the 1920s he took control of the party by out-manoeuvring his rivals and setting them one against the other. Bukharin, Zinovev and Lev Kamenev (1883–1936) were all dealt with in this way; Trotski, his main competitor, was removed as Commissar of War in 1925, and by 1929 had been sent into exile abroad. In the same year Stalin's name, which had previously appeared in its alphabetical order in communications of the politburo, began to appear first.

Economic policy and the artistic heritage

In 1925 Stalin rejected the theory, widely accepted in Bolshevik circles, that a world-wide communist revolution was necessary to Soviet development. His new slogan of 'communism in one country' defined the goal, and the party embarked on a huge economic and industrial adventure to achieve it. There were two planks to the plan: the collectivisation of agriculture, which took place largely in 1929–32, and the first Five-Year Plan of 1928–32; between them they effectively brought Lenin's NEP to an end.

Collectivisation wiped out the class of private peasants. This caused great suffering and almost beggared the country. Peasants resisted herding into giant collective farms by slaughtering their own livestock and refusing to work. Millions died as famine, artificially maintained to crush peasant resistance, gripped the Ukraine.

15

Boris Iofan,
Vladimir Gelfreikh,
Vladimir Shchuko
Model for Palace of the
Soviets, 1934.
415 cm (163 in) high.

The party ruthlessly reduced an estimated 25,000,000 private farms in the mid-1920s to less than a quarter of a million, or 1 per cent, by 1932.

The first Five-Year Plan was the crowning development in a process of reconstruction which had begun after the civil war; it dragged the fledgeling state into the industrial age. Enormous projects were undertaken, such as the *Dneprstroi*, the dam on the river Dnepr, and Magnitogorsk, a vast steel-producing plant in the Urals. Stalin's goal was industrial self-reliance, the creation of an economic base on which a socialist society could indeed be fashioned and maintained by the resources of one country alone.

These great projects became important subjects for Soviet artists; but they also sheared away much of the Soviet cultural inheritance. To raise foreign capital for the Five-Year Plan, the sale of paintings from the Hermitage and the New Museum of Western Art was sanctioned by Stalin, in opposition to Lunacharski's wishes. Anastas Mikoyan (1895–1978), one of Stalin's political protégés, organised the disposal of many great masterpieces: works by Titian, Rembrandt, Raphael, Botticelli, Rubens, Veronese, Van Gogh and Cézanne were lost abroad in this way, bought largely by millionaire collectors such as Andrew Mellon, Calouste Gulbenkian and Armand Hammer. In the peak years of 1928–33 it is estimated that, in addition to masterpieces of painting, some 6,000 tons of valuables – icons, jewellery, objets d'art, religious treasures – were flogged off, often for absurdly low prices. These sales undermined Bolshevik claims to be protecting the country's art heritage; for Stalin, art of any kind was never to be more or less than the means to a political end – the establishment of communism.

Architecture and design: the activity of the avant-garde

Although many avant-gardists abandoned painting and sculpture in the early 1920s, they often continued to work in fields of applied art, where, throughout the decade, their ideas were still looked on favourably. Rodchenko designed furniture and explored a constructivist vision in photography. Tatlin, working in Kiev from 1925 to 1927 and then in Moscow, constructed a flying machine, the *Letatlin*, which displayed all the structural beauty and brazen impracticability of his earlier monument to the Third International. The Moscow *InKhuK* was devoted to the idea of a functional art. Some avant-gardists created architectural projects of great interest. Malevich, working at the Leningrad *GInKhuK*, State Institute of Artistic Culture, from 1923 until about 1928, produced a whole series of works he called *arkhitektons* and *planits*: designs for the cities of an ideal future which looked very much like three-dimensional embodiments of his earlier suprematist paintings.

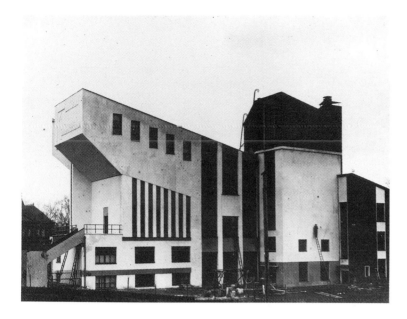

16

Konstantin Melnikov
*The I. V. Rusakov
Workers' Club*, 1927–9,
Moscow.

The ending of the civil war and establishment of a relatively stable regime gave constructivist architects a chance to carry out a string of innovative buildings. Commissions were also given to leading foreign architects such as Le Corbusier. In the late 1920s and early 1930s Moscow became a centre of architectural experiment, of which the workers' clubs of Konstantin Melnikov (1890–1974) are a fine example [pl. 16].

Lenin's mausoleum

The period 1924–32 is clearly marked, at beginning and end, by two great architectural projects which encapsulate the development of architectural thought over these years.

The first was the project for a mausoleum for the dead leader, Lenin, who had been embalmed at Stalin's insistence.[6] His body was given three mausoleums in turn, each more remarkable than the last. The first, erected in two days in January 1924, was a grey-painted wooden hut put up in Red Square to shelter the body while mourners trooped past it. This was soon replaced by a second, more elaborate wooden structure, which bore the novel feature of two tribunes above the entrance, intended to accommodate party leaders. This mausoleum had a dual purpose, the one – the housing of Lenin's body, laid out in a sarcophagus designed by the constructivist, Melnikov – lending authority to the other – the assembling of his successors on ceremonial occasions in Red Square. The building thus blended the mysticism and didacticism which, as we

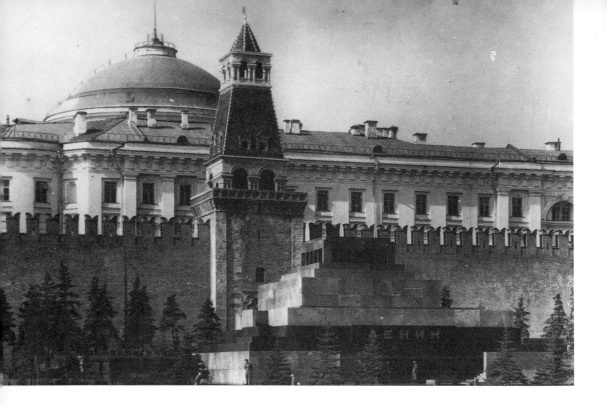

17

Aleksei Shchusev
Lenin's Mausoleum,
1929–30.
Red granite and black
labrador stone.
Red Square, Moscow.

have seen, characterised Lenin's own plan for propaganda by monuments.

In January 1925 a competition was announced for a permanent mausoleum to be built in stone. The winning design [pl. 17] belonged to Aleksei Shchusev (1873–1949), originator of the earlier wooden structures, of which it was a development. It was selected from a large submission, including one project from Tatlin that would have incorporated an auditorium, telephones and a radio station. Shchusev had already designed a number of important buildings in a range of styles. Before the revolution he had helped to restore churches and built Moscow's Kazan station, combining in it both classical and old Russian influences. In the 1920s he developed avant-garde ideas, carrying out such works as the headquarters of *NarKomZem*, the People's Commissariat for Land, in modernist style.

Shchusev's mausoleum is really a modernist work, too. Its pyramidal structure – a massive base incorporating a portal; stepped tribunes above; a crowning portico – consists, essentially, of cuboid blocks of diminishing size. The cube, for Shchusev and other avant-gardists, was of almost transcendental import. Its symbolism in relation to Lenin was perhaps best summarised by Malevich, who wrote of it as 'a new object with which we try to portray eternity, to create a new set of circumstances, with which we can maintain Lenin's eternal life, defeating death'. These words not only lend credence to the view that the striving of the avant-garde was at

bottom spiritual rather than material, but they also emphasise that the avant-garde were no more averse to Lenin-worship than any other strain of Soviet artist at the time; Malevich had plans for a thorough-going cult of Lenin, with cubes in every home![7]

Shchusev's building combined modernist simplicity with a veiled glance back at the classical heritage. This is apparent in the unrealised plan to decorate the interior with murals, but above all in the overall form of the mausoleum: a pyramid. It even seems possible that the design of the mausoleum, like the decision to embalm Lenin's body, was in part a response to the discovery in 1922 of Tutankhamun's tomb in Luxor – an event which made news around the world. Shchusev's return, in 1924, to such an ancient source was in stark contrast to the mainstream of Soviet architecture; and yet it was a gesture that was to prove prophetic.

The Palace of the Soviets

During the late 1920s, the debate about the proper relationship of Soviet architecture to past traditions was intense. This debate came to a head in 1931, when a competition was announced for the right to design the Palace of the Soviets. This building was intended to be the seat of government and the single most important structure in the entire Soviet Union.

Competition entries came from around the world, from Le Corbusier and Gropius among others. After a preliminary selection of the projects considered most suitable, the government issued in 1932 a decree that gave guidance on their further development: 'the construction council considers that research should be directed towards using both new and also the best elements of classical architecture, relying at the same time on the achievements of contemporary techniques of architectural construction'. Articles also appeared in the press stressing the need for the Palace to have a classical orientation; the novelist, Aleksei Tolstoi, writing in the party newspaper, *Izvestiya*, said grandiosely that it should incorporate 'the whole cultural inheritance of the past'.

So the party came down firmly on the side of a neo-classical solution, which was confirmed when, in 1934, a decision was finally made in favour of the project submitted by Boris Iofan (1891–1976) and developed with the assistance of Vladimir Gelfreikh (1885–1967) and Vladimir Shchuko (1878–1939). It had a façade that was to be covered in pillars and bas-reliefs in the classical style – and a rocket-like thrust to an intended height of 300 metres. This huge size was a reflection of the technological aspirations of Stalin's Five-Year Plans.

Most staggering of all was the decision – legend says it was Stalin's – to crown the building with a vast figure of Lenin, intended to rise another 100 metres [pl. 15]. This commission was given to

the sculptor, Sergei Merkurov (1881–1952), who in 1924 had been given the task of making Lenin's death-mask. Merkurov's Lenin, arm imperiously outstretched, echoed a number of sculptures of Lenin made in the 1920s, notably a work by Ivan Shadr (1887–1941) erected at *ZAGes*, a great hydro-electric power station, in 1927. The Palace of the Soviets project confirmed this pose as the main iconographic solution to the portrayal of Lenin; it was later to be used for other Soviet leaders.

The building itself was effectively cast in the role of a gigantic pedestal; the vast bureaucracy it was to house subordinated to the great idea – Soviet communism – of which Lenin's image, no less than his embalmed body, was now the symbol.

It would be wrong to over-emphasise the classical aspect of the Palace of the Soviets. Its towering circular form was an unmistakable echo of that great constructivist landmark, Tatlin's *Monument to the Third International* [pl. 7]. Thus the design of the Palace of the Soviets, which was to influence the thinking of Soviet architects throughout the 1930s and 1940s, represented not a complete break with the architectural ideas thrown up by the revolution, but a profound transformation of them, signifying the new desire of the Soviet state to measure its culture against the great achievements of the classical past.

Foreign opinion was appalled by the winning project. Le Corbusier, Gropius and others wrote to protest, utterly unable to comprehend such a massive slight to their own artistic principles. And indeed, this insolent abnegation of everything that the Modern Movement held dear heralded the birth, at the start of the 1930s, of Stalinist culture proper.

Art: control by commissions

After Lenin's death, the party intervened more and more to direct the activity of artists. Around 1925, for example, communist professors were introduced into the art schools as a matter of policy. Central to the party's attempt to exercise increased control in the art world was the commissioning process. In the period 1924–32 the commissioning of works of art, always irregular under Lenin, became widespread. At first, money was channelled through a variety of organisations, such as *Izo NarKomPros*, the Red Army and the trade unions, all of which ordered works on themes that suited them. In 1929, an attempt was made to systematise the procedure by the establishment of *VseKoKhudozhnik*, a handy acronym for the All-Russian Union of Co-operative Comradeships of Workers of Representational Art. Under the directorship of Yuvenal Slavinski, branches of *VseKoKhudozhnik*, the so-called *tovarishchestva* or comradeships, were set up all over the country. They worked through the system of *kontraktaktsiya*, which meant that they entered into

contracts with artists for the production of work, which was then sold on to institutions, from museums to ministries, factories and sanatoria. *VseKoKhudozhnik* was joined in 1930 by *IzoGIz*, a newly formed state publishing house devoted to the visual arts. It took responsibility for posters, reproductions and books on art.

These two organisations worked closely with interested bodies such as the Red Army and the Peoples' Commissariats. They were guided above all by the party and its policies. For example, a decree of the Council of People's Commissars in July 1930 resulted in 200 artists being sent for a period of two months each to construction sites and collective farms. Their task was to make propaganda on behalf of the Five-Year Plan and the collectivisation programme. Thirty per cent of the work they produced was rejected – a common occurrence; the purchasing committees of *VseKoKhudozhnik* and *IzoGIz*, composed of artists and critics, had the power to ask an artist to rethink or rework a commission if they deemed it unsatisfactory, and even to tell him what changes to make. In this way, the principle of collective as opposed to individual judgement was installed as the critical ideal.

Art: style

A condition of uncertainty and debate about the proper language of painting and sculpture prevailed in the mid-1920s as a host of groups, each espousing a form of figurative art, aspired to the leading role. This state of affairs was consonant with a decree of the party Central Committee of July 1925, the party's first important intervention in the field of culture since Lenin's attacks on the *proletkults*. Although this decree referred to *belles lettres*, it was understood (in common with all pronouncements of the party that made reference to one artistic discipline) to refer to cultural activity in general. It stated the need, 'using all the technical achievements of old mastery, to work out a . . . form, understood by millions.' The party was not specifying too narrowly the exact nature of such a mass art; it accepted, by implication, a plurality of styles. This reflected the wishes of Lunacharski and also the influence of Bukharin (himself an amateur painter of good standard) who valued stylistic variety.

The groups and the individual

Membership in one of the burgeoning number of artistic groups was not obligatory, and many artists changed groups or spent time both in and out of them. Some groups, all of which had to be registered with the authorities, existed for only a few months or the space of a single exhibition, and all had a constantly shifting mem-

bership. But the group was the effective unit; it reflected the communist ethic of collective activity and enabled its members to approach the authorities for funds and studio and exhibition space.

Artists outside groups were given, like it or not, a collective epithet – *khudozhniki-odinochki*, artist-loners; and they became, *de facto*, a group of sorts because exhibitions were organised of their work. Many of these artists, by temperament reserved, not disposed towards self-promotion, and also by their very isolation ill-suited to critical attention at a time dominated by the aggregate voice, have been largely ignored until recent years. One outstanding example is Antonina Sofronova (1892–1966). She moved to Moscow from Tver in 1921 and ploughed a lonely furrow, exhibiting infrequently and attracting no critical attention. In the late 1920s, she began to paint the simplified, cool-toned landscapes of Moscow for which she is now famous [pl. 18]. Her best work is of the highest quality, yet she achieved prominence only briefly at the time, by virtue of a single exhibition with the Group of 13 graphic artists in 1931.

The groups: *OSt*

OSt, the Society of Easel Painters, was formed in 1925 under the chairmanship of Shterenberg. Many of its thirty or so members were former students at *VKhuTeMas*, where they had studied under teachers such as Shterenberg, the outstanding graphic artist Vladimir Favorski (1886–1964) and a number of avant-gardists. *OSt* inherited, in effect, the mantle of the old avant-garde; its members combined ideological commitment with an interest in the formal possibilities inherent in painting and revealed by modernism.

The subject of industry was central to the ambitions of *OSt*, which strove, in the words of its manifesto, towards 'revolutionary contemporaneity and clarity in the choice of subject'. The other great subject of *OSt* artists was the New Soviet Person, whose appearance had been predicted first by the avant-garde: in their evocation of this person, members of *OSt* were often guided by industrial metaphors. Their New Soviet Person functioned in muscular harmony with machinery in factories and on construction sites; sometimes he or she was a sportsperson, the embodiment of discipline and efficiency.

These ideas received their most perfect expression in the work of the outstanding figure in *OSt*, recognised as such from the beginning – Aleksandr Deineka (1899–1969) [pl. 19]. His startling graphic flair was revealed in the many illustrations he executed in the 1920s for journals such as *Bezbozhnik u Stanka*, The Atheist at Work. His paintings are gloriously deft: Deineka used to say that to touch any part of a painting with the brush more than twice was excessive.

Other leading members of *OSt*, such as Aleksandr Labas (1900–1988) and Yuri Pimenov (1903–1977), shared Deineka's graphic verve and enthusiasm for socialist construction. *OSt* artists also depicted military scenes and painted portraits (a portrait of Feliks Dzerzhinski, founder of the Soviet secret police, by Pyotr Vilyams (1902–1947) hangs today in the KGB club in Moscow). But *OSt*, like most groups in the 1920s, was a broad church. One of its most important members was Aleksandr Tyshler (1898–1980), in whose work the primacy accorded by *OSt* artists to drawing was united with an original strain of fantasy, to the point where it strayed beyond the limits of an overtly social art. Even though Tyshler's work provides a poetic – and sometimes disturbing – image of the relation of man to society [pl. 20], his outlook on life was not ordered by ideology; the lyricism and intimacy of his work repudiate rhetoric. He once listed doing the washing up and going shopping among his favourite activities, and his art is an attempt to make numinous the rituals of everyday life with poetry.[8]

18

Antonina Sofronova
Ostozhenko Street, 1932.
Oil on canvas,
65×80 cm
(25½×31½ in).
State Tretyakov Gallery.

The groups: *OMKh*

OMKh, the Society of Moscow Artists, was formed in 1927 on the base of an earlier grouping, the Moscow Artists (formed 1924, disbanded 1926). It represented the survival of a liberal establishment, of sorts, in the arts. The leading members of this group, such as Konchalovski, Falk, Ilya Mashkov (1881–1944), Sergei Gerasimov

(1885–1964), Aristarkh Lentulov (1882–1943) and Aleksandr Osmyorkin (1892–1953), had in many cases made a reputation for themselves before the revolution as members of the Jack of Diamonds, the leading group of Russian artists to respond to the work of Cézanne. Now a number of them held important teaching posts in *VKhuTeIn*, as the Moscow *VKhuTeMas* was renamed in 1925.

Despite a whiff of avant-gardism which was still attached to Cézanne in Russia and their publicly stated belief in painting as a 'mass art', the real enthusiasms of *OMKh* members were unimpeachably traditional and resistant to political ideology. Landscape, portrait and above all still-life were their preferred genres, approached often in sombre tones that were a legacy of the nineteenth century [pl. 23].

The groups: The 4 Arts

The declaration of The 4 Arts, formed in 1925, stated: 'we consider the French school the most valuable for us, as the one most fully and comprehensively developing the basic properties of painting'. These words reflect a continuing international outlook among painters and sculptors despite the dissolution of the avant-garde; they testify to the influence upon Soviet artists exerted by the French impressionism on show at the New Museum of Western Art, a great source of national pride.

The 4 Arts was a group whose members paid particular attention to the formal language of art. They included such leading avant-gardists as El Lissitski. Other significant figures were Kuzma Petrov-Vodkin (1878–1939) a painter, teacher and theoretician who exercised powerful influence in Leningrad, and the sculptor, Vera Mukhina (1889–1953), a former pupil of Bourdelle in Paris. Both practised a realism in which the method of depicting solid bodies was refined by the influence of cubism. Forms in Mukhina's monumental, defiantly public sculpture, *Peasant Woman* [pl. 21] are pared down and given some of the self-sufficiency of geometry.

Members of The 4 Arts, which had branches in Moscow and Leningrad, hailed from all over the Soviet Union, and some of them specialised in the portrayal of life in the outlying regions of the new Soviet empire. Notable among these artists were Martiros Saryan (1880–1972), a painter of Armenia, and Pavel Kuznetsov (1878–1968), who in the late 1920s and early 1930s made trips to the Crimea, Armenia and Azerbaijan. Kuznetsov was a considerable figure in the art world of the 1920s: a member of the *Kollegiya of Izo NarKomPros*, a teacher, chairman of The 4 Arts. He often made use of primitive, non-academic conventions of space and light [pl. 22]. These he may have derived from the example of his father, an icon painter, or from an early experience of painting church murals in his home town of Saratov; but, as the self-conscious adaptation of a naïve mode, they also underline his sophistication and awareness of international trends.

The groups: The Circle

Members of The Circle, a group formed in Leningrad in 1925, strove towards the creation of 'the style of the age'. For a number of Circle artists, such as Vyacheslav Pakulin (1900–1951), Aleksei Pakhomov (1900–1973) and Aleksandr Samokhvalov (1894–1971), this declared aim did not exclude, however paradoxically, a revival of stylistic elements from old Russian religious painting. (Indeed, despite the state's avowed atheism, the influence of Russian icon painting and church murals is apparent in the work of important artists from a variety of groups, of which Petrov-Vodkin and Kuznetsov of The 4 Arts are outstanding examples.) Samokhvalov was inspired by time spent in 1926–7 restoring frescoes in the Georgiev cathedral in Ladoga. His work demonstrates how well the monumental single figures, shallow illusion of space and decorative articulation of the picture-surface which typify this old, Byzantine-derived art chimed in with the formal concerns of European modernism, to which the Circle artists also looked [pl. 24].

The groups: *AKhRR*

To its initial declaration of May 1922 – the promise to depict the life of the Red Army, workers, peasants, revolutionary activists and heroes of labour – *AKhRR* added a lengthy gloss in May 1924. This took the form of an open letter from its presidium and party section. It stressed the importance of the Russian school, and singled out certain of the Itinerants – Repin, Vasili Perov (1833–1882), Vasili Surikov (1848–1916) – for praise, contrasting their example to the 'empty decorativeness, retrospectiveness, effete decadence' of the pre-revolutionary period. The letter was subtly against foreign influence in the arts, and that of French art in particular; it rejected an apolitical stance; it preferred an art patriotic in its origins, realistic in style, and devoted to the cause of the revolution.

AKhRR: the *kartina*

Central to the contribution of *AKhRR* in the 1920s was the big 'thematic picture', the *kartina*. Although the first declaration of *AKhRR* makes no reference to such a mode of expression, it soon became an idea that *AKhRR* keenly supported. Opening the seventh *AKhRR* exhibition in 1925, Lunacharski, who had bent in the ideological wind and put himself wholeheartedly behind this grouping of realists, declared: 'The proletariat needs the *kartina* – the *kartina* understood as a social gesture', and urged artists to strive towards

'the great social *kartina*, which will be the start of a new era in art'. And he was right: the *AKhRR kartina* was the forerunner of the socialist realism of the 1930s, 40s and 50s.

Foremost in the development of the *kartina* was Brodski, a member of *AKhRR* from 1923 to 1928. Among his most important works at this time was *The Shooting of the 26 Baku Commissars*, showing the execution of communist revolutionaries by English-led counter-revolutionary forces during the civil war [pl. 25]. Ambitious in scale, composition and theme, Brodski's pictures were regarded as landmarks. Several features of his method – fastidious academic technique, scrupulous historical research, the combined use of both photographs and drawings from life in the execution of a large canvas – anticipated the working practice of many Soviet artists in the coming decades.

Grand works were created on many subjects, but most of all on the civil war, a store of dramatic subjects. Pavel Sokolov-Skalya (1889–1961), a pupil in Ilya Mashkov's private studio before the revolution, painstakingly depicted the motley Red Army crossing Lake Taman in the Crimea for a clash with the White enemy [pl. 26]. After Lenin's death, *AKhRR* artists turned adroitly to the Lenin theme; their open letter of May 1924 cited 'the death and burial of the leader of the revolution' as a subject in itself. Sokolov-Skalya painted peasants as they trooped in mourning to see Lenin lying in state; Brodski depicted a living Lenin in several ambitious pictures [pl. 27]. These panoramic scenes typify an iconographic ambition of the *AKhRR kartina*: the attempt to portray the masses, that fundamental, much idealised, unit of Soviet society.

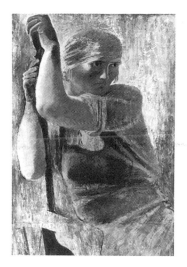

24

Aleksandr Samokhvalov
Woman with a File,
1929.
Tempera on canvas,
107×70 cm (42×27½ in).
State Russian Museum.

AKhRR: genre

The majority of *AKhRR* members did not display the high technical ambition of Brodski and Sokolov-Skalya. They were, to all intents and purposes, genre painters who adapted a traditional technique to the new world created by the revolution.

The new Soviet woman was a subject of particular significance for *AKhRR* artists. A point of revolutionary pride was the claim that women had been liberated and given an equal role in society. This idea inspired a number of paintings by Georgi Ryazhski (1895–1952) which became well-known through *AKhRR* exhibitions. A communist activist even as a student, he liked to portray women who occupied positions of some prestige, rather than simple workers. These he could endow with a commanding hauteur [pl. 28]. In sharp contrast is a picture by Evgeni Katsman (1890–1976), a founder of *AKhRR* and one of its most virulent polemicists. His *Kalyazin Lacemakers* [pl. 29] is an image of humble workers, executed in pastel, the artist's favourite medium. We are presented with a scene which speaks of working conditions vastly improved since the revolution. The woman on the left is

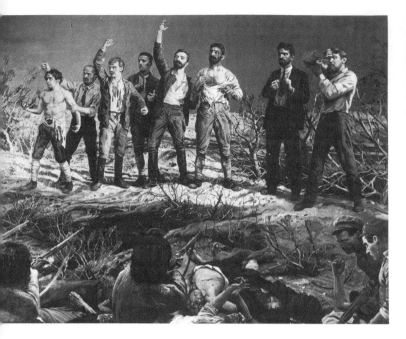

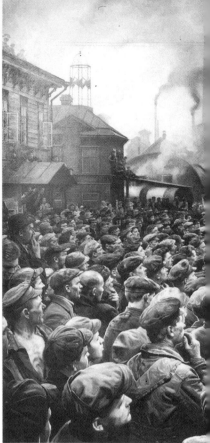

25

Isaak Brodski
*The Shooting of the 26
Baku Commissars*, 1925.
Oil on canvas,
detail 200×265 cm
(78¾×104½ in)
(whole 332×500 cm).
Lenin Museum, Baku.

26

Pavel Sokolov-Skalya
The Taman March, 1928.
Oil on canvas,
250×320 cm
(98½×126 in).
State Tretyakov Gallery.

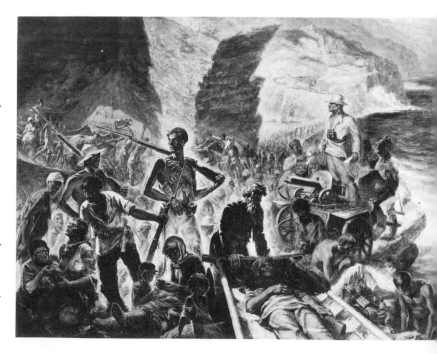

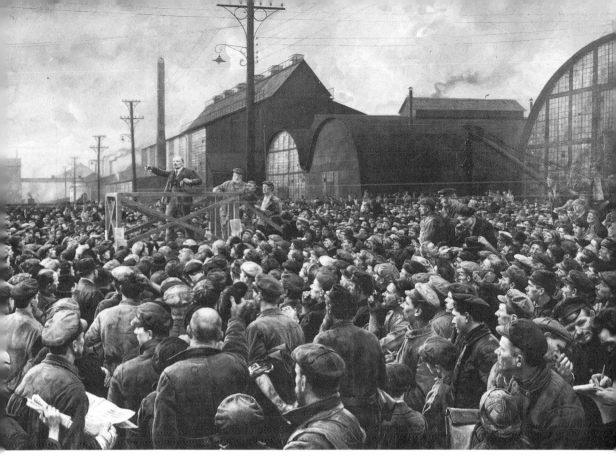

reading to the four workers – here the viewer would have seen a reference to the success of the government campaign to eradicate illiteracy. The reading woman also provides a metaphor for the role of art, as an enabling and sustaining element in the life of the Soviet worker.

In their portrayal of contemporary life *AKhRR* artists accorded a special position to the Red Army. *AKhRR* exhibitions were devoted to the fifth and tenth anniversaries of the Red Army, and many ambitious pictures showing military action, usually in the civil war, were painted by *AKhRR* artists. Outstanding was the work of Mitrofan Grekov (1882–1934), who had ridden with the Red Cavalry and became its devoted chronicler. In a gesture consonant with Lenin's view that *narodnost*, an organic link to the people, was essential to art, *AKhRR* members also helped run drawing classes for soldiers, the subject of a picture by one of the masters of *AKhRR* genre painting, Serafima Ryangina (1891–1955) [pl. 30].

It would be wrong to underestimate the variety and the degree of conviction displayed by *AKhRR* artists. They set out to provide a record of everyday life and, while mindful of the need to extol government policy, they created a picture of society that was more than merely doctrinal.

27

Isaak Brodski
Lenin's Speech at a Workers' Meeting at the Putilov Factory in May 1917, 1929.
Oil on canvas,
280×555 cm
(110×218½ in).
Central Lenin Museum,
Moscow.

28

Georgi Ryazhski
The Chairwoman, 1928.
Oil on canvas,
109×73 cm (43×29 in).
State Tretyakov Gallery.

29

Evgeni Katsman
Kalyazin Lacemakers,
1928.
Pastel on paper,
91×142 cm (36×56 in).
State Tretyakov Gallery.

Aleksandr Gerasimov, son of a cattle-dealer, painted what are perhaps his best pictures in the 1920s. The robustly painted *The Slaughter* [pl. 31] casts an unsentimental eye on the slaughter of a bull. He recalled, in a monograph published in 1954, how as a child 'for days on end I had to stand and watch the slaughter . . . suddenly the slaughterer would say: "Sasha, take a couple of bulls, slaughter them: I'm going to have a smoke." And I did.'

Fyodor Bogorodski (1895–1959) painted Soviet low life, its prostitutes and orphan-beggars [pl. 32]. Gangs of orphans, children whose parents had died in the civil war, or of hunger or of typhus, or else whose fate had been simply to be thrown onto the street to fend for themselves, were a familiar and sometimes threatening feature of street-life in the 1920s. Bogorodski's interest was probably the legacy of his own life – as unpredictable as any orphan's. He had been a law student, circus performer, war pilot and member of the *Cheka*, the Soviet secret police – an association that was to last many years – before he entered *VKhuTeMas* in 1922. A party member since 1917, he had become a member of the Moscow Council in 1923. Bogorodski's career is a prime example of a Soviet artist's urge to link artistic with social and political activity.

AKhRR: party propaganda

AKhRR welcomed the leading role of the party in art and boasted an active and well-organised party section. The party in its turn looked above all to *AkhRR* for works of artistic propaganda.

30

Serafima Ryangina
Red Army Art Studio,
1928.
Oil on canvas,
155×133 cm
(61×52¼ in).
Central Red Army
Museum, Moscow.

31

Aleksandr Gerasimov
The Slaughter, 1929.
Oil on canvas,
225×280 cm
(88½×110 in).
Gerasimov Museum,
Michurinsk.

32

Fyodor Bogorodski
An Orphan, 1925.
Oil on canvas,
78×66 cm
(31¼×26½ in).
State Tretyakov Gallery.

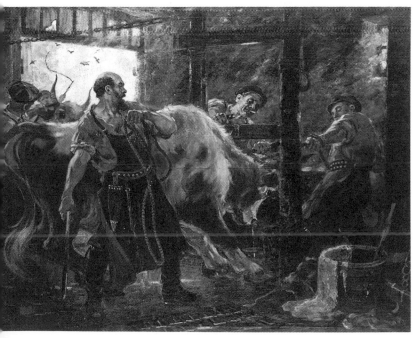

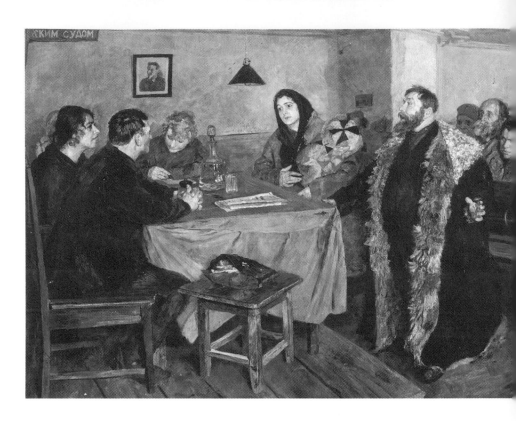

33

Boris Ioganson
A Soviet Court, 1928.
Oil on canvas,
80×108 cm
(31½×42½ in).
State Tretyakov Gallery.

The painting *A Soviet Court* [pl. 33] by Boris Ioganson (1893–1973) is the second version of a picture commissioned originally by *AKhRR* publishers for reproduction and mass circulation (the first version was reproduced in an edition of 40,000). It seeks to demonstrate the new power put into the people's hands by the revolution, and is effectively a piece of propaganda on behalf of the policy of collectivisation which, in 1928, was getting under way in earnest. It depicts a rich peasant, a *kulak* (also the Russian word for fist, conveying a grasping character) trying to justify his avarice before a people's court.

Like so many works by *AKhRR* artists, *A Soviet Court* relies heavily on the work of the Itinerants. Ioganson, a pupil of Konstantin Korovin (1861–1939), delights in the evocation of character, in the creation of narrative drama, in the decorative possibilities of peasant dress and in a broad painterly execution that is typical of nineteenth-century Russian realism. But such a comparison leads us to consider a crucial difference between the Itinerants and *AKhRR* artists: while the Itinerants were free agents with a critical approach to the state, *AKhRR* artists were the purveyors of official values. The fact, often trumpeted, that the work of *AKhRR* artists is comparable to that of the Itinerants because it is tendentious – that is, married to a particular cause – is irrelevant. The question is:

whether the individual responsibility of the artist for what he creates includes a dimension of social responsibility.

The reality of peasant life was – increasingly – to become something quite different from the scene of cosy legality depicted by Ioganson. Already by 1928 starvation was threatening the Soviet Union as a result of a drop in agricultural production; in 1927 it exported 277,000,000 poods of grain, in 1928 it exported none. This was because high taxes on peasant profits and a deliberately low grain price had destroyed the incentive to work. Those who did work risked being denounced as *kulaks* and having their grain confiscated: 25 per cent of this confiscated grain was then distributed among the poor to encourage them to denounce their neighbours. By the early 1930s, millions of peasants, arbitrarily labelled *kulaks*, had been dispossessed, exiled and slaughtered in Stalin's pursuit of collectivisation: both agriculture and justice were left in ruins.

History has provided a gloss to this picture which Ioganson could not easily have foreseen in 1928 (although the *kulak* was the subject of more than one work of Ioganson's in the 1930s). At that time, there was real enthusiasm for Stalin's policies, and an artist need not have known about the true conditions prevailing in the countryside. Yet we must remember the requirement for *partiinost*, party consciousness, in art, which was eagerly acknowledged by the *AKhRR* and tacitly accepted by many other artists. *Partiinost* encouraged the artist to let the party take moral decisions on his behalf; he was discouraged from making investigations or coming to conclusions of his own on most subjects, let alone the rights and wrongs of collectivisation.

An artist might accept this state of affairs for a number of reasons: he had faith in the revolution and believed its shortcomings would be temporary; he was, as the product of a society which had only recently emerged from feudalism, disposed to accept authority; he was tempted by the rewards for compliance; and he knew, by the late 1920s if not earlier, that if he stepped too far out of line it could cost him his life. This combination of stick and carrot was used to direct the activity of the great mass of artists in the succeeding decades of Stalin's rule.

Art in the non-Russian republics

Stalin pronounced in 1925 on the proper form of national culture in the Soviet state. In his speech 'On the Political Tasks of the University of the Peoples of the East', he said: '. . . proletarian culture, socialist in content, acquires various forms and means of expression with various nations . . . ' At the 16th party congress in June 1930 this formula was amended; Stalin talked of the building of socialism as 'a period of flowering of national cultures, socialist in content and national in form'. This described the party's view of the

proper nature of artistic expression in the many Soviet republics, and the definition gained wide currency.

Thus in the 1920s and early 1930s many artists from the republics other than Russia interpreted socialist themes with the help of their own indigenous traditions. This approach, in the simplification and stylisation of form it entailed, was arrived at through a certain sophistication and awareness of modernism.

The Georgian, Lado Gudiashvili (1896–1980), had spent five years in Paris and in the late 1920s and the early 1930s was a professor at the Academy of Arts in Tbilisi. He portrayed the expulsion of *kulaks* from a collective farm as a kind of biblical allegory, using a pictorial language which was indebted to Georgian folk art [pl. 34]. Prominent among Georgian realists, with whom Gudiashvili and his supporters conducted a constant debate, was the dynasty of Moisei Toidze (1871–1953) and his son, Irakli.

In the Ukraine the outstanding movement was that of the Boichukist artists led by the painter and muralist, Mikhail Boichuk (1882–1939), who were putting into practice Lenin's plan for monumental propaganda. Under the guidance of Boichuk, who had studied in Paris and made friends with the great Mexican muralist, Diego Rivera (he visited Boichuk in the Ukraine in or around 1926), and was a professor at Kiev Art Institute from 1924 to 1936, they executed murals in a style derived from the Italian Primitives and old Ukrainian religious art. None of these murals, and hardly any of Boichuk's individual work, have survived. Boichukism was the dominant movement in the Ukraine in the 1920s, inspiring artists in a number of towns and cities, notably a group in Odessa [pl. 35].

In Tashkent, Uzbekistan, Aleksandr Volkov (1886–1957) also led

34

Lado Gudiashvili
Expulsion of the Kulaks,
1931. Pencil on paper,
36×51 cm (14×20 in).
State Museum of the
Arts of the Georgian
Soviet Socialist
Republic.

35

Iosif Gurvich,
Grigori Dovzhenko,
Pasternak,
Aleksandr Shemko,
Fresco, 1929–30.
House of Print, Odessa
(destroyed).

36

Aleksandr Volkov
Cotton, 1930–1.
Oil on canvas,
132×342 cm
(52×134½ in)
overall (triptych).
State Museum of the
Karakalpak Autonomous
Soviet Socialist
Republic, Nukus.

a band of muralists. His own work is a bouquet of influences: old Russian religious painting, folk art, cubism. In an autobiography published in 1935 he stated: 'The painting of the East is built chiefly on the primitive and on a painterly, decorative beginning. This is the basis of my work. Elaborating works of primitive flatness, I have introduced a whole system of triangles and other geometric forms and arrived at the depiction of man based on the triangle, that being the simplest of forms.' This emphasis on decorativeness and formal simplification characterises much of the most vital art of the eastern republics throughout Stalin's rule. Volkov's work of the early 1930s expresses some of the enthusiasm felt for the first Five-Year Plan and the mechanisation of agriculture in the more backward republics [pl. 36].

Art and the leadership: Stalin

Stalin's pronouncements on the proper nature of national culture are some of his few public utterances to have a direct bearing on the arts, but during the late 1920s it became clear where his sympathies lay.

One important sign was his decision to attend, along with his colleagues from the Kremlin, the tenth exhibition of *AKhRR*, held in 1928 and dedicated to the tenth anniversary of the Red Army. It was a large and prestigious show, in which prominent artists not associated with *AKhRR*, such as Deineka and Petrov-Vodkin, agreed to participate (Deineka quarrelled with his colleagues and left *OSt* in order to do so); 10,000 people attended the opening; and it was the first of only two exhibitions which Stalin himself is known to have visited.[9]

He arrived on foot with a small group from the Kremlin and was first spotted as he queued for a ticket – a manifestation of the public cult of modesty on which he laid so much emphasis. When shown around the exhibition by artists he ventured no opinions about art except to say that his favourite picture was Repin's *The Zaporozhe Cossacks*. This painting depicts the eponymous Cossacks writing a rude and rebellious letter to the Turkish sultan in reply to his demands for their capitulation. The Cossacks are collectively splitting their sides in anticipation of the Sultan's reaction. The epithet of 'witty' often applied to this painting by Soviet commentators may not be the *mot juste*, but it is impossible to view it for the first time without a broad grin of appreciation for its grim humour, and it is an undoubted masterpiece of patriotic narrative painting. On leaving the exhibition, Stalin wrote modestly in the visitors' book: 'Was at the exhibition on 26.ii.28. Generally, in my opinion, good.' Never again was he to be so forthcoming in public on the subject of the visual arts.

Stalin's visit, so unremarkable in itself, was important for artists

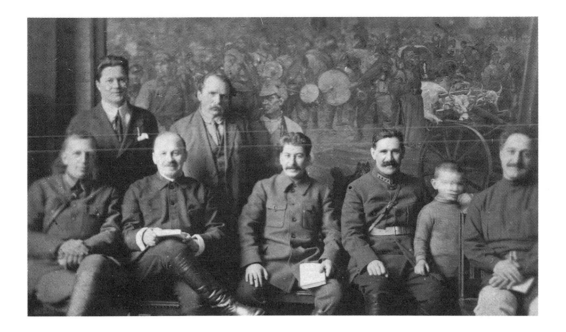

at the time, and even more so in retrospect, from the vantage-point of the 1930s and 1940s, when Stalin's power was absolute. By praising Repin's work, Stalin gave his blessing to an art such as that of *AKhRR* – patriotic, realistic, levelled at the popular imagination. That this was the art favoured by him and most of his colleagues is underlined by the fact that during the 1920s leading members of *AKhRR* had permanent passes to the Kremlin and socialised with the political leadership [pl. 37].

Stalin also authorised attempts in the mid-1920s to lure Repin himself back to the Soviet Union from self-imposed exile in Karelia. Both Repin and his artist son were offered lucrative commissions; Voroshilov wrote the old master letters, and Katsman and Brodski went to visit him. But even a gift of two thousand dollars was to no avail. These efforts underline the fact that the political leadership and members of *AKhRR* apparently had the same taste in art. Indeed, Aleksandr Gerasimov used to claim his favourite picture was *The Zaporozhe Cossacks*, just like Stalin.

Efforts to win back Repin were part of a party policy intent on winning international prestige for Soviet culture. A similar campaign was directed at the writer, Maksim Gorki (1868–1936), who from 1921 had been living in the West. Stalin wrote to him personally, offering the tubercular writer the services of a Soviet doctor. His efforts paid off: in 1931, Gorki returned to the Soviet Union from Capri, and spent the remaining years of his life enthusiastically promoting Stalinist policies in the arts.

37

Stalin at the 10th *AKhRR* exhibition, Moscow, 1928. Standing (left to right): Fyodor Bogorodski; Pavel Radimov, first chairman of AKhRR. Seated (left to right): Andrei Bubnov (1883–1940) who was to take over from Lunacharski as Commissar for Education; Bukharin; Stalin; Baumann, the Moscow party boss; Ordzhonikidze.

Art and the leadership: Voroshilov

The head of the Red Army from 1926 to 1940 was Commissar for Defence, later Marshal, Kliment Voroshilov (1881–1969). After Trotski's disgrace and flight he became the public embodiment of Soviet armed might. Voroshilov was, however, more than a figure-head for artists. He took more interest in the arts than any of the political élite, reciprocating the interest shown by artists in the Red Army. He was a collector of nineteenth-century Russian realism and something of a friend to a number of Soviet artists. Most significant in this respect was his friendship with Aleksandr Gerasimov, who was to become perhaps the most notorious figure in the history of Soviet art.

In 1925, Gerasimov returned to Moscow from Kozlov, where he had weathered the civil war, and joined *AKhRR*. He secured an introduction to Voroshilov through a fellow member of *AKhRR*, a sculptor called Mariya Denisova-Shchadenko. Voroshilov agreed to sit for a portrait – a broadly painted, thoroughly traditional image of the commissar seated in an armchair, that was exhibited in 1927. For Gerasimov, forceful, insinuating, audacious and self-deprecating by turns, who had spent twelve years at art school, was self-taught in several languages and was determined to pull himself up by his bootlaces, it was an opportunity to be made the most of. He charmed Voroshilov, and the long alliance between the Commissar for Defence and the artist which ensued was to prove flattering to the former, in terms of his various pictorial incarnations, and incalculably useful to the latter.

The Lenin cult

As we have seen, the Lenin cult was being developed by the party leadership from about 1923 onwards, after Lenin was incapacitated. Stalin was its prime mover: he insisted on Lenin being embalmed against opposition from Trotski, Bukharin and Kamenev, and began to exploit his memory shamelessly, beginning with his famous oath at the Second All-Union Congress of the Soviets in 1924. There he swore fidelity to Lenin's ideals, enumerating the articles of his faith in the manner of a catechism, beginning each time: 'We swear to you, comrade Lenin . . .' Lenin's death led to Petrograd being renamed Leningrad in his memory, and provided the pretext for the so-called Lenin levy, a mass conscription of new members, drawn exclusively from the proletariat, into the party to strengthen its popular base.

The importance of the Lenin theme in the arts was recognised soon after his death in a decree of the party Central Executive

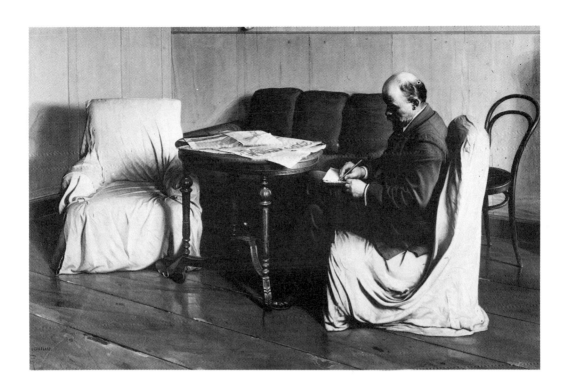

Committee of April 1924, 'On the proper manner of production and distribution of busts, bas-reliefs, pictures, etc. representing V. I. Lenin.' The dissemination of works in all media except photography were to be controlled by the Committee for the Immortalisation of Lenin's Memory; works suitable for mass reproduction were chosen by a commission headed by Vyacheslav Molotov (1890–1986), one of Stalin's political favourites. In 1925, Lenin toys were produced, and Lenin appeared on cigarette packets and sweet-papers; (these latter were swiftly withdrawn because it led to Lenin's image being trodden underfoot[10]).

The German critic, Walter Benjamin, on a visit to Moscow in 1926–7, noted how mass-produced images of Lenin stood cheek-by-jowl with newly minted icons still on sale at street markets. He concluded a description of this visit with the thought that one day Lenin might take on the religious significance of a biblical figure. In other words, as Benjamin observed, a process of transference was taking place: the popular need for a faith, so deeply rooted, was being given a new object: Lenin was being elevated to the god-head.[11] This idea, as we have seen, was implicit in the design of his mausoleum and was made explicit in the project for the Palace of the Soviets.

In sculpture, the great exponent of Lenin, until his death in 1932, was Nikolai Andreev [pl. 56]. He was one of the select band to draw

38

Isaak Brodski
Lenin in Smolny, 1930.
Oil on canvas,
190×287 cm
(74¾×113 in).
Central Lenin Museum,
Moscow.

Lenin from life. Other artists, if they were lucky, had access to one of Merkurov's death masks, which had been cast in several examples. Otherwise they made do with photographs.

In the field of painting, Brodski most assiduously portrayed the dead leader during the 1920s. A celebrated work is *Lenin in Smolny* [pl. 38], painted in 1930. Lenin is depicted in Petrograd in 1918, accommodated in the sumptuous Smolny Convent. Outside, the civil war is raging; even to the most partisan its outcome must seem uncertain, but Lenin continues to work unruffled, sustained by a supreme conviction of eventual victory. In his asceticism and absorption, he has not even removed the dust-covers from the costly furniture. It is the supreme expression of what was held to be Lenin's greatest virtue – his modesty.

Aleksandr Gerasimov's great public success came in 1929, when he painted *Lenin on the Tribune* [pl. 39]. By his own account, he was helped by the frequent visits paid to his studio by Voroshilov, who told him when Lenin finally looked right. The painting established Gerasimov as a major figure in party eyes. It was, above all, an unequivocal statement: compromised neither by an absorption in formal problems nor by any reticence in its revolutionary enthusiasm, it was as uncomplicated as a recruitment poster.

Strife: the groups

Each of the various groups of artists which sprang up in the mid-1920s strove to assert the superiority of its position. *AKhRR*, which enjoyed the largest membership (some 300 members in Moscow alone at its peak – more than all the other Moscow groups combined), the greatest resources and was most aggressive in promulgating its philosophy, drew the fire of the smaller groups. Thus the platform of *OSt* rejected the methods of the Itinerants, an implicit criticism of *AKhRR*; *OMKh* attacked the outlook of *AKhRR* by rejecting 'naturalistic depictions of everyday life'; and for The 4 Arts, subject-matter – the be-all and end-all for *AKhRR* – was 'only a pretext for the creative transformation of material into artistic form'. The critic most eloquent in defence of these groups, and of *OSt* in particular, was Yakov Tugendkhold (1882–1958), who depreciated *AKhRR* as a group of artists 'of average, narrow-minded type'.

AKhRR, for its part, was firmly opposed to any stylistic deviation from a prosaic realism; it approved Russian traditions and complained about artists who responded to Cézanne, Derain and Picasso. Its guiding light was revolutionary content, the absence of which in a work of art it deemed tantamount to 'counter-revolution'. Indeed, *AKhRR* artists sometimes professed not to understand what pictorial form, independent of content, might mean. Punin wrote of the first *AKhRR* exhibition in Leningrad that 'authors call such problems as the representation of a crowd or a

red director the formal aspect of the picture. My attempts to explain to them that all that is not the formal side of art . . . had no success.' In promoting its uncomplicated vision, *AKhRR* had the support of Yaroslav Emelyan (1878–1943), a prominent party activist who made forceful speeches on *AKhRR*'s behalf.

Why did these groups feel the need to wage a war of attrition with one another, utilising manifestos and declarations, letters to the press, critical articles, speeches – any means to hand, even fisti-cuffs? Why did they not live and let live? This may be put down to the natural competitiveness of artists, apparent also in the West, or else ascribed to a genuine revolutionary idealism, a belief in the rightness of a chosen path; but it is also the product of the peculiar conditions of the Soviet art world: it stemmed from the realisation that, ultimately, there was only one patron and paymaster, one critic and art historian, one arbiter of everything that touched on an art-ist's life: the party.

Strife: the individual

For many artists, this cannot have been a happy state of affairs, if only because *AKhRR* was clearly the organisation favoured by the party. Advantages of size and funding had been enhanced in 1928 by the cachet of Stalin's visit and the new status, granted by the party, of a nationwide organisation, permitted to set up branches throughout the Soviet Union. By this time the professional situation of avant-gardists or members of groups such as *OSt*, *OMKh* or The 4 Arts was uncomfortable. They wished fervently to respond in some measure to Western culture and to the Modern Movement (what *AKhRR* termed a 'petty-bourgeois pre-revolutionary decadent' mode of expression). They still appreciated the first, international ideals of the revolution. When, in their manifestos and speeches, these groups rejected the principles of *AKhRR*, they were expressing more than aesthetic distaste: they perceived the works of the *AKhRR* artists as a microcosm of how art would be if the Soviet Union, already culturally isolated, abandoned internationalism entirely. They foresaw and feared their land closing itself off alto-gether from the outside world.

There were good grounds for their fears in a series of decrees passed from 1926 to 1929 inhibiting contact with foreigners, travel abroad and the admission of foreign artists to the Soviet Union. In 1926, Soviet citizens returning from higher education abroad were required to pass tests on Soviet society; in 1927 a decree stipulated 'a strict cutback in foreign trips' by Soviet citizens; in 1928 a special commission was set up to regulate the hiring of foreign art-workers in the Soviet Union and of Soviet art-workers abroad; in 1929, it was decreed that those sent on trips abroad should not be allowed to change the route of their journey.

39

Aleksandr Gerasimov
Lenin on the Tribune,
1929. Oil on canvas,
288×177 cm
(113×69¾ in).
Central Lenin Museum,
Moscow.

Scarcely less dismal were most of the visiting exhibitions of foreign art organised by *VOKS*, the All-Union Association for Foreign Cultural Relations, which were almost invariably dour displays of work by communist sympathisers such as Frank Brangwyn, Kathe Kollwitz, Franz Maserel and the John Reed Club of America.

Not surprisingly, therefore, some artists became increasingly anxious and began to take what steps they could to protect their interests. In 1927 Malevich, working in Leningrad, travelled to Warsaw and Berlin with a one-man exhibition, and in a bold and resourceful response to forebodings about his own future in the USSR, he contrived to leave all his work behind in the German capital.

In Moscow, the case of Robert Falk is instructive. During the 1920s he clearly strove to conform to the requirements of Soviet art. Paintings such as *Likbez*, illustrating Soviet attempts to eradicate illiteracy, and his decision to join *AKhRR* in 1926 point to this. However, he soon quit *AKhRR*, and, notwithstanding the more congenial comradeship he found in *OMKh*, in 1928 he left the Soviet Union altogether for Paris. The ostensible reason for his trip was to study, for a few months, the classical heritage. But, in a letter of 1928 asking for an extension of his stay away from *VKhuTeIn*, where he was a lecturer, Falk made it clear that a contributory factor to his departure was the activity of *AKhRR*: 'But one circumstance is even more decisive. It is that dangerous wave of superficial naturalism, which has begun to act on artists from the light (or more accurately from the heavy) hand of *AKhRR*. Even certain extremes in the modelling of artistic forms are better than something so prosaic, devoid of free-will and character.'[12]

Falk claimed to be disappointed by Paris, but he stayed away from the USSR for ten years. His long absence is often blamed by Soviet art historians on ill-health; but we can fairly surmise that it was prompted by his distaste for the way Soviet art and society was developing.

A number of other artists took the same decision as Falk, among them the outspoken futurist, Nathan Altman, who left for Paris in 1928. Less fortunate were a husband-and-wife pair, members of *OMKh*, Aleksandr Drevin (1889–1938) and Nadezhda Udaltsova (1886–1961). Like Falk, they were teachers at *VKhuTeIn*; and in the same year that Falk left for Paris, they applied for permission to do the same. They were inspired by a big exhibition of contemporary French art held in Moscow in the autumn of 1928, at which the work of Russian émigrés was also shown – the last genuinely liberal gesture of the Soviet art world for many years. But they were driven, above all, by horror at what was unfolding in the Soviet countryside. This is testified to by Udaltsova's diaries at this time. Permission to leave, however, was refused.

Among the avant-garde a strikingly unruffled figure was Pavel Filonov, who in Leningrad had gathered a group of disciples around

him, mostly students or ex-students of the Leningrad *VKhuTeIn*. They styled themselves the Collective Masters of Analytical Art. Filonov required his followers to use bright colour and to work with a small brush and a fine point; they were enjoined to accumulate large forms out of small details – to work the other way round, from the general to the particular, Filonov termed 'charlatanism'. The result was a kind of painting which, at its most extreme, has a violent effect on the retina [pl. 40]. Filonov's aim – a variation of avant-garde utopianism – was a 'world flowering' through art. However, his means to this end were not always purely optical; during the 1920s and 1930s he often painted recognisable industrial subjects in a watered-down version of his pointillist language.

Filonov's determination notwithstanding, the apprehensions of artists began to be justified. In 1928 the first of Stalin's show trials, at which purported 'wreckers' were induced to confess to crimes

40

Pavel Filonov
Spring's Formula,
1928–9.
Oil on canvas,
250×285 cm
(98½×112 in).
State Russian Museum.

they had never dreamt of committing, was held; collectivisation got going: the country entered the period of its nightmare. Lunacharski resigned in 1929, depriving Soviet art of its even-handed helmsman. In 1930 the twin bastions of the avant-garde, the *VKhuTeIn*'s in Moscow and Leningrad, were closed down; Malevich was put under arrest for 3 months, interrogated ('What is this cézannism talk about? What is this cubism you preach?' he was asked) and emerged an ill man;[13] Filonov himself had a one-man exhibition cancelled after pressure from realist artists and Mayakovski, the exemplar of revolutionary enthusiasm in the arts, shot himself in despair.

Strife: the proletarian art debate

Ever since Lenin's debunking of the *proletkults*, Bogdanov's theory of the independent evolution of proletarian culture had been discredited; no artist now questioned – openly, at least – the party's parental role. In the mid-1920s an artist's social origins remained important, but he or she demonstrated class-consciousness above all by responding to the lead given by the country's 'fighting avant-garde' (as *AKhRR* put it): the communist party. But throughout the 1920s the party failed to give clear directions on the form art should take under a dictatorship of the proletariat. Lunacharski tried to foster the best efforts of artists working in a variety of styles. But despite his efforts to nourish a degree of pluralism, the proletarian art debate flared up with sudden virulence in 1928; by the time he resigned in 1929, it had come to dominate artistic life.

This was as a result of political developments. The introduction, in 1928, of the Five-Year Plan and collectivisation signalled an intensification, as the party would have it, of the class war. The class enemies of the proletariat, Stalin said, were the *NEPmen* – those who had benefited from the liberal New Economic Policy introduced by Lenin; the bourgeois remnants (including the cultural intelligentsia) and counter-revolutionary 'wreckers' opposed to socialist construction; and above all, the *kulaks*.

The debate affected all the arts, literature, music, architecture and cinema, as well as painting and sculpture. The supposed class nature of an artwork assumed fresh importance. Thus the Tretyakov Gallery began in 1928 to label its exhibits according to their class origins; and in Leningrad the director of *VKhuTeIn*, Maslov, revived the philistinism of the avant-garde by smashing plaster casts and vandalising canvases belonging to the museum of the old Academy, where *VKhuTeIn* was situated – because they were products of bourgeois culture. Class battle-lines were drawn up in the art world. In Moscow, *AKhRR* pledged to '. . . help the proletariat accomplish its class goals' and brought out a new journal, *Art to the Masses*. In the same year an important new group,

October, was formed, and there was a change in the complexion of
AKhRR, whose policy began to be dominated by a young group of
communist idealists unsympathetic to much former practice. From
1928 onwards, these two groupings waged a war of attrition for the
holy grail of a proletarian art.

October

October united practitioners of the 'spatial arts' – architecture,
painting, sculpture, graphics, industrial design, photography,
cinematography – in the service of the proletariat. Its members
included painters, such as Deineka; the monumental artist, Bela
Uitts (1887–1972); Gustav Klutsis (1885–1938), a master of photo-
montage and poster design; visionary constructivist architects, such
as the Vesnin brothers, Aleksandr (1883–1959) and Viktor
(1882–1950); Eisenstein the film-maker; and leading marxist critics
such as Alfred Kurella (1895–1975), Ivan Matsa (1893–1974) and
Pavel Novitski (1888–1971). Uitts was a Hungarian immigrant,
Kurella a German who settled in Russia; and October also co-opted
the Mexican muralist, Diego Rivera, as a member. Thus the group
represented the persistence of internationalist ideals in the arts.

October required a critical attitude to the art of the past, a rejec-
tion of 'naturalistic realism', and 'the creation . . . of new types and a
new style of proletarian art'. It was to be an art of mass production,
intended for collective use; its basis was to be new technology. To
make of it a real art of the people, October sought a 'blending of the
amateur art of proletarian art circles and workers' clubs and peasant
amateur art with highly qualified professional art, standing on the
level of the artistic techniques of the industrial epoch'. October's
manifesto recalled the striving of the constructivists, the *proletkults*
and the production artists of *InKhuK*: it was the last surge of the
avant-garde.

Critical support for October was provided by marxist theor-
eticians who accepted its fundamental thesis that a new proletarian
art must develop new forms, unique to itself. As the October youth
section put it in a letter to their counterparts in *AKhR* in 1930, the
language of art contained 'the class essence' of an artist. Supporters
of October damned realism as a bourgeois throwback and cloak for
fellow travellers. A typical October rallying call was: 'Long live the
struggle for the method of dialectical materialism in the creative
practice of proletarian artists.' This brand of theoretical marxism
and sweeping condemnation of pre-revolutionary culture echoed
the work of Mikhail Pokrovski (1868–1932), author of the first
comprehensive marxist history of Russia.

AKhR

41

Taras Gaponenko,
Ivanov,
Fyodor Konnov,
Nina Korotkova,
Ilya Lukomski,
Fyodor Malaev,
David Mirlas,
Aleksei Nemov,
Fyodor Nevezhin,
Yakov Tsirelson,
Lev Vyazmenski
Sketch for a fresco in the
club of the Red
Proletariat printing
works, 1931.

In 1928 *AKhRR* changed its name to *AKhR*, the Association of Artists of the Revolution, at its first nation-wide congress. The elimination of reference to Russia signalled the emergence of a new pan-Soviet role for the organisation, whose members now travelled through the Soviet republics, setting up affiliated groups and seeking out and encouraging realist artists. At the same congress, a declaration was adopted which marked a shift in policy away from the practice of easel painting, formerly the main plank of *AKhRR* activity. It stated that public art and the design of items for mass use 'stand before artists of the proletarian revolution as urgent tasks'. At the congress, a group of some thirty-five members of the *AKhRR* youth organisation were accepted into *AKhRR* proper; some of them were voted onto the governing council and into the secretariat. This new blood included a number of monumental artists who were also ardent communists. The influence of their ideas can also be traced in the congress declaration, where heroic realism was now qualified as a 'monumental style'.

A telling sign of the new orientation of the group in 1928 – to the

dismay of many of its members – is the fact that Brodski, an artist of enormous repute, was driven out of the association. His scrupulous imitation of reality was now deemed retrograde, and slanderous rumours were circulated that he was prepared to 'immortalise' people in his densely populated pictures in return for a suitable sum. Then, at the third *AKhR* plenum in 1929, former leading-lights of *AKhRR* such as Katsman and Ioganson were prevailed upon to admit their 'political errors'. *AKhR* leadership was now placed in the hands of its 'proletarian nucleus' which approved monumental and public art above all else. In the period 1928–30 a whole stream of traditional realist painters left *AKhR*, unable or unwilling to adapt to the revised idea of a proletarian art.

RAPKh

Despite these resignations, easel painting remained the dominant activity of the *AKhR* membership. This left the fierce clique which was attempting to transform *AKhR* in the search for a proletarian art dissatisfied. In May 1931, in an attempt to give artists a new ideo-logical impetus, the party section of *AKhR* instigated the formation of *RAPKh*, the Russian Association of Proletarian Artists. Its

nucleus was of party members of proletarian origin, drawn largely from *AKhR*. The stress on party membership echoed Stalin's policies in the country at large, where hundreds of thousands of new members were being accepted to broaden the party's base and overcome opposition to the collectivisation programme. The emphasis on the proletarian backgrounds of *RAPKh* members was a signal resurrection, in the interests of class warfare, of a concept which had once guided the discredited *proletkults*. Prominent in *RAPKh* was a group of graduates of the department of monumental painting at *VKhuTeIn*, including Yakov Tsirelson (1900–1938), Lev Vyazmenski (1901–1938) and Fyodor Konnov (?–1938). *RAPKh* was the youngest of a whole family of proletarian groupings across the arts; its most vociferous sibling was *RAPP*, the Russian Association of Proletarian Writers, headed by Leopold Averbakh (1903–1939).

RAPKh promulgated a particular ideal of a proletarian art which rejected both the technological enthusiasm of October and also the bias to easel painting which had not been expunged from *AKhR*. It laid stress on figurative mural painting (in accordance with Lenin's plan for monumental propaganda) carried out by brigades of artists – a method consonant with a belief in the value of collective work [pl. 41]. Very few of these murals were actually executed, and none has survived.

RAPKh, in harness with other proletarian arts organisations, raised the temperature of debate to a level uncomfortable for nearly everyone. In its journal, *For a Proletarian Art*, it mounted strong attacks on important members of *AKhR* such as Bogorodski and Aleksandr Gerasimov, terming the latter a fellow traveller, and denounced supporters of October, prominent among whom was a young painter-turned-critic, Vladimir Kostin (born 1905). For a brief time it wrested the revolutionary high ground from its rivals. It announced with satisfaction in 1931 that *AKhR* painters had at last gone over to the brigade method of production, renouncing the individualism of the easel; and in July 1931 October waved an olive branch, stating in a communique that it agreed with *RAPKh* principles and desired a rapprochement. The theoretical position of October had been undermined as the ideas of the historian, Pokrovski, fell into disrepute after Stalin embarked, around 1930, on his campaign to rewrite the story of Bolshevism in his own favour. In late 1931, many former members of October, including such outstanding figures as Deineka, were received into *RAPKh* ranks.

The party takes a grip

Tsirelson, Konnov, Vyazmenski and their colleagues were zealots who were encouraged in their crusade by the higher echelons of the

party itself. Some commentators on this period believe that the mood of antagonism whipped up by *RAPKh*, which was paralleled in the other arts, was a piece of cynical manipulation on Stalin's part, a means of breaking down the traditional infrastructure of the art world the better to seize control of it. However, it is more straightforward to equate the ideological fervour of *RAPKh* with that of the party itself in pushing through its policies of industrialisation and collectivisation. It seems likely that the frenzy in the art world reflected the state of the country as a whole rather than being the product of some far-sighted strategy.

Indeed, despite the strife, the party for some time had been asserting a firmer grip on the arts than had obtained under Lenin. A decree of December 1928 stated that the sole function of literature (and by inference of the other arts) was to be communist education. In 1929, a further decree criticised a group of Siberian writers, *proletkult* members, who had attacked Maksim Gorki as a reactionary influence; this decree underlined the party requirement for faithful service in the arts. Steps were also taken to bring a number of artists' groups into a more wieldy single organisation. In June 1930 a Federation of Associations of Soviet Workers in the Spatial Arts, *FOSKh*, was formed, which incorporated *AKhR*, *RAPKh*, *OSt* and groups of book and poster designers.

These moves towards a confederation of groups and increased party control of the arts culminated in a decree of April 1932, which abolished all proletarian artistic and literary organisations and required artists who supported 'the platform of Soviet power' to come together in a single union. The decree claimed that 'the frames of reference of existing proletarian literary and art organisations are already becoming narrow and hindering the broad scope of artistic creativity'.[14]

This was a rude shock for *RAPKh*, which was brought up in mid-charge, but its guiding philosophy of a purely proletarian art was now no longer expedient. At a speech to business executives on 23 June 1931, Stalin had effectively declared an end to the class struggle he had whipped up in order to impose collectivisation. Now, looking ahead, he sought to conciliate those with useful skills. 'No ruling class has managed without its own intelligentsia,' he announced, and stated that the proletariat needed one, too. It was a sharp about-turn, a demonstration that the party and the people were now firmly under Stalin's control.

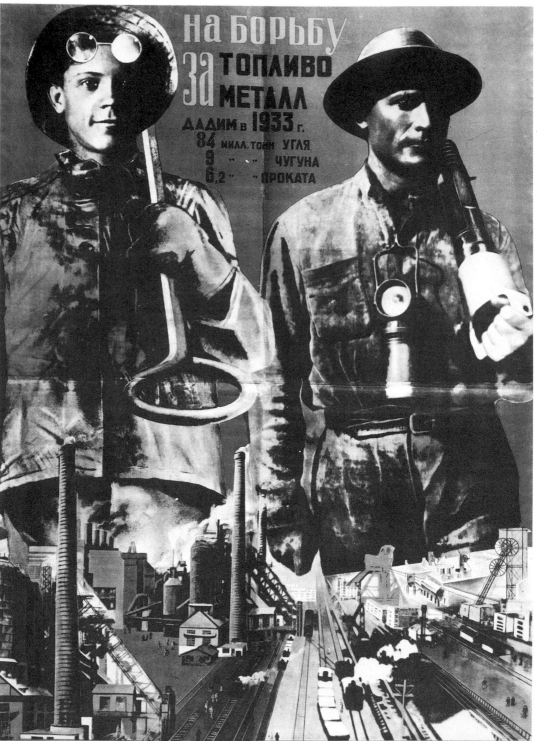

2 'Living has got better, living has got jollier'

Developed Socialism 1932–41

Stalin in charge: politics

The 1930s was the most terrible decade in Soviet history. The juggernaut of collectivisation was followed by a pogrom of the party faithful, professional classes, military élite and intelligentsia. That collective sleight of conscience, the show trial, at which alleged enemies of the state were induced to confess to treachery they had never contemplated, evolved into an expert political art, a species of black magic. All those who had been Stalin's competitors for power in the 1920s were exterminated. Zinovev and Kamenev were convicted and executed in the summer of 1936; Bukharin, the amateur artist (he took part in the 1935 autumn exhibition of Moscow painters), met the same fate in 1938; by way of finale, the exiled Trotski was assassinated in Mexico in 1940.

42

Gustav Klutsis
In the Struggle for Fuel and Metal, 1933.
Poster.

Stalin in charge: economics

The second Five-Year Plan of 1932–6 featured Stalin's new thinking – the need for a Soviet intelligentsia and specialist cadres, whose wages, he said, would be dictated by their achievement. In the elaboration of the new social hierarchy, an important phenomenon was the stakhanovite movement. Stakhanovites were super-workers who took their name from Andrei Stakhanov, a miner who on a legendary day in 1934 apparently produced fourteen times the norm of coal – a feat that was, we know, extensively stage-managed. The stakhanovites held their first conference in 1935, when Stalin extolled the technical sophistication and bodily stamina which had enabled them to achieve their records. He argued that this

43

Ivan Zholtovski
House on Mokhavaya
Street (now Marx
Prospect), Moscow,
1934.

erosion of the boundaries between mental and physical labour represented an ideal of communism. It was an ideal which now became, however implausibly, a slogan to condition artists.

The second Five-Year Plan boasted a number of great achievements in construction, such as the Moscow–Volga canal. In 1935 the ration-card system for basic commodities which had existed since the 1920s was finally repealed. Stalin could claim a certain amount of success for his policies, and announced in the mid-1930s that socialism, the preliminary stage to communism, had been achieved in Soviet society. But the great canal and other massive accomplishments of the second and subsequent Five-Year Plans relied on the forced labour of millions of camp convicts who received nothing except starvation rations.

Despite the benefit of this free labour force, the third Five-Year Plan of 1937–41 brought less in the way of gains. It was overshadowed by the show trials and the revival of the notion of class conflict within the USSR that these entailed, and also by the worsening relationships between the countries of Europe. In 1940 an *ukaz* of the Supreme Soviet forbade workers to leave their jobs voluntarily – effectively making not only the convict, but the average Soviet citizen, into a slave of the state. This introduction of slavery conditions of employment in 1940 can be seen, in retrospect, not only as a preparation for war but as the tacit admission of a failed economic strategy.

The policy of funding the Five-Year Plans by the sale of historic art and precious objects abroad was progressively curtailed in this period because the cost to Soviet international prestige was too high. In 1934 Stalin halted sales of the Hermitage paintings. In 1938 the introduction of a new, less favourable rouble exchange rate and new customs regulations put an end to all this denuding trade. Its last great beneficiary was the American ambassador of 1937–8, Joseph Davies, whose collecting was encouraged because of his credulous response to the courtroom dramas of Stalinist repression.[15]

Architecture

Architectural thinking yearned towards the classical heritage under the impetus afforded by the design of the Palace of the Soviets. Although work on the Palace itself proceeded slowly – by the time war broke out in 1941 only the metal framework for the lower stories had been erected – a mass of other projects were enthusiastically realised. Buildings such as the house on Mokhavaya Street [pl. 43] by Ivan Zholtovski (1867–1959) were a frank tribute to Palladian principles. Schools, apartment blocks, sanatoria, railway stations, workers' clubs, cinemas, stadiums – all the amenities which the state now offered its people (including the leaders'

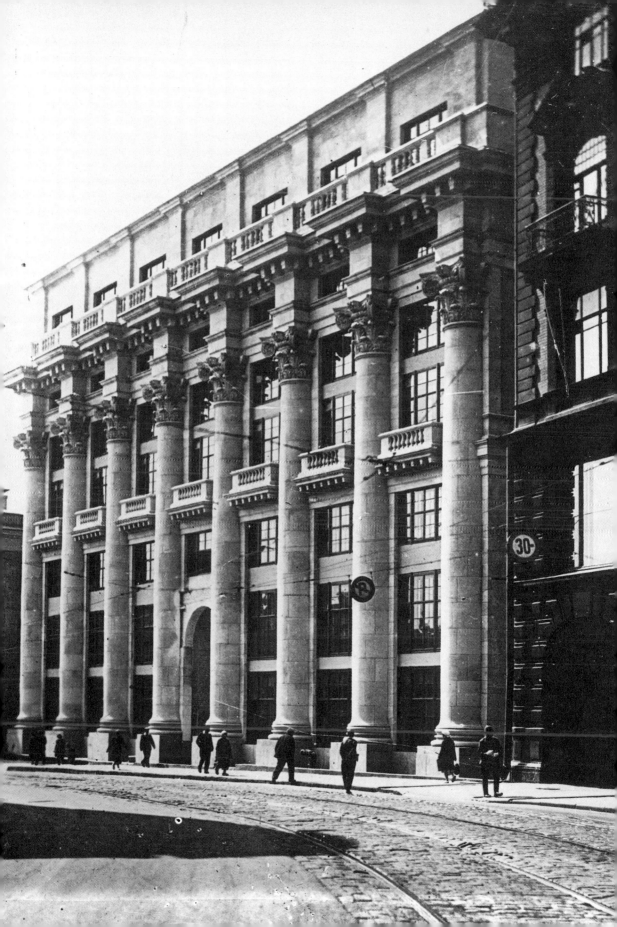

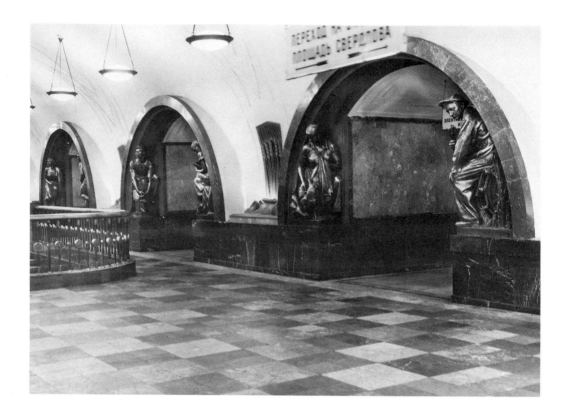

44

Aleksei Dushkin
(architect), Matvei
Manizer (sculptor)
'Revolution Square
metro, 1935–8, Moscow.

dachas) were built in a neo-classical manner. Shchusev, the one-time avant-gardist, announced proudly: 'We are the only direct successors of ancient Rome'.[16]

The most famous construction project of the time, in which the new architectural principles were implemented with relish, was the Moscow metro, where the first train ran in May 1935 [pl. 5]. Secret branches linked it to the Kremlin and to Stalin's dacha. Its marble-clad, chandelier-lined interiors are doubly impressive for being conceived in the context of a subterranean railway. Stalin visited Revolution Square [pl. 44], where the sculpture was designed by Matvei Manizer (1891–1966) and approved it; he said the figures were 'as if alive', and this, according to Brodski, was the highest compliment Stalin could pay a work of art.[17]

In common with the design for the Palace of the Soviets, many classically oriented buildings and architectural projects of the 1930s make at least a nod in the direction of modernism. One example is the Moscow Hotel [pl. 45], designed under Shchusev's control. The hotel is of particular interest because its façade, for no clear aesthetic reason, is asymmetrical. Legend has it that Stalin himself,

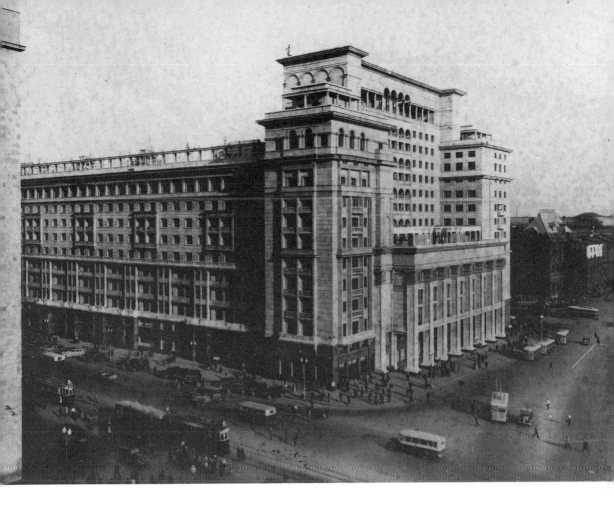

when presented with a drawing that incorporated, on either side of a vertical axis, two alternative designs for the façade, placed his signature in the centre of the sheet, apparently approving either or both variants. No one dared tell him – whom the Union of Soviet Architects addressed as 'Chief Architect and Builder of our Socialist Motherland' – of his oversight, if oversight it was.

If we believe another legend, Stalin was not the only architectural genius among the leadership. Lazar Kaganovich (born 1893), the politburo member who took the greatest interest in architecture, is said to have inspired the design of the Red Army Theatre by drawing around his five-pointed inkpot [pl. 46]. This is one more example of a building being conceived in sculptural terms. What is more, its terms are highly symbolic. It cannot be properly perceived from street-level [pl. 47] that the theatre is star-shaped: one must know its form, intellectually, if one is to appreciate it as an echo of the five-pointed stars on the Kremlin towers, erected in 1935 as a symbol of the Soviet state. It is, like the projected Palace of the Soviets, a piece of *architecture parlante* – an attempt to narrate the ideology of the party to the masses.

45

Aleksei Shchusev, L. Savelev, O. Stapran The Moscow Hotel, 1936. Moscow. The façade in question is visible to the right.

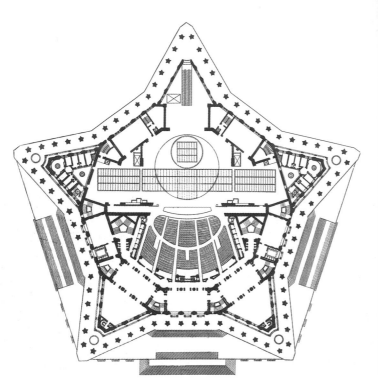

The symbolic design was also bound up with a monolithic ideal. Architects dreamed of a Moscow in which each architectural part was an image in small of the overall conception. Thus even 'each railing of a new bridge' was thought of as 'a link in the chain of the organic ensemble of the city'[18] – just as each humble individual was understood to be a link in the organic ensemble of the state.

In line with this thinking, architects drew up plans for the wholesale reconstruction of Moscow. Working under the auspices of the Moscow Council and at the political direction of Kaganovich, their aim was to weld the higgledy-piggledy city of wooden houses and onion-domed churches into a functional whole. The General Plan for the reconstruction of Moscow was approved by the Central Committee of the party in 1935 and caused the gigantism, engendered and typified by industrial projects such as the *Dneprstroi*, to be fully visited on the city. The Garden Ring (which

continued to be so-called even after all its trees and greenery had been uprooted) around Moscow's centre was broadened; monuments of old Moscow were demolished; and prodigal amounts of densely packed old buildings were razed to make way for magisterial boulevards such as Gorki Street.

Public art: parades

The General Plan, like Hausmann's reconstruction of Paris, was both functional (the new broad streets would permit easy detoxification of the city after a gas attack) and ceremonial in intent. Great parades were to have a grand setting on their way to Red Square. These officially controlled successors to the improvised demonstrations of the futurists which had ushered in the revolution now

48

Sergei Luchishkin
Constitution Day, 1932.
Oil on canvas,
130×458 cm
(51×183 in)
overall (pentaptych).
State Tretyakov Gallery.
Panels from left to right:
*Carnival on the Moscow
River; Keep-Fit Girls;
Mass Festival in the
Sparrow Hills;
Foreign Guests; Meeting
on the Square.*

assumed forms as articulate as that of the Red Army Theatre. Constellations of *fizkulturniki*, fitness fanatics, formed stars and hammer-and-sickle emblems [pl. 48]; they raised human pyramids and powered mocked-up tanks like hamsters on a wheel. The parades, welcomed by the people because they signified public holidays, were proof of the plasticity of the masses.

To accompany such parades, Moscow was rousingly decorated. Many artists, often young and unestablished, were given work of this kind. Taras Gaponenko (born 1906) was employed painting huge portraits of the leadership, using as a studio the building that houses Moscow's main department store, GUM. He told me how swimming pools were once commandeered as processing-tanks for a vast photographic portrait of Lenin. Tatlin also worked in this field. His project for the decoration of Manezh Square, devised in collaboration with younger artists, is a marriage of his old constructivist ideas with a newer, self-consciously classicising impulse [pl. 49].

Soviet celebrations were compared to the parades and festivals of ancient Greece and Rome. The colour red sang out against the stone-colours of the reconstructed city. One art magazine enthused: 'The red colour of innumerable pennants, flags, clusters of banners and huge canvases on the houses glows especially brightly on such a day. Born as a symbol of the people's oppression and revolt, as a symbol of the hatred of each and every oppressor, the colour red acquires at the time of our revolutionary ceremonies a joyful and ringing tone never seen before.'[19]

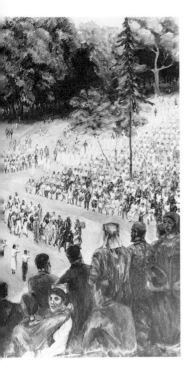
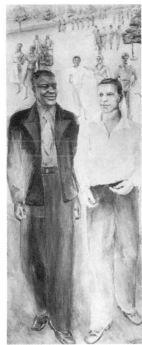
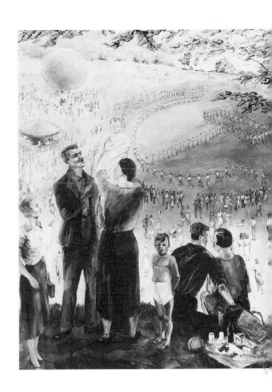

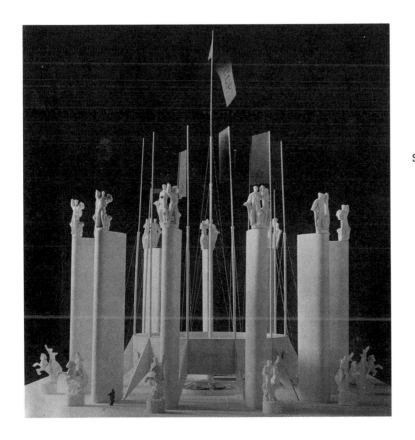

49

Vladimir Tatlin,
Georgi Rublyov,
Nikolai Prusakov,
Aleksei Zelenski
Project for the
decoration of Manezh
Square, 1937, Moscow.

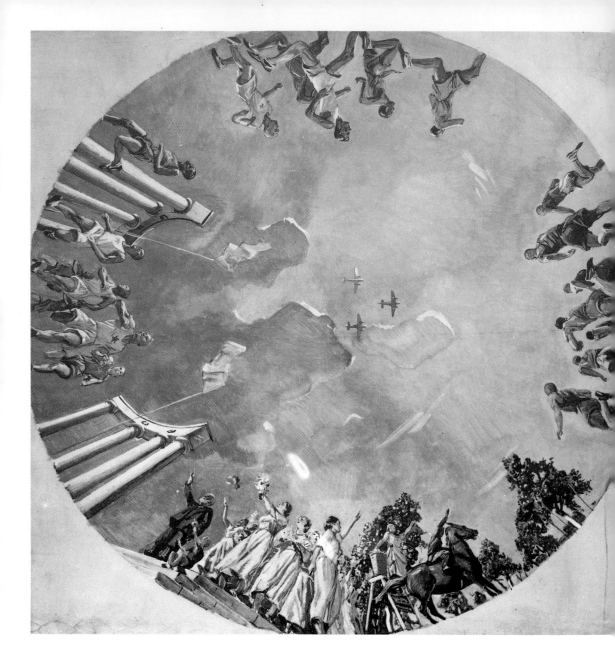

Monumental art: two dimensions

Integral to the architecture was monumental art. Here again, the Palace of the Soviets was the model: it was intended to have some 250 rooms, decorated variously by sculpture, painting, bas-relief, fresco and mosaic; studios were set up in which artists were set to work under the direction of Bela Uitts.

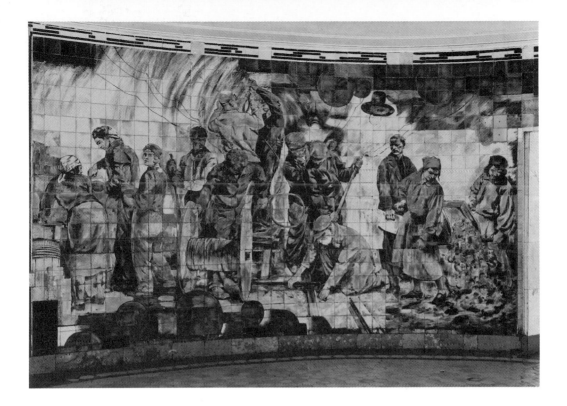

A multitude of other prestige buildings were also decorated. By eating in the restaurant in the Moscow Hotel under the ceiling designed by Evgeni Lansere (1875–1946), one can, to this day, experience something of the ambience, both gay and grand, set fair for popular enjoyment yet with a calculated aura of privilege, that Stalin's architects and designers strove to create. Deineka created a fine ceiling painting for the Red Army Theatre [pl. 50]. In the late 1930s monumental works at last began to be widely realised in the kind of lasting materials that Lenin had in mind when he published his plan for monumental propaganda in 1917. Lansere designed a majolica mural on industrial subjects for the Komsomolskaya metro [pl. 51]. Deineka's thirty-five small mosaic ceilings in the Mayakovskaya metro station were the first, gloriously successful, use of that medium, so characteristic of ancient Rome, in Soviet art.

Monumental art: sculpture

Sculpture now played an important role in architectural settings. For the banks of the Volga-Moscow canal Merkurov made giant stone figures of Lenin [pl. 52] and Stalin. The several blocks that comprise these figures were each cut individually and do not always match up perfectly: massive figures such as these presented a

50

Aleksandr Deineka
Sketch for a ceiling painting in the Red Army Theatre, 1937.
Tempera on canvas, 135×135 cm (53×53 in).
Deineka Picture Gallery, Kursk.

51

Evgeni Lansere
Majolica panel in Komsomolskaya metro (opened 1935).

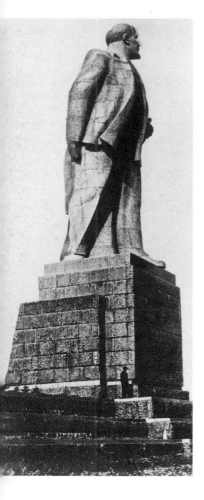

52

Sergei Merkurov
V. I. Lenin, 1937.
Granite, 1600 cm (630 in)
high; base
1600 cm (630 in) high.

serious technical challenge at this early stage in the Soviet development of monumental art. The canal was built by concentration-camp prisoners from the Dmitrovlag; thousands of their bones are concreted into its structure or buried along its banks. One cannot help feeling that the great size of Merkurov's figures aptly expresses, willy-nilly, the despotic relation of state power to those wretched individuals.

The most celebrated monumental sculpture of the 1930s was the *Worker and Collective Farm Girl* [Half-title] made by Vera Mukhina to stand aloft the Soviet pavilion at the 1937 international exhibition in Paris. It became the great symbol of Stalin's USSR, defined in a new constitution of December 1936 as 'a state of workers and peasants'. Fashioned from the novel material of stainless steel, it was conceived as an image of Soviet industrial progress. In fact, it was completely hand-made, laboriously fashioned in individual sections, each shaped on a carved wooden template.

This work established Mukhina as the most celebrated Soviet sculptor of her age, both at home and abroad. Molotov took Stalin to see it at night, and he conceived an enormous regard for it. (After the war, unsuccessful overtures were made by Stalin to get Mukhina to do his portrait.) The sculpture relies much on the rising dynamic of its profile and owes little to its existence in the round. Like the figure of Lenin on the Palace of the Soviets, but much more successfully, it used Iofan's pavilion as a mere pedestal, a launching pad. For me, the work's appeal consists in its combination of great formal brio – huge size, dynamic design, stainless steel skin – on the one hand, and unabashed corniness on the other.

At the international exhibition in New York in 1939 there was a pedestrian attempt to repeat the Paris triumph with another pavilion by Iofan and a crowning figure of a worker by Vyacheslav Andreev (1890–1945). Perhaps more interesting were the huge paintings created for the interior of the pavilion, each executed by a team of painters. *Well-Known People of the Soviet Country* covered 170 square metres; *Sports Parade* covered 150 square metres and was used as the backdrop for a 6-metre maquette of the Palace of the Soviets. These were great physical feats, a reflection in the arts of the stakhanovite ethic, which required mental and physical labour to become one.

Monumental art: the Agricultural Exhibition

The All-Union Agricultural Exhibition of 1939 was the Soviet Union's answer to the international exhibitions of Paris and New York, a display of the fruits of the soil and a great showpiece of architecture and monumental art. The main entrance to the exhibition was decorated with reliefs by the sculptor Georgi Motovilov

(1884–1963), well accommodated to their architectural setting [pl. 54]. Pavilions were built to represent and exhibit the achievements of the various Soviet republics (with the signal exception of Russia herself) and the Soviet economy; there was even a pavilion devoted to the construction achievements of *GULag*, the prison camp administration. The pavilions were often exotic syntheses of indigenous architectural traditions with neo-classicism. Perhaps the most striking work on display was Merkurov's sculpture of Stalin [pl. 53]. Contemporary photographs suggest that it was a magnificent, brooding figure, eloquent with all the qualities Stalin wished to project, but remaining, to the dispassionate eye, every inch the image of a despot. This is not to say, of course, that Merkurov wanted other than to exalt Stalin, but his work demonstrates the uncanny ability of a work of art to arrive at a profound truth, however constricting the cultural conditions that gave rise to it.

The exhibition, due to open in 1937 as a celebration of the USSR's first 20 years, had a difficult birth, partly because many of its prime movers, such as its chief architect, Oltarzhevski, were arrested at the time of the show trials of 1936–8 – a time of unparalleled collective paranoia. A search was even made inside Merkurov's figure of Stalin to ascertain whether a bomb had been planted there.[20] This is an indication of the almost supernatural significance that was now attributable to images of the leader: as if a terrorist, intent on doing maximum damage to the Soviet state, might therefore choose to blow up not a railway bridge or pipeline, but a statue of Stalin. There is perhaps a cultural parallel to be found in the attitude to icon painting in old Russia. Icons were invested with superhuman powers; those that failed to perform could be made to face the wall or even be beaten.

The exhibition was finally opened on 1 August 1939 by Molotov. As a tribute to the collectivisation programme, it presented a great fiction of abundance (not until Stalin's death did Soviet agriculture attain the levels of productivity of pre-revolutionary Russia, so battered had it been by mismanaged collectivisation). The pavilions displaying the achievements of Soviet agriculture by means of diagrams, photographs and bald piles of produce were decorated with murals [pl. 55]. These, like the panels for the New York exhibition, were often created by artists working in brigades.

This method of working had of course been practised a decade or more earlier, notably by *RAPKh* artists and Boichuk's group. Only in the late 1930s, however, did brigade work begin to exercise many major talents – and now, of course, artists combined less from conviction than by order. The chief artist of the exhibition, Vasili Yakovlev (1893–1953), characterised it as the style of the Stalinist epoch by virtue of its being synthetic, a combination of several contributions. It recognised the communal imperative. In executing a brigade painting, every artist had to abandon something of his own personality, to relinquish his claims as an individual. Brigade paint-

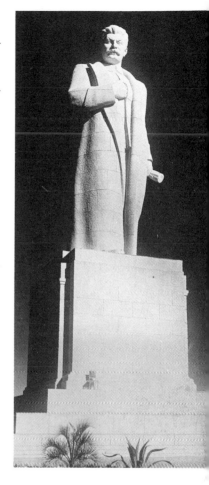

53

Sergei Merkurov
Figure of I. V. Stalin in
Mechanisation Square at
the All-Union
Agricultural Exhibition,
1939. Concrete, 3000 cm
(1,180 in) high
(destroyed).

54

Georgi Motovilov
Relief on the entrance to
the All-Union
Agricultural Exhibition,
1939, stone
(destroyed).

55

Georgi Rublyov
(designer)
Interior of the pavilion
'Corn' at the 1939 All-
Union Agricultural
Exhibition.
The mural at the end of
the pavilion was
executed jointly by
Aleksandr Gerasimov,
Evgeni Kalachev, Fyodor
Modorov and Dmitri
Panin; it is entitled
*Comrade Stalin together
with the Leading
Workers of the Party and
the Government Inspect
the Work of a Soviet
Tractor of a New Type.*

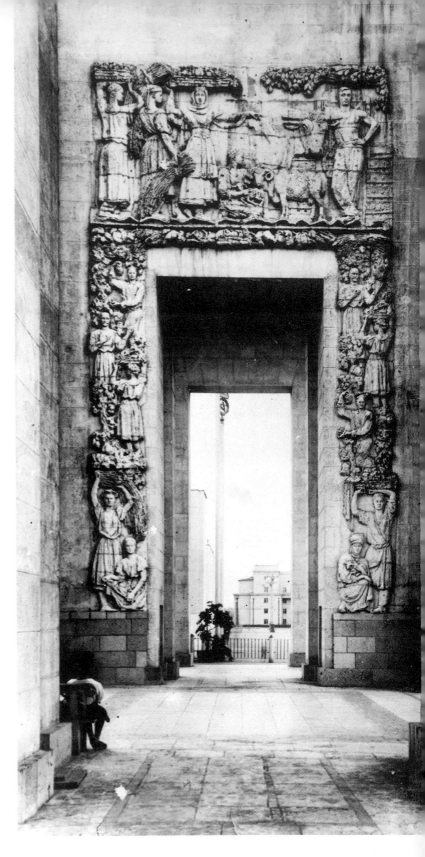

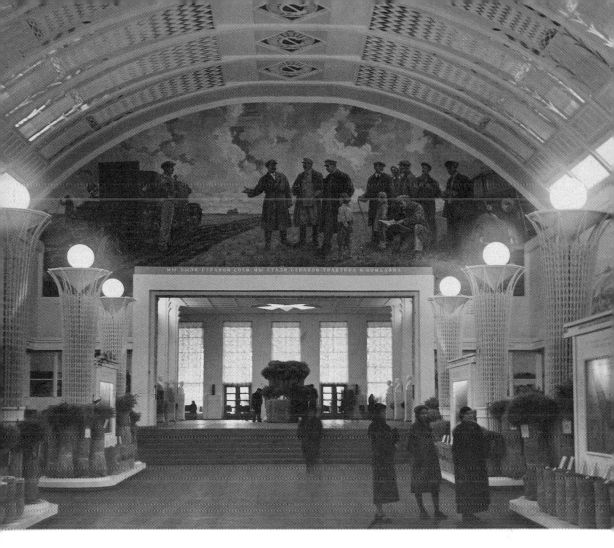

ing corresponded with the striving towards a monolithic society, in which social and individual differences would be abolished.

The new art world: the unions

The requirement of the April 1932 decree for all those artists who 'support the platform of Soviet power and are striving to take part in socialist construction' to form a single union meant in practice that not only proletarian art groups, such as *RAPKh*, but all groups were disbanded; their continued existence would have implied opposition to Soviet principles. Despite the element of coercion, many artists welcomed the formation of a single union and an end to the group strife which had become such an egregious factor in the Soviet art world.

What actually happened at this juncture was the formation of

separate artists' unions in Moscow, Leningrad and in other towns and republics of the Soviet Union, rather than the establishment of a single, unifying body. Each regional union enrolled practitioners of a variety of disciplines – painters, monumental artists, graphic artists, theatre and poster designers. Sculptors in Moscow had their own, separate union until 1940, when steps were taken to unite them with their fellow-artists.

MOSSKh, the Moscow section of the intended Union of Soviet Artists, was the most significant of the unions in terms of its size, the eminence of its members and the salient role it played among the evolving artistic constraints of the 1930s. Its members were despatched to outlying republics in order to set up unions, exhibitions and art-educational institutions, and to report back on the development of art in the regions. In July 1939 a so-called *Orgkomitet*, or Organising Committee, of a country-wide union held its first plenum, but at least until then it was *MOSSKh* which took an organisational lead across the whole of the Soviet Union. In the end, despite the foundation of the *Orgkomitet*, a single artists' union, embracing the whole of the USSR, was not to hold its inaugural conference until as late as 1957, or 25 years after the decree which paved the way for it.

MOSSKh

MOSSKh was born on 25 June 1932, some two months after the April decree, when working parties from the now-defunct Moscow artistic groups met to elect its directorate. Aleksei Volter (1889–1974), a party member and a former member of *AKhR/R*, was chosen as chairman of some 20 leading figures, drawn from a variety of groups. They asserted the structure of the union in terms of areas of responsibility: there was a painting section, a theatre section, a section for criticism, and soon afterwards followed sections for monumental art, graphic art and a foreign relations bureau.

Volter, by profession a painter but notable only as an administrator, became chairman of *MOSSKh* for the next five years. The first head of the painting section was Sergei Gerasimov. He is remembered by his contemporaries as a man of broad sympathies and conciliatory manner, a distinct contrast to his namesake (but no relation), Aleksandr Gerasimov. In the early 1920s Sergei had been a member of the *Makovets* group, whose almost subversively tolerant manifesto had claimed 'We are not fighting with anyone', then of *OMKh* and later of *AKhR*. He was an ideal candidate to unite and smooth over the differences between the former members of many different groups.

Careful control was exercised over the induction of ordinary members into *MOSSKh*. A commission was set up under Ryazhski, a party member and agent of the secret police, to examine the

claims of Moscow artists.[21] It found in favour of all the salient figures of the 1920s, but a number of gifted artists, such as Antonina Sofronova, were overlooked.

MOSSKh: art journals

MOSSKh controlled two new art magazines with a nation-wide remit, both of which were first published in 1933. They were intended to replace the broadsheets and journals previously put out by the disparate artists' groups. Both *Tvorchestvo*, Creativity, and *Iskusstvo*, Art, were edited by one man, Osip Beskin (1892–1969), head of the critics' section of *MOSSKh*. The decision to give a single person such all-embracing responsibility pre-empted all possibility of debate between the two publications: in keeping with the spirit of the 1932 decree, the aim was to promote a single ideological line in the arts. However, they did differ in style. *Tvorchestvo* had a larger format and a popular approach; *Iskusstvo* was thicker and more highbrow. *Iskusstvo* also aspired to international status: it provided captions to its illustrations in both Russian and French.

MOSSKh: its ideological role

The essential role of *MOSSKh* was ideological. Artists did not receive money from *MOSSKh*; they continued to get bread-and-butter work from *VseKoKhudozhnik* or *IzoGIz*, and major commissions from various government organisations on the occasion of big thematic exhibitions. Similarly, artists in outlying cities and republics continued to rely on their local branch of *VseKoKhudozhnik* to make a living. (This was often of a stultifying kind, involving the copying of popular paintings from poor quality reproductions or even from postcards which themselves may have had a few figures or a pot of flowers added by a retoucher!) In 1937 an Art Fund was formed to look after the supply of art materials and the provision of studio space. All this left *MOSSKh* and the other unions as a forum for supervised debate (always within the parameters of ideology and often in response to articles in newspapers or party decrees); a medium for communication with the government; an organising and, above all, an evangelising entity.

MOSSKh: the party section

Integral to a union's activity was the work of the party 'fraction' explicitly provided for in the 1932 decree. Its role was spelt out to *MOSSKh* party members by comrade Kogan of the Moscow party committee at a meeting in 1936. He told them: 'You have to be the

ideological fist of the party, so that they [artists] understand that there subsists in you a control which will not overlook or turn a blind eye to anything.' That this exhortation had compelling arguments to back it up was underlined as Kogan continued: 'Remember that you answer for everything that happens on the art front and that "for Bolsheviks, ignorance is no excuse". And if you don't know that, it will bury you.'

The power of the party within each union was considerable. Although democratic procedures were available to its members, the initial slate of candidates for any election would be produced by the party section. Any union member who objected to one of these candidates or suggested one of his own – as he was entitled to do – would thus be displaying, or risk suggesting, outright opposition to the party: an intimidating prospect for some. None the less, when elections for a new directorate were held in 1937, there was in fact considerable public debate among the rank and file; and in the postwar period *MOSSKh* with even its limited democracy was viewed by the party with some antagonism.

It should be appreciated that the party's tentacles in the art world extended way beyond the strict confines of union affairs. Kogan made this, too, transparently clear: 'You must know the mood of every artist, his works, his problems, his successes, his dreams and hopes. Out of non-party artists you must create for yourselves an agency to disseminate your ideas among the mass.'[22] The hidden,

56

Interior of the exhibition 'Artists of the Russian Federation over Fifteen Years', 1932–3. At the end of the hall stands Nikolai Andreev's *Lenin on the Tribune*, 1924–9.

sad corollary of comrade Kogan's requirements was, of course, a network of stool-pigeons and informers.

Socialist realism: state of the art

The state of Soviet art at the time of the 1932 decree was best represented by the panoramic exhibition, Artists of the Russian Federation over Fifteen Years [pl. 56]. It opened in Leningrad in 1932 and moved to Moscow in June 1933. It marked the end of an era. The work of Malevich and other avant-gardists, although it was exhibited in Leningrad, was left out when the show re-opened in Moscow. The purpose of this censorship was, said the exhibition director Nikolai Shchekotov (1884–1945), to warn young artists not to take the 'formalist' path represented by these artists.[23]

This was also Filonov's last exhibition. Henceforth artists such as these, with their pupils and followers, were to sink out of sight, sometimes excluded from the new unions and usually deprived of the opportunity to exhibit. Soviet art was to be urged down a single, increasingly narrow path, guided by a new beacon: socialist realism.

Socialist realism: what's in a name?

The term, socialist realism, probably first occurred in print in an article in the *Literary Gazette* in May 1932. It stated: 'The masses demand of an artist honesty, truthfulness, and a revolutionary, socialist realism in the representation of the proletarian revolution.' In 1933, Maksim Gorki published an important article, 'On Socialist Realism', talking of 'a new direction essential to us – socialist realism, which – it stands to reason – can be created only from the data of socialist experience'. In 1934, at the first conference of the Union of Writers, socialist realism was proclaimed as the definitive Soviet artistic method.

During the 1930s, Stalin himself was revealed, if not as the originator, then as the prime mover in the adoption of the term. He was said to have settled on it at a party in Gorki's apartment in October 1932, while vying with Gorki and others to think up a suitable name for an intrinsically Soviet art. This – whether true or not – was only logical. Because art was considered to be an ideological phenomenon, both reflecting and acting in the interests of a certain set of social attitudes, then its highest arbiter must be not the artist or critic, or even public opinion, but the ideologist. Thus Stalin became, among other things, the Soviet Union's chief art critic. As *Tvorchestvo* put it in 1939: 'Comrade Stalin's words of genius about Soviet art as an art of socialist realism represent the peak of all the progressive strivings of the aesthetic thought of mankind.'[24]

Socialist realism: the party line

Socialist realism did not emerge fully armed like some Minerva. Its theory was elaborated progressively throughout the 1930s. In this and subsequent decades, the theory was subject to constant emendation and reinterpretation by the party and by artists. Thus socialist realist art was never a static phenomenon: it reflected the development of Soviet society and party policy.

The pronouncements of the party élite were beacons to artists. At the 1934 writers' conference, Andrei Zhdanov spoke on the party's behalf. Some of the content of his speech was incorporated by the conference, sometimes verbatim, into the constitution of the Union of Writers, and has remained current to this day.[25] Following Zhdanov, the writers' constitution states that socialist realism 'demands from the artist a true and historically concrete depiction of reality in its revolutionary development . . . combined with the task of educating workers in the spirit of Communism'.

One should not expect too much from this definition: it does not adumbrate all of what socialist realism was to become, nor is it entirely clear in itself; but it still repays analysis.

The phrase 'true and historically concrete' suggested that artists turn to actual events and real personalities for their subject matter. The requirement for reality to be depicted 'in its revolutionary development' implied a tendentious interpretation of events from a Bolshevik viewpoint, isolating in them their relevance to the revolution. From this latter stipulation stemmed a particular trait of socialist realism: its obligatory optimism. The equation was simple: everything was to be depicted from the point of view of the Bolshevik revolution; the Bolshevik revolution was an unambiguously good thing and promised a glorious future; therefore an event portrayed from this point of view should be an optimistic image. As Zhdanov put it in his speech: 'Soviet literature must be able to show our heroes, must be able to glimpse our tomorrow.'

The second part of the definition is self-explanatory and equates art with party propaganda. What emerges is an art which focuses on real people and events, which sees them in the light of the revolution, which is optimistic and devoted to the party line.

At the same 1934 writers' conference, Zhdanov offered up a Goebbelsesque phrase of Stalin's, describing the writer as an 'engineer of the human soul'. The artist was to instil the communist ideal into the Soviet consciousness, and to convince the people of the value of that ideal whatever the reality.

Socialist realism: theory

The theory of socialist realism elaborated during the 1930s sought intellectual roots. This search led to the publication of a number of books in the second half of the decade: *Marx and Engels on Art* (1937); *Lenin on Culture and Art* (1938); *Gorki on Art* (1940).

A precedent for socialist realism was discovered in Engels' requirement for a 'tendentious' art, devoted to the workers' cause. Forbears were discovered in the 'optimistic' fiction of Maksim Gorki; his novel *Mother* (1906) was deemed a particular exemplum.

Gorki himself had quite a lot to say about socialist realism. He stated that the hero of socialist realism would be Toil and that the toiler would be unthinkable outside the collective. Individualism he called 'bankrupt', 'decrepit' and, mercilessly, 'zoological'. Like Zhdanov, he required artists to look at the present day from the point of view of an assured glorious future, 'from the height of the great goals of the future'. Most famously, he asserted that the artist should be both 'midwife and gravedigger', that he should 'bury everything harmful to people, harmful even when they like it'. In other words, the artist was called upon not only to create a new art, but to exterminate the pernicious elements in the old.

Above all, the party aestheticians turned to Lenin's published thoughts and writings, and there they found the perfect embryo of the new art of the Stalin era.

The qualities Lenin desired in art – its *narodnost*, or orientation towards the people; its *ideinost*, or ideological content; its *klassovost*, or class content – were isolated as the essential characteristics of socialist realism. But most important of all was the quality of *partiinost*, party consciousness, which Lenin had called for in his article, 'On Party Organisation and Party Literature', in 1905.

Partiinost was strongly implied in the 1934 writers' conference definition quoted earlier, i.e. in the task of 'educating the workers in the spirit of communism'. Once the principle of *partiinost* was accepted, the other principles followed as night the day, for was not the party the representative of the people's interests, the purveyor of ideology, the leader of the class struggle? Thus the concepts of *narodnost*, *ideinost* and *klassovost* were subsumed in the idea of *partiinost*; and they meant, at any particular time, only what the party wanted them to mean.

Socialist realism: style

Stalin never said publicly what socialist realism ought to look like in the visual arts. Igor Grabar (1871–1960), the only artist delegate at the writers' conference, was scarcely more helpful, vowing only that

artists would use 'this well-tested method, the best of all existing ones' – although how socialist realism, sanctioned by Stalin only in 1932, could have been well-tested by 1934 is not clear. These two words, a symbiosis approved by 'genius', are really a rune for interpretation by initiates. However, although realism is always a fuzzy concept, it is fair to assume that abstract art was ruled out.

A stylistic model for socialist realism emerged during the mid-1930s. The ground was prepared for this by a meeting in 1933 between Stalin and Voroshilov on the one hand and Brodski, Aleksandr Gerasimov and Katsman on the other.[26] This meeting was mentioned by Brodski in his memoirs (1940), and has been recorded by Aleksandr Gerasimov in typically superior fashion: while Brodski and Katsman hang on the leader's words, Gerasimov himself, not being in need of guidance, is busy professionally, drawing the leader with his little red pencil [pl. 57].

Stalin laid upon these artists the task of establishing their brand of realism, based on the methods of the Itinerants and Russian academics, as the dominant one. This approach reflected both Stalin's personal tastes (cf. his fondness for Repin) and his understanding that the resulting art would be the most easily understood by the masses; it would be both popular and, as a story-telling art, the best vehicle for propaganda.

Katsman, in particular, set to work with a will. In March 1933 he engaged Ivan Gronski, editor of the party paper, *Izvestiya*, to lecture to *MOSSKh* members. Gronski stated that 'socialist realism is Rubens, Rembrandt and Repin put to serve the working class' and attacked artists espousing other traditions (in response to which

Shterenberg and others engaged the liberal writer, Ilya Ehrenburg (1891–1967), to give a speech putting a different point of view). As Katsman's letters to Brodski demonstrate, he was a zealot: ' . . . soon it will become clear to all – only a realist can be a Soviet artist. Whoever is not a realist is complete shit . . . '[27]

Brodski was made director in 1934 of the All-Russian Academy of Arts in Leningrad, where he reinstituted the academic teaching methods rejected in the 1920s under the *VKhuTeMas/VKhuTeIn* regime. A similar move was made in Moscow in 1936, when a painting course was opened at the Moscow Institute of Visual Art (MIII) (the first such course in the capital since the closing of *VKhuTeIn* in 1930). Here, too, the technical training now resembled the academic methods of the pre-revolutionary art schools.

At the same time, the heritage of the Itinerants was selectively resurrected to provide a historical basis for the new Soviet art. The characterisation, widespread in the 1920s, of the Itinerants as a bourgeois movement was decisively rejected by the critical establishment now that it was centralised under party control. Artists such as Repin, Surikov, Kramskoi, Levitan, who in 1893 had rejoined the fold of the Academy – still a byword for tsarist rule – and enjoyed its honours and privileges, were officially portrayed as models of radical, proto-revolutionary thought.

This rewriting of Russian art history to suit the demands of the party was part and parcel of a wider revision of Russian and Soviet history which began in the late 1920s, as soon as Trotski had left the Soviet Union, and gathered pace in the 1930s. The new history eschewed the theoretical marxism of Pokrovski that had held sway in the 1920s and bolstered such groups as October; it required the personification of heroes and villains from the Russian past, rather than an abstract analysis of movements and ideologies – from which no one emerged in an unambiguously positive light. Pokrovski was criticised, for example, for ascribing Napoleon's defeat to the inadequacies of his army, rather than viewing it as a heroic feat of Russian arms.

The new history was put into action by a decree of May 1934, 'On the teaching of civil history in the schools of the USSR'. This was followed by the publication of a number of new textbooks to replace Pokrovski's, of which the most important was *A Short Course in the History of the All-Union Communist Party (of Bolsheviks)* (1938, reissued 1940), in which the role of Trotski and others in the revolutionary movement was entirely written out and Stalin's contribution, and his intimacy with Lenin, enlarged out of all proportion. The *Short Course* provided the theoretical basis for a cult of Stalin in the arts (although the cult was entrenched before its publication) and became the standard reference book for Soviet artists painting history pictures.

The concoction of a pantheon of Russian artistic heroes drawn from the Itinerants entailed as much sophistry and over-simplifica-

tion as the *Short Course* itself. Young critics such as Pyotr Sysoev (born 1906) began to write in praise of Repin the revolutionary, glossing over his rapprochement with the Academy and enjoyment of a vast country estate. Kramskoi's advice to artists to paint 'typical' representatives of social groups was echoed, but not his view that art was intended to soothe and induce repose. An analogous process of revision took place in all the arts; Dostoevsky was downgraded for his mysticism, Pushkin exalted for his ability to exploit the vernacular in the context of high art. In a sublime expression of the new approach to the Russian cultural heritage, a fine statue of Gogol, completed in 1912 by Nikolai Andreev, was removed in 1935 from its prominent site in Moscow because it was deemed a too 'pessimistic' image of the great writer.

In 1936–8 major exhibitions were mounted of the works of Repin, Surikov, Kramskoi and Levitan; whole editions of *Tvorchestvo* were devoted to them. By 1939 the art historian Aleksei Fyodorov-Davydov (1900–1969) felt that the reputation of these artists was now secure enough for him to advance the audacious theory that nineteenth-century Russian landscape painters had influenced the French at least as much as the French had the Russians; although he prudently conceded that this proposition had not been properly studied.[28]

This emphasis on the tradition of Russian realism corresponded not only to the demands of political expediency and popular taste; it also represented the interests of the overwhelming majority of Soviet artists. The painting section of *MOSSKh* in 1932 (comprising over half the total membership of the union) contained 197 former *AKhR/R* members and eighty-two former *RAPKh* members; as against fifty-four from *OMKh*, thirty from *OSt* and sixty-five from all other groups. Thus the stylistic conservatives enjoyed a 2:1 majority, mostly drawn from *AKhR/R*, self-styled heir of the Russian realist tradition.[29] In other words, the imposition on Soviet art of such a style was not simply an autocratic decision of the party; it reflected the preferences of the majority of artists.

Despite the clarity of the party line, and its acceptability to the bulk of Soviet artists, involved and bitter debates about the proper formal nature of socialist realism were endemic throughout the 1930s. Some artists were happy to promote socialism, but were reluctant to give up the stylistic freedoms of the 1920s. Later in the chapter I shall deal with the vicious campaign against these artists, dubbed formalists, which began in earnest in 1933 and cruelly excluded them from artistic life.

Socialist realism: commissions

Artists did not sit in their studios and paint works extolling the socialist state without encouragement. The spiritual engineering

that Stalin looked for was to be guided by the state. Socialist realism, as befitted the art of *partiinost*, was ninety-nine per cent commissioned on themes devised by committees and approved by the political leadership.

Bread-and-butter commissions continued to be handled by *VseKoKhudozhnik* and through the system of *kontraktaktsiya*. However, in the mid-1930s this system was modified; artists were no longer contracted merely to produce a certain number of works, perhaps on a broad theme, over a long period of time – say a year; they were now contracted to produce specific works, each on a given subject – a real diminution of freedom.

In January 1936 the KPDI, the Committee for Art Affairs, was formed, answerable directly to the Central Committee of the party. It took over from the *NarKomPros* responsibility for the visual arts; its remit extended to music, the theatre and the cinema. The KPDI now oversaw the commissioning of works for major exhibitions.

For the first great exhibition held under the banner of socialist realism, 20 Years of the Workers' and Peasants' Red Army and Navy of 1938, artists could pick a title from a list of over 100 on offer under a variety of headings. In the section entitled 'The Red Army was Built and Tempered Under Fire' an artist might choose the title *It is Necessary to Understand*, supplied with the rubric 'A Bolshevik worker tells a soldier of the Tsar's army why he should help in the struggle against the Tsar'. This particular list was drawn up by the art department of the People's Commissariat for Defence, in other words by a joint committee of art specialists and military men, i.e. much as a Western Defence Ministry might plan an advertising campaign today.[30]

Socialist realism: the public

To help the public reap full benefit from socialist realism, the party arranged incentives. Museum directors and their staffs received handsome bonuses for exceeding the planned number of visitors to an individual exhibition or over a complete year. Of the 160,000 visitors to the great art exhibition of 1939, The Industry of Socialism, during its first nine months, 96,000 came on organised tours and 23,000 on mass visits arranged with industrial concerns (i.e. only about a quarter came under their own steam).[31] Socialist realism was being comprehensively engineered as a mass art. How genuinely popular it was is hard to say. The available evidence of letters to the press, visitors' books and so on can only give a limited and risky view of this matter. However, familiarity with popular attitudes in the USSR today suggests that, just as in the West, there is a large body of conservative opinion among the general public whose views on art, such as they are, may well have been served by Stalin's cultural policies.

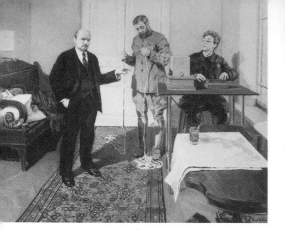
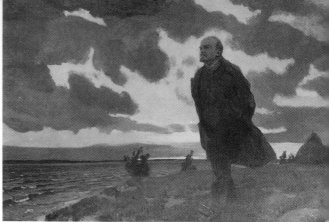

The genre of the leader: Lenin

The lynchpin genre of socialist realism was that of the leader. An image of Lenin or Stalin was the artistic embodiment of communist ideology and party striving. This was also true of other powerful figures, although their careers, and thus their importance for artists, were less secure. After the Soviet Union's rebuff in the war with Finland of 1939–40, for example, Voroshilov was removed from his post as commander-in-chief of the Red Army and ceased to figure prominently in the work of Soviet artists.

Lenin in the sculpture of the 1930s acquired the monumental presence seen in Merkurov's vast figures [pl. 52]. He was typically represented arm extended, as if to quieten an excited crowd; or else stepping forward – a metaphor for the promise of a bright communist future (statues of Stalin, too, exploit this small, decisive step forwards).[32] Sometimes, as a token of his humanity, he clutches a cap or carries a coat over his arm.

Paintings were focused mainly on Lenin's activity in the years immediately before and after the revolution. If there is a unifying theme in these works, it is Lenin's superhuman intellectual capacity, his ability to analyse and solve problems – a reflection of the holy status given posthumously to his written oeuvre and recorded utterances. Sometimes he displays a Solomon-like wisdom, as in pictures where he receives *khodoki* – peasants who travelled great distances on foot to state a grievance and seek advice. At other times he was the ideologist, giving rousing speeches. But above all he was the great strategist, planning the revolution and directing the Red Army's campaign in the civil war.

Lenin at the Telegraph [pl. 58] by Grabar shows a scene from the civil war; Lenin, having had news of the struggle read out to him, is dictating his orders to the telegraph boy, whose expression betrays his admiration of the leader's masterful handling of the situation. It is dawn, and on the sofa sleeps the telegraph boy's replacement – a

reminder of Lenin's round-the-clock industry. This painting is typical of many in which artists excavated significant, 'historically concrete' moments in the lives of their leaders and created from them allegories of Bolshevik virtues. Grabar himself was a cultural jack-of-all-trades with a career extending back long before the revolution. In St. Petersburg he studied academic subjects at the university and then art at the Academy. Subsequently he studied art and then architecture in Munich. His career combined painting with writing art history, museum administration and extensive teaching. Grabar demonstrated how talents cultivated before the revolution could be made to serve successfully in the Soviet art world; all the more so because traditional art practice was now being reappraised and reanimated.

Part and parcel of this reaffirmation of tradition was an attempt to lure into the socialist realist camp painters of the older generation who had stood to one side of the earlier debates about proletarian art and had often been rudely treated by Shterenberg and *Izo NarKomPros* in the 1920s. The well-known landscapist Arkadi Rylov (1870–1939) painted his romantic image *Lenin in Razliv* [pl. 59] in calculated response to exhortation of this kind. It depicts Lenin while in hiding prior to the revolution. Rylov described this painting in 1935 in a letter to a fellow artist: 'He [Lenin] walks up and down the river bank, waiting for news from the town. When the sun sets, an underground go-between will come to him. Lenin's plan for the struggle with the temporary government is already ripe and thought out in detail. Vladimir Ilich will give the necessary directions to his comrades. The theme, *Lenin in Razliv*, was ordered from me by the Leningrad Council, and I devised the whole composition and the moment itself. Communists like it.'[33]

The genre of the leader: Stalin

The putative closeness of Lenin and Stalin was one of the major inventions of the historians who were given the job of rewriting Russian and Soviet history. The newspaper *Soviet Art* which on 19 January 1936 announced the formation of the KPDI also bore on its cover a photograph purporting to represent Lenin and Stalin in happy propinquity [pl. 60]. In fact, it was a montage, a fake; but it served as the source for more than one sculptural composition. In painting, the young Stalin was often represented immediately adjacent to Lenin, as his right-hand man; or sometimes on equal terms with him. Stalin was also represented as Lenin's intellectual and spiritual heir; 'Stalin is Lenin Today' ran one widely disseminated slogan. A significant work was *Leader, Teacher and Friend* (1937) by Grigori Shegal (1889–1956). It shows Stalin at a conference, standing in front of a vast statue of Lenin – an iconographical paraphrase of this succession. This work, in which Stalin bends to give advice

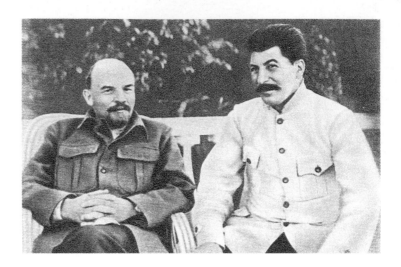

60

Montage photograph of
Lenin and Stalin
published in *Soviet Art*,
19 January 1936.

to a peasant woman called upon to chair a great conference, also exemplifies the way in which Stalin assumed, in his public image, the virtues ascribed to the departed leader: wisdom, modesty and a fatherly concern for his people.

In 1935 Lavrenti Beria (1899–1953) published a brief work entitled 'On the Question of the History of the Bolshevik Organisations of Transcaucasia'. This told a rousing tale of Stalin's pre-revolutionary activity and served as the source-book for many paintings at an exhibition of Georgian art held in Moscow in 1937, where an entire painted hagiography of Stalin's youth was put on display.[34] This historical consolidation of Stalin's heroic past was completed by the *Short Course* in 1938, and marked in the art-world by a decision of the KPDI to celebrate Stalin's 60th birthday in 1939 with an exhibition. However, there were not enough Stalin pictures ready in time, and the show had to amalgamated with another, initially quite separate exhibition.[35]

To Stalin the friend and successor to Lenin and Stalin the idomitable revolutionary can be added the following important incarnations. First, Stalin the *fons et origo* of ideology. Here perhaps the most compelling images were a series of half-length protraits by Aleksandr Gerasimov depicting Stalin giving his reports to the 16th, 17th and 18th party congresses. Second, Stalin out and about in the Soviet country, visiting new canals and power stations and meeting ordinary people – conferring his blessing on the range of socialist striving. Indeed, images of Stalin in the 1930s often stress his humanity and active participation in the lives of ordinary people. The most celebrated painting of such a subject was *An Unforgettable Meeting* [pl. 61] by Vasili Efanov (1900–1978), which shows Stalin greeting a delegate at a Kremlin conference. As Tvorchestvo put it,

'To see Stalin, to shake his hand, is the supreme reward for the creme de la creme of the people of the Soviet country.'

However, after the purges of 1936–8, which included the massacre of the top ranks of the Red Army, and in the context of a growing threat of war, the image of Stalin at the end of the decade began a metamorphosis. It became less appropriate to portray Stalin's common touch, more so to stress his omnipotence. Aleksandr Gerasimov's *Stalin and Voroshilov in the Kremlin* [pl. 3] gave Stalin a new monumental presence, shot through with intimations of power and spirituality. The twin representatives of civic and military might are taking a turn in the Kremlin. A recent downpour has ceased, flecks of blue sky are evident amid the racing clouds. There is, perhaps, the metaphorical sense of a tempest – the purges – past and plain communist sailing ahead. Stalin's gaze is most certainly of transcendental import: it penetrates not only space but time: it sees clearly into a dazzling, sunlit communist future. As the artist himself put it laconically, 'Stalin – is victory.'[37]

Stalin presented, in theory, the opportunity to draw him from life, but this rarely came about. Even the most privileged artists were compelled to make do with swift sketches while he went about his public business, and to work largely from photographs. This state of affairs perhaps arose in part from Stalin's sense of his own physical imperfection: he had a withered arm and a poor complexion, ravaged by psoriasis. It was probably compounded by his dissatisfaction with the two portraits of him which were executed from life, by the sculptor, Boris Yakovlev, and the painter, Dmitri Sharapov. Sharapov came from Leningrad to Moscow to do Stalin's portrait; he was arrested after two sessions because Stalin was displeased with the way he was portrayed.[38]

61

Vasili Efanov
An Unforgettable Meeting, 1936–7.
Oil on canvas,
270×391 cm
(106×154 in).
State Tretyakov Gallery.

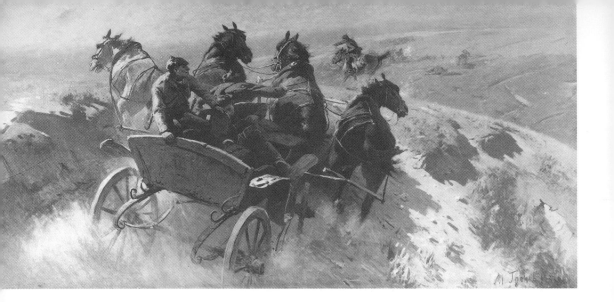

Mitrofan Grekov
*The Machine-Gun
Carriage: Driving Out
Into Position*, 1933.
Oil on canvas,
150×300 cm (59×118 in).
Central Museum of the
Soviet Army, Moscow.

The Red Army

Military metaphors permeated writing about art, underlining a close relationship between art and the Red Army which had begun with the formation of *AKhRR* in 1922. Favourite references were to the 'struggle' on the *izofront*, the art front, and to the pencil or brush as a 'weapon'. Two major exhibitions were devoted to the Red Army during the period we are considering, on the occasion of its fifteen- and twenty-year jubilees in 1933 and 1938. The first of these is believed to be only the second, and the final, exhibition visited personally by Stalin. No comment by him appears to have been recorded.[39]

The planned link between art and the military was personified on the one hand by Voroshilov, a collector and patron of the arts. Voroshilov was the subject of Brodski's last major painting, *The People's Commissar for Defence, Marshal K. E. Voroshilov, Out Skiing*. On the other hand were artist-soldiers such as Mitrofan Grekov. Grekov's scenes of civil-war action – for a long time, the only real fighting done by the Red Army – are often of good quality [pl. 62].

In 1934, Grekov was posthumously honoured by the foundation of the Grekov Studio, which was set up on Voroshilov's initiative and blessed with the auspices of the Red Army itself. Staffed by eminent professionals, it was created to train soldiers to express themselves in the visual arts. This was one more example of a philosophy of aesthetics that laid stress on *narodnost*, the popular nature of art and the creative work of ordinary people. A number of the soldier-students reached a professional standard in their work, allowing *Tvorchestvo* to enthuse: 'The appearance of such talents shows what a great role our beloved Red Army plays in the cultural life of the country.' This attempt to elide apparent polar opposites –

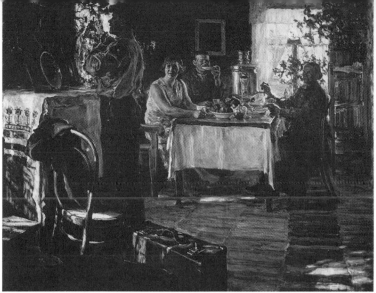

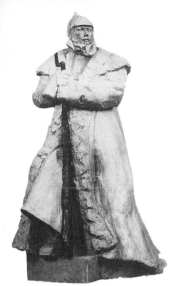

the pursuits of art and war – was a microcosm of the greater attempt to build a monolithic society, one in which the old social antagonisms and distinctions – between classes, between intellectual and physical work, between the amateur and the professional – could be made redundant.

Before the revolution, there had been battle-painting studios at the St. Petersburg Academy run by Nikolai Samokish (1860–1944). After the hiatus of the 1920s, Soviet artists reanimated this tradition, planning huge dioramas (paintings that curved through 180 degrees) and panoramas (which made a full circle, completely enclosing the viewer). Prime movers were Samokish and his former pupils Mikhail Avilov (1882–1954) and Rudolf Frents (1888–1956) One of the first works of this kind was *The Storming of Perekop*, executed by a brigade of artists in 1934–8. In order to help artists envisage the struggle for Perekop, a major engagement of the civil war, the Red Army even staged a dramatic reconstruction of the battle. This huge painting was destroyed during the Second World War.

Artists popularised the Red Army in pictures such as the sentimentalising *The Departure of a Recruit from a Collective Farm* [pl. 63] by Aleksandr Moravov (1878–1951), an early member of *AKhRR* who himself taught art to soldiers in the Grekov Studio. If the pleasure of the young man's mother in his departure seems exaggerated, one should recall that when Stalin in 1929 announced the policy of liquidating the *kulaks* as a class, he specifically exempted those with sons in the Red Army.

Great stress was laid on the defence theme. The heroes of this genre were the *pogranichniki*, the border guards, and the humble *chasovoi*, or sentry. That such figures should so often have been made into heroes symbolises the Soviet Union's isolation from the rest of the world – an isolation which in the 1930s became absolute for the mass of the population. This was felt in the arts; by 1938

63

Aleksandr Moravov
The Departure of a Recruit from a Collective Farm, 1935.
Oil on canvas,
135×160 cm (53×63 in).

64

Leonid Shervud
The Sentry,
1932–3. Plaster, wood,
267 cm (105 in) high.
Museum of the Visual Arts of the Tartar Autonomous Soviet Socialist Republic,
Kazan.

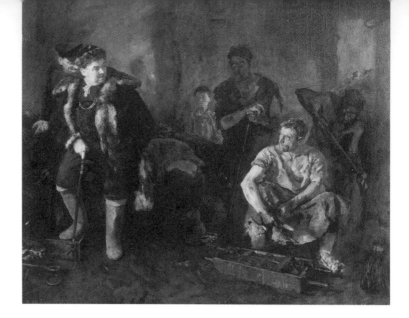

visits and exhibitions by foreign artists had dwindled to a very few indeed, and the same was true of trips abroad by Soviet artists, which were at most a perk of the most privileged, such as Deineka and Aleksandr Gerasimov. The sentry, unflinching son of the Motherland and guardian of her purdah, was marvellously portrayed in a sculpture [pl. 64] by Leonid Shervud (1871–1954).

The idea that the Soviet Union was surrounded by mortal enemies – which it was – gained weight in the late 1930s as relationships between European states deteriorated. The non-aggression pact signed by Molotov and Ribbentrop in 1939 was one defensive measure. Soviet artists also did their best to be prepared. In December 1939 the *Orgkomitet* initiated a Military-Defence Commission of the Union of Artists of the USSR. Plans were made for brigades of artists to visit army barracks and soldiers' clubs to teach and put on exhibitions; in their turn, these artists were expected to learn how to handle weapons and engage the enemy, in case they suddenly found themselves attacked.[40]

History

Two paintings of historical subjects by Ioganson became especially famous. Although they are not based on actual events they exemplify the Stalinist requirement to emphasise the individual in history, to avoid abstract explanations and embody virtues in people. One, *Communists under Interrogation* (1933), was the stuff of the *Boys' Own Paper*: two communists captured by sinister and bloated White Guards during the civil war display a stiff Bolshevik upper lip in the face of dire threats. Less melodramatic and more convincing was his slightly later work, *In an Old Urals Factory* [pl. 65]. This picture seeks to encapsulate the social and psychological origins of revolu-

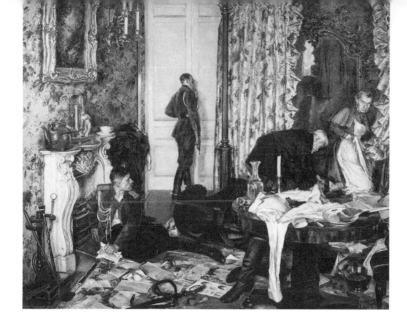

tion. It depicts the instant when the oppressed worker cuts the Gordian knot of fear and indoctrination and first has the idea of turning on his oppressor. Ioganson caught splendidly the sudden unease of the factory owner, intimidated by the worker's sharp response to an unwarranted rebuke. The model for the fat, fur-coated figure (a choice that is an ironic tribute to Ioganson's psychological insight) was none other than Aleksandr Gerasimov – a man who in the years to come was himself, much like a factory owner, to lord it over Soviet artists.

Figures more 'historically concrete' than Ioganson's were resurrected or excavated. Negative aspects in Russian history could be personalised, as in the portrayal of Kerenski, vacillating Prime Minister of the provisional government ousted by the Bolsheviks in 1917, by Shegal. The chaos surrounding his departure from luxurious surroundings stands for the weakness and trembling of the bourgeoisie as a whole when faced by Soviet power [pl. 66]. Shegal's picture exemplifies the satirical approach adopted by most Soviet artists in the 1930s when treating the Russian, pre-revolutionary past.

Indeed, despite the trend towards a more selective, robust and colourful interpretation of Russian history, paintings of this past were not often commissioned in the 1930s. Not until the end of the decade, after the publication of the *Short Course* defined the official line, were plans laid for a large exhibition, Our Motherland, devised to survey the history of the Soviet Union and its republics over the centuries. The first section of the exhibition was to be called 'From the Glorious Past of Our Motherland', and the first subject in this section was *Ivan the Terrible and his Struggle for the Creation of the Russian State.*[41] There can be little doubt that this choice was made with the approval of Stalin, who took a close interest in the reinterpretation of Russian history carried out in the 1930s. Stalin,

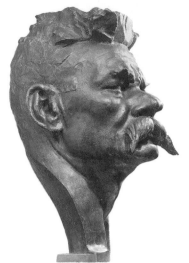

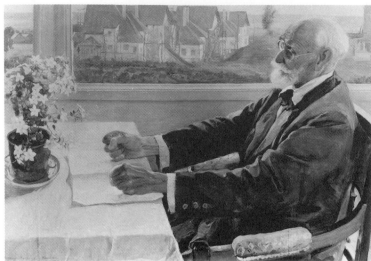

67

Ivan Shadr
Head of Gorki, 1939.
Bronze, 51 cm (20 in)
high.
State Tretyakov Gallery.

68

Mikhail Nesterov
*Portrait of the
Academician I. P. Pavlov*,
1935.
Oii on canvas,
83×121 cm
(32½×47½ in).
State Tretyakov Gallery.

greatest despot of the twentieth century, saw in the cruellest tsar a worthy forbear. Plans for this exhibition, which was to have opened in 1942 to celebrate twenty-five years of Soviet power, were aborted because of the outbreak of war in 1941.

Portraits

Under Stalin there was no clear distinction between the historical and the contemporary. The most recent pronouncements of the party were commonly described as 'historic'. Even contemporary figures and scenes from contemporary life were 'historic' because the Bolshevik party, and the personalities and events it sponsored, were deemed to be glories in the political history of mankind. Socialist realism assumed a certain clairvoyance. Sustained by the certitudes of Marxism-Leninism, which viewed the eventual triumph of communism as a logical necessity of world-wide historical development, it imagined that a dazzling future was inevitable. As Beskin put it, the socialist realist must look at life 'from the position of a builder of communism, with a broad projection into the future.'[42]

For this reason even representations of contemporary figures and contemporary life acquired an heroic, even mythic ambience, as though they were made from the point of view of an admiring posterity.

Apart from the perpetual task of portraying the party elite, the great challenges offered to sculptors in the 1930s were competitions for monuments to Pushkin (on the hundredth anniversary of his death in 1837); and to Gorki, who died in 1936. In 1939 sculptors'

69

Ilya Lukomski
*The Factory Party
Committee*, 1937.
Oil on canvas,
251×351 cm (99×138 in).
State Russian Museum.

projects were submitted for three statues of Gorki, one each to stand in Moscow, Leningrad and Gorki (formerly Nizhny-Novgorod and renamed in his memory). The winner of the competition for the Moscow monument was Ivan Shadr. It was to be the last important work for this gifted sculptor, one of whose tasks had been to design the tombstone for Stalin's wife, who took her own life in 1932. Shadr died before he could carry out his figure of Gorki, although he left two expressive heads of the writer [pl. 67].

Konchalovski painted outstanding portraits, such as one of the actor and director Vsevolod Meierhold (1874–1940) shortly before his arrest and death. Eloquent works came from Pavel Korin (1892–1967) and his mentor, Mikhail Nesterov (1862–1942). He had made a considerable reputation for himself before the revolution as a painter of religious subjects. After the revolution he had been virtually excluded from artistic life, and his rediscovery in the 1930s, was a token of the increased interest in traditions of Russian realism. His *Portrait of the Academician I. P. Pavlov* [pl. 68], the originator of the psychological theory of behaviourism, emphasises the sitter's mortality, his essential human frailty, and this degree of pathos makes it an old-fashioned portrait, at odds with the heroicising instincts of socialist realism. Nevertheless, the painting is fully of its time in that it expresses the striving towards, and unwavering belief in, a bright future. This is conveyed by the old man's outstretched arms, his clenched fists and, in front of them, a pot of flowers.

Large group portraits were also attempted, such as Efanov's *A Meeting of Students of the Zhukov Airforce Academy with Artistes of the K. S. Stanislavski Theatre* and Aleksandr Gerasimov's *The People's Commissariat for Heavy Industry.* Painters of figure compositions

70

Georgi Nisski
Autumn Signals, 1932.
Oil on canvas,
54×69 cm (21¼×27 in).
State Tretyakov Gallery.

71

Yuri Pimenov
New Moscow, 1937.
Oil on canvas,
140×170 cm (55×67 in).
State Tretyakov Gallery.

72

Aleksandr Drevin
*Construction of a
Railway Bridge in
Armenia*, 1933.
Oil on canvas,
100×120 cm
(39½×47 in).
Private Collection.

73

Serafima Ryangina
Higher and Higher, 1934.
Oil on canvas,
149×100 cm
(58½×39 in).
State Museum of
Russian Art, Kiev.

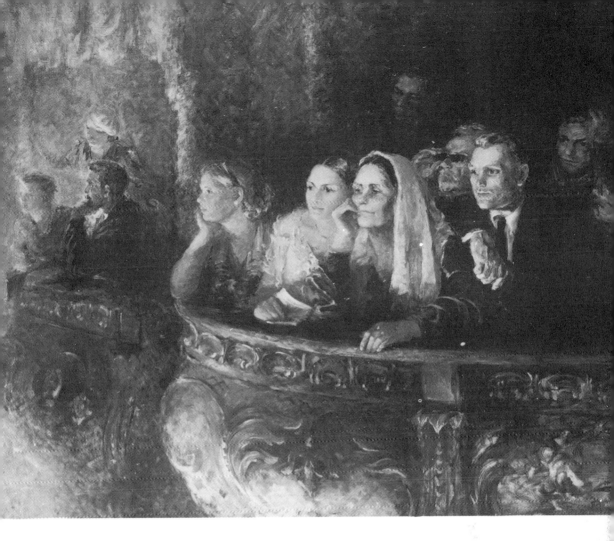

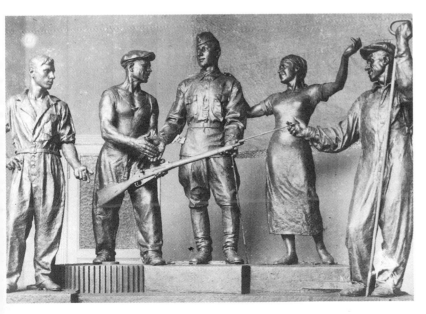

74

Olga Yanovskaya
*Stakhanovites in a Box
at the Bolshoi Theatre*,
1937.
Oil on canvas,
175×210 cm
(69×82½ in).

75

Vsevolod Lishev
Industry and Defence,
1938.
Plaster,
110×305×20 cm
(43×120×8 in).

were encouraged to enhance the documentary role of their work by avoiding the use of models and portraying people in their real-life situations. *The Factory Party Committee* [pl. 69] by Ilya Lukomski (1906–1954), the subject of which is a komsomol member's acceptance into the party, depicts the actual membership of the Stalinogorsk communist party at the time. The applicant stands on the left, answering with anxious resolve questions put to him by the committee. The painting lacks drama, but the social importance of its theme – this moment was advertised as being the most significant in a person's life – caused it to be widely discussed in the art press at the time.

Industry

Paintings of industrial subjects can be divided into two categories. First, there was the industrial landscape – views of the new dams, canals, railways and buildings put up under the 5–year plans. The landscape shaped by technology [pl. 70] found its poet in Georgi Nisski (1903–1987), a disciple of Deineka. *New Moscow* [pl. 71] by Pimenov, is a paean to the reconstruction of Moscow, to the Soviet motor industry and even to the emancipation of women in communist society. Second, there were the workers themselves. Serafima Ryangina's *Higher and Higher* [pl. 73] conflates a young couple's mutual attraction with their love of the task of socialist construction. We may understand the message to be that building communism is downright sexy (although a contemporary critic would have been most unwise to say so).

Stakhanovites in a Box at the Bolshoi Theatre [pl. 74] by Olga Yanovskaya (born 1900) depicts the super-workers enjoying the fruits of their labour. Not only had Stalin instituted a hierarchy of rewards, but the form these rewards took was being moulded by familiar bourgeois values of exclusiveness and of visual splendour.

The industrial genre was much explored by sculptors. Fine single figures were created by Motovilov (a steelworker) and Sarra Lebedeva (1892–1967) (a miner). One of very few works attempting a group composition, was *Industry and Defence* [pl. 75] by Vsevolod Lishev (1877–1960), an academically trained master of the older generation who, as a teacher in Leningrad in the 1930s, was instrumental in reviving a traditional art training. It depicts a workman handing over to a soldier a newly made rifle, a subject which emphasises the collective nature of communist striving.

Some sculptors continued to attempt a more integral relationship with modern technology and mass production – a distant echo of the ambitions of the avant-garde. Mukhina's use of stainless steel in her *Worker and Collective Farm Girl* is one example of this; she also made experiments with sculpture in glass. Sarra Lebedeva created

an inspired model for a shop-window dummy, an elegant distillation of archaic seriousness [pl. 76].

Artists travelled the length and breadth of the Soviet Union with commissions to record the effects of the Five-Year Plans on the remote regions of the vast country. Some of those from Russia and the European republics fell in love with the Eastern republics, appreciating their climate, their culture and, it may be, their distance from Moscow and her ideologues. Indeed, under Stalin there was a broad popular yearning towards exotic climes (witness the palms planted in front of the Red Army Theatre [pl. 47]) keenly felt by artists. Drevin, an enthusiastic hunter, and his wife, Udaltsova, spent the summers of 1933 and 1934 in Yerevan. Under the Armenian light, Drevin finally achieved the silvery tonality which today seems to typify his work. All the while, he strove, in defiance of realist norms, to unite a response to subject-matter with an exploration of the inherent qualities of oil paint [pl. 72].

The climactic statement about Soviet industrial striving and accomplishment was the exhibition, the Industry of Socialism. It was due to open in 1937, to mark twenty years of Soviet power and the start of the third Five-Year Plan, but Stalin's decision to purge the top echelons of the party and its administrative organs delayed its opening until 1939. Dozens of artists were compelled to repaint their works time and again as the people they portrayed were arrested. Dmitri Nalbandyan (born 1906), an ambitious young artist from Tbilisi who arrived in Moscow in 1931 and quickly ingratiated himself with the political leadership, has related the troubled genesis of one of the works he had at the exhibition:

'I began to work. The canvas was big, two metres by three. Voroshilov came to pose in a white jacket. Vlasik was Stalin's bodyguard at this time, he gave me his suit and boots. I invited a Georgian whom I found in Nogina Square to be a model, dressed him up like Stalin and painted him.

I had almost finished the painting of Stalin, Voroshilov, Kirov and Yagoda at the White Sea Canal when suddenly one morning I read in the paper: 'Yagoda is an enemy of the people.' What was I to do?

I phoned Voroshilov straight away and asked him to come round. He arrived and had a look: 'Splendid picture!' And then he said: 'I already know what to do. You paint out that place where Yagoda is. Here in the foreground throw a coat over the handrail. It will look like my coat. And so you don't waste your time on mechanical work, I'll call out some restorers.'

And on Voroshilov's orders restorers were called out from the Tretyakov Gallery, they cleaned everything up. The picture dried out in two days and I showed it. It met with great success, they made a lot of reproductions from it.'[43]

76

Sarra Lebedeva
Model for a Shop-
Window Mannequin,
1936. Plaster, 200 cm
(78¾ in) high.

77

Marina Ryndzyunskaya
*A Stakhanovite Girl of
the Cotton Fields*, 1940.
Granite, 200 cm (78¾ in)
high.
State Tretyakov Gallery.

78

Ilya Mashkov
Soviet Loaves, 1936.
Oil on canvas,
145×175 cm
(57×68¾ in).
Museum of the Visual
Arts of the Tatar
Autonomous Soviet
Socialist Republic,
Kazan.

Peasant life

One of the aims of the second Five-Year Plan was 'the unwavering growth of the standard of living of the toilers'. Newspaper headlines along the lines of 'The Soviet Country is Heading for an Abundance of Produce' (*Pravda*, 24 January 1936) proliferated. Paintings such as *Soviet Loaves* [pl. 78] by Ilya Mashkov (1881–1944), a still-life specialist [pl. 23] who strove manfully to adapt to socialist realism, provided a visual accompaniment to such claims. For this doughy *tour de force*, Mashkov had a number of loaves specially baked.

Cornucopian images of Soviet plenty abounded. Peasant paradise is depicted in the sprawling *Collective Farm Festival* [pl. 4] by Arkadi Plastov (1893–1972), one of the major artists of the period, who himself preferred to live not in Moscow but in the depths of the Russian countryside. In this picture, an avuncular image of Stalin beams down on the revels. He is their guiding spirit; and a stretched banner bears a key slogan of the decade, Stalin's famous analysis of the quality of Soviet life: 'Living has got better, living has got jollier', uttered by him at the first congress of stakhanovites and published in the preface to the first Soviet cookbook.

Plastov's painting is a fiction in so far as it extols a peasant existence which, we know, was frequently grim; but it still attains a kind of truth. It stresses a harmony with nature, earthy pleasures and the importance of communal activity – values which may have influenced the development of Soviet communism, but which are most deeply rooted in the traditions of the Russian peasantry. It was precisely this ability of some artists to find an accommodation between the demands of a party art on the one hand and their private affections on the other which gave rise to the most convincing works of socialist realism. Plastov's work also exemplifies the attempts of many Soviet artists to convey, in the most meticulously plotted compositions, the variety and subtlety of natural light: a striving inherited from the French impressionists.

Some fine sculpture was created in praise of peasant life. Outstanding was the work of artists who drew on the example of archaic Greek art. The most important of these were Sergei Bulakovski (1880–1937) and Marina Ryndzyunskaya (1877–1946). Bulakovski studied under Bourdelle in Paris, returning to the Soviet Union after the revolution in 1922. Ryndzyunskaya was his great friend; her *A Stakhanovite Girl of the Cotton Fields* [pl. 77] is a convincing attempt, echoing the ambition of architects, to draw on antique culture in the service of the Stalinist ideal.

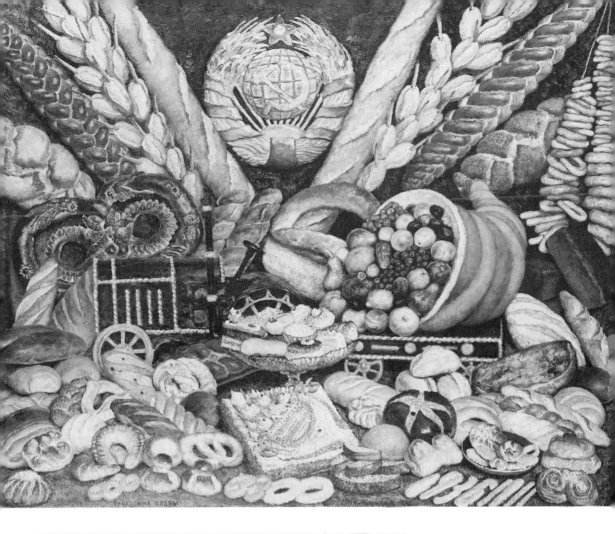

Art in the non-Russian republics

Artists' unions were established in all the Soviet republics in the 1930s. They were often set up and run by artists educated in, and retaining strong links with, Moscow. For example, Semyon Chuikov (1902–1980), born in Pishpek, the capital of Kirgizia, and a graduate of the Moscow *VKhuTeIn*, was the first chairman of the Kirgiz artists' union. The work of figures such as Chuikov and the Armenian, Saryan, which observed academic norms in the modelling of form and space but was distinguished by the mild exoticism of strong colour and broad handling, was adduced as a proper response to Stalin's dictum that art should be socialist in content, national in form.

Realist art did not take root easily when foisted on the Muslim republics: it was culturally alien. In Kazakhstan, the biggest Muslim republic, Abylkhan Kasteev (1904–1973) was almost alone in his struggle to move from folk art to a style based on that of his Russian peers. A similar situation obtained in Uzbekistan, where except for

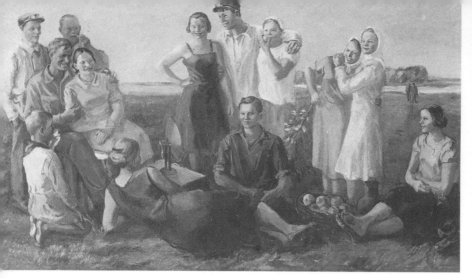

Aleksandr Volkov and Ural Tansykbaev (1904–1974), the best talents were not homegrown. Outstanding in Tashkent were Orgnes Tatevosyan (1889–1974), an Armenian, and Aleksandr Nikolaev (1897–1957), a Russian who adopted Islam and the name Usto Mumin. In Samarcand two Russians, Pavel Benkov (1879–1949), a graduate of the St. Petersburg Academy, and his former pupil, Zinaida Kovalevskaya (1902–1972), organised and ran the first Uzbek art school.

There is little doubt that artists such as Benkov chose to work in Soviet Asia in part because its distance from Moscow afforded some release from ideological pressure.[44] On a less happy note, the prison camps of Kazakhstan were also home to several avant-garde artists arrested during the purges, among them Malevich's pupil, Vera Ermolaeva.

People in art: the collective

Gorki believed that the hero of a work of socialist realism was 'unthinkable outside the collective'. The collective principle, in works as diverse as Plastov's *Collective Farm Festival* [pl. 4] and Lishev's *Industry and Defence* [pl. 75], was broadly extolled in the art of the 1930s. The same principle is inherent in the creative process of monumental art, which is often a collaboration between artist and architect; and as we have seen, by the end of the decade the collective ideal had begun to guide an artist's working methods in the form of brigade painting.

Stalin's attempt to abolish private life was as much in the interests of absolute social control as it was in the pursuit of a communist ideal. A reflection of this truth in the visual arts is the painting *Collective Farm Youth Listening to the Radio* [pl. 79] by Fyodor Antonov (born 1904). The painting was commissioned by *VseKoKhudozhnik* in 1934. The subject, rendered with a blunt charm by the

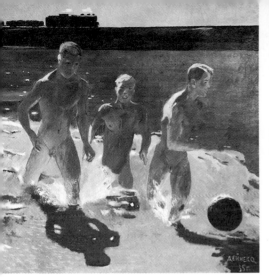

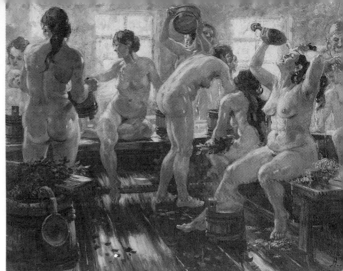

artist, was thought up after a decree of the Council of People's
Commissars of July 1933 which required all radio sets to be
registered. The painting demonstrates the proper, Stalinist way to
listen to the radio – not at home by oneself (where one might
inadvertently pick up who-knows-what on the short-wave) but in a
healthy group.

Soviet society was fairly puritanical: the dissemination of
pornography brought a five-year jail sentence, and in socialist
realism there are none of the erotic nudes which abound in Nazi
art, to which it is sometimes compared. Vasili Yakovlev was roundly
condemned for painting a brothel scene in the 1930s; and the per-
sonal denigration of Solomon Nikritin for alleged 'pornography' in
an inoffensive, if second-rate, work by a committee of
VseKoKhudozhnik has been transcribed in Kurt London's *The Seven
Soviet Arts*. But wholesome, patriotic nudity and a sense of unin-
hibited community are recurrent elements in the work of several
major artists of the 1930s. Aleksandr Gerasimov's major non-politi-
cal project at this time was a series of works on the subject of the
banya, the Russian communal bath. It was an idea he pondered for a
long time but only really came to grips with in the late 1930s.
Gerasimov had a mock-up bath-house built in his garden so as to
paint his models from life. Two major paintings [pl. 81], two large
watercolours and many studies resulted. Voroshilov expressed his
admiration for these pictures on the unlikely ground that they were
free of sexual overtones.[45] This opinion observes the puritanical
social norms of the time, but in fact the sensuousness of
Gerasimov's *Russian Communal Bath* series is unabashed: I cannot
conceive that the artist's stimulus was not primarily erotic.

Indeed, an undertow of artifice and voyeurism in Gerasimov's *A
Russian Communal Bath* is thrown into relief when it is contrasted
with Deineka's *Lunch-Break in the Donbass* [pl. 80]. This image of a
team of young mineworkers racing through the water is a joyful
painting with a lasting message, a celebration of the gifts of nature.

But it is not devoid of metaphors which link it firmly with its time. Both the steaming locomotive and the racing young men invoke an ideal of Stalinist society, the call not only for muscular efficiency in industry, but for the appearance of a New Soviet Person. As Deineka himself said later in life: 'I don't see the point of land-scapes with machines if ugly human beings, flabby and weak-willed, appear in them . . . '[46]

People in art: the New Soviet Person

The appearance of the New Soviet Person had first been predicted by the avant-garde. He, or she, would understand the new con-structivist principles of design, would love the new materials, would live appreciatively in the suprematist dream cities planned by Malevich, the Vesnins and others. This was not to be; and the marbled subterranean opulence of the Moscow metro replaced a dream of light and space and geometry. But the idea, nietzschean in flavour, that a New Soviet Person, different from all the peoples of the world, past and present, would emerge out of the revolution survived and became, after Stalin's victory in the class war with the *kulaks*, an object of renewed interest for Soviet artists.

The New Soviet Person was first and foremost a moral and intel-lectual exemplar. The courage of Ioganson's worker turning on his exploiter [pl. 65], the scientific achievements of Pavlov [pl. 68], Gorki's dedication of his art to the party line [pl. 67] – these were his measure. Stalin himself perhaps represented the ideal. The heroic exploits of his youth were retailed in the *Short Course*; his pronouncements guided the ideological debate. He was even a scholarly authority: in 1940 *Tvorchestvo* published an article in which a politburo member, Mikhail Kalinin (1875–1946), opined: 'If you were to ask me who knows the Russian language best, I would answer – Stalin.'[47]

The New Soviet Person in the visual arts was also a physical type. Just as the Itinerants painted 'typical' representatives of social groups, so Soviet artists fleshed out communist virtues. The New Soviet Man was a repository of conventional masculine qualities, of good looks and athleticism; he could have been a Hollywood lead-ing man. The New Soviet Woman, however, went against the deli-cate grain of the Western ideal. She was a physically robust version of womanhood – broad-shouldered, broad-hipped, big-boned – in short, the type of the Russian woman herself. This muscular ideal reflected the new role for women themselves under socialism: they were required to do many jobs which in the West would have been a male preserve [pl. 82].

Deineka painted this ideal often, famously in *A Mother* [pl. 83], a monumental Soviet madonna. Once in the mid-1930s, when asked about this aspect of his work at a lecture he was giving, he demon-

82

Aleksandr Samokhvalov
Woman Metro-Builder with a Pneumatic Drill,
1937. Oil on canvas,
205×130 cm (80¾×51 in).
State Russian Museum.

83
Aleksandr Deineka
A Mother, 1932.
Oil on canvas,
120×159 cm
(47×62½ in).
State Tretyakov Gallery.

strated his point by taking hold of a young listener, Angelina Shchekin-Krotova. She, he said, represented the type of dainty, aristocratic elegance favoured by Turgenev; what was needed today was a new type of woman, full of the vigour of the young Soviet state. Thus he made his point elegantly, paying the young woman a covert compliment in the process.[48]

Female artists often shared this image of their own sex: witness Mukhina's sculpture, *Worker and Collective Farm Girl*. A Deinekaesque woman, full of inner grace, was the subject of another famous sculpture of the 1930s, the larger-than-life *Girl with a Butterfly* [pl. 84] by Sarra Lebedeva. It is a deeply charming work, a monumental meditation on the sculptor's absolutes of motion and stillness, weightlessness and gravity.

Art against ideology: landscape and animal sculpture

In the 1930s the conditioning of art by party ideology became thorough and unapologetic. Artists were not only required to reflect the broad principles of policy but were given commissions geared to its every fresh nuance. For example, after a decree was passed in 1936 banning abortions (earlier legalised by Lenin) there was a spate of pictures on the subject of birth. As the dissenting Semyon Chuikov put it at a meeting of *MOSSKh*, 'in two or three months

84
Sarra Lebedeva
Girl with a Butterfly,
1936. Bronze, 200 cm
(78¾ in) high.
State Tretyakov Gallery.

hastily executed pictures on the theme of birth were strewn everywhere'.[49] The most successful of these, *Oktyabryny*, depicting the Soviet version of a christening ceremony, was by the young Aleksandr Bubnov (1908–1964).

In the face of the attempted systematisation of art and extirpation of individual initiative, not a few artists jibbed. They resented the intrusive demands of ideology on a practice that in pre-revolutionary Russia, and even in the 1920s, had always enjoyed a large measure of autonomy.

Some, such as Konchalovski, found refuge and respite in still-life painting; many more, in landscape. It was a common gripe of Moscow critics in the 1930s that when artists were given a free hand in what to exhibit rather than being guided by a socialist realist subject-plan, then the show in question would have a huge preponderance of landscapes. This was an important tradition in Russian art and, for many, patriotic in a larger and more lasting sense than that of the communist project. It provided a link with the nineteenth-century formal values insisted upon in the 1930s, but obviated the other legacy of that period – the socially engaged nature of art. Outstanding among these Moscow landscapists were the young Aleksandr Mozoroz (born 1902) and the middle-aged generation: Nikolai Krymov (1884–1958), Aleksandr Kuprin (1880–1960) [pl. 85], and Sergei Gerasimov, who, despite his job as head of the painting section of *MOSSKh*, was a man of broad artistic sympathies. Gerasimov's *Winter* [pl. 86], although it is the work of an artist with important official responsibilities, lies outside the boundaries of what we can usefully term socialist realism.

In sculpture an analogous haven was found in the practice of

animal sculpture. The supreme exponent of this genre was Aleksei
Sotnikov (1904–1989). Sotnikov was one of a number of talented
students at the *VKhuTeIn* in the late 1920s whom Tatlin selected to
assist him with the construction of the *Letatlin*. Although Sotnikov,
after early forays in the field of design (he designed a superb set of
ceramic utensils for feeding babies warm milk), rejected a modern-
ist language, his work always retained a powerful constructive sense.
Sotnikov created many works by commission for public places –
fantastic ceramic fountains, decorative reliefs, commemorative
vases – but his most compelling images are of animals, fish and
birds. For Sotnikov, the image of a lamb [pl. 87] was a symbol, as it
is in the Christian faith, of innocence and of the human capacity for
suffering. It is a saintly image created in defiance of a pagan age;
those who knew Sotnikov view it as a spiritual self-portrait.

The debate about form

The real weight of critical opprobrium and social victimisation
landed, however, on artists other than the ideologically neutral
landscape painters and animal sculptors. The gradual establishment
as the artistic ideal of a concept of realism based on the methods of
the Itinerants, discussed at the start of this chapter, entailed a paral-
lel destruction of the claims of all other styles of figurative art. A
two-pronged attack was mounted by artists, critics and party organs
on the twin evils of 'formalism' and 'naturalism' in art. These two
became, as it were, the Scylla and Charybdis of style between which
the socialist realist must steer a bold path.

Naturalism

Although they were so often paired in the critical discourse of the 1930s, these two anathemas attracted unequal amounts of attention. The debate that raged around formalism, which I shall deal with at length, was considerable: it involved many artists, affected livelihoods and even lives, and most of its participants understood more or less what it was about. The battle with naturalism, on the other hand, was sometimes compared to that of Don Quixote with his own imagination. There was no consensus about the nature of naturalism. Some critics claimed that it differed from realism not in its form, but in its false world view, at odds with Bolshevik principles; others, the majority, indeed deemed it a matter of form, consisting in pedantic attention to detail. Thus Brodski and Katsman were criticised for naturalism. But they had been received by Stalin and had helped set the hidden agenda for the development of Soviet art in the 1930s; Stalin, one must assume, liked naturalism, if that is what the work of Brodski and Katsman represented; he even awarded Brodski an Order of Lenin. While artists took it seriously, the debate around naturalism was a blind for the party, providing an illusion of balanced discussion. No painter or sculptor suffered more than a modicum of criticism because of his work's real or imagined naturalism; but for those accused of formalism the consequences were of a different magnitude altogether.

Formalism: Beskin opens fire

The campaign against formalism in the 1930s was led by Osip Beskin, making full use of the platform provided by his position as head of the critics' section in *MOSSKh* and editor of its two art journals. In 1933 he published a book, *Formalism in Painting*, in which he laid out the theoretical basis for his campaign and named a number of artists whom he considered guilty of formalism. The first sentence of Beskin's book sets out his fundamental thesis: 'Formalism in any area of art, in particular in painting, is now the chief form of bourgeois influence.' He found the theoretical support for this in Marx's statement that 'language is no more or less than practical, existing ... actual consciousness'; thus formalist, modernist discoveries in art, about which the West was enthusiastic, were to be seen as expressions of a bourgeois, anti-Soviet consciousness. This was, of course, an inversion of the idea expressed by avant-gardists at the time of the revolution – that realistic art was essentially bourgeois. However, the principle behind these two opposing attitudes was the same: that artistic form has an ideological content.

Beskin arraigned a list of artists, of whom the most prominent were Shterenberg, Tyshler, Labas, Drevin and Udaltsova, Filonov, Malevich, Shevchenko and Ivan Klyun (1873–1943). Other zealots added fresh names to Beskin's list, including those of Konchalovski and Lentulov, both former members of *OMKh*, plus the entire Group of 13 graphic artists. What all these artists had in common in the early 1930s was a failure to adapt their work to the simple realistic style favoured by the party and the majority of artists in *MOSSKh*. Many others – former members of the *OSt* such as Deineka and Pimenov are examples – had bent sufficiently in the prevailing wind for this criticism only to graze them.

Formalism: the role of the union

Meetings held by *MOSSKh*, and to a lesser degree those held by the artists' unions of other cities and republics, were an organic part of the anti-formalist campaign. Any meeting could be a pretext for evangelising. Thus at a meeting of *MOSSKh* in April 1933, convened to discuss the *MOSSKh* production plan for the year and to choose a revisionary committee (a small group which oversaw all decision-making), the *MOSSKh* chairman, Volter, was able to mount such menacing digressions as:

Formalism is in essence the expression of a bourgeois ideology and world-view, and it is from this point of view that we must consider those comrades who use this bourgeois formalism and, perhaps without wanting to, mechanically transfer bourgeois ideology to us . . .[50]

At such meetings, those criticised were encouraged to reply and, ideally, to recant. Long sessions were held in cramped circumstances; tempers rose. It was the sort of situation in which anyone could easily say the wrong thing and compromise himself badly. In the eyes of some artists, this was obviously the whole sinister point of the discussions. The monumental artist and painter, Viktor Elkonin (born 1910), who during the 1930s worked as a critic for the *Literary Gazette* under the pseudonym Viktorov, told me that from the first he and his friends decided that the debates held by *MOSSKh* were a *provokatsiya*, a calculated provocation, and they attended as little as possible.

Formalism: the role of the party

In its campaign against bourgeois influence in the arts, the party worked at first through its faithful agents in *MOSSKh* such as Volter, Ryazhski (both members of the party section), Aleksandr Gerasimov and Katsman, and through leading conservatives in Leningrad such as Brodski. Then in 1936 it began to offer more

than tacit support. Articles criticising formalism in the arts were published in *Pravda* in January-March 1936. The first two articles – 'Balletic Falsity' and 'Confusion Instead of Music' – fastened onto the eminent figure of the composer, Dmitri Shostakovich. The latter article accused him, in the opera *Lady Macbeth of Mtsensk*, of producing 'leftist confusion instead of music for people' and compared his music to similar leftist manifestations in other arts including painting. It was clear, after the attacks on Shostakovich, that there were to be no holy cows in the arts.

A third article, 'Triteness and Simplicity', dealt with the theatre, calling for 'the complex richness of Shakespeare and Beethoven' – a reasonable, if ambitious requirement, but one which underlined the need for a return to tradition. The final article, 'On Artist-Daubers', attacked the Leningrad illustrator and painter Vladimir Lebedev (1891–1967) for the bourgeois and formalist nature of his children's illustrations. In fact, Lebedev's collaborations with the writer Marshak are among the glories of Soviet illustration; the article signified not only that all the old artistic freedoms of the 1920s were defunct, but that the high quality of an artist's work was irrelevant if its style was judged to be the product of an enemy ideology. The *MOSSKh* directorate was so eager to discuss these articles that it convened a meeting in February 1936, before the one piece directly pertaining to the visual arts even appeared.

At the same time as these articles were appearing, on 19 January 1936, the KPDI, the Committee for Art Affairs, was formed. Its visual arts section was run by politicians and party-oriented art critics. As well as taking over the running of museums and art schools, of the art journal, *Iskusstvo*, and overseeing exhibitions, its chief ideological task was the battle with formalism. The first chairman of the KPDI, Platon Kerzhentsev (1881–1940), said in March 1936 that '. . . a discussion about formalism – that was the first directive of the party, which was given before the creation, or more accurately on the same day as the creation of the Committee for Art Affairs, when the article on Shostakovich came out in *Pravda*. In other words, the party gave the Committee and me personally a definite line.'[51] For the rest of the Stalin period, the KPDI was to oversee and direct the whole anti-formalist campaign.

Formalism: recantation

Just as Stalin liked to compel his victims to confess and repent their putative crimes publicly, so any signs of recantation, in whatever form, were in great favour with the leaders of the anti-formalist crusade. An article in *Tvorchestvo* was devoted to a single painting of Drevin's, *The Hunters' Breakfast*, exhibited at the 5th Moscow Artists' Exhibition in 1937, on the ground that it was 'overcoming formalism for realism'. Similar signs of improvement were discovered

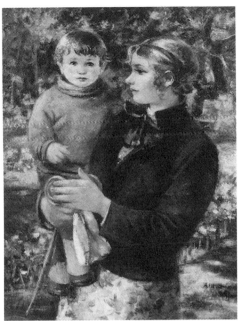

in Pavel Kuznetsov's work in the late 1930s, and he was also publicly applauded for devoting himself seriously to industrial subjects. But it was considered best for artists themselves to warn against the thorny path of sin. The young painter Nikolai Romadin (1903–1988), never himself criticised as a formalist, was prevailed upon to write an article denigrating his education at the *VKhuTeIn* in the 1920s – an education which in fact, according to his wife, he valued highly.[52]

Formalism: attempts at reconstruction

A striving to reconstruct the artistic self in response to criticism can be seen in the work of many artists. One can compare two paintings by Aleksandr Shevchenko, his *Girl with Pears* [pl. 88] of 1933 and *Maternity* [pl. 89] of 1938, and discover a radical shift in style. By his daughter's account, Shevchenko was a politically naïve man who accepted the project of socialist realism wholeheartedly. It was always his belief that his art complied with its precepts, and he suffered grievously from criticism that he received. In early 1933 an exhibition of his was summarily closed on account of its formalism. In the end, he graduated to a form of straightforward realism, in which he genuinely rejoiced. His last years were devoted to painting childlike, sun-dappled landscapes and pictures of women with children. He died with a brush in his hand and with the consciousness, perhaps, that socialist realism had been a boon.[53]

88

Aleksandr Shevchenko
Girl with Pears, 1933.
Oil on canvas,
110×88 cm (43×34½ in).
State Russian Museum.

89

Aleksandr Shevchenko
Maternity, 1938.
Oil on canvas, 97×80 cm
(39×32 in).
Private collection.

However, for many artists the campaign against formalism became a curse on their existence. The stenograms of meetings arranged by *MOSSKh* at this time indicate the dilemma faced by Shterenberg. He had struggled manfully to accommodate his work to the demands of socialist realism, but this was not enough to outweigh his long association with the avant-garde. At a meeting held in 1937 to discuss new candidates for the *MOSSKh* directorate Shterenberg was himself nominated – not by the party committee, but by popular demand. He, a communist, responded by saying he would be put forward by the party or not at all. In reply a representative of the *MOSSKh* party section explained to him that they only wanted 'to choose comrades who have approached most closely the goal formulated by the party and the government'. And he added patronisingly: 'I think that this in no degree excludes an artist from artistic life, from history . . .' For Shterenberg, who had once controlled *Izo NarKomPros*, this excommunication from the bureaucratic heights of Soviet art must have been painful indeed.[54]

Formalism: the fate of the avant-garde

The waves emanating from *MOSSKh* did not have time to break fully upon Malevich. He died in 1935 and was buried with full suprematist honours – conveyed to the cemetery in a catafalque bearing a black square on its bonnet and interred in a coffin of his own design. In his last years he had resumed painting in earnest and created works of great interest and originality. Some, in which figures with realistically painted faces and hands are clothed in costumes inspired by suprematism, are an uncomfortable attempt by the artist to marry his interests to traditional realism. Others are more successful. Here he depicted peasants in a language of flat, bright colours and simple modulations, leaving their faces blank like an unwritten book [pl. 90]. On these faces, one feels, the fate of the Soviet revolution will be inscribed. These are never the works of a man conforming to party requirements; they are truly numinous, inspiring a kind of metaphysical terror.

Few members of the revolutionary avant-garde who survived Malevich could aspire to the elasticity, useless though it was, of Shterenberg. For them, the advent of socialist realism and the anti-formalist campaign co-ordinated by the party was the dawn of a bitter period. Their work was not accepted at exhibitions, they could not get commissions. The formalist tag made them targets not only for critical abuse; it also raised in their mind the spectre of arrest and repression. Rodchenko kept a low profile, taking no part in art debates. During the 1930s he worked as a photographer, but even here the amount of work he received gradually declined. By 1935 he had enough free time to re-start painting, and began to paint pictures of the circus, which had been a focus of his dreams as

a child. These paintings, often melancholy and sometimes grotesque, are a reflection of the life Rodchenko felt himself to be leading. His *Clown with a Saxophone* [pl. 91] is a self-portrait.

Still sadder was the decline of Tatlin, who began in the 1930s to take to heart his exclusion from the mainstream of artistic life. He had jobs as the director of art in Moscow's sewing institute, doing the decorations for big public celebrations, and working as a theatre designer. His individual work, deprived of all buoyancy, altered radically, abjuring every declamatory or avant-garde trait. He painted small, impressionistic landscapes and still-lifes and arranged regular life-drawing sessions in the studio with his friend, Labas. He began to suffer from anxiety which had its roots in his difficult early life, when he had often had to go hungry. A friend of Tatlin's from their days at the Kiev Art Institute in the 1920s, Nikolai Tryaskin, remembers visiting him in Moscow in the 1930s to be treated to a single biscuit hidden in a secret cavity in the wall.[55] Tatlin, brought low both professionally and psychologically, exemplifies the decline of the once-powerful avant-garde.

Filonov, by unique insight, seemed to set his face early on against compromise with the official art world. He worked until his death in 1941 in conditions of penury, refusing to sell his work and sustained by the dream of a museum of analytic art and a small group of disciples. This state of affairs involved considerable risk for him and them – after all, independent artistic groups had dissolved after the April 1932 decree.[56] For the last eight years of his life he did not exhibit at all, but he continued, in shimmering, abstract (or virtually so) canvases and works on paper, to strive towards the 'flowering' which was his goal. Filonov's oeuvre is the most important example of a trenchant, stylistically independent artistic statement in Soviet art of the 1930s.

The great paradox of Filonov is that despite the execrable conditions of his existence he did not appear to consider himself at odds with Soviet society as a whole: 'I am a non-party Bolshevik, I am busy with painting, I have not the time, or I would have joined the

90

Kazimir Malevich
Three Female Figures,
1928–32.
Oil on canvas, 47×
63.5 cm (18¾×25½ in).
State Russian Museum.

91

Aleksandr Rodchenko
*Clown with a
Saxophone*, 1938.
Oil on canvas,
100×80 cm (39×31½ in).
Private Collection.

party.'[57] He maintained until his death a pure, almost abstract vision of the revolution that Stalinism does not seem to have obscured. In this he manifested a capacity for the transcendental that is characteristically Russian and perhaps hard for a Westerner to grasp.

Formalism: escape to the theatre

92

Pyotr Vilyams
Stage Design for The Pickwick Club, 1933.
Gouache on paper,
26×25.5 cm
(10½×10¼ in).
Museum of the Moscow
Arts Academic Theatre,
Moscow.

The theatre was the haven for many artists, branded formalists, who were unable or unwilling to bend the knee to socialist realism in painting. Among these artists are Tatlin, Favorski, Altman (on his return from Paris in 1935), Pimenov, Vilyams and Tyshler. The theatre allowed their imagination a longer leash; they imported a painter's eye and a painter's concerns, and helped to bring about a rich period in the history of Soviet theatre design.

Among outstanding stage designs executed by painters-in-exile was Vilyams's for *The Pickwick Club*, based on Dickens's serial story [pl. 92]. Here the painter who likes to compose on a two-dimensional surface is very much in evidence. Vilyams became a major figure in theatre design over the next few decades.

Formalism: art in danger

The anti-formalist campaign not only threatened artists personally; it also inflicted damage on works of art. A number of fine pieces of monumental art created in the early 1930s were destroyed, among

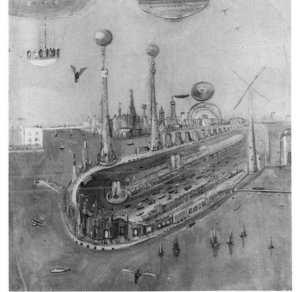

93

Aleksandr Labas
Sketch for *A City of the Future*, mural executed in Moscow House of Pioneers in 1935. Watercolour on paper, 42×35 cm (16½×13¾ in). Location unknown.

94

Georgi Rublyov
Iosif Vissarionovich, 1935. Oil on canvas, 152×152 cm (60×60 in). Private Collection.

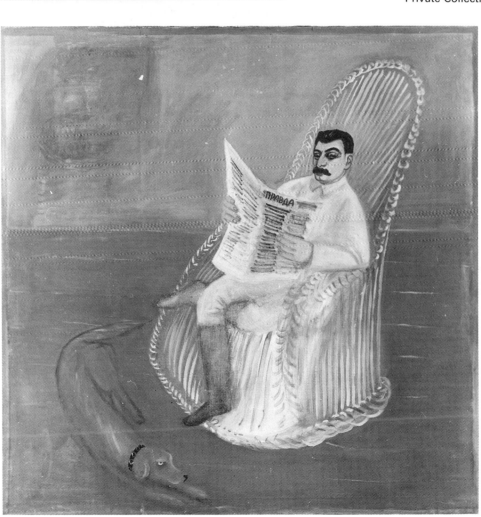

them works by Boichuk's school, Favorski and Labas, whose mural in the Moscow House of Pioneers gave full expression to the utopian technological vision [pl. 93], a dream of the 1920s, to which the artist continued to adhere.

An untold number of pieces of painting and sculpture were scrapped by artists themselves, either because they feared their discovery or were convinced by the evangelists of realism that their work had no future. One artist who preserved intact a large body of work in a 'formalist' vein from the late 1920s and early 1930s was Georgi Rublyov (1902–1975), a graduate of *VKhuTeIn* who made a living as a monumental artist [pl. 55]. Rublyov kept his acute portrait of a sly, Georgian Stalin [pl. 94] – in some ways, the best painting of him that I know of – turned to the wall in his studio from the early 1930s until his death: its combination of a pictorial language which would undoubtedly have been deemed formalist, and an ambiguous characterisation of Stalin would have made it a dangerous painting for him to display.

Persecution: Miturich

By 1937, in the full glare of the show-trials, the formalist, as an importer of bourgeois ideology, faced a real threat to his own existence. A notorious victim of hounding at this time was Pyotr Miturich (1887–1956), whose story illuminates the mechanics of Stalinist persecution.[58]

Miturich, like Tatlin, found in the teaching of Velimir Khlebnikov (1885–1922) an inspiration to pursue not only art but technological invention. He took his cue from Khlebnikov's belief that 'man, in the final analysis, is lightning . . . that is, he has an electro-magnetic structure' and also, apparently, from Einstein's Theory of Relativity, with its stress on how energy is transmitted in wave-form. On this pseudo-scientific basis he devised projects no less imaginative than Tatlin's and perhaps more feasible, such as an underwater vehicle, the *volnovik*, that moved not with the help of a propellor but by waggling its flexible, multi-jointed body like a fish. Miturich was also an outstanding draughtsman [pl. 95], and it was around his work in his capacity as a drawing teacher at the Institute for Raising the Qualifications of Artists and Graphic Artists that, in 1937, a scandal blew up.

Miturich's views on art were expounded in lengthy treatises such as 'An Artist on a New Understanding of the World' and 'Elementary Foundations of Art' which had once formed the basis for lectures and which, during the 1930s, he repeatedly tried to have published. At the start of 1937, he was circulating these documents among his students and encouraging discussion of his ideas. When the show trials of 'Troskiite Bandits' – that is, of Stalin's political rivals and putative enemies of the people – began in Moscow, a copy

of Miturich's treatises was sent by his institute to the Institute of Red Professorship for review, where Ivanov, head of the philosophy department, drew up a damning analysis of them which was forwarded to the Committee for Art Affairs. The report stated that 'Miturich directly expresses his ideological kinship with counter-revolutionary terrorists' and concluded with the opinion that his views were 'antagonistic to socialist construction and to culture'.

Indeed, there was plenty in Miturich's writing to upset the orthodoxy of the time. He inveighed against academic realism as exemplified by Brodski, whose *The Shooting of the 26 Baku Commissars* he called a 'representational lie'. He similarly criticised Repin, adducing details irritating to those who invoked him as a forbear of socialist realism, such as the fact that his models for *The Zaporozhe Cossacks* were not cossacks at all but the St. Petersburg bourgeoisie. He extolled Cézanne and Van Gogh, and considered the émigré Mikhail Larionov (1881–1964) to be the best Russian artist. He maintained that those attracted by state commissions were 'talentless hacks'. Clearly, the influence of such ideas in an environment committed to teaching the principles of socialist realism was tremendously threatening. And Ivanov's accusations were, correspondingly, potentially lethal for Miturich.

On 21 January 1937 the Pedagogical Council of the institute met to confirm Miturich's dismissal from his teaching post. Miturich, like Filonov a firm believer in his own conception of the revolution and the art it deserved, would not take this lying down. On 3 February 1937 he wrote to the Committee for Art Affairs, complaining about his dismissal on the basis of Ivanov's report and supplying a detailed rebuttal of it. This riposte contained such ingenuous justi-

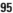

95

Pyotr Miturich
Dzhubra, Fvening, 1938.
Ink on paper,
31×39 cm (12×15 in).
Private Collection.

fications of his acerbic views on socialist realism as: 'I consider the use of amateurish artists under party control entirely justified – only on such terms can their work be of use to our country.' More in Miturich's favour was the fact that Ivanov had demonstrably extemporised some of his charges – they had no basis in Miturich's writing. And Miturich was also able to point out that he had been for four years a front-line soldier in the Red Army, taking part in the civil-war campaign against Yudenich.

But to no avail. On 11 February 1937 an article entitled 'The Dwarf and the Sun', attacking Miturich, appeared in the newspaper *Soviet Art*. Once more, a false case was constructed against Miturich by deliberate misquotation of his texts. One effect of this article was to cause the Tretyakov Gallery to remove Miturich's work from display. The artist wielded his pen again in self-defence. On 17 April 1937 he wrote to Molotov, enclosing a drawing as proof of his credentials. In this letter he went beyond the confines of the dispute thus far to offer Molotov the benefit of his technological research: 'I am an inventor, I offer apparatuses for wave motion and maintain: this is how we will move in future.' The Soviets were great ones for speculative science during Stalin's time, the most salient example of this being the credence attached to Lysenko's theories of biology: perhaps Miturich's inspired offer spared him further persecution. He was not reinstated as a teacher but remained a member of the artists' union. Scientific investigation into the viability of his ideas of wave motion was being seriously considered. In early 1941 funds were finally provided to build a full-scale *volnovik*, but the project was cut short by the outbreak of war in June of that year.

Repression: form

The campaign against formalism merged, in the period 1936–8, with the policy of wholesale repression in Soviet society as a whole. At this time, the reproach that formalism was essentially a bourgeois ideology was developed to its logical conclusion: the formalist, as a purveyor of such an ideology, was a class-enemy, liable to arrest. A number of artists, dubbed formalists, met such a fate. However, it is difficult to isolate a case where formalism in an artist's work was the prima-facie cause of his repression; in every case a victim's selection seems to have been guided by principles additional to the simple equation, formalism = bourgeois ideology.

Consider the fate of the graphic artist, Mikhail Sokolov (1885–1947), who was arrested soon after Ryazhski, the best-known *NKVD* agent in *MOSSKh*, assessed his work publicly as follows: '. . . what is it? Soviet art? It's blatant formalism, and what is more it follows a filthy path.'[59] It is tempting to see Sokolov's arrest and incarceration as a simple consequence of this attack on him by

the powerful and insidious Ryazhski. However, his flamboyant, disdainful bearing was calculated to irritate many of those with whom he came in contact. He laid great emphasis on personal elegance; this, and attendant habits, such as kissing ladies' hands, lent him a distinctly bourgeois demeanour quite apart from the message of his art. And his work was calculated to offend communists not only in form, but in content; during the 1930s it contains frequent melodramatic renditions of the crucifixion and Christ's agony – an intimation, perhaps, of future suffering. Thus Sokolov was a marked man in many ways.[60]

Repression: religious belief

A leaning towards religion, such as that displayed by Sokolov, was anathema to the atheist stalwarts of socialist realism. Katsman wrote to Brodski in 1934 that Favorski, whose work was greatly influenced by icon painting, 'is poisoning our youth with church realism'.[61] Tsirelson, a rabidly communist former leader of *RAPKh*, complained in 1937 that Pavel Korin was working on a painting that depicted enemies of the people.[62] This was his grand project *Departing Rus*, a work intended as an elegy to Russian Orthodoxy. Throughout the 1930s Korin, the son of an icon painter and a deeply religious man, was making studies for this work, many of great beauty [pl. 96]. Notwithstanding the accuracy of Tsirelson's allegations, Korin was not interfered with. He enjoyed a great deal of secret respect. Voroshilov and Gorki used to pay him visits in the early 1930s, and Korin related the following anecdote: 'Voroshilov said: "Korin, stop painting popes!" We grabbed hold of each other and began to wrestle, fell onto the sofa, and then continued on the floor ... He was strong, but so was I. I was pleased: Voroshilov commanded the army, but he did not command art.'[63]

Repression: content

In the 1930s it was inconceivable that any work containing a social or political protest or criticism of the regime should be put on display. There is, however, the obscure story of the 'counter-revolutionary sally' of the artist – the 'scoundrel' – N. Mikhailov. In 1937, this unfortunate artist did a portrait of Stalin (some say of Stalin standing by Kirov's coffin) on a piece of paper or canvas on which he had previously drawn either a skeleton or the figure of death with a scythe. Although it had been concealed by a layer or two of primer, this figure was perceptible looming up behind Stalin; legend has it that Stalin himself first noticed it in a photograph of the portrait presented for his approval. It is almost inconceivable that the artist could have intended such an innuendo: it would have

been tantamount to suicide. According to varying accounts, either the *NKVD* shared this view and Mikhailov, having been arrested, was released; or else, just as plausibly, the wretched artist was shot.

Another example of the paranoia of 1937: when Mukhina's *Worker and Collective Farm Girl* was completed, it was subjected to rigorous scrutiny because it was rumoured that Trotski's profile was somewhere apparent in the modelling of the drapery.[64]

Repression: Bolsheviks, nationalists and foreigners

96

Pavel Korin
A Group of Three,
(study for
Departing Rus)
1933–5.
Oil on canvas,
190×110 cm (75×43 in).
State Tretyakov Gallery.

Some artists who were liquidated were victims of their own revolutionary past. A root cause of the purges was Stalin's decision to destroy the old revolutionary guard, whose idealism and commitment to the more humane and liberal principles of the 1910s and 1920s caused him embarrassment. Thus Aleksandr Drevin (who had tried unsuccessfully to leave the country with his wife in 1928), the avant-gardist turned graphic artist, Gustav Klutsis, Voldemar Anderson (1891–1938), Karl Veideman (1897–1944) and Vilgelm Yakub (1899–1938) were arrested and executed because they were former members of the Latvian Rifles, a revolutionary band formed in Riga which had guarded Lenin at the time of the revolution.

Stalin, of course, already had designs on the Baltic states; the fact that these artists hailed from Latvia, where in 1935 there had been a Fascist coup, and might dissent from the idea of its annexation may have been an additional factor in their deaths. In the Ukraine, the extermination of Boichuk and several of his school had a comparable aspect. Their art, once so highly regarded, now stood for a sense of discrete Ukrainian identity that was no longer tolerable, all the less so because Stalin coveted the Western Ukraine, which in 1937 was Polish territory. The Boichukists were executed because, in their devotion to Ukrainian folk tradition, they posed a nationalist threat.

Artist-communists who had immigrated to the Soviet Union, such as Uitts and Heinrich Vogeler (1872–1942), were also arrested at this time. One lucky escape was that of the German architect, Ernst May (1866–1970), who had been working in Moscow but left in 1933, before the purges really got under way. When Soviet architects complained to Molotov in 1937 about his buildings, he is said to have mused 'We ought to have put him inside for a ten-year stretch.'[65]

Repression: the in-fighting

The repression of certain figures in the art world can be ascribed to personal and professional jealousies. From 1936 to 1938, the meet-

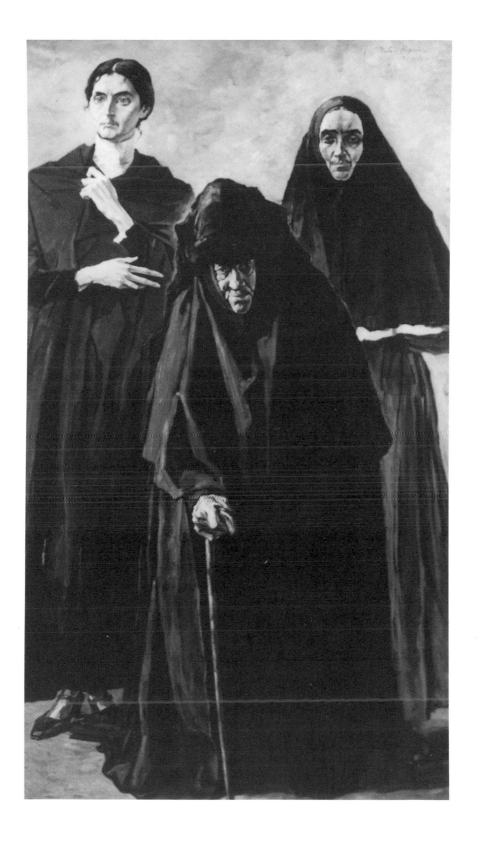

ings of *VseKoKhudozhnik*, *MOSSKh*, *LOSSKh* (the Leningrad art-
ists' union) and of regional unions resounded with denunciations
and denials as artists, using the deadly rhetoric of the era, attacked
their personal enemies across the floor.

In 1936, Slavinski, head of *VseKoKhudozhnik*, was asked at a
meeting of the *VseKoKhudozhnik* party section about his relationship
with his former boss, the head of the trade unions, Mikhail Tomski
(1880–1936). Tomski was a friend of Bukharin and had been
accused of Trotskiism; he had committed suicide in order to pre-
empt the inevitable. 'We know that this relationship of yours was
most close and intimate; we want to know whether it was like that
until recently or not. Did you have political conversations with
Tomski?' To his eternal credit, Slavinski replied that he had always
been on the best of terms with Tomski and would continue to help
his family. He went to Tomski's funeral and played the piano. Soon
afterwards he was arrested and shot.[66]

In May 1937, after Bukharin's expulsion from the party, a couple
of months after Stalin announced a new 'sharpening' of the class
war, *MOSSKh* held a general meeting that lasted for two weeks. Its
ostensible aim was to discuss the successes and failures of
MOSSKh over five years and elect a new directorate. However, the
atmosphere was poisonous. Many speakers, either frankly or by
innuendo, used the opportunity to charge others with allegiance to
the ideas of Trotski or Bukharin – a potentially lethal smear.[67]

The persistence of old rivalries, dating back to group strife of the
1920s, was palpable. Ryazhski, incensed by a suggestion that his
former colleagues in *AKhRR*, Aleksandr Gerasimov, Katsman and
Viktor Perelman (1892–1967), had got Trotski to approve and sign
an important *AKhRR* declaration in 1928, only shortly before his
banishment, turned on the source of this rumour, Elbrut Gutnov:

*'In honest, Bolshevik fashion, I want to ask you a question. Were
you a member of October?'*

'I was.'

'Comrades, you know what October was?'

(Voices from the hall: We know, it was a Bukharinite organisation.)

*'It was a Bukharinite, Trotskiite organisation. And you were a
member. You were a team, a troika. You, some comrade or other and
Amosov. Amosov has been arrested for political reasons ... Comrades,
for me this a question of principle, of political importance ... when it
[AKhRR] is subjected to criticism by such a person, who was in October
and keeps quiet about October, to me that seems suspicious.' (Applause).*

Sometimes these accusations were even more hoary. A
monumental artist, Lev Bruni (1894–1948), was forced to admit
that during the civil war he had designed a poster for the White
Army. The principle in all cases was guilt by association. There was
often no logic to a charge other than personal vindictiveness;
Gutnov, for example, had not been a leading member of October,

whereas others, such as Deineka, had been; yet Deineka did not face criticism.

This conference provides an unique insight into the considerable personal tensions that existed between artists at the time, many of whom lived in close, virtually communal conditions with one another, in the purpose-built blocks of flats and studios on Maslovka Street. A painter, Mikhail Gurevich (1904–1943), claimed a conspiracy by Grabar and others was preventing his work from being accepted for exhibition. Tsirelson recklessly accused members of the *MOSSKh* directorate of collusion with Slavinski. It was claimed that Bogorodski had threatened an artist who called him a *zhulik*, a hooligan, with the state prosecutor. Volter was said to have threatened another artist with the Lubyanka. An artist named, a well-known graphic artist and book designer, Mak-Ridi related an example of what he described as tactics of *zastrashivanie*, intimidation, practised by some artists against others: 'That Katsman – he's a sly one. He got hold of one comrade who had spoken out against him at a meeting at *VseKoKhudozhnik* in the cloakroom, pulled out his notebook and gave him a police inter-rogation. (Voice from the hall: Who?) Me. (Laughter. Applause.) He asked who I was, what I was, where I was from, hadn't my grandmother been a formalist, what did I eat, how did I feel, where did I work, my home address and telephone number. I didn't give him the address. True, I gave him the telephone number, but he hasn't called me.'

Aleksandr Gerasimov's speech made pointed reference to 'wreckers' in art, but it was also a masterpiece of self-deprecation, 'Bolshevik self-criticism'. Acknowledging what everyone knew and many resented – that he spent much time hob-nobbing with the political élite and little on his duties as a member of the *MOSSKh* directorate – he said: 'I have to admit that I am not only unable to say that I worked badly, but I have to confess frankly that I did not work at all.' More startling was his admission that he had signed a letter in support of Slavinski after his arrest. After all, reasoned Aleksandr Gerasimov, if I did not believe in his honesty when I worked under him in *VseKoKhudozhnik*, why did I not say so at the time? This was perhaps the sort of humility a man could afford when he was absolutely secure in his power, but it also bespeaks a certain sense of irony, an ability to juggle with some of the absurdi-ties of existence under Stalin (such as the retrospective cloud that hung over the executed Slavinski's former associates), which sets him apart from many contemporaries who were no less ambitious and perhaps no less elastic in their moral and political principles. And the letter he signed was, on the face of it, a real attempt to save Slavinski's life.

Some artists did eschew mud-slinging and came out of this meet-ing, the most important in *MOSSKh*'s short history, with credit. Sergei Gerasimov; the graphic artist, Dementi Shmarinov (born

1907); the poster designer, Dmitri Moor (1883–1946); Favorski and the young painter Semyon Chuikov all spoke frankly on subjects which had a bearing on the quality of art. Sergei Gerasimov regretted the fact that questions of creative practice, rather than ideology, were no longer the hub of *MOSSKh*'s activity; Shmarinov asked for more contact with foreign art; Favorski asked for socialist realism to acknowledge a variety of styles; Chuikov complained about a commissioning system that prevented artists painting what was dear to them. But one senses that the collective voice of artists such as these was not equal to the salvoes of vilification and self-justification projected by others. The meeting was a kind of mass inquisition presided over by the Soviet Torquemada, Stalin.[61]

Repression: the verdict

During the bloody years of 1937–9, *MOSSKh* (in 1938 it was re-designated *MSSKh*, the Moscow Union of Soviet Artists) was under the chairmanship of Aleksandr Gerasimov. He was elected to the directorate at the general meeting described above, and made chairman at the party's suggestion. He was probably called on to approve many arrests. We have, of course, no way of knowing the options that faced him or whether, by his intervention, anyone was saved; his son-in-law relates that he, just like a multitude of others, was in perpetual fear of arrest himself. In 1939, the bloody work accomplished, he was replaced as chairman of *MSSKh* by his namesake, Sergei.

The list of artists arrested in Moscow, let alone across the whole of the Soviet Union, is incomplete, although it ran into dozens in Moscow alone. Some artists denounced at the conference of May 1937, such as Gutnov, were arrested in the same year. A group of former members of *RAPKh* – Konnov, Vyazmenski, Tsirelson and Fyodor Malaev (born 1902) – were arrested in the first months of 1938. Konnov, Vyazmenski and Tsirelson were shot, probably soon afterwards. They were the last – and most fervent – of the social and artistic idealists thrown up by the 1920s; they had carried the banner of a proletarian art until Stalin's abrupt policy change of 1931–2. Both this idealism and the undiminished outspokenness of figures such as Tsirelson made them an embarrassment at a time when cynicism and self-ingratiation were, perhaps more than ever, essential qualities for advancement; nor, one imagines, had former members of *AKhR/R*, now predominant in *MSSKh*, forgiven and forgotten the attacks made on them by *RAPKh* in 1931–2.

A conspiracy was even discovered among students at the Moscow Institute of Visual Art. Rostislav Gorelov (born 1916), son of the well-known painter Gavriil Gorelov (1880–1966), and six of his fellow students were charged with membership of a 'fascist organisation' known to their interrogators as The Blue Lily. This

name is an echo of The Blue Rose, a well-known artistic grouping in pre-revolutionary Russia, and suggests a commendable level of culture in the *NKVD* organs which thought it up. Gorelov himself survived incarceration, but some of his friends perished.[68]

The art bureaucracy geared itself smoothly to those terrible events. On page 119 of the accounts of the exhibition, The Industry of Socialism, for which commissions were first handed out in 1935, there is a list of artists, some of them, at least, victims of the repression, and the sums they have been advanced. The page is headed: 'Doubtful advances. Whereabouts of artists unknown.'[69]

End of the decade: returnees

Despite the terror, despite the growing cultural intolerance, both of which were apparent abroad, a number of artists chose to return to the Soviet Union in the 1930s. The unfortunate Vasili Shukhaev (1887–1973) was swiftly imprisoned for his pains. Viktor Bart, Mark Nalevo and Simyon Fiks, who all returned from France, were cruelly harassed. Dmitri Tsaplin (1890–1967) fared a little better. He returned in 1935 with the first shoots of a reputation in Western Europe, after civil war broke out in Spain, his adopted home. He brought with him some 100 works, including the marble sculptures of birds, fish and animals that were to prove the outstanding achievement of his career. During the 1930s he was given commissions, and eventually he received a studio a stone's throw from the Kremlin; but he was never to adapt fully to the conditions of a Soviet artist's life. In the archive of the Committee for Art Affairs there is a file entitled 'Tsaplin's Complaint' which contains, among other things, a letter from Tsaplin to Molotov detailing his impoverished life in a basement flat with a wife and two children.[70] Elsewhere he rebelled against the autocratic powers of purchasing committees; but despite his travails, he strove mightily to adapt his art to the demands of socialist realism and made an original contribution to the movement [pl. 97].

The other notable figure to return was Robert Falk in 1937. The Moscow art world he came back to was changed out of recognition: there could be no question of his receiving a hero's welcome. In 1939 he had a one-man exhibition in the Central House of Art-Workers, and he closed it with a speech criticising moribund French art and extolling Russian traditions. But this was not enough to rehabilitate him; if Shterenberg was irredeemably associated with avant-gardism, then Falk – whether he liked it or not – stood for all the bourgeois artistic values that were associated with Western Europe. One might perhaps discover an act symbolic of this in his decision in 1939 to make Angelina Shchekin-Krotova, the fragile, aristocratic beauty rejected by Deineka in favour of robuster womanhood, his companion and his wife. Falk was thus

97

Dmitri Tsaplin
*They Shall Not Pass:
Spanish Freedom
Fighter*, 1937. Artificial
stone, 51 cm (20½ in)
high.
Private Collection.

cast in an invidious role, but one that was to give him a unique place in post-war Soviet art.

End of the decade: privilege and the artist

The mounting ideological pressure on artists in the 1930s came increasingly to be balanced by a system of handsome rewards for those who could satisfy the leadership. In effect, the old incentive to Soviet artists – enthusiasm for the revolution – gave way to one that, if more banal, was more to be relied upon – money. At the 1939 exhibition, The Industry of Socialism, Lishev received 66,000 roubles for *Industry and Defence*, and for a single painting Aleksandr Gerasimov, Ioganson, Nesterov and Sergei Gerasimov received 55,000, 50,000, 45,000 and 40,000 roubles respectively. These were substantial sums. The director of a leading museum might expect a yearly salary, with perquisites, of not more than 10,000 roubles; and the out-of-favour Shterenberg, for a work entitled *Blacksmith's Workshop* commissioned for The Industry of Socialism, received a miserly 1,000 roubles.[71]

By 1939, however, it was adjudged that even these incentives were not enough and, on the day before Stalin's birthday, the institution of Stalin prizes was announced. These prizes were to be awarded every year for outstanding works in a variety of cultural fields. The prizes might be of the first or second class and offered rewards of 100,000 and 50,000 roubles respectively.

The first Stalin prizes in art were awarded in early 1941. First-class awards went to Aleksandr Gerasimov, for *Stalin and Voroshilov in the Kremlin* [pl. 3]; to Ioganson, for *In an Old Urals Factory* [pl. 65] to Nesterov, for his portrait of Pavlov [pl. 68]; to Merkurov, for his figure of Stalin at the Agricultural Exhibition [pl. 53]; and to Mukhina, for her *Worker and Collective Farm Girl* [half-title]. A prize also went to Grabar for his two-volume work on Repin.

It should be noted that the three painters to receive first-class prizes were the same three to receive the most lucrative commissions for the Industry of Socialism exhibition. This consensus of opinion contrasts strongly with the violent debates of ten years earlier: the art world was now firmly under state control.

The enormously privileged position achieved by the top Soviet artists by the end of the 1930s can be gleaned from an *ukaz* of the Supreme Soviet of April 1943, entitled 'On Income Tax'. A special table was drawn up for workers in art and literature, in which the top bracket was an astonishing '300,001 and above roubles'. The same *ukaz* exempted Stalin Prize laureates from paying any tax at all on their rewards.[72] This was an extreme development of the inequality which, Stalin claimed, was fully commensurate with a classless society.

It should be realised that the vast majority of artists in Moscow could not aspire to the riches enjoyed by Aleksandr Gerasimov and a few others. If, in the 1920s, there had been a democracy of poverty and hunger in the Soviet art world, by 1940 there existed an extreme hierarchy of money and privilege, regulated by the party.

End of the decade: formalism

In 1939 an exhibition of French landscape painting opened in Moscow's Museum of New Western Art. It was devoted to the Barbizon and Impressionist schools and was drawn from the museum's own collection, from the Pushkin Museum, the Hermitage and provincial museums in Penza and Saratov. It was a major event, requiring serious evaluation.

Tvorchestvo, under Beskin's editorship, devoted much of issue no. 7, 1939, to this exhibition. Its judgement was generally favourable. An editorial claimed that Impressionism had ceased to look like a break with tradition; it was identified instead as a child of the French Revolution and, as such, a precursor of socialist realism. The critic and painter Amshei Nyurenberg (1887–1979) deprecated the way in which critics fought shy of mentioning the influence of French art on any Soviet artist, pretending instead that such an artist 'has achieved by his own efforts just what Monet achieved'. Most significantly, Beskin gave room to an article by another painter, Aron Rzheznikov (1906–1943), in which he praised highly the work of Cézanne.

Beskin allowed a contrary view to be expressed: an article by Aleksei Fyodorov-Davydov claimed that the Russian landscapist Levitan was superior to the Impressionists in that he had resolved the problems of depicting space and the open air but rejected Impressionist technique. But his article did not alter the overall effect made by this edition of *Tvorchestvo*: Beskin had given his blessing to French art, to Impressionism, and even – by giving space to Nyurenberg and Rzheznikov – to Cézanne.

This was unpalatable to the leadership both in the arts and in politics. Aleksandr Gerasimov, who made a trip to Paris in 1935, did admit, in his autobiography of 1963, to a liking for Monet, but he never could tolerate Cézanne. Now he echoed the attitudes of the party leadership, for whom cultural chauvinism and even the slandering of foreign achievements was an important tool for the manipulation of the masses. Beskin's sympathies would have been unremarkable in the 1920s, but in the present context – and notwithstanding the fact that he had led the attack on formalism in the early 1930s – they had a too liberal flavour. In 1940 he was removed as editor of *Tvorchestvo* and his job given to Polikarp Lebedev (1904–1981).

Soviet art and Western culture

The development of Soviet art and architecture in the 1930s echoed some cultural developments world-wide. Social, if not socialist, realism in art became a feature in many countries in the 1930s, although this was probably more inspired by the Soviet example than an influence on it. A kind of neo-classicism was attempted by architects in many countries, notably in Fascist Germany but also in liberal democracies. Soviet architects were aware of this and eager to compete. Iofan's Soviet pavilion and Speer's Nazi pavilion stood face-to-face at the 1937 Paris exhibition; Speer's building was conceived after he caught sight of the secret Soviet plans detailing Mukhina's gigantic figures, striding from East to West, and was designed to 'check this onslaught'.

More broadly, many commentators lump socialist realism and Nazi art together under one heading, that of totalitarian art, as though they constituted an international phenomenon independent of national roots. There is not room in this book for a comparative analysis, but socialist realism was significantly different from the Nazi version of totalitarian art; moreover, this difference had a national origin, in the Russian artist's traditional sense of his social mission and the Russian people's habituation to autocracy. Nazi art was imposed from above in 1933, whereas Russian and Soviet artists, from the first days of their revolution, lobbied for a social role. Punin declared that futurism was 'state art', not Lenin; *AKhRR* of its own accord approached the party for direction. Hitler (a failed artist) took much more interest in the arts than either Lenin or Stalin; the style of Nazi art was his creation (he even designed furniture and cutlery for the Reich Chancellery), whereas socialist realism evolved as a collaboration of the majority of artists – realists – and the party. Socialist realism was also the more radical movement; the nineteenth-century-style genre paintings devoid of contemporary reference, the many landscapes and the sexy mythological nudes favoured by Hitler and his colleagues would all have been denounced in the Soviet Union as apolitical, bourgeois or pornographic; the style of much Nazi art, reliant on graphic solutions in painting and stylisation in sculpture, would have been deemed formalist. A perspective taken from the end of the century must perceive the Hitler style as a blip, a short-lived aberration. Soviet socialist realism was grounded far more surely in the popular will; it has its origins in the first years of the revolution and is still a presence – admittedly a much diminished one – in the Soviet Union today, some seventy years later.

One can equally well cite parallels between Soviet and American culture in the 1930s. Iofan was sent to the United States in 1934 to gather ideas for the development of the Palace of the Soviets;

Moscow's steel-girder Krymski bridge was completed in 1937 and was viewed by Soviet architects as their answer to the Golden Gate bridge, built in the same year; at the 1939 New York exhibition, Soviet artists were impressed more than anything else by American monumental sculpture, to which, quite unusually, an article was devoted in *Tvorchestvo*. American social realism of the 1930s and the American investigation of mural art (through the state-sponsored WPA programme and in private commissions, such as Rivera's work at the Ford factory in Detroit) suggest that the artistic striving of the Soviet Union may well, in its turn, have made an impression in America.

Conclusion

During the 1930s, the Soviet art establishment had acquired a new and formidable countenance. Artists had been welded into a single union and set trundling down a single, ever-narrowing path called socialist realism. Outspoken, idealistic artist-communists such as Tsirelson and his colleagues had been exterminated. The same fate had met artists with too strong a sense of their own, non-Russian, national identity, such as the Boichukists. A new sense of officially sponsored hierarchy had been introduced in the form of the Stalin prizes and by the creation of the *Orgkomitet*, headed by Aleksandr Gerasimov. Beskin's attempts to accommodate a diversity of critical opinion had been crushed.

Artists had been forced to consider where they stood in relation to the politically inspired artistic orthodoxy. Some, such as Aleksandr Gerasimov, Brodski or Merkurov, had committed themselves wholeheartedly to the service of the party leadership (although even Gerasimov's attempt to gratify the narcissism of power was accompanied, in his *Russian Communal Bath* paintings, by an attempt to map out a personal response to life). Others, such as Sergei Gerasimov, tried to combine a faith in the central import-ance of the creative act, as something outside ideology, with administrative work at a high level. Figures such as Plastov and Deineka rejected both the temptation to glorify the leaders and the opportunity of directing artistic life: they sought to make an accom-modation between the evangelising demands of socialist realism and their own values. These artists, and many like them, still evinced enthusiasm for the Stalinist project. Others, in particular those who stuck doggedly to the practice of landscape painting, implicitly eschewed the whole notion of a socially engaged art. And still others – the saddest figures – were artistic pariahs, forcibly excluded from the mainstream: Filonov, Shterenberg, Tatlin, Labas – these artists in the 1920s had thought themselves the natural inheritors of a revolution which now offered them the cold shoulder.

On 22 June 1941 Hitler invaded.

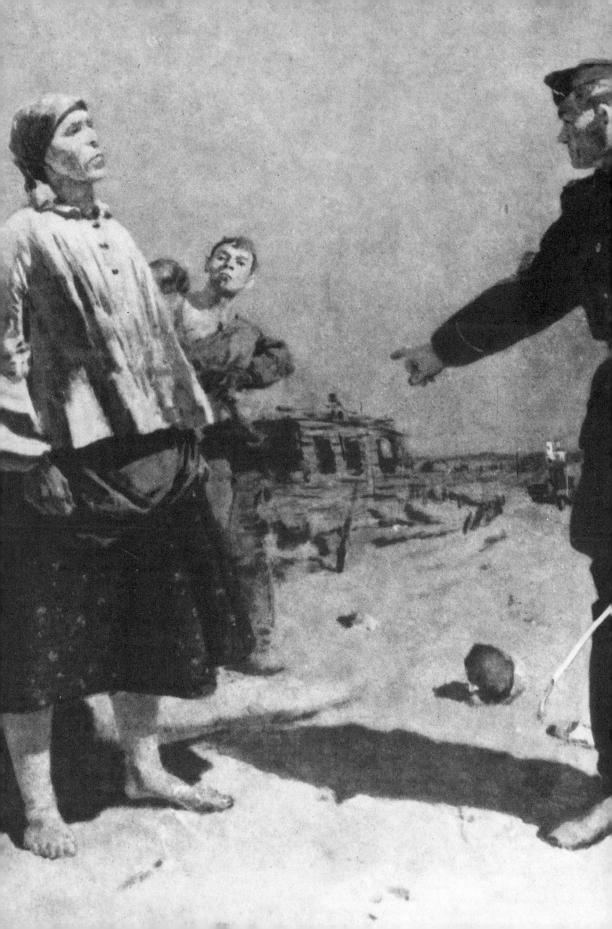

3 The Fight for Life

The Great Patriotic War 1941—5

Architecture: the tasks

At the start of the war, faced with the overriding necessity to preserve Soviet industrial capacity from the Nazis' lightning advance, the decision was taken to evacuate industry to the far eastern provinces of the USSR. The activity and output of some 1,500 enterprises was moved from the south and west into rapidly built factories and workshops in the east. Architects had to cope with the demands of all this as well as with the requirements for fortifications, shelters, field hospitals and canteens.

After Hitler's progress had been halted in 1942 and put into reverse following bitterly fought actions along the Volga, the chief of these being the battle for Stalingrad, Soviet architects began to plan the reconstruction of towns and cities. Despite the disruption caused by the war and the shock it had given to national self-confidence, these schemes demonstrate that Soviet architects were still planning for a glorious future. They were guided by the politburo member, Mikhail Kalinin, who in October 1943 wrote to Arkadi Mordvinov (1896–1964), head of a newly formed Committee for Architectural Affairs, that 'The new construction offers great opportunities for the construction of fundamentally socialist cities . . .'[73] In an article in *Izvestiya*, published two months later, Kalinin stated that cities should not just be rebuilt, they should be replanned, even if this cost more.[74]

The centres of many historic towns and cities had been destroyed. The redesign of Kiev's main street, the Kreshchatik, was put up for competition; other projects were assigned to studios set up in late 1944 in the Academy of Architecture. Towards the end of the war, to the task of rebuilding cities, was added another: the

98

Sergei Gerasimov
The Mother of a Partisan, 1943 (detail).
Oil on canvas,
184×232 cm
(72½× 91 in).
State Russian Museum.
(see pl. 175)

design of war memorials. These were conceived of as more than Lutyens-like obelisks or triumphal arches; in an attempt to speak to the people, they often housed museums. In their work, architects continued to draw on classical sources, and in an upsurge of national pride they also now turned to old Russian architecture for their inspiration. This resurrection of the artistic heritage was, in a way that perhaps only architecture can be, a public symbol of the Soviet people's craving for regeneration.

Architecture: Stalingrad

The single most significant task was the reconstruction of Stalingrad, where not a single building had remained undamaged. It was a unique opportunity to create a city virtually from scratch. Work on the Stalingrad project began before all the others, in 1943, soon after the city's liberation. The plan was drawn up under the direction of Karo Alabyan and executed under the control of Vasili Simbirtsev, who together had previously designed the Red Army Theatre. Their solution was a development of the idea of an *architecture parlante* particularly visible in the Red Army Theatre itself. The plan treated the town centre as a spacious ceremonial ensemble opening onto the river Volga [pl. 99]. A series of squares, each with its own theme, led in a portentous narrative to the river bank

along an axis perpendicular to it. Three broad highways parallel to the river linked the outlying regions of the city, stretching some seventy kilometres along the side of the river, to its centre. It was envisaged that the climactic structure would be a huge monument built on Mamaev Hill, scene of the bitterest fighting, but this was not carried out until the 1960s.

Architecture: the metro

The Stalingrad project was a symbol of Soviet determination, not simply to win the war but to raise out of the rubble something more splendid than what had existed before. The same spirit informed the decision to build and open seven new stations on the Moscow metro during the war. They were symbols of defiance. Mosaic panels designed by Deineka for the Novokuznetskaya metro station were created in blockaded Leningrad and airlifted to Moscow on special transports. Monumental art enjoyed an important patriotic role, exemplified by the sculptures of Matvei Manizer (1891–1966) at Izmailovskaya. Academically trained before the revolution, Manizer was prominent in the Soviet art world: a professor of sculpture in Leningrad, doctor in art history and winner of a second-class Stalin prize for his statue of Lenin in Ulyanovsk, erected in 1940. His figure of the partisan Zoya Kosmodemyanskaya [pl. 100] observes the formal, almost ceremonial nature of its setting; the only relief from stillness is afforded by the ruffling of her skirt, as if by a breeze.

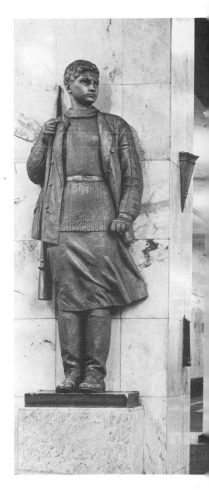

Reorganisation of the art world

Along with industry, much of the art world was directed eastward in the first shock of war. The most valuable possessions of museums were crated up and transported to safety on special trains. Uzbekistan was the haven for many: the Moscow State Art Institute and the Leningrad Academy, together with institutes from Kiev and Kharkov, continued their work in Samarcand, taking artists along with them to teach, and a large contingent of artists moved to Tashkent.

Even in evacuation, artists were expected to serve the war effort with their art, and a quantity of big canvases on war subjects were executed in Uzbekistan. Perhaps *partiinost*, the principle of art's duty to serve the party, meant that artists were effectively already conscripted. Certainly, socialist realism came into its own now, because the individual shared precisely the same goals as the state, accepting the necessity for a strictly patriotic point of view, popular subject-matter and a straightforward mode of expression. The principles of socialist realism determined that Soviet war art should be very different from its British equivalent, overseen by the War

100

Matvei Manizer
*Zoya
Kosmodemyanskaya*,
1944. Plaster 270 cm
(106 in) high.
Izmailovski Park metro
(formerly Izmailovskaya
metro), Moscow.

Artists Advisory Committee. If British art during the war often retained a reflective, even a lyrical quality typical of it in peacetime, Soviet art was as direct as a bullet. Ambitious exhibitions were held, devised to inspire the populace, such as The Great Patriotic War of 1942 and The Heroic Front and Rear of 1943. Thus during the war, the integral place of the artist within Soviet culture was to be reaffirmed and even strengthened.

The relationship between artists and the army had been friendly since the foundation of *AKhRR* in 1922; now it became one of passionate intensity. This is one of its documents:

Socialist Agreement

101

Viktor Koretski
Warrior of the Red Army, Save Them! 1942.
Poster.

1. I, mortar-fighter Demin I. F., having a personal tally of 123 Fascists killed, having become acquainted with the love and enthusiasm with which Leningrad artists are working towards the twenty-fifth anniversary exhibition of the Red Army, take upon myself the socialist obligation of killing seventy-seven more fascist scum by the time of this people's celebration, taking my personal tally of hatred and revenge to 200.

I challenge to a socialist competition with me the artist Serebryany I. A.

2. I, artist of the Leningrad Union of Soviet Artists Serebryany I. A., admiring the valour and courage of the Red Army, accept the challenge of famous mortar-fighter Demin I. F., whose portrait I have painted, and undertake, by the time of the twenty-fifth anniversary exhibition of the Red Army, to carry out, using all my creative powers, five more portraits of heroes of the Leningrad front, valorous defenders of the famous city of Lenin.

3. The final date for execution of obligations is 23 February 1943.

4. We request the editorial staff of Leningrad Pravda to act as referee in the control of our socialist obligations.

16 January 1943.[75]

Although many artists – all the best-known ones – were provided with a *bron*, or exemption from ordinary conscription, other artists were less fortunate. They – some 900 members of artists' unions around the country – had to join up; and many of them died at the front. Among them were some of those who had incurred the anger of the art establishment in the 1930s, such as Aron Rzheznikov, whose article praising Cézanne had been so controversial in 1939, and Mikhail Gurevich, who had complained publicly about a cabal acting against him in *MOSSKh*.

Posters

The quintessential art-form of the war was the poster. On the evening of the very day when the Nazis invaded, the department of agitation and propaganda of the party Central Committee met and discussed the production of posters. The publishers *Iskusstvo* put

out their first war poster, *We Will Mercilessly Rout And Destroy The Enemy*, on 24 June. It was designed by the Kukryniksy, a composite name for three artists: Mikhail Kupriyanov (born 1903), Porfiri Krylov (born 1902) and Nikolai Sokolov (born 1903). They had met and begun to collaborate as students at *VKhuTeMas* in the 1920s, when they signed a contract (in force to this very day) to share equally their combined income, and had established themselves in the 1930s as leading caricaturists and illustrators. They worked collectively, by passing a design around among themselves for each to alter and improve as he saw fit.

Three days later appeared the first of many Windows of TASS: swiftly crafted, stencil-cut posters put up under the auspices of TASS, the Soviet press agency, in windows all over the country. In Leningrad the Fighting Pencil, an organisation which had published propaganda during the war with Finland, resumed work. Many painters and illustrators, and even some sculptors, few of whom had ever designed a poster before, now began work as poster artists. Poets were employed to think up the slogans, some in verse form. By the end of the war some 800 different posters had been published in Moscow, 700 in Leningrad, and many more in other cities.

In the first wave of war posters, artists used vicious satire. The past masters of this approach were the Kukryniksy. In March 1942 the *Orgkomitet* passed a resolution calling for the heroic to be given greater emphasis in poster design. This led to the creation of such popular works as *Warrior of the Red Army, Save Them!*, by Viktor Koretski (born 1909), a work based, unusually, on a photograph rather than a drawing [pl. 101]. It was published in an edition of 14 million copies. From 1943 onwards, as Soviet forces gained the upper hand, posters became more optimistic and, as a result, more stereotypical. The Kukryniksy, however, were unrelenting in their vituperative assault on Hitler and his gang [pl. 102].

102

The Kukryniksy
An Audience with the Raving Commander-in-Chief, 1943. Poster.
General from the eastern front: What should we do now, Führer?
Hitler: Let me collect my thoughts.

Graphic arts

The graphic arts as a whole resumed the leading role they had played during the revolution and civil war. A mobile lithography workshop was sent to the front; and in the wake of the first Soviet military successes, artists were sent into liberated regions to work. The drawings they made were often used in newspapers in preference to photographs: an echo, possibly, of the requirement to avoid naturalism – a too unvarnished picture of the world – in socialist realism.

Among the most celebrated work was a group of lithographs of life in Leningrad during the days of the blockade by Aleksei Pakhomov and the series of charcoal and watercolour drawings, *We Shan't Forget, We Shan't Forgive* [pl. 103], by Dementi Shmarinov.

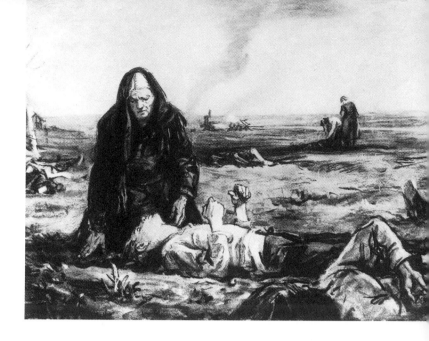

Shmarinov was a disciple of Sergei Gerasimov who valued highly his technical freedom and sensitivity to material qualities. *We Shan't Forget, We Shan't Forgive*, executed in Moscow in 1942, drew on photographs of Nazi atrocities. Its specific inspiration was the Nazi occupation of Shmarinov's Ukrainian homeland around Kiev; but it also reflected his long-held ambition (realised immediately after the war) to tackle that most deeply patriotic of Russian novels, Tolstoy's *War and Peace*. Fyodorov-Davydov, writing in *Pravda*, characterised the series of twelve drawings, a narrative of the travails of the Soviet people, as optimistic for all the tragedy of their subject-matter: 'the victims in Shmarinov's drawings are inwardly stronger, morally superior and spiritually richer than their executioners.'[76]

Mothers and sons

The image of a bereaved mother was to become an icon of Soviet wartime art. Maternal steadfastness was expressed in attitudes of defiance and preparedness for self-sacrifice. A famous painting of these war years is Sergei Gerasimov's *The Mother of a Partisan*, carried out by the artist in Samarcand at the time of his evacuation with the Moscow State Art Institute [pl. 98]. It gained in pathos from the artist's decision – most unusual in socialist realism – to make a heroine whose looks did not conform to canons of the good, proud or noble. Such qualities in socialist realism, no less than in Hollywood, were the property of the conventionally good-looking.

Battle painting

The conditions of war were not suited to the creation of the grand *kartina*, which required a long period of undisturbed concentration virtually impossible to attain. The most elaborate battle paintings were carried out wholly or largely after the war ended.

Nevertheless, many artists tackled battle themes with considerable panache. Outstanding was Deineka's *The Defence of Sebastopol* [pl. 104], which depicts the heroic defence of the city by sailors of the Black Sea fleet. Deineka was inspired to paint it after Sebastopol, which had been the backdrop to many of his pictures in the 1930s, fell into Nazi hands after a long, agonising siege. This painting exemplifies the attitude of the socialist realist in a war of machines and long-distance killing. As the new history of the 1930s made clear, centre stage must be the human being and his or her capacity for heroism. Thus Deineka portrayed war as, virtually, a state of hand-to-hand combat. This imaginative licence, required of him by socialist realism, enabled him to arrive at a powerful image; one that conveys the atavism of war, predicated on the lasting human capacity for barbarism.

The Grekov Studio had evolved away from its original conception as an organisation for training soldiers to draw and paint; by the time the war began it had become instead a grouping, under Red Army auspices, of professional artists dedicated to military subjects.

104

Aleksandr Deineka
The Defence of Sebastopol, 1942.
Oil on canvas,
200×400 cm
(78¾×157 in).
State Russian Museum.

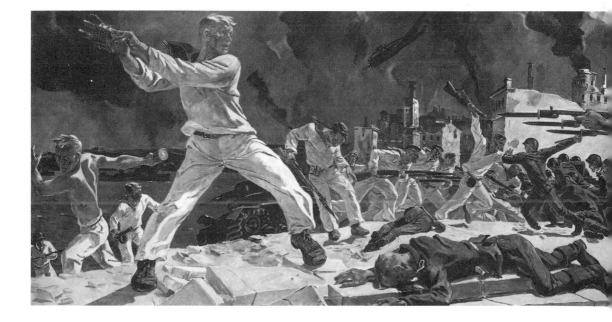

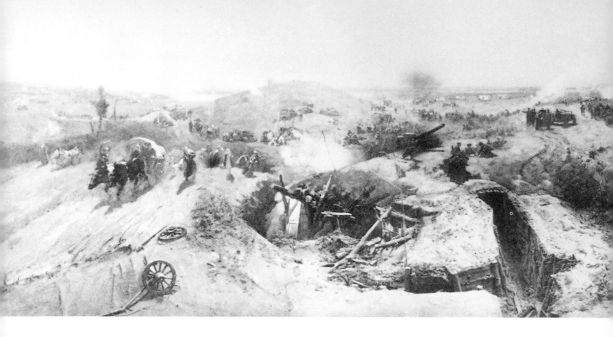

Its importance was recognised by the party when, in 1943, it awarded the new head of the studio Nikolai Zhukov (1908–1973) a Stalin prize. The *grekovtsy* produced posters, innumerable studies and several big paintings. One of the most ambitious undertakings was a diorama, *Soviet Troops Crossing the Dnepr in the Region of Kremenchug* [pl. 105], carried out by a team of four artists.

History

Although the exhibition, Our Motherland, planned for 1942 to survey Russian history, did not take place, the recasting of history in the 1930s, involving the creation of a pantheon of patriotic heroes, was reflected in much art of the war years. In particular, the history of Russian arms before the revolution acquired a new significance. This reflected an upsurge of Russian nationalism as people sought a psychological resource that would help them endure hardship and loss.

The latent force of this nationalist feeling was appreciated and exploited by the leadership. At the famous parade in Red Square on 7 November 1941, when the siege of Moscow had entered its decisive period, Stalin exhorted the Soviet troops: 'May you be inspired in this war by the courageous example of our great forbears – Aleksandr Nevski, Dmitri Donskoi, Kuzma Minin, Dmitri Pozharski, Aleksandr Suvorov, Mikhail Kutuzov.' The sculptor Nikolai Tomski (1900–1984) based a series of reliefs in the Novokuznetskaya metro station on Stalin's speech.

War artists were now being encouraged to create images of hero-

ism and victory framed from historic feats of Russian self-defence. The newspaper *Literature and Art*, which for much of the war was the only publication dealing with the arts (*Tvorchestvo* and *Iskusstvo* had closed for the duration in 1941), announced on 8 August 1942 that a number of painters had set to work on portraits of outstanding Russian leaders, to wit: Aleksandr Gerasimov on Kutuzov, Katsman on Suvorov and Korin on Aleksandr Nevski.

The last-named painting became the most celebrated – partly, perhaps, because of its enormous size, but also because Korin used a pictorial language more frankly decorative than socialist realism allowed [pl. 106]. As well as sounding a patriotic call to arms, it was a homage to the artistic values of the past, for example those of Vrubel and The World of Art. In this, no less than in his project *Departing Rus*, Korin revealed his uncommon sense of history and his independent attitude to the artistic dictats of the time.

In 1942 Mikhail Avilov (1882–1953), a founder member of the Leningrad *AKhRR* in 1922, was evacuated via the 'Road of Life' across Lake Ladoga from Leningrad to Moscow. Located in the Soviet capital from 1942 to 1944 he painted a major series of pictures that chronicled the liberation of old Russia from the Tartar yoke. In these he drew on a lifetime's devotion to battle and military painting, beginning with his training in the battle-painting studios of the Academy of Arts in St. Petersburg.

The masterpiece of his wartime Tatar cycle is *The Joust of Peresvet with Chelubei* [pl. 107]. Its subject is the prelude to the decisive meeting between Dmitri Donskoi's troops and those of the Tartar invaders on Kulikov Field in 1380. It shows the single combat between Peresvet, the Russian champion (to the left) and Chelubei,

105

Anatoli Gorpenko,
Viktor Konovalov,
Filipp Sachko,
Fyodor Usypenko
*Soviet Troops Crossing
the Dnepr in the Region
of Kremenchug*, 1945.
Oil on canvas,
250×850 cm
(98½×335 in)
(diorama).

106

Pavel Korin
Aleksandr Nevski,
1942–3.
Oil on canvas,
275×632 cm
(108×249 in)
overall (triptych).
State Tretyakov Gallery.
Panels from left to right:
A Northern Ballad;
Aleksandr Nevski;
An Ancient Tale.

107

Mikhail Avilov
The Joust of Peresvet
with Chelubei, 1943.
Oil on canvas,
327×557 cm
(128¾×219 in).
State Russian Museum.

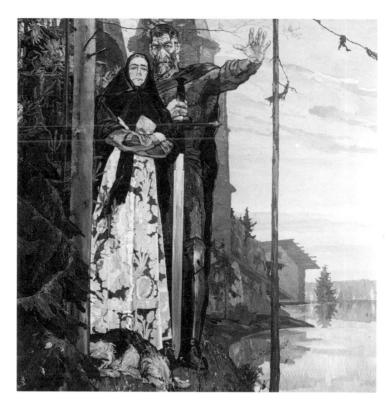

his Tartar opponent, preceding the battle proper. Old chronicles have it that both warriors died as a result of this clash; but Avilov seizes a moment a fraction before death which underlines the Russian knight's moral superiority: although he has received a deadly blow, both his gaze and his seat remain firm when the Tartar is already sliding from the saddle. Peresvet's unflamboyant dress, in contrast to that of his enemy, and the good order kept by the Russian troops, stress social values of self-discipline and sartorial modesty. Although this picture derives from a well-known nineteenth-century work, *The Battle Between Russians and Scythians* by Viktor Vasnetsov (1848–1926), it remains one of the most striking works of socialist realism.

Dmitri Donskoi's reckoning with the Tartars inspired a second major painting at this time. Bubnov's *Morning on Kulikov Field* [pl. 6] was begun during the war but finished two years after it. Earlier work on brigade paintings for the New York exhibition and the Agricultural Exhibition had shown him the possibilities of large, densely populated compositions; and in *Morning on Kulikov Field* a sense of the latent power of the people is at the very heart of the picture. Like Avilov, Bubnov focuses on the prelude to Donskoi's decisive victory: the massing of Russian troops, resolute and eager

as dawn breaks to allow the start of battle. His personal passion, as far as it can be isolated in the work, is that of the man absorbed by the Russian saga, its pageantry, peasant communities, folk-tales and ancient chronicles. This deeply rooted culture, buried by the revolution, was now, in wartime, being allowed to rise up to buttress the communist state.

A licence for the Church

The retrieval of pre-revolutionary values went as far as tacit acknowledgement of the power and role of the Church. Stalin realised that if the nation was to survive, it could not do so on communism alone. In 1943, he met the Metropolitan Sergias, leader of the Russian Orthodox Church, and permitted the re-establishment of the Holy Synod. But this, from the point of view of socialist realism, was to be a warrior Church. The face of Christ on the banner in Bubnov's painting is the face, above all, of a war leader. Similarly, in the Kukryniksy's *The Flight of the Fascists from Novgorod* [pl. 108], the ancient religious centre has acquired an ominous outline. The structure of the church massed against the sky has become once more – in the metaphor its builders intended – a cluster of gigantic, helmeted warriors.

108

The Kukryniksy
*The Flight of the
Fascists from Novgorod,*
1944–6.
Oil on canvas,
198×229 cm (78×90 in).
State Tretyakov Gallery.

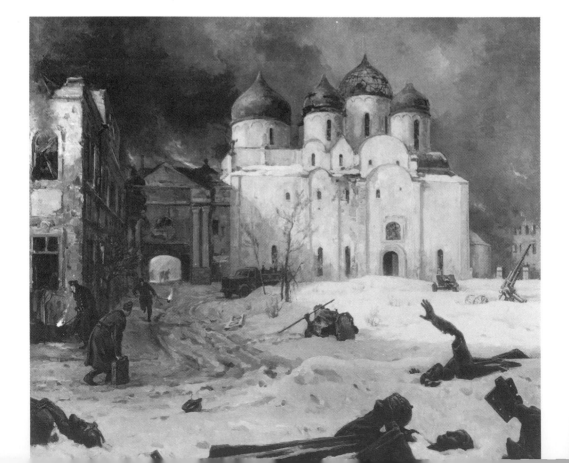

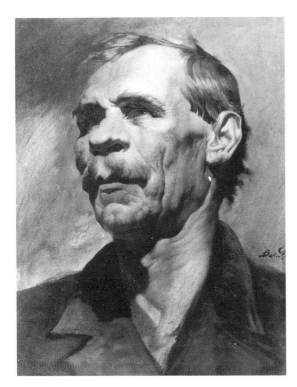

Portraits

Painters and sculptors at the front and in liberated areas made innumerable portrait studies. Many finished works were created for major exhibitions. Fyodor Modorov (1890–1967) made his name with a series of pictures of partisans from Belorussia, the republic to suffer most bitterly at Nazi hands. Outstanding were the portraits of Vasili Yakovlev. He had been one of the first members of *AKhRR* in 1922. In a search for technical mastery he later explored techniques of icon painting, restoration (he restored, or helped restore, works by Raphael, Rembrandt, Titian and Correggio) and even sign painting. These researches underpinned his love of minutely rendered detail; he was one of those artists who had been charged with naturalism in the 1930s. However, his scrupulousness is not inhibiting but passionately convincing. *Head of a Partisan* [pl. 109] is one of the best Soviet wartime paintings. We must regret that the conditions of war led to the ruin of much of this artist's earlier work, which he buried for safe keeping in his garden only to have it destroyed by flooding.

The spirit of resolve evoked so well by Yakovlev is also apparent in several sculpted portraits executed by Mukhina, such as her

109

Vasili Yakovlev
Head of a Partisan, 1942.
Oil on canvas,
65×50 cm (25½×20 in).
State Tretyakov Gallery.

110

Sarra Lebedeva
*Portrait of the Artist
V. E. Tatlin*, 1943–4.
Bronze, 38×21×24 cm
(15×8×9½ in).
State Tretyakov Gallery.

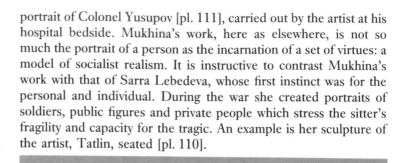

111

Vera Mukhina
*Portrait of Colonel
Yusupov*, 1942.
Bronze, 34 cm (13½ in)
high (base 15 cm (6 in)
high).
State Tretyakov Gallery.

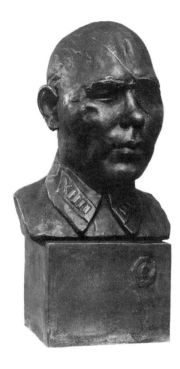

portrait of Colonel Yusupov [pl. 111], carried out by the artist at his hospital bedside. Mukhina's work, here as elsewhere, is not so much the portrait of a person as the incarnation of a set of virtues: a model of socialist realism. It is instructive to contrast Mukhina's work with that of Sarra Lebedeva, whose first instinct was for the personal and individual. During the war she created portraits of soldiers, public figures and private people which stress the sitter's fragility and capacity for the tragic. An example is her sculpture of the artist, Tatlin, seated [pl. 110].

Art behind the lines

Not all art was conscripted. Lebedeva's portrait of Tatlin, her friend, is a work prompted by personal as well as more broadly patriotic considerations. Many artists evacuated to Samarcand and Tashkent, as well as working on big pictures dedicated to the war effort, produced paintings and drawings of their absorbing new surroundings. A series of abstract pictures carried out by Rodchenko in the war period, culminating in a large canvas painted in a way that resembles the drip technique of Jackson Pollock, is a curiosity of Soviet art history which no one has fully explained. (The conditions of the Stalin period prevented Rodchenko from ever exhibiting these works and ensured that they had no consequences for Soviet art.) But these were all exceptions to the rule. Most works reflected, in one way or another, the conditions of wartime existence, which were incomparably harsher and more anxious than those in other European countries.

Deineka's *After Battle* [pl. 113], a frieze of soldier-Adonises taking a shower, illustrates the need Soviet artists felt – now more than ever – to give even prosaic scenes a heroic air. None of Deineka's works illustrates more clearly than this one his vision of the healthy human body as the supreme symbol of virtue. Plastov's *Tractor Drivers* [pl. 112], painted in 1943, is apparently oblivious to the war. It stresses the continuing values that Plastov held dear: the peasant's simple life and a primal closeness to nature. However, it has in common with Deineka's picture the subject of bathing, which in both works suggests spiritual, as well as physical, refreshment – an echo, perhaps, of the suppressed religious feeling given a new lease by abominable war conditions.

Landscape

During the war, landscape fully recovered the status of which the revolution had deprived it. It ceased to be viewed as an escapist activity of artists who wished to avoid ideological commitment. The reappraisal of the virtue of landscape painters can be regarded as

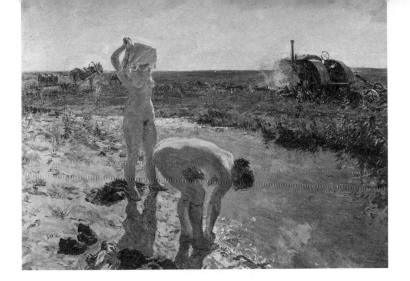

part of the wartime revival of old Russian cultural values. In a country ravaged by war, perhaps only nature seemed immutable; the perpetuity of landscape seemed to guarantee the survival of the Motherland.

On 1 January 1942 a major exhibition of landscape painting, The Landscape of Our Motherland, opened in Moscow. It proved enormously popular with the public. In March 1942 a Stalin prize was awarded to one of the senior Soviet landscapists, Vasili Baksheev (1862–1958), a former member of *AKhR/R*, for his 'many years of outstanding service' in art. He is best known for his paintings of silver birch trees, which are a symbol of Russia herself [pl. 114].

The young Nikolai Romadin's decision, after his one-man exhibition in 1940, to devote himself to landscape was probably prompted by a moral awakening to the hypocrisy and cruelty of the Stalin regime. During the 1930s Romadin was a model socialist

realist, creator of several propaganda pictures (his article condemning *VKhuTeIn* has been mentioned in the previous chapter). His rejection of this role was conspicuous, and attributable to more than his simply having found his metier as a landscapist: as his son confirms, he realised that Stalin was responsible for a catalogue of black acts. Romadin blossomed into one of the best landscape painters of the period. For the series of paintings he carried out in 1944–5, under the collective title *Volga – Russian River*, depicting scenes in the newly liberated countryside [pl. 115], he received a Stalin Prize.

Artistic life in Leningrad

If artistic life maintained a certain equilibrium in Samarcand and Tashkent and, from 1942, in Moscow and liberated regions, then the state of affairs in Leningrad was for a long time desperate. The blockade of the city, which lasted nearly 1,000 days, reduced the populace to unimaginable conditions of starvation.

The head of the Leningrad Union, elected at a notably young age just after the start of the war, was Vladimir Serov (1910–1968). Serov had made his name during the 1930s with a series of large thematic pictures, and had taken over the running of Brodski's studio in the Academy of Arts after the latter's death in 1939. His first propaganda poster, bearing the pugnacious, if at the time unfounded, slogan 'We've beaten them, are beating them and will beat them', appeared three days after the start of war. His decision to join the party and not to opt for evacuation with the Academy,

115

Nikolai Romadin
The Herd, 1944.
Oil on Whatman paper
mounted on board,
31×81 cm (12×32 in).
State Tretyakov Gallery.

and his total commitment to realism in art confirmed Serov, in party eyes, as the ideal leader of the Leningrad Artists' Union.

During the terrible blockade meagre but life-saving privileges, such as special ration cards, were available to artists. The dispensation of these privileges was in the remit of Serov, with the result that, in many cases, he held the fates of artists and their families in his hands. Among those who died of want were many of the Leningrad 'formalists': Filonov, Nikolai Tyrsa (1887–1942), Vladimir Sukov, David Zagoskin (1900–1942), Aleksei Karev (1879–1942), Georgi Traugot, Leonid Chupyatov (1890–1941), Pyotr Osolodkov (1898–1942), Nikolai Lapshin (1888–1942) and others. It is sometimes suggested that the deaths of some of these may be attributable to Serov's belief – in line with the tenets of socialist realism – that only the efforts of realist artists were germane to the war effort.

Even at the height of the siege, in the winter of 1941–2, a major exhibition, Leningrad in the Days of the Patriotic War, was organised and visited by Leningrad's starving citizens. In late 1942 another exhibition of work by Leningrad artists was airlifted over the blockade to Moscow. It is hard to conceive of any other country valuing and fostering art to this extent in such circumstances; undertakings such as these underline the importance of art in Stalin's scheme of things.

In near impossible conditions, the Leningrad paintings were executed in double-quick time. Serov, together with Iosif Serebryany (1907–1979) (whose agreement with mortar-fighter Demin is set out above) and Anatoli Kazantsev (1908–1973), painted *A Breach in the Blockade* [pl. 116] flat-out in days rather than

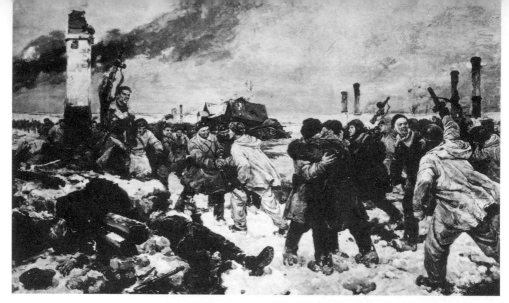

116

Vladimir Serov,
Iosif Serebryany,
Anatoli Kazantsev
*A Breach in the
Blockade*, 1943.
Oil on canvas,
294×500 cm
(115¾×197 in).
State Russian Museum.

117

Aleksandr Shchipitsyn
Evacuation, 1941.
Oil on canvas,
75×100 cm (29½×39 in).
State Tretyakov Gallery.

weeks or months; it was shown in Moscow at the exhibition, The
Heroic Front and Rear, in 1943. Many of these ambitious, multi-
figure compositions carried out by Leningrad artists during the war
suffered from poor-quality materials and a lack of finish; but what is
astonishing is that they were painted at all. All the necessary think-
ing, preliminary drawing, composing, underpainting and so on were
press-ganged into service on the same conditions as poster art. The
art of wartime Leningrad is in this respect the most clear-cut
expression of a paradoxical feature of socialist realism, one which
was striking even in peacetime: despite its harking back to classical
forms and its aspiration to live for centuries in the future, it spent
every day in a tremendous hurry.

Moscow: life as usual

Many artists today confirm that the war engendered a sense of genuine comradeship after the old bickering which had gone on, in conditions of specious unity, in the 1930s. However, among the artists who stayed in Moscow through the war, or returned there after the threat to it was lifted, professional rivalry still smouldered under the blackouts. On 21 March 1943, *Literature and Art* listed the Stalin prizes for 1942. Among the winners of prizes of the first degree, worth 100,000 roubles, were Aleksandr Gerasimov and Matvei Manizer. The following week, on 27 March, *Literature and Art* revealed that Gerasimov had donated 50,000 roubles from his personal funds for tank construction. A superb gesture, but unfortunately overshadowed by the accompanying announcement that Manizer had given the entire value of his prize, 100,000 roubles, to the General Command. But Gerasimov now showed his mettle: the next week's edition stated that he had contributed 'his prize to the sum of 100,000 roubles – in addition to the previously contributed 50,000 roubles (cf. 27 March) – to tank building'.

Many of the problems faced in peacetime by those artists whom the establishment rejected were exacerbated by the advent of the Nazis. The death of Filonov and others from starvation was the tip of the iceberg; day-to-day existence was precarious for many. Miturich, for example, used to sell the bottle of vodka which his artist's rations allowed him once a month in order to buy food to survive on.[77]

Repression

The fate of Aleksandr Shchipitsyn (1896–1943) was particularly bitter. A former student of Falk, Drevin and Shterenberg in the 1920s, he had lived and worked in 1930–2 with Tatlin in his unique studio in a tower of the Novodevichi monastery. Then in 1933 Beskin labelled him a 'romantic-intuitive' in his book, *Formalism in Painting*, and from 1934 on his pictures did not appear at exhibitions. Irredeemably tubercular, unwelcome in the union, he spent the 1930s in a struggle for health and the opportunity to paint. When the war came, Shchipitsyn strove to respond as an artist. *Evacuation* [pl. 117] depicts the war as a tragedy of an elemental kind, biblical in its reverberations through man and nature. But Shchipitsyn now speculated – in jest, but with wild imprudence – in conversations with artist-friends in the studios in Maslovka Street, that landscape painters might be able to live and work under Nazi rule, and for this he was arrested and executed.[78]

Shchipitsyn's end was not unique at this time. The war added, to

Stalin's own instinct for self-preservation by repression, the natural anxiety of the entire nation. But for the painter, Fyodor Malaev, a former member of *RAPKh* who had been arrested and incarcerated during the purges of the 1930s, the war afforded a sudden upturn in his fortunes. He volunteered, in exchange for his freedom, to join a suicide battalion. On his first mission, he was one of only a dozen men to survive out of a force of more than 300 – the beginning of a run of luck that saw him safely through the war.[79]

Victory and its aftermath: mourning

The decisive battle for Stalingrad at the end of 1942, followed by the lifting of the Leningrad blockade in 1943, preceded a long advance by Soviet troops into the German heartland. Finally, on 2 May 1945, Sovinformbyuro announced the capture of Berlin by Soviet troops. Distinguished artists such as Deineka and the Kukryniksy, provided with high rank and uniform, were sent to record events in the fallen capital. The Kukryniksy remained behind in order to cover the Nuremberg trials.

Victory was won at enormous cost by the Soviet people. Paintings of 1945 express a belief – conventional in socialist realism – in coming happiness, but their optimism is often tempered by a sense of loss. The destruction of Soviet manhood in the war is implicit in paintings of lonely women, such as Pimenov's *Night Station* and *Spring* [pl. 119] by the young Maks Birshtein (born 1914).

Like the image of woman, work on the land was now, more than ever, a metaphor for future hopes. One stark and powerful work depicting peasant labour was the monumental *Resurrection* [pl. 118] by Fyodor Shurpin (1904–1972), a graduate of *VKhuTeIn* whose love of Titian and Rembrandt led him to develop a broad, vigorous manner. The vast bleak landscape is an image of the country's loss. Perhaps the supreme evocation of this loss is Plastov's *Haymaking* [pl. 1]. The solemn progress of four peasants through a sun-drenched Eden embodies, in the act of renewal, the fact of tragedy: only the very young and the very old have been left to work the land.

Bogorodski's *Glory to the Fallen Hero* [pl. 120] is expressive of what might be regarded as the communist, the official, attitude to grief. The bereaved mother displays extraordinary – one is tempted to say aristocratic – restraint. Her gaze rests on the glorious Soviet future bought so nobly with his life by her son. This is a highly formalised, disconcertingly frigid expression of qualities to be desired: self-control in the face of personal loss, pride in the achievements of the dead and, most importantly, faith in a Stalinist future. The painting exemplifies a feature of many works on this most emotive theme: the exclusion of a sense of personal tragedy. The figures in Bogorodski's picture are symbols, exemplars of stoicism for a society which aspired to succeed ancient Greece and Rome.

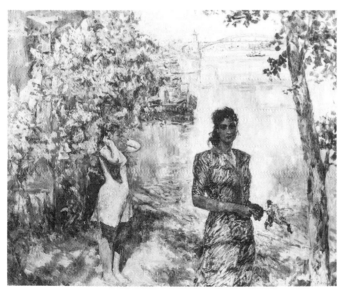

118

Fyodor Shurpin
Resurrection, 1945.
Oil on canvas,
229×340 cm (90×134 in).

119

Maks Birshtein
Spring, 1945.
Oil on canvas,
120×150 cm (47×59 in).
Private Collection.

120

Fyodor Bogorodski
Glory to the Fallen Hero,
1945.
Oil on canvas,
247×297 cm (97×117 in).
State Tretyakov Gallery.

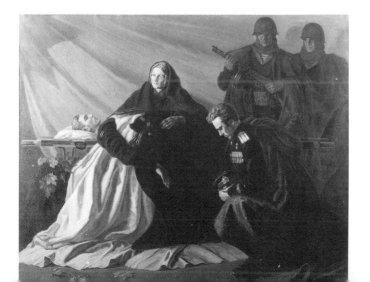

Hope

The war, which in many ways seemed to confirm the values of the Soviet state – its jingoism, its espousal of communal values, its emphasis on iron discipline – also threatened to undermine these same values. It had contrived to erode the image of iniquitous capitalist society and to replace it, indeed, with a suspicion that the working man in the West was better-off. Many soldiers, whether as POWs or members of the liberating army, had glimpsed a life they had never conceived of before. They had seen the reality of private car ownership, virtually unheard of at home; they had seen superior Western amenities and supped on Western rations. Clothing clandestinely imported by returning troops became a fashionable sign of liberation, in startling contrast to the drab uniform of the Soviet worker. Such lendings, in their variety, evoked memories of pre-war bourgeois society, to which the grey uniformity of Stalinist costume was an intended reproach. People were jubilant with victory and felt – not unlike their counterparts in Britain – that something in the old order would have to give.

In the Soviet Union, there were no democratic institutions through which such a feeling could be given political expression; but the anticipation and immediate aftermath of victory were marked by an efflorescence in the arts, tinged with a new liberalism and openness to Western ideas. The period from 1944 to the start of 1946 saw the premières of Shostakovich's 9th Symphony and of Prokofiev's ballet *Zolushka* (designed by Vilyams); concerts by Yehudi Menuhin; the emergence of Svyatoslav Rikhter and Mstislav Rostropovich as winners of the first post-war music competition; the appearance of Eisenstein's *Ivan the Terrible, Part 1*; and the decision of the Committee for Art Affairs to circulate several foreign plays for performance to Soviet theatres. This may amount to meagre fare in Western eyes, but to the Moscow public it was a real abundance, not only in contrast to wartime cultural rations but to the siege mentality increasingly apparent in Soviet culture towards the end of the 1930s.

This new relaxed and gregarious perspective seems to have been shared in the art world. In 1945, an exhibition of work by Nadezhda Udaltsova, wife of the repressed Drevin, opened in the Gipsy Theatre. She painted still-lifes and gipsy themes with the same relish for the abstract qualities of paint that she had displayed in the 1930s. In Leningrad a show was mounted of work by Tyrsa, the avant-gardist who had died during the war. In the paper *Soviet Art* of 26 October 1945 it was announced that four paintings by the former émigré to France, Robert Falk, had been chosen for the forthcoming All-Union Art Exhibition. The exhibition opened in January 1946 to wide acclaim; Ioganson called it a veritable 'Festival

of the arts.' On 24 December 1945 the critic, Pyotr Sysoev, wrote to his colleague in the Committee for Art Affairs, its chairman Mikhail Khrapchenko (born 1904), asking him to request a Red Star of Labour from the government for Sergei Gerasimov, in view of his 'outstanding services' to Soviet art. At the same time the *MSSKh* party bureau passed to the union directorate a recommendation that Gerasimov's sixtieth birthday should be marked by a special celebration. Thus steps were taken to honour the most influential liberal voice in the art bureaucracy.

On a grander scale was the plan for a Museum of World Art drafted by the Committee for Art Affairs in 1945. It was intended to combine the separate collections of the Museum of New Western Art and the Museum of Oriental Culture. That this was to be a genuine artistic initiative and not simply an administrative measure is made clear in a draft letter from Merkurov, recently installed as director of the Pushkin Museum, and Khrapchenko. In this letter the idea is mooted of buying works for the new museum in international auctions and even of exchanging Soviet works for those of contemporary Western masters. This was a considerable advance on the attitudes which had prevailed in the 1930s, when works of contemporary foreign art were either received as gifts or purchased on rare occasions from Soviet citizens.

However, this velvet gesture clothed an iron fist, for the letter also suggests the seizure, as war booty, of important art-works from the Axis countries: 'The museums of Axis countries are full of remarkable masterpieces, which should be given to the Soviet Union as compensation. All valuables received from Axis countries should be concentrated in one place and could serve as a superlative monument, devoted to the glory of Russian arms ... Filling the museum's collection with first-class masterpieces will immediately give it a leading place among the museums of Western Europe and America.'[80]

There is a sad irony here when one remembers the sales of great masterpieces from the Hermitage in the 1920s and 1930s, authorised by Stalin to raise foreign currency; as a result, the world-wide standing of the Hermitage had been significantly diminished.

Merkurov and Khrapchenko's letter remained a draft proposal, but it is revealing as a microcosm of debate – over a wide spectrum – in Soviet society. This debate was between a desire, given impetus by the allied victory, to consolidate that part of the Soviet cultural and intellectual heritage which was European in its origins and affections; and the inclination, deep-rooted in the Russian psyche, to treat Western culture and its institutions from a standpoint of cultural isolation, self-sufficiency and competitiveness.

This had been, of course, a central dilemma of Soviet art since the first days of the revolution. Now, in the post-war decade, after a short period of grace extending into 1946, Stalin finally would try to resolve it.

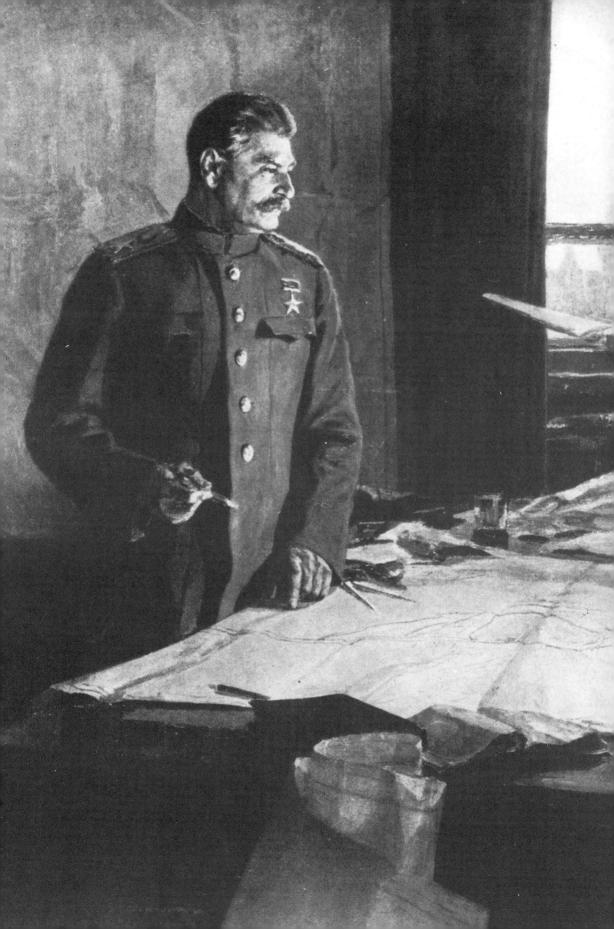

4 The Cult of Personality

The Apotheosis of Stalin 1945–56

Russia triumphant

In May 1945 a banquet was held in the Kremlin to mark victory
over the Nazis. Stalin gave a toast which became famous. It began:
'I drink, first of all, to the health of the Russian people, because they
are the most outstanding of all the nations that make up the Soviet
Union' [pl. 166].

Stalin's words gained the more éclat because he was a Georgian:
overt Russian nationalism had been licensed during the war to raise
morale; now, after a campaign and a triumph which had left the
people materially beggared, but enriched by a sense of extraordi-
nary achievement, Russia's victory could not be gainsaid. By far the
largest, most populous of the Soviet republics, Russia had suffered
more than any other; now victory seemed to be above all a Russian
achievement. After the war, Russia began to consider herself, in
relation to the other Soviet republics, more equal than others.

Russian nationalist feeling was a force Stalin manipulated to his
own advantage. Russia's pride in victory helped console the grief of
millions of her people; it also deflected attention from blunders in
the country's defence. Russian nationalism now provided a nucleus
of stability in an empire which, in the post-war period, might
otherwise have begun to come apart. In the Baltic states, annexed
in 1939 by agreement with Hitler, partisans struggled for
independence; other national groups within the Soviet Union had
also been stirred up by the war and the experience of alien rule:
Stalin sometimes dealt with them by wholesale deportation from
their homeland, a policy that threatened to arouse rebellion.

Even before the war, Russian culture had predominated in the
Soviet Union, but a theory of cultural equality between Soviet

121

Fyodor Reshetnikov
*Generalissimus I. V.
Stalin*, 1948.
Oil on canvas,
147×119 cm
(58×46¾ in).
State Tretyakov Gallery.

122

Lev Rudnev,
S. Chernyshyov, Pavel
Abrosimov,
A. Khryakov
(architects);
V. Nasonov (engineer)
Moscow State
University, 1949–53.

123

Nikogos Nikogasyan
Sculpture on the high-
rise building in
Vosstanie Square,
Moscow, 1953.
Limestone.

124

M. Posokhin,
Ashot Mndoyants
Central vestibule of the
high-rise building on
Vosstanie Square,
Moscow, 1950–4.

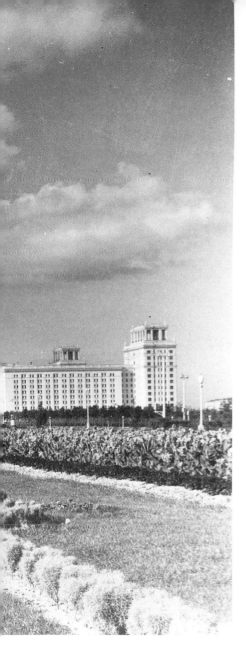

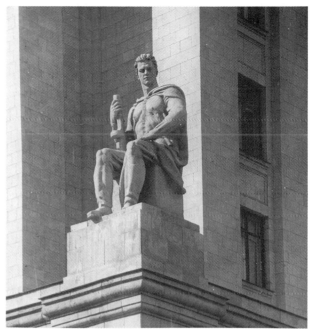

republics had been publicly maintained. Culture, according to Stalin, was to be socialist in content but national (Ukrainian, Armenian, etc.) in form. In the post-war period this formula was ignored and Russian traditions in painting, sculpture and architecture were elevated above all others. This new Russianism was the extreme development of the chauvinist, isolationist tendencies that had surfaced when Stalin first came to power and, in 1925, advanced the slogan of 'Communism in one country'.

Architecture and post-war reconstruction

Renewal of the country's ruined industrial infrastructure was the priority of post-war Five-Year Plans, i.e. the fourth (1946–50) and the fifth (1951–5). The Dnepr dam was rebuilt and spectacular new projects, such as the Volga–Don canal, linking the country's two great rivers (a long-standing dream, first attempted by Peter the Great), were undertaken. Yet in the context of the industrial breakdown and human deprivation caused by the war, requiring for their relief the utmost concentration of resources, one feature of Stalinism became strikingly apparent: its scorn for the day-to-day needs of ordinary people. For example, new residential building, excepting prestige projects, fell off dramatically, condemning millions of people to cramped and insanitary lives which only began to improve under the more humane Khrushchev. Yet at the same time, money was no object to Stalin's architects as they embarked on ever more splendid showpiece buildings in Moscow and other major cities.

A patriotic architecture

Architects partook fully of the new Russianism confirmed by Stalin in his victory speech. In designing the Volga-Don canal, they harked back to the style of Russian classicism at the time of victory over Napoleon. The architecture of the post-war metro stations exploited a range of architectural canons – Doric, Venetian Renaissance, Roman Renaissance – but here, too, architects also drew on Russian achievements. Russian classicism inspired the design of the Oktyabryaskaya metro station in Moscow. The architectural source of Serpukhavskaya Square metro was the twelfth-century architecture of Vladimir and Suzdal. The Komsomolskaya–Koltsevaya metro, decorated with mosaic panels by Korin, was conceived as a monument to victory in the war; its architecture was modelled on the Russian baroque of a splendid church in the kremlin, or fortress, in Rostov-on-Don. One can argue about the extent to which Russian classicism and baroque may be considered indigenous (so many of St. Petersburg's great buildings in these styles

were built by foreigners), but the very indeterminate nature of the tradition makes the attempts of Soviet architects to isolate and exploit it all the more poignant.

The high-rise buildings

Architects were now planning to re-establish Moscow's ancient skyline of a low-built city punctuated by a few tall, regal edifices. This had been the landscape of Moscow in centuries past, when the wooden housing huddled beneath the domes of its great cathedrals and monasteries, but it had been grubbed up and overwhelmed by new building of an increased average height in the twentieth century.

The centre-piece of the post-war plan was to be the fabled Palace of the Soviets, begun in the 1930s and now further than ever from completion: its foundations and steel framework had been torn out for munitions, leaving a yawning pit. But the idea of it still guided building in the capital. A series of eight carefully sited high-rise buildings was now planned as an accompaniment to the Palace. Thus Moscow was meant to be remodelled very much along lines suggested by its Russian Orthodox past.

The Palace of the Soviets was never built (a swimming pool now sits in its place); the project was finally abandoned after Stalin's death in the 1950s; but seven of the eight buildings conceived as its entourage were completed, and they are the most remarkable architecture of the Stalinist era.

Given that their intention was to articulate for the eye the topography of the rapidly expanding city, these towering structures were effective. Their height and characteristic profile make them unmistakable landmarks. Their location – two along the river bank, two on the Garden Ring and one adjacent to it, and one on the square known as Three Stations, where trains arrive from all over the country – marks the course of Moscow's natural and man-made arteries. Moscow University alone [pl. 122] was sited away from the centre to the south-west of the city. It marked, like an exclamation mark already prepared by a writer grappling with a statement of great length and importance, the chief direction of Moscow's expansion at the time.

Simplification of form (a legacy of 1920s modernism), which had leavened much of the neo-classical work of the 1930s and endowed it with an authoritative severity, was banished: each of these high-rise buildings is a massive, gaudy statement. Architects weighed them down with a huge mass of decorative detailing, echoing architectural traditions of the Soviet East, and with reliefs and sculptures [pl. 123] in their determination and haste to arrive at a wholly Soviet style. Although much of this ornament is poorly visible from street level, it contributes to the portentousness of the buildings.

Pomposity is likewise a quality of the interiors [pl. 124], eerily reminiscent of *Citizen Kane*'s Xanadu.

Nowadays these buildings are described by Muscovites as 'wedding cakes' or as examples of the 'Stalinist Vampire' style. Moscow University is situated high in the Lenin Hills and overlooks the city like a fairy-tale castle; its central spire is sometimes lost in cloud. The buildings certainly exude a sense of authoritarian hierarchy, despotism even, in their carefully modulated ascent (the crowning spires are said to have been Stalin's idea). But the upward striving is better understood by analogy with the dynamic of Gothic church architecture. Although the high-rise buildings are, variously, apartment blocks, hotels, official buildings and a university, they, like churches, pay scant regard to human function; the Ukraine Hotel has only fourteen per cent dwelling space; communications in Moscow University are strained by its spidery ground-plan, conceived with an eye to the patterning of exterior space rather than the working needs of the university. They embody the fundamental dialectic of Stalinism, between the spiritual and the functional, the despotic and the popular. Grim, flamboyant, sexy, they suggest that, for all its overt materialism, communism of the Stalin period was above all a gigantic enterprise of the spirit.

The Agricultural Exhibition: swan-song of Stalinist architecture

In the early 1950s, following the example of the seven sky-reaching buildings, Soviet architecture attained its peak of decoration and eclecticism. This trend was most apparent at the Agricultural Exhibition, reopened in 1954 after rebuilding and refurbishment. As in 1939, many of the pavilions showed a striking synthesis of national architectural traditions with the classical orders [pl. 125]. The Golden Ear of Corn fountain [pl. 126] was a statement of the Soviet dream of agricultural abundance and the state's predilection for mineral sumptuousness (stainless steel, marble, glass mosaic, granite) – not to be confused with mere luxury or comfort.

The Agricultural Exhibition was the last gasp of Stalinist style in architecture. From about 1950 there was growing unease among architects about the failure of new building to meet people's needs. Its splendour, like that of a night out at the Bolshoi Theatre, bore little relation to everyday life. In 1953, Stalin, 'Chief Architect of the Soviet Motherland', died; in November 1954 an All-Union conference of architects and builders, called by the Central Committee of the party and the Council of Ministers, discussed the future of architecture; and from 1955 it took an entirely new path, renouncing neo-classicism and hand-crafting in favour of the functional, prefabricated forms that were the legacy of the Modern Movement and which Stalinist culture had rejected so decisively.

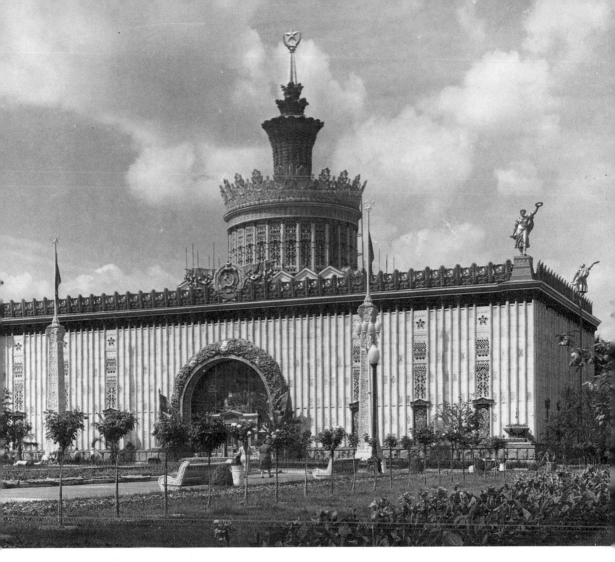

125

A. Tatsim
The Ukrainian pavilion at
the All-Union
Agricultural Exhibition,
Moscow, 1954.

126

The Golden Ear of Corn
fountain at the All-Union
Agricultural Exhibition,
Moscow, 1954.

Monumental art

Monumental art in the post-war decade echoed the example of the high-rise buildings, inclining towards greater decorativeness and size. An immense canvas by Georgi Rublyov and Boris Iordanski (1903–1987), whose turgid title – *The Ceremony of Socialist Construction of the Buryat-Mongol People* – belies its exuberance, was fastened to the ceiling of the Theatre of Opera and Ballet in Ulan-Ude [pl. 127]. In this period Rublyov and Iordanski, often working together, established themselves as the leading Soviet monumental painters; Rublyov became deputy-chairman of *MSSKh*.

The most celebrated sculptural monument was Merkurov's titanic figure of Stalin in Yerevan (1950) [pl. 2]. It stood on an ornate pedestal as big as a house which, like some of the war memorials, housed a museum. It seems likely that the model which Soviet artists and architects had in mind when devising schemes of this kind was New York's Statue of Liberty (of which they were acutely aware), which also boasts a museum in its base, although I have traced no such reference in print.

New rules for art: the Russian academic tradition

Painters and sculptors in the post-war period were required, as were architects, to prefer Russian cultural traditions over all others. During the 1930s, a comparable bias had favoured the work of the socially concerned Itinerants; at the same time the Imperial Academy of Arts which the Itinerants had rejected in the 1860s, continued to be deemed a bourgeois institution, and the work of its more prominent artists, although on display in Moscow and Leningrad, was not advertised by the party. Now this situation changed significantly. The old objection, that academic art-language was inherently bourgeois, was decisively rejected. To the names of Repin and Surikov in the Russian artistic pantheon were added those of Karl Bryullov (1799–1852) and Aleksandr Ivanov (1806–1858), nineteenth-century Rome scholars and authors of huge academic masterpieces. It was no longer of any account that painters such as these had been favourite painters of the Tsars or that they had painted huge academic *machines* on mythological and religious subjects. Their methodology – huge scale, meticulous execution, and a straining to evoke an ideal world – was what Stalin now hoped to instil into Soviet art.

Existing organisations such as the *Orgkomitet*, headed by Aleksandr Gerasimov, and *MSSKh*, with its semblance of democratic procedure, were deemed inadequate to the task of educating Soviet

artists in the revised artistic requirements. They lacked both the will
and the clout. For this reason the Council of Ministers published a
decree on 5 August 1947 depriving the Leningrad art school, the
All-Russian Academy of Arts, of its name, and creating an Academy
of Arts of the USSR. Modelled on the old Imperial Academy, the
new institution took over the administration of art schools in
Moscow and Leningrad; it was given its own art history research
institute and publishing house; it had studio space and technical
facilities. Most important of all, it took orders directly from the
Committee for Art Affairs, and thus enjoyed the party mandate in
whatever it attempted. We can say it was really the perfected vehicle
for the Leninist concept of *partiinost*.

Its members, in true Stalinist style, were given the greatest poss-
ible incentive to serve the party: the president was to receive 20,000
roubles per month, ordinary members 10,000 roubles – staggering

127

Boris Iordanski,
Georgi Rublyov
*The Ceremony of
Socialist Construction of
the Buryat-Mongol
People*, 1948–50.
Tempera on canvas.
Theatre of Opera and
Ballet, Ulan-Ude.

sums even if the considerable post-war inflation is taken into account. Ordinary administrative staff of the Academy received a comparatively meagre 500–2,500 roubles per month.[81] The foundation of the Academy marked the final stage in the imposition of an authoritarian hierarchical structure on the Soviet art world.

The Academy's presidium was appointed by the Committee for Art Affairs, which drew up a list of academicians that was approved by the Council of Ministers in October 1947. Its first president was Aleksandr Gerasimov.

The decree creating the Academy obliged it to develop art on the basis of the Russian school, thereby confirming the central role of the new Russian chauvinism in Soviet cultural life. Gerasimov's inaugural speech touched repeatedly on the revised, Russian chauvinist, concept of socialist realism. The old slogan 'socialist in content and national in form' was given a jesuitical gloss: 'The study of the great realist heritage of Russian art is most significant for the ascent and flowering of the art of the fraternal republics and nationalities . . . ' he said; elsewhere he talked of 'The development and flowering of the multinational art of the peoples of the USSR, led by the Russian art of the Soviet epoch . . . '[82]

The great art of the European past was now regarded in the same immodest spirit as the art of the non-Russian republics: Gerasimov's speech shows, even when allowance is made for a sense of occasion, that socialist realism – much like the Soviet architecture which created the high-rise buildings – was going for broke: 'Soviet art opens a new era in world art, its strength and brilliance – and this cannot be doubted – will eclipse even the most outstanding epochs of art's flowering in the past.'

The creation of such an Academy and the regeneration of the Russian academic tradition ran counter to the state-sponsored art-historical discourse of the previous three decades. The dissolution of the Imperial Academy at the time of the revolution had been a symbol of liberation from tsarism. However, the reanimation of this 'canonical ice-cream factory' derided by the futurists is quite understandable. Stalin himself favoured the arch-academic, Brodski. Academic teaching methods had been reintroduced in art schools in the 1930s, and the classical heritage in architecture was well regarded. Moreover, the trend in art was towards an increasingly narrow definition of 'realism', coupled with demands for a highly varnished picture of Soviet life. The Academy was a logical innovation.

The revival of academicism and Russianism was confirmed in 1948 during a speech delivered by Zhdanov to the élite of the music world. He drew specific analogies between music and the fine arts. Declaring the party's opposition to formalist schools, he said: 'The Party has completely resurrected the inheritance of Repin, Bryullov, Vereshchagin, Vasnetsov, Surikov. Did we do right in preserving the treasury of classical painting and smashing the liquidators of

painting? . . . In preserving the classical inheritance in painting did the Central Committee act "conservatively", find itself under the influence of "traditionalism", of "unoriginal imitation"? That's utter rubbish.'[83] As Zhdanov's words imply, the return to academicism and redoubled emphasis on what was Russian entailed, no less than in the 1930s, the persecution of dissenters. We will scrutinise this invidious campaign later.

Stalin himself put the finishing touches to the academic revival in 1950, when he published a pseudo-learned work entitled *Marxism and Questions of Linguistics*, which stated as a principle that language was a class-independent, eternal medium. Although Stalin was writing about verbal language, his views were considered, in critical essays of the time, to apply also to artistic language.

The Stalin cult

In 1947, John Steinbeck visited the Soviet Union and wrote in his diary: 'Everything in the Soviet Union takes place under the fixed stare of the plaster, bronze, drawn or embroidered eye of Stalin. His portrait does not just hang in every museum, but in a museum's every room. Statues of him dignify the façade of every public building. His bust stands in front of all airports, railway and bus stations. A bust of Stalin stands in every classroom, and often his portrait hangs directly opposite. In parks he sits on plaster benches and discusses something or other with Lenin. In schools children embroider his portrait. In shops they sell million upon million of images of him, and in every home there is at least one portrait of him. Without a doubt, one of the greatest industries in the Soviet Union is the drawing and casting, embroidering and forging of images of Stalin. He is everywhere, he sees everything . . . we doubt whether Caesar Augustus enjoyed during his life the prestige, the worship and the godlike power over the people of which Stalin disposes.' [pl. 129].[84]

Stalin's virtual deification by the Soviet people, which reached a peak of intensity in the post-war years, is termed the Cult of Personality by Soviet historians. Perhaps there existed some predisposition in the Russian people in their old custom of tsar worship and their religious cast of mind, but the cult was put into practice and manipulated by Stalin and his entourage. 'The ideals of the people, its striving, receive their most complete incarnation in the image of Stalin' was the sort of numbing phrase that peppered *Tvorchestvo* and *Iskusstvo* (revived in 1946 and 1947 respectively). The party provided a place of homage: Stalin's humble childhood home in Gori, enshrined by a roof of coloured glass held up on gilded marble columns and flowerbeds planted with pink blooms [pl. 135]. Few leaders in history have received adulation on such a scale and of such intensity. To us it may seem bizarre, but at the

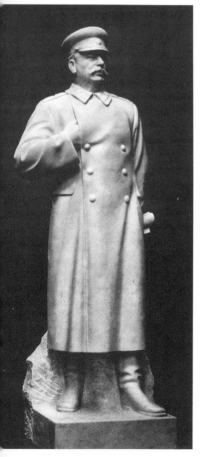

128

Nikolai Tomski
Stalin, 1947.
Marble, 250 cm (98 in)
high.
USSR Ministry of
Culture.

time, to a people in the steel grip of the communist dream, it was perfectly comprehensible.

The visual arts must surely have played a considerable role in bringing about this state of affairs. The integral power of paintings and sculptures of Stalin over unsophisticated minds is one thing; but, because of their ubiquity, they also featured in endless news photographs and films. When framing a shot, a cameraman could often make no choice more likely to be approved than to include an image of Stalin. Moreover, the distinction between the fictive image – painting – and the documentary – photography – was not as clearcut as one might assume. Paintings were often made from photographs, and in any case presented a quasi-photographic view of the world; photographs approached art by being retouched and, sometimes, created by montage. Reproduced in the newspapers of the period (as they frequently were), paintings could be hard to distinguish from photographs, which lent them an air of veracity.

Victory provided Stalin with a new role in art – war leader. There had been a few attempts at such a subject in the 1930s, depicting scenes from the civil war, but now they assumed categorical importance. Stalin had never gone to the front, so not much could be made of his personal heroism; instead, in works such as *Generalissimus I. V. Stalin* [pl. 121] (a new roman-style title Stalin gave himself after the war) by Fyodor Reshetnikov (1906–1988), his strategic genius was evoked.

Stalin's image also underwent a metamorphosis in other contexts. When portrayed in Lenin's company he no longer had to play second fiddle – indeed, he could even be shown telling Lenin what was what. A spate of pictures harking back to Stalin's youth appeared around the time of his 70th birthday in 1949. These far outdid comparable efforts of the 1930s in the creation of a kind of matinee idol, dark-haired and handsome, his gaze alternately dreamy or fiery as the subject of the painting required [pl. 134]. In the 1930s such paintings were created almost exclusively by Georgian artists; after the war, many were painted by Russians, a sign of the increased importance attached to them.

The mature Stalin also evolved. In the art of the 1930s Stalin's humanity is commonly emphasised by his interaction with other people, even if they are only party officials. But in the post-war decade the most highly praised images emphasised Stalin's separateness from and superiority to everyone else. He is frequently depicted alone. When surrounded by others he is typically either set apart from them, as in *Stalin on the Cruiser 'Molotov'* [pl. 131] by Viktor Puzyrkov (born 1918), a painting distinguished by its splendidly realised *plein-air* effects, or raised above them, on a platform or podium, as in Aleksandr Gerasimov's nostalgic *There is a Metro!* [pl. 130], depicting the ceremonial opening of the metro in 1935. Artists who attempted to portray Stalin enjoying too-human

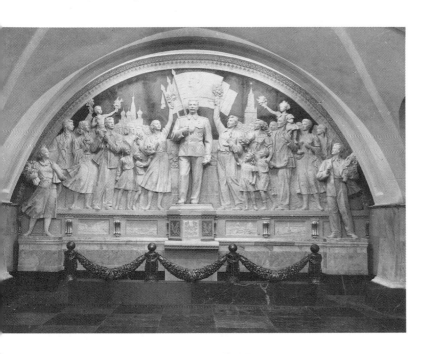

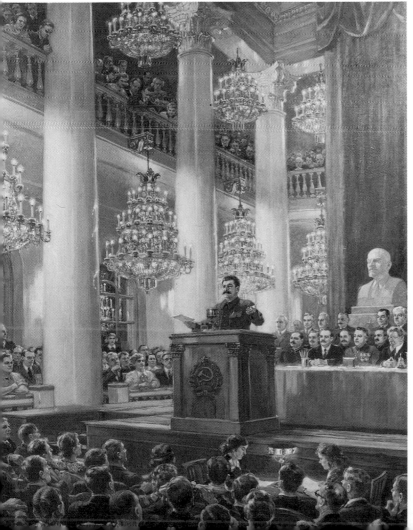

129

Evgeniya Blinova,
Pavel Balandin
*I. V. Stalin among the
People*, 1950.
Plaster. Metro
Taganskaya. Moscow
(destroyed).

130

Aleksandr Gerasimov
There is a Metro! 1949.
Oil on canvas,
380×300 cm
(150×118 in).
USSR Ministry of
Culture.

intercourse with the people, in the manner of the 1930s, were criticised.[85]

The second feature of the post-war Stalin is his static pose. His qualities are no longer expressed by deeds depicted or intimated. If Stalin is represented doing anything in post-war art, it is usually either receiving homage or, more commonly, making a speech – in other words, uttering tablets of stone. Thus in sculpture, added to the 1930s innovation of an arm inserted Napoleon-style into the coat, was another detail: Stalin clutching a rolled-up document, perhaps a speech [pl. 128]. In essence, he was required simply to be, to exist as a presence in painted or sculpted form. Artists no longer portrayed the man, as it were, but the idea of the man; as flesh and blood he might have ceased to exist; he had become a bundle of concepts, the embodiment of all virtue, a divinity.

In a sense, what artists were depicting – and this was a unique attempt in the European academic tradition – was God.

A clever artist could worship in all sorts of ways. At the 1951 All-Union Art Exhibition, for example, Tomski showed sculptures of Kutuzov, Lomonosov and Gogol – representing, as it were, the military, the sciences and the arts; and four sculptures of Stalin, implying that the Soviet leader was more than equal to all these worthies put together.

The god-like quality of Stalin was supremely evoked in *The Morning of Our Motherland* [pl. 132] by Fyodor Shurpin. Stalin is dressed in white; dawn breaks as He surveys the Russian agricultural vastness, whose fertility is the fruit of His Five-Year Plans. Although Shurpin took a model out into the countryside to help him paint the picture, it is not conceived primarily as the portrait of a figure in a landscape; it is an icon, the image of a holy figure with Stalin's attributes. It told the Soviet people: Stalin is everywhere present and watching over you; he understands your hopes and has your best interests at heart. This picture was a striking excursion in the career of Shurpin, hitherto known as a painter of peasant life

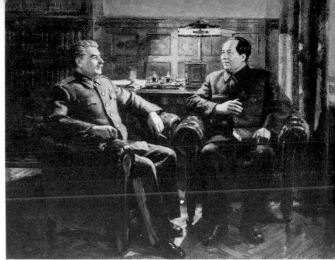

134

Fyodor Modorov
(left), Dmitri Nalbandyan
(centre), Aleksandr
Gerasimov (right) with
Nalbandyan's charcoal
drawing of the young
Stalin, c. 1950.

135

Stalin's childhood home
in Gori, 1952.

[pl. 118] and buxom peasant madonnas; some of his friends and supporters regarded it as a brazen attempt to earn money, but his son told me that Shurpin executed it in perfect good faith.

In Nalbandyan's *A Great Friendship* [pl. 133], which shows Stalin with Mao Tse-tung, who was feted on the visit to Moscow in 1949–50 (which resulted in a treaty of friendship between the USSR and China), the significance of the two leaders consists in their mere presence, in the fact that they exist; they are scarcely required to interact. From the point of view of what this tableau aims to portray – the dual incarnation of communism – their very woodenness is a dramatic virtue.

The late 1940s witnessed the rapid rise of Dmitri Nalbandyan, who is said to have remarked, frequently and with commendable honesty, 'I work in the genre of the leader'. Long hours spent in the 1930s dry-brushing official portraits from photographs for *VseKoKhudozhnik* bore fruit after the war. Nalbandyan's hyper-real images, almost a parody of academicism, were based on his pick of the official photographs. They are not well painted, but seem curiously appropriate to the age he flourished in, which strained towards the transcendental while teetering on the brink of the ludicrous.

A telling demonstration of Stalin's own attitude to art came in 1949, when the Pushkin Museum was closed down and reopened as a museum displaying the many gifts Stalin had received over the previous two decades. This was a far cry from the director, Merkurov's, plan for a Museum of World Art. To his credit Merkurov, creator of the most dramatic monuments to Stalin [pls. 2, 53], resigned.

136

Dmitri Mochalski
*They've Seen Stalin
(After the
Demonstration)*, 1949.
Oil on canvas,
69×131 cm (27×51½ in).
State Tretyakov Gallery.

Lenin

In contrast to the static, iconic images of the mature Stalin, the great paintings of Lenin in the post-war era stress his qualities as a man of action. Serov received a Stalin prize in 1948 for his *Lenin Declares Soviet Power* [pl. 137]. In a similar vein is the stirring *V. I. Lenin* [pl. 138], executed by the young Viktor Tsyplakov (1915–1988) with considerable painterly assurance and verve. We see here an ambitious young artist investing the traditional Lenin gesture, an outstretched arm, with new dramatic significance.

The images of Lenin and Stalin in post-war art are perhaps complementary. The mature Lenin is dynamic, the mature Stalin static. On the other hand, paintings and sculptures of Lenin's youth began to appear after the war, and these stress not the emotional – the visionary and rebellious character ascribed to Stalin – but the intellectual. Celebrated works were the sculpture, *V. I. Lenin, High-School Student* (1949), by Vladimir Tsigal (born 1917) and the painting, *V. I. Lenin Taking an Exam in Petersburg University* (1944–7), by Viktor Oreshnikov (1904–1987). It seems possible that this contrast was designed by the KPDI to stress the symbiotic relationship of the two leaders. Even the initials of Lenin and Stalin, V. I. and I. V., are a fortuitous inversion of each another.

137

Vladimir Serov
Lenin Declares Soviet Power, 1947.
Oil on canvas,
270×210 cm
(106×82½ in).
State Tretyakov Gallery.

138

Viktor Tsyplakov
V. I. Lenin, 1947.
Oil on canvas,
300×200 cm (118×79 in).
Central Lenin Museum,
Moscow.

Brigade art: the triumph of the collective method

In 1949 Efanov and a team of young artists painted *Leading People of Moscow in the Kremlin* [pl. 139]. This work stimulated a revival in the practice of creating pictures by brigades, the method that had been adopted at the end of the 1930s for the New York international exhibition and the pavilions of the Agricultural Exhibition. Now a method of working once restricted to the fulfilment of special projects became commonplace. This accorded with the pressure on artists to to produce bigger and yet bigger pictures in academic style – while the party allowed no extra time for their creation. The nineteenth-century master, Aleksandr Ivanov, had spent twenty years on his *The Appearance of Christ to the People*: Soviet artists were now required to execute dense compositions of comparable or greater size in a few months.

Brigade painting gained another justification, inherent in communal endeavour. This was the inevitable elimination of much personal style, affecting all participating artists. Their work approached an ideal of wholly anonymous academic execution; the brigade method predicated the whole Stalinist straining towards a mass culture and the eradication of individual difference.

The collective ideal of brigade painting coexisted with an inbuilt authoritarian principle, for whereas the huge paintings for the 1939 exhibition in New York had been created by groups of equals, now each brigade was led by one artist, usually an Academician. Thus important brigade paintings were executed not only under Efanov, but under Aleksandr Gerasimov [pl. 140], Nalbandyan, Sokolov-Skalya and Ioganson. Typically, these artists would devise a composition and then employ younger, less well-established artists to carry out the chore of innumerable portrait and architectural studies. Sometimes, however, under pressure of a deadline, the working method became more fluid: Ioganson's *Lenin's Speech to the Third Congress of the Komsomol* [pl. 141] was improvised on the canvas with only a rudimentary idea of the intended outcome.

Sculptures too began to be executed by brigades. The first works of this kind, a series of giant plaster reliefs which panelled an entire hall entitled *Lenin and Stalin, Founders and Leaders of the Soviet State*, were shown at the 1949 All-Union Art Exhibition [title-page]. Subsequently figure compositions in the round were carried out by teams under the direction of Manizer, Mukhina and others.

The inducements for artists to make brigade works were considerable. There was the spur of ambition: the oceans of faces in paintings led by Efanov and Ioganson are as expansive as anything painted by Surikov or Repin, against whom Soviet artists measured themselves; and for those sculptors who were enchanted by the

classical past, the current lack of multi-figure compositions in Soviet art had become a serious deficiency for which brigade work offered relief. There was also a lot of money to be earned. The state paid over a quarter of a million roubles to the artists who, under Ioganson's direction, painted *V. I. Lenin's Speech at the Third Congress of the Komsomol*. And for young artists in the post-war era, the invitation to collaborate on a brigade work became an important experience of patronage, a stepping-stone to Stalin prizes and prestigious commissions of their own.

Brigade art: iconography

Brigade works illustrate two, perhaps contradictory, aspects of the society Stalin had created: the importance of the mass as a social unit and a sense of rigid hierarchy. The acreage of upturned faces suggested that first and foremost the individual should be conscious of himself as part of the mass. However, the *mise-en-scène* is usually opulent, emphasising the grandeur of the players and their superiority to the daily grind. This was the world to which ordinary people, if they would only work hard enough to become 'Leading People', could attain. Another layer of hierarchy is often created by setting a smaller group of people apart from this exclusive crowd; and then the protagonist – often, but not always, Stalin – is further isolated and made the centre of attention. An image of supreme importance is sometimes inserted in the form of a large sculpted bust or head of Lenin or Stalin. The social structure evoked by these pictures is pyramidal, an echo of the geometric form which underlies much Stalinist architecture, from Lenin's mausoleum

through the Palace of the Soviets to some of the high-rise buildings. Brigade paintings are today often execrated, but, whatever their aesthetic failings, to the extent that they express the hierarchical society Stalin brought about, they are works which attain to a kind of truth.

Ceremonial

The ritual side of social relations – speeches, conferences, toasts, award-giving ceremonies – which is stressed in the brigade works, was featured in much art of the post-war decade. *To the Great Russian People* [pl. 166], by Mikhail Khmelko (born 1919), which depicts Stalin's victory toast of 24 May 1945, is a famous example. But this emphasis could extend even to still-life painting; thus *Still-Life with the Medals of M. Isaakova* [pl. 142] by Anatoli Nikich-Krilichevski (born 1918) conveys the idea of sporting achievement by an array of pennants and medals; in the background, one of Moscow's high-rise buildings is being built: the painting attempts the kind of forced identity between athleticism and socialist construction familiar in, say, Deineka's work, but in symbolic terms.

The war

The tragic theme of recent war was a compulsive subject. Great sculptural monuments were provided by Evgeni Vuchetich (1908–1974), a most robust servant of the new academicism. The *Warrior-Liberator* [pl. 143] is Vuchetich's contribution to the Treptov Memorial Park in Berlin, a huge ensemble of architecture and sculpture, constructed out of the rubble of the Reich Chancellery and dedicated to the Soviet victory over fascism. This figure is to the post-war period what Mukhina's *Worker and Collective Farm Girl* was to the 1930s: it was the Zeitgeist realised in monumental form. Whereas Mukhina's figures, hammered out of stainless steel, are the embodiment of constructive enthusiasm, Vuchetich's bronze soldier and child acknowledge the fact of a tragedy; the sword invokes the whole history of Russian arms; the child is hope for the future.

The Kukryniksy's *The End* [pl. 144] depicts Hitler's death by self-administered poison. This painting is a summing-up of the artists' long years devoted to anti-Nazi vituperation, an entertaining piece of Grand Guignol. The Kukryniksy never failed to convey the communist message. The upturned gilt chair, the crumpled oriental rug, the disarray of luxuriously framed paintings – all evoke Hitler's death as a catastrophe of the bourgeoisie. A sense of melodrama is also evident in paintings of war subjects by Pyotr Krivonogov (1911–1967), a stalwart of the Grekov Studio, and Sokolov-Skalya.

143

Evgeni Vuchetich (sculptor), Ya. Belopolski (architect) *Warrior-Liberator*, 1949. Bronze, 1300 cm (512 in) high. Treptov Park, East Berlin. The sculpture stands on a base containing a memorial room which is itself raised on a mound, adding 1700 cm (669 in) to the height of the ensemble.

144

The Kukryniksy
The End, 1948.
Oil on canvas,
200×251 cm
(78¾×99 in).
State Tretyakov Gallery.

145

Aleksandr Laktionov
A Letter from the Front,
1947.
Oil on canvas,
225×115 cm
(88½×45 in).
State Tretyakov Gallery.

146

Pavel Sokolov-Skalya,
Andrei Plotnov
*The Storming of
Sebastopol*, 1944–7.
Oil on canvas,
315×500 cm
(124×197 in).

147

Yuri Neprintsev
A Rest after Battle, 1955
(a slight variation on the
first version of 1951).
Oil on canvas,
192×300 cm
(75½×118 in).
State Tretyakov Gallery.

148

Ekaterina Zernova
Nadezhda Durova, 1948.
Oil on canvas,
160×160 cm (64×64 in).
Geological Prospecting
Board, Ufa.

The Storming of Sebastopol [pl. 146], a vast diorama, is especially rich in *Boys' Own* anecdote.

Other artists remained in touch with human values more abiding than the rhetoric of victory. *A Rest After Battle* [pl. 147] by Yuri Neprintsev (born 1909) captures the mood of irrepressible hilarity that soldiers can experience in the pauses between battles. This group euphoria emphasises, of course, a tradition of communal life, and was fully in keeping with social injunctions that found their most extreme expression in the brigade paintings of Efanov and others. Neprintsev's protagonists are gathered together, however, in joy rather than in stupefaction; they tap a social spirit independent of, and much older than communism. Judging by the visitors' book at the 1951 All-Union Art Exhibition, where it was first shown, it was an enormously popular work.

A sense of this genuine, as opposed to politically engineered, community pervades one of the most famous of Soviet paintings of a war-time subject, *A Letter from the Front* [pl. 145], by Aleksandr Laktionov (1910–1972). He was a favourite pupil of Brodski's in Leningrad before the war, and he inherited Brodski's love of anecdotal detail. In the post-war period his meticulous manner came into its own, answering calls for a return to academic principles. The public immediately took *A Letter from the Front* to its heart, even though it offers no obvious heroism, no suffering transcended – nothing significantly to rouse the spirit. Instead the painting seems unashamed of 'naturalism' in its over-scrupulous rendering of a poor home and the inclusion of a wounded comrade who has paused to listen. We can sense here the artist's deliberate rejection of the requirement to spruce up reality. Laktionov received a Stalin prize for it in 1948; Stalin, with his enthusiasm for portraits of people who were 'as if alive', probably liked it very much.

History

149

Sergei Orlov,
Nikolai Shtamm,
Anatoli Antropov
(sculptors),
V. Andreev (architect)
*Monument to Yuri
Dolgoruki*, 1954.
Bronze sculpture 560 cm
(220 in) high, granite
base 711 cm (280 in)
high.
Soviet Square, Moscow.

In line with the new Russianism, the KPDI and *VseKoKhudozhnik* continued to commission works that dealt with the wider history of Russian arms. Gavriil Gorelov produced some vast multi-figure compositions of good quality. *Nadezhda Durova* [pl. 148], by Ekaterina Zernova (born 1900), an artist who liked to paint female protagonists, portrays a heroine of the Napoleonic War. The scene itself, in which a medal is bestowed, shows, in common with much Soviet art of the post-war period, the importance attached to the ritual and symbolic – to the formal occasion. The history of Russian arms provided the subject for one of Moscow's best-known public monuments – the bronze figure of Yuri Dolgoruki, the legendary founder of Moscow, that stands today in Soviet Square [pl. 149]. It was designed by Sergei Orlov (1911–1971), a self-taught artist best known at the time for his elaborate ceramic sculptures.[86]

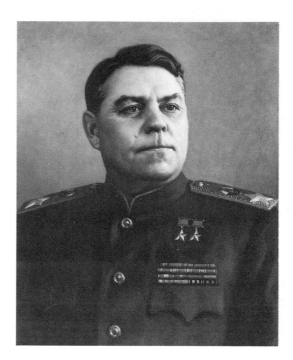

150

Aleksandr Laktionov
Marshal Vasilevski, 1948.
Oil on canvas,
90×70 cm (35×27½ in).
Private Collection.

151

Evgeni Vuchetich
Marshal Vasilevski, 1947.
Bronze, 83 cm (32½ in)
high; base 19 cm
(7½ in) high.
State Tretyakov Gallery.

152

Nikogos Nikogasyan
Portrait of Louis Aragon,
1952.
Bronze, 93×55×43 cm
(36½×21½×17 in).
State Tretyakov Gallery.

153

Vladimir Favorski
*P. V. Favorskaya and E.
V. Derviz*, 1945. Pencil
on paper, 62×44 cm
(24×17 in).
State Russian Museum.

154

Konstantin Maksimov
*Sashka the Tractor
Driver*, 1954.
Oil on canvas,
56×45 cm (22×17¾ in).
State Tretyakov Gallery.

Portraiture

Portraits of political and military figures after the war reflect most clearly the revived academic ideal. A fine example of the new academicism is Laktionov's *Marshal Vasilevski* [pl. 150], which exemplifies the precise expectations of official portraiture in the post-war period. The preferred form was the bust, consisting of two essential regions, head and breast (in painting, the resultant image approximated to the kind of portrait photographs which would appear in newspapers). The head, modelled to a remarkable degree of solidity in Laktionov's picture, conveys character. Here we sense both resilience and humanity, and are pleased the artist does not deny the wart on the sitter's cheek. The breast, by contrast, is often little more than a flat expanse, like a baize-covered noticeboard; it is the field on which the sitter's social achievements and position, signified by his medals, orders or dress, are displayed.

A similar format, indebted to academic traditions, was adopted in sculpture for ceremonial busts, executed in marble or bronze and set upon classical plinths. The impetus for these works was a scheme hatched in the war by the Committee for Art Affairs to create portraits of all those who had twice been created Hero of the Soviet Union. The task of making all these works took several years

and occupied many sculptors. They were often carried out from photographs because Twice Heroes were reluctant to pose; one reason was their fear that, should they be seen to have time to sit for artists, they would be deemed to be neglecting their duties. An example of this style of bust, pompous in conception and clinical in execution, is a portrait of Laktionov's eminent sitter, the war hero Marshal Vasilevski, by Vuchetich [pl. 151].

However, many artists resisted such exaggerated, petrified versions of academicism. The Armenian, Nikogos (also known as Nikolai) Nikogasyan (born 1918) modelled a portrait of Louis Aragon, the French communist and littérateur [pl. 152]. Nikogasyan caught him in thoughtful mood, staring out of a window, and in a few short sessions achieved a remarkable portrait devoid of all rhetoric. Robust painterly values and narrative tableaux – qualities epitomised, in the 1930s, by Nesterov's work – continued to guide many painters, and these were not condemned. Nesterov's influence can be seen on the work of Korin, a major portraitist in the post-war period. One of the best portraits of the time is *Sashka the Tractor Driver* [pl. 154] by Konstantin Maksimov. Maksimov, a wartime graduate of the Moscow State Art Institute, was one of the first batch of painters trained in the Soviet period entirely according to academic principles; on such painters the hopes for socialist realism rested. The irresistible portrait of Sashka seemed to many to be a fulfilment of these hopes, and was given, despite its modest

155

Vladimir Tsigal
A Young Commando,
1948.
Bronze, 58×46×33 cm
(23×18×13 in).
State Tretyakov Gallery.

156

Fyodor Reshetnikov
Low Marks Again, 1952.
Oil on canvas,
101×93 cm (40×36¾ in).
State Tretyakov Gallery.

157

Sergei Grigorev
Young Naturalists, 1950.
Oil on canvas,
100×170 cm (39×67 in).
Kiev Museum of
Ukramian Art

158

Ekaterina Belashova-
Alekseeva
*Schoolgirls Who Get
Top Marks*, 1950.
Plaster, 83×150×52 cm
(32½×59×20½ in).
House of Children's
Books, Moscow.

size, pride of place in the Tretyakov Gallery at the 1954 All-Union Art Exhibition.

Sashka complies with the requirement of socialist realism for optimistic images. An antidote to this strain (which in lesser hands than Maksimov's was a guarantee of banality) is a series of double portraits carried out after the war by Favorski [pl. 153]. Favorski had been criticised as a formalist in the 1930s, and to the extent that these drawings are realistic in style they suggest that he responded to pressure; but as human statements they are oblivious to the ideology of socialist realism. They depict the artist's family and friends and convey much of the dark spirit of an intellectual's existence, suffering want and personal grief, and seeking sustenance, perhaps, in art. Favorski himself lost two sons in the war.

Children

Images of children are a distinct feature of post-war Soviet art – a reflection, perhaps, of the shared longing for regeneration. In a manner familiar from election campaigns in the West, Stalin was frequently presented by artists in the company of children. The viewer's sense of the essential sweetness and probity of the leadership was bolstered by paintings such as Efanov's *Stalin, Molotov and Voroshilov with Children*. A more inventive exploration of the same idea was *They've Seen Stalin (After the Demonstration)* [pl. 136] by Dmitri Mochalski (1908–1988), an artist who made a speciality of young subjects. Paintings such as this were reproduced in poster form in editions of tens of thousands.

Works on war subjects were sometimes lent pathos by a child protagonist. Vladimir Tsigal mined a sentimental vein in works such as *A Young Commando* [pl. 155], in which a youthful warrior relates deeds of derring-do to an awestruck little companion. His sculptures of child partisans are based on his own wartime experiences as a volunteer at the front; but the ragamuffin young soldiers might be nineteenth-century shepherd boys from a pastoral scene were it not for their accoutrements of war.

Prominent among the specialists in the portrayal of children were the sculptor, Ekaterina Belashova-Alekseeva (1906–1971), whose *Schoolgirls Who Get Top Marks* [pl. 158] is a saccharine exhortation to Soviet youth, and the painter, Sergei Grigorev (1910–1988). Grigorev made well-known works of transparent *partiinost*, such as *Entry into the Komsomol* (1949). It is perhaps typical of artists guided, to the extent that Grigorev was, by party ideology, that when they attempt an unabashed approach to nature – to existence pure and simple – as Grigorev did in *Young Naturalists* [pl. 157], they should lose their footing and slide into bathos.

Fyodor Reshetnikov (1906–1988) was a caricaturist and painter who most convincingly explored the child-genre. *Low Marks Again*

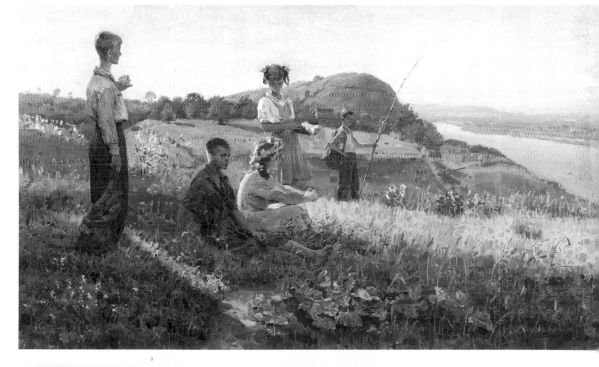

159

Aleksandr Bubnov
Corn, 1948. Oil on
canvas, 180×390 cm
(71×153½ in).
State Russian Museum.

[pl. 156] is a picture of a most uncommon theme in socialist realism – disappointment. The cause of the little boy's poor performance at school, news of which he has just given to his family, is admirably suggested by the ice-skate that pokes out of his bag. An older sister's reproving gaze (her expression gives us to understand she is a superior scholar), a mother's sympathetic pain, a little brother's malicious enjoyment of the situation – all are magically caught.

Peasant life

Paintings of peasant life in the post-war period express an understandable yearning for renewal after the war, but in many paintings a faith in the future seems less firmly rooted in the conditions of everyday life than before the war. Artists often reveal a striving to escape from, or transcend, the bleak conditions of the present.

Bubnov's picture, *Corn* [pl. 159], shows a collective farm. The old man signifies the loss of the younger generation, the burgeoning cornfield – hope for the future. This scene could easily be placed in the nineteenth century or earlier, were it not for the distant figure of an electricity pylon. Bubnov was enthralled by the Russian past; to me, his picture conveys something of the helpless nostalgia of a nation which the revolution had seized by the scruff of the neck, which the war had ravaged, and which longed for the certitudes of a rural idyll that was half remembered, half a dream.

In Peaceful Fields [pl. 160], which won a Stalin prize for the young Andrei Mylnikov (born 1919), is unmistakably optimistic. Yet here, too, the Russian artist has created a supernatural ambience (note the halo that surrounds the heads of the two women nearest the viewer). He speaks of peasant labour not so much as a familiar and useful activity, but as something holy, superior to the mundane con-

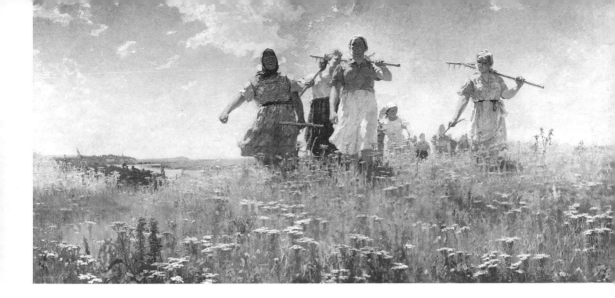

ditions of everyday life.

Paintings such as these would appear to be on the verge of reject-
ing the quotidian altogether. Their deep sense of nature-bound
ritual links them with the great brigade paintings of communist
ceremonies that were being executed at the same time. They share
a common understanding of the need to sanctify all Soviet life and
exalt it above the inglorious, harshly controlled post-war reality.
Their exaltation of the cornfield signifies the almost holy status
which bread had acquired during the war, when it had often been
the only food.

Landscape

Landscape painting, which had gained official favour during the
war, continued to enjoy a renaissance. However, the Committee for
Art Affairs wanted more *ideinost* – more ideas, more ideology, more
social significance. Landscape was now required to emulate the
brigade paintings. Many of the more striking landscapes of the
post-war era are panoramic and painted with an academic attention
to detail. Vasili Yakovlev's labour of love, *Svistukha* [pl. 161], for
example, attempts a positive compendium of a country existence.
Rather as the brigades would proffer a vast sea of faces, so land-
scapes were now often considerably extended horizontally, in order
to encompass as much of the Motherland as possible. This trait is
typified in an epic example of the new approach to landscape, preg-
nant with patriotism and nostalgia: *A Stormy Day in Zhiguli:*
[pl. 162] by Aleksandr Gritsai (born 1914). It depicts the Volga, the
river which is a symbol of Russia; her presence pervades Russian
art, literature and music. Gritsai first thought of his subject when he
was caught in a boat on the Volga by a sudden violent storm. He felt

161

Vasili Yakovlev
Svistukha, 1948.
Oil on canvas.
Location unknown.

162

Aleksandr Gritsai
A Stormy Day in Zhiguli,
1948–50.
Oil on canvas,
60×180 cm (23½×71 in).
State Tretyakov Gallery.

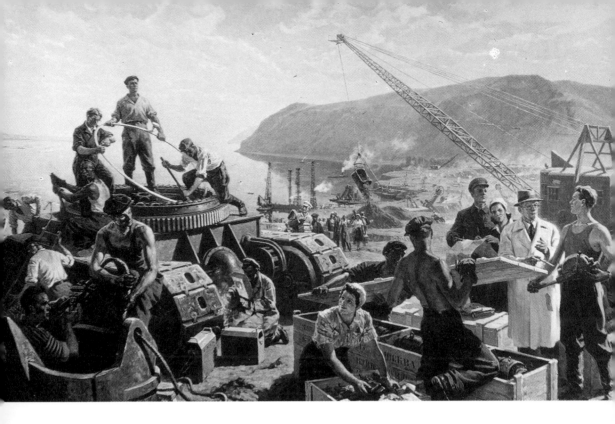

163

Pavel Sokolov-Skalya,
Lev Narodnitski,
Andrei Plotnov,
Viktor Sokolov,
Nikolai Tolkunov,
Mikhail Volodin
*On the Great Stalinist
Construction Site*, 1951.
Oil on canvas,
290×550 cm
(114×216½ in).
USSR Ministry of
Culture.

he was being shown the indomitable spirit of the river on whose banks the great battles of the Patriotic War were fought. As befits an epic, the picture was a grand undertaking, constructed from many studies and from memory.

Aside from the ambitions of the Committee for Art Affairs, Gritsai and others still found in landscape a store of profound truth which could not but subdue the nagging of ideology. He explained to me how, after six years in the army during the war and after, including service as an ordinary soldier, he developed antipathy towards *konyunktura* – the making of works on subjects suggested by social and political developments. Much socialist realism is the quintessence of *konyunktura*. In landscape he discovered something akin to a religious authority, unimpeachable by political slogans. This attitude was shared by many artists existing either outside or on the fringes of the art establishment, who, as in the 1930s, could pursue landscape painting free of charge and without fear of recrimination (although, for security reasons, painting and drawing in cities often required special permission in the Stalin era).

Industry

Documentary truth had always been an ideal of socialist realism, but now, as the example of the brigade painting suggests, it was urged on artists with increased insistence, particularly affecting the

painting of industrial scenes. The flights of fancy commonplace in works of 1930s, such as *Higher and Higher* [pl. 73], all but vanished. Innumerable portraits of workers were executed, of which the most celebrated was perhaps Gavriil Gorelov's image of Subbotin, a steelworker (1948). Exceptions to the dour rule were provided by the young Mikhail Kostin, a wartime graduate who imparted vigour to factory scenes by means of dramatic chiaroscuro, and Konstantin Yuon (1875–1958), a veteran artist who carried out a charming landscape, *The Morning of Industrial Moscow* (1948).

The brigade method was used for *On the Great Stalinist Construction Site* [pl. 163], which displays all the blandness that team-painting was capable of generating. There is a cursory appeal to romantic instincts in the figure of a young blond-haired team-leader in a red tee-shirt. The drama of the picture consists in his discussion of the construction plan with an academician, a female engineer and a party worker: formulaic embodiments of communist virtues. The dramatic deficiencies of this work were remarked upon by critics on its appearance; but they were surely the product, in part, of contemporary critical discourse, for which the bald facts of content and verisimilitude had become a be-all and end-all in the post-war period.

A far more compelling collaborative work – whose focal point is also a youth in a red shirt – is *A Fresh Edition of the Factory Newspaper* [pl. 164], by Anatoli Levitin (born 1922) and Yuri Tulin (1921–1988). Here, subversively, the young man's gaze has been

164

Anatoli Levitin,
Yuri Tulin
A Fresh Edition of the Factory Newspaper,
1950.
Oil on canvas,
168×232 cm (66×91 in).
State Russian Museum.

drawn not by the eagerly awaited broadsheet but by a statuesque young woman. Their example is outweighed by that of the crowd around them; it indicates, perhaps, the narrow limits of the humour permitted at the expense of the communist cause.

Art in the non-Russian republics

165

Georgi Melikhov
*The Young Taras
Shevchenko Visiting the
Artist K. P. Bryullov,*
1947.
Oil on canvas,
289×295 cm
(113¾×116 in).
State Museum of
Ukrainian Art, Kiev.

The post-war elevation of Russian traditions and academic method presented a challenge to artists in the many Soviet republics, brought up to believe that their culture ought to be, in Stalin's pre-war dictum, 'socialist in content, national in form'. The new thinking in the arts reflected Stalin's broad political strategy – to subject the republics to greater control from Moscow.

Paintings fully expressive of the fealty required are the Ukrainian, Khmelko's, *To the Great Russian People* [pl. 166] and *The Young Taras Shevchenko Visiting the Artist K. P. Bryullov* [pl. 165] by another Ukrainian, Georgi Melikhov (1908–1985). The artist depicts Shevchenko, the national poet of the Ukraine (and a not inconsiderable painter) on a visit of homage to the studio of Karl Bryullov, the great Russian academic painter. For his elegant treatment of this subject

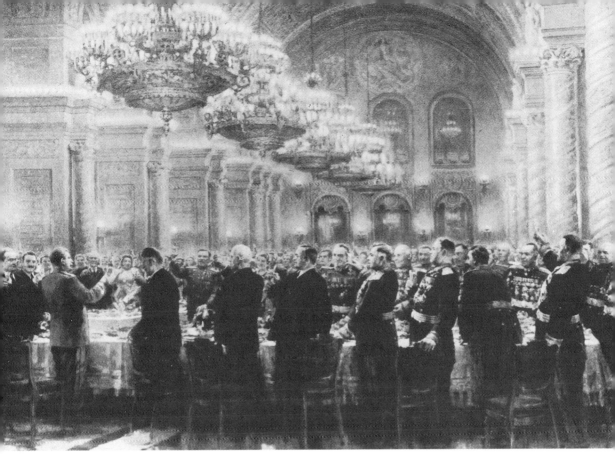

– a world away in form and content from the efforts made towards a proletarian, national art by his compatriots, the Boichukists, in the previous decade – Melikhov received a Stalin prize in 1948.

Similar paintings can be found in the art of other republics. In Latvia, for example, Aleksandr Toropin painted *Makovski Giving Advice To Rozentals On His Diploma Work* (1952), a scene in which Janis Rozentals (1866–1916), a graduate of the St. Petersburg Academy widely regarded as the founding father of a national school of painting in Latvia, is shown getting, in art school jargon, a 'crit' from one of the foremost Russian realists of the nineteenth century.

The example of these paintings was echoed by the establishment in 1947 of a Studio of Nationalities at the Academy of Arts. It gave art education to students from the non-European republics, aimed at raising the standard of their work for entry into the art-school proper. On graduation they returned home to form cadres of national artists trained in the academic tradition.

Their great model was Semyon Chuikov, who (like Plastov) found exceptional favour with both artists and the Party. His *A Daughter of Soviet Kirgizia* [pl. 167] is a paradigm for Soviet art at the time. Its format is characteristic of the post-war decade; as in

166

Mikhail Khmelko
To the Great Russian People, 1947.
Oil on canvas,
300×515 cm
(118×203¾ in).
State Museum of
Ukranian Art, Kiev.

167

Semyon Chuikov
A Daughter of Soviet Kirgizia, 1948.
Oil on canvas,
120×95 cm (47×25½ in).
State Tretyakov Gallery.

168

Zinaida Kovalevskaya
Tomato Picking, 1949.
Oil on canvas,
150×180 cm (59×71 in).
Private Collection.

Shurpin's *The Morning of Our Motherland* [pl. 132] an iconic fore-ground figure is placed against a landscape. But whereas Shurpin's Stalin is invested with a trumpery holiness, Chuikov's proud schoolgirl is a noble creation. The artist makes us look up at her, increasing our sense of her dignity. She embodies, in her resolute progress across the expanse of her native land, the future hopes of a small, once backward nation, now offered – under Soviet power – the benefits of a modern educational programme.

On an aesthetic level, as well, the picture is a forceful manifesto. Chuikov, unlike Russian artists attuned to the tonal painting tradition, constructed his work on the basis of colour relations. The dazzling blue sky, azure waistcoat, red headscarf and white skirt richly variegated in its shadows are evidence that the decorativeness fundamental to the art of the East could, in bold hands, coexist with the dour post-war aesthetic principles. Chuikov's handling is broad, but shows just the necessary degree of deference to the authorities' insistence on academic finish. But analysis creates the wrong impression: the painting as a whole is not some stroke of aesthetic diplomacy: it comes from the heart. It conveys enthusiasm for the

emancipating side of the communist project that was still felt at the time by many citizens in the smaller and less-developed Soviet republics.

It was artists from the eastern and trans-caucasian republics who, unhampered by a Russian sense of desolation, produced the most frankly joyful scenes of peasant life in the post-war decade. An outstanding artist, Zinaida Kovalevskaya, lived and worked in Uzbekistan. First as the pupil and then as the companion of Pavel Benkov, she learnt from him a feathery touch that abided well with her love of bright colour and powerful decorative sense. *Tomato Picking* [pl. 168] is painted with the mellifluous delicacy of a Renoir, the clusters of scarlet tomatoes incandescent amid silvery tones of sunlight and shade.

Carpet-Makers of Armenia Weaving a Carpet with a Portrait of Comrade Stalin [pl. 169], by the Armenian, Mariam Aslamazyan (born 1907), demonstrates the uninhibited use of colour typical of artists from beyond the Caucasus, and characteristic of Aslamazyan herself in particular. The skeins of wool, the peasants' scarves and costumes – in all cases local colour is rendered to a degree of satur-

169

Mariam Aslamazyan
Carpet-Makers of Armenia Weaving a Carpet with a Portrait of Comrade Stalin, 1949.
Oil on canvas,
147.5×122 cm
(59×48¾ in).
Private Collection.

ation that flouts Russian academic norms and gives the painting an air of calculated naïvety, perhaps also of refusal to relinquish a national heritage for a Russian-dominated, pan-Soviet one. The picture is also interesting because of its subject-matter. Here we see how traditional folk arts were pressed into the service of the Stalin cult no less than the high arts.

To figures such as Chuikov, Kovalevskaya and Aslamazyan may be added those Russian artists who, in the post-war period, fell in love with the Soviet East. In the blazing sunlight they discovered, above all, the power of saturated colour. Outstanding among these artists was the sculptor, Zinaida Bazhenova (1905–1988), who had got to know Uzbekistan during the war, when she was evacuated to Tashkent. In the post-war period the country and its people were an inspiration. Her polychrome heads and figures are a major achievement in the ceramic sculpture so widely practised by Soviet artists from the 1930s onwards [pl. 170].

170

Zinaida Bazhenova
Head of an Uzbek Woman, 1947.
Majolica, life-size.
State Tretyakov Gallery.

The *zhdanovshchina*

To indicate thus far, on the basis of paintings and sculptures, the story of Soviet art in the post-war decade is to offer only a glimpse of the constraining ideological pressures. For in the last years of Stalin's life the party finally attempted to take that decisive hold on the creative spirit implied in the Leninist concept of *partiinost*, and its campaign against dissidence from official norms in art reached a new level of ferocity.

The beginning of this crusade was a series of decrees passed in 1946–8 and accompanied by key-note speeches given by Zhdanov, the Leningrad party boss, to selected groups of cultural workers – creative people, critics, administrators. Like the anti-formalist campaign of the 1930s, it affected all the arts; pronouncements directed at one discipline held good for all. Zhdanov died in 1948, but his influence continued to be felt; in his honour, this stifling period in Soviet art, stretching from 1946 until Khrushchev's anti-Stalin speech in 1956, is known as the *zhdanovshchina*. However, we should not overlook the guiding contribution of another man, who was head of the department of agitation and propaganda in the party Central Committee from 1946 until his death: Mikhail Suzlov (1902–1982).

The *zhdanovshchina*: four decrees

The first decree concerning culture, entitled 'On the Journals *Zvezda* and *Leningrad*', was issued on 14 August 1946 and published in *Pravda* on 21 August. These publications were criticised for printing the works of Mikhail Zoshchenko (1895–1958),

the greatest Soviet satirist of the 1920s and 1930s, and the equally great poet, Anna Akhmatova (1889–1966). It was said that Zoshchenko had for a long time specialised in preaching 'a rotten lack of ideology, banality and lack of political direction, calculated to disorientate our youth and poison its consciousness'. Akhmatova's poems were described as pessimistic, decadent, bourgeois-aristocratic works 'which will do harm to the education of our youth and cannot be tolerated in Soviet literature'. The journal *Leningrad* was accused of publishing works imbued 'with the spirit of servility before everything foreign'. The decree reaffirmed the requirement for *narodnost* and *partiinost* in the arts; indeed, it made it clear that these were one and the same thing: 'The strength of Soviet literature . . . consists in the fact that it is a literature which cannot have other interests besides the interests of the people, the interests of the state.'

This decree was in essence an exhaustive and virulent restatement of the terms of the anti-formalist campaign of the 1930s. It effectively confirmed the essential properties of Soviet art, its *ideinost, narodnost, klassovost* and all-defining *partiinost*; it stressed the need for optimistic works, and warned against the influence of foreign culture. These ideas were further expounded by Zhdanov in two speeches given in Leningrad, which included the notorious description of Akhmatova as 'a cross between a nun and a whore', and in two more decrees which followed in quick succession.

The second decree, 'On the Repertoire of Dramatic Theatres and Measures for its Improvement,' appeared four days after the first. It concentrated on the pernicious nature of foreign influence in the theatre, regretting the circulation of plays by Maugham, Pinero, Kaufmann and Hart and others by the Committee for Art Affairs in a rush of post-war affection for the Soviet Union's allies, and required the staging of more patriotic plays of Soviet origin.

Ten days after that, a third decree was published, entitled 'On the Film *Great Life*' and directed at the cinema. The first part of *Great Life* had been made in 1939; it dealt with the work of coal miners and their attempts to unmask class enemies, and had been an official success. The second part, completed in 1946, depicted efforts to reconstruct Soviet industry after the war and painted a grim picture that the party found unacceptable; it was banned until after Stalin's death. The decree also criticised other films, notably the second part of Eisenstein's *Ivan the Terrible*, also completed in 1946. As has been suggested, Stalin identified with Ivan; the decree charged Eisenstein with portraying Ivan's 'progressive' army, the *oprichniki*, as a 'gang of degenerates.' These words put a telling gloss on Stalin's exaltation of Russia and her history, for the *oprichniki* were a special security force of signal cruelty, created by Ivan to exterminate the internal opposition; attacks on them could be understood as veiled criticism of Stalin's *NKVD*. The essence of this third decree was the requirement for Soviet artists to present an

unfailingly positive and optimistic image both of contemporary life and of history.

The effect of these three decrees was to destroy the tiny liberal shoots released within Soviet culture at the end of the war. After a pronounced interval, a fourth decree on culture was published by the Central Committee in February 1948. It was entitled 'On the Opera *A Great Friendship*' by Muradelli. *A Great Friendship* was intended as a paean to Stalin's native Georgia. Its protagonist was Sergo Ordzhonikidze, a leading Georgian communist who died in 1937. It is believed today that his death was brought about by Stalin, and this may have been sufficient to turn Stalin against the opera, which was accused of unspecified 'historical inaccuracies'. Be that as it may, much of the decree was devoted to attacks on Shostakovich, Prokofiev and other composers with a world-wide reputation. It was this decree which was followed by Zhdanov's speech to leading figures in the music world (see pp. 174–5) in which he drew analogies between art and music. The broad effect of the decree, in which the party 'decisively condemned all attempts to separate art from politics', and of the speech was to reinforce the anti-formalist message familiar from the 1930s and emphasise the importance of indigenous, classically oriented culture.

The *zhdanovshchina*: first reaction in the art world

These decrees were binding on all the arts. In 1946, the *Orgkomitet* of the artists' unions, chaired by Aleksandr Gerasimov, passed an enthusiastic resolution welcoming the first three. It noted how undervalued in Soviet art were 'works saturated with ideas and formally complete, answering to the needs of the people, educating the Soviet person in the spirit of cheerfulness . . . ' The All-Union Art Exhibition of 1946, visited by 800,000 people and so highly praised when it opened, became the target of fierce criticism. The selection of four works by Robert Falk for this exhibition had been deemed a positive event in October 1945; at the end of 1946 he submitted ten works for the 1947 exhibition, and only one was chosen.

The party's crack thought-police were the membership of the Academy of Arts itself. An open letter to the Academy from the Committee for Art Affairs, read aloud at its first session in 1947, stated: 'The Academy of Arts must wage a relentless struggle against all the various forms of toadying to bourgeois art.' Ghostly words, which echo the rhetoric used in the 1930s in the crusade against formalism. Indeed the new attempt to constrict and channel art was in many ways a continuation of the old. But it introduced two important refinements, two fresh anathemas – cosmopolitanism and Impressionism. These were the negative corollaries of the posi-

tive principles the Academy strove to promote: the importance of Russian traditions and of the academic heritage.

Cosmopolitanism: the campaign against critics

Cosmopolitanism signified more than the merely bourgeois or Western: it meant anything foreign and incompatible with Soviet principles; principles which, in the arts as elsewhere, were identified by a narrow and Russian chauvinism. The campaign against cosmopolitanism, a kind of McCarthyism occupying a stage – the whole of Soviet intellectual and cultural life – far too broad to embrace in this book, also became a mask for varieties of racism, and for anti-Semitism in particular. It was less usual for the criticism of cosmopolitanism to attach to concrete works of painting and sculpture (although it could do so) than to views expressed in writing. Accordingly, cosmopolitanism was flushed out in the critical discourse surrounding the visual arts.

In May 1946 – foreshadowing the decrees of the Central Committee – Aleksandr Gerasimov broached the idea that some critics might be doing harm to art by their lax standards in an article called 'More about Criticism', in *Soviet Art*. He complained about the *alliluishchina*, the ritual chorus of alleluyas with which, he said, critics greeted inferior work.[87] In his inaugural speech at the first session of the Academy of Arts in November 1947, he took up this idea again and singled out Punin for criticism. In February 1948, Gerasimov's *Orgkomitet* passed a decree dissolving the critics' section of *MSSKh*; it was re-formed with the exclusion of Abram Efros (1888–1954), a Jew, who had been its chairman.

In the same year, Georgi Rublyov, deputy chairman of *MSSKh* and a party member, chaired a discussion about naturalism. He allowed Jewish critics Beskin and Aleksandr Kamenski the opportunity, in castigating naturalism, to state some of their 'cosmopolitan' views. For this, Rublyov suffered a studio visit by a delegation from *MSSKh*, which looked for evidence of formalism in his work, and he was subsequently sacked from his post in the *MSSKh* directorate. Beskin was soon after expelled from *MSSKh*.

It was natural for the Academy, which was, in effect, the executive arm of the Committee for Art Affairs, to head the crusade against cosmopolitan critics. The Academy devoted much of its third session, in January 1949, to problems of criticism. Again, Aleksandr Gerasimov made the opening speech, one of real vituperation: 'Recall the "works" of Tugendkhold, Punin, Efros, Matsa, Arkin and of the last "prophet", Beskin. They all bear the stamp of malicious hatred and slander of great Russian artists and our Soviet masters of art.'[88] The keynote speech on criticism, 'The Condition and Tasks of Soviet Art Criticism', was given by the

critic, Andrei Lebedev (born 1908), deputy chief of the visual art department of the KPDI. The main points of this speech were contained in a resolution of the Academy issued on 1 February 1949. It described Punin, Matsa, Beskin, David Arkin (1899–1957), Kostin and Yakov Pasternak (b. 1910) as 'rootless cosmopolitans' and 'aestheticising anti-patriots'. Cosmopolitan tendencies were descried in the writings of Alfred Bassekhes (1900–1969), Kamenski and Aleksandr Romm (1887–1952).

With the exception of Kamenski, a young man, and of Beskin, these were critics who had been prominent in the 1920s and 1930s as supporters of the stylistically more progressive artists and groups. But most ironic was the attack on Beskin; for it was he who, back in 1933, had first offered official auspices to the war against formalism with his book, *Formalism in Painting*, and who had orchestrated the campaign in the pages of *Tvorchestvo* and *Iskusstvo*. His failure to denounce impressionism during the debate about it in the pages of *Tvorchestvo* in 1939, and post-war utterances of his such as 'I, for example, consider the affirmation of impressionism now taking place in our art to be . . . most natural . . . Impressionism is receiving a second life in Soviet art'[89] were now used in evidence against him. Like so many figures in the Stalin period, Beskin had sown the wind by his opportunism and now reaped the whirlwind.

Newspaper articles reinforced the campaign against this circle of proscribed critics. Their vilification knew no bounds: Lebedev described Efros as 'a miserable pygmy, a bastard aestheticising degenerate, looking in servile awe at every foreigner'.[90]

The artists' unions were obliged to participate in this witch-hunt. In March 1949, after a meeting of *MSSKh* devoted to 'the anti-patriotic activity of cosmopolitan critics', the bureaux of the painters' and critics' sections of *MSSKh* met to discuss the work of Vladimir Kostin. He was criticised for being a follower of Beskin, for praising Cézanne and Van Gogh in the 1930s, for complaining about the 'harsh academic painting' of Laktionov's *A Letter from the Front*, and for talking about painting in terms of colour and formal elements. Kostin's reply, in which he was forced to betray all his best instincts and convictions, is an illustration of the hopelessness of the predicament in which he and others found themselves: only a full recantation might spare him further harassment; defiance might have been literally fatal. He admitted, 'I consider the harsh party criticism of my work entirely justified.' Acting on advice from Sergei Gerasimov, and fully aware of the racist nature of the campaign against critics, he attempted to avert the full force of the blow prepared for him by stressing his origins: 'I am a Russian Soviet person, the son of a peasant.' But to no avail; the campaign, while fundamentally anti-Semitic, was hungry for blood. Kostin was ejected from *MSSKh*; and although (perhaps because he was not a Jew) he was soon reinstated as a *MSSKh* member, he was not able to publish again as a critic until after Stalin's death.[91]

Punin's fate was most bitter of all. In September 1949 the once great propagandist of futurism was arrested. He died four years later in a labour camp in Siberia. Across the arts, many people died in this wave of repression. Solomon Mikhoels (1890–1948), director of the Jewish Theatre, who had put so much work in the way of artists estranged from the establishment, was assassinated in Minsk. His theatre was closed down. Hundreds of Yiddish writers were imprisoned, and some were executed after a secret trial in August 1952. The climax of the purge in society as a whole was the so-called Doctors' Plot: in January 1953 nine doctors (six of them Jewish) were arrested and charged with attempting to poison the political leadership. Only Stalin's death in March saved them from execution; they were afterwards released and charges were dropped.

The campaign against cosmopolitanism was an umbrella for a variety of persecutions. From the party's point of view, it diverted the public mind towards an enemy within; it channelled the patriotic pride prompted by victory and fastened a chastity belt against Western influences after the war. For those with high positions in the cultural world such as Aleksandr Gerasimov and Andrei Lebedev, the controversy promised to strengthen both their position in the art establishment and the kind of art, founded on narrowly Russian traditions, for which they undoubtedly cared – although it may have provided an outlet for personal anti-Semitism.

The anti-Semitic character of the campaign had a number of causes. Anti-Semitism was and is a tradition in Eastern Europe, and as such likely to unite Russians and non-Russians, such as the potentially rebellious inhabitants of the Baltic states. Stalin was also worried by the newly created state of Israel, to which he feared Soviet Jews might covertly transfer their allegiance; and Trotski, whose memory still rankled, had been a Jew. However, some Jews in the art world flourished; Grabar and Katsman were both Jews.

Cosmopolitanism: Cold War art

The anti-cosmopolitan campaign was a manifestation of the Cold War. During the 1930s Soviet painters and sculptors had been required to ignore the international situation and concentrate on domestic events. There were apparently no paintings or sculptures commissioned on subjects such as the bombing of Guernica, which would seem to have lent itself to socialist realist treatment (Tsaplin's 1937 sculpture of a Spanish freedom fighter [pl. 97] was a rare exception in this respect). In the post-war decade the Committee for Art Affairs, reacting to the acquisition of the nuclear bomb and new Soviet participation in armed struggles world-wide, and prompted by the need to abruptly recast wartime allies in the roles of enemies and aggressors, changed tack and began to commission and encourage works on international subjects.

We Demand Peace! [pl. 171], a brigade sculpture executed under Mukhina's direction (she was responsible only for the figure of a grieving mother holding forth her dead child), is an early example of the peace propaganda which continued to occupy Soviet artists until the advent of Gorbachev. Pyotr Belousov (1912–1989), one of Brodski's favourite pupils, illustrated a Greek communist partisan in jail [pl. 172]. It is a striking example of the new academicism; until one makes out the partisan's captors peering through the grating, one could take this for a painting by Bryullov.

The Soviet orchestration of the International Peace Movement led to the institution in 1951 of the international Stalin prizes, awarded by a committee presided over by foreign sympathisers such as Aragon. That some artists accepted party Cold War propaganda wholeheartedly is demonstrated by Nalbandyan's claim in the early 1950s (he kept the source of his information a secret) that criticism of him in *MSSKh* was funded by Eisenhower.[92]

Impressionism: the offence

Impressionism, newly identified in the post-war period as a virulent strain of formalism, was the term most frequently used to describe the work of those artists who failed to comply with the new requirement for *zakonchennost*, academic finish. This usage derived, of course, from the freely-painted work of the French Impressionists, which had fallen foul of chauvinist criticism at the end of the 1930s.

However, the term 'Impressionist' was more than a mere epithet describing pictorial form; it had an ideological dimension. Impressionism was a foreign movement, and this sufficed for it to fall foul of the new mood of exaggerated Russianism. For the work of Russian masters such as Repin and Surikov, the official antecedents of socialist realism, to have been unfavourably compared with French Impressionism by Soviet critics was now considered intolerably unpatriotic. Impressionism was also a potent and threatening symbol in ways less easy to describe. It evoked all the close pre-revolutionary ties between Russian and French culture, for which considerable nostalgia was still felt: during the 1940s the old Russian intelligentsia, seeing out their lives under communism in dingy communal apartments, might still converse in French. Moreover Impressionism, being founded above all on the practice of landscape painting, landscape painting of a type obsessed with the translation of visual sensation, was an encouragement to artists to neglect thematic art in favour of an apolitical idyll.

Lenin's old bugbear of machism, the harmful philosophy, was invoked. Learned articles appeared in *Iskusstvo*, purporting to prove that Impressionism, being an attempt 'subjectively to convey fleeting moments', was a reflection in art of 'a reactionary idealist philosophy antagonistic to materialism'.

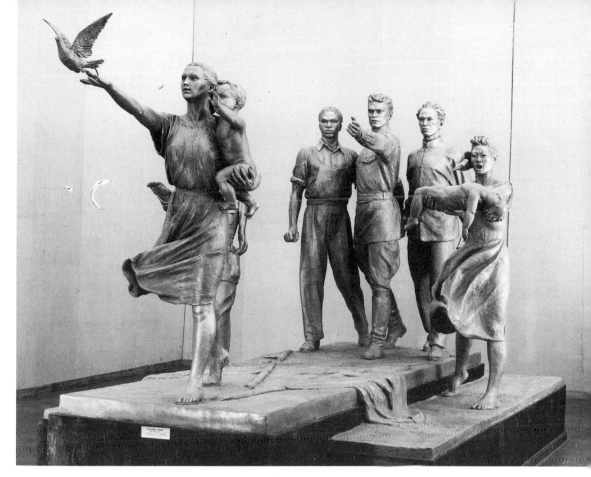

171

Vera Mukhina,
Zinaida Ivanova,
Nina Zelenskaya,
Aleksandr Sergeev,
Sergei Kasakov
We Demand Peace!
1950. Plaster,
205×215×455 cm
(80¾×85×179 in).
A cast of this sculpture
is now situated outside
the Exhibition of the
People's Economic
Achievements, Moscow.

172

Pyotr Belousov
A Greek Partisan, 1954.
Oil on canvas, 66×58 cm
(26½×23¼ in).
Private Collection.

Aleksandr Gerasimov and Voroshilov began to wage brutal war against Impressionism. In 1948 they paid a visit to the temple of the movement in Moscow, the Museum of New Western Art, and had it closed down. Its collection of masterpieces was dispersed and not put on display again until 1955. Its splendid premises were given away – to the Academy of Arts. This was an ironic epilogue to the 1930s, when despite the war on formalism the Museum of New Western Art had remained a source of national pride. In 1939, the State Purchasing Committee had acquired a Van Dongen and had commented proudly that 'it will be a splendid addition to the museum exposition'.[93]

Impressionism: a question of style

The campaign against Impressionism influenced a whole generation of younger artists whose style was not yet fully formed. The discussion that surrounded the painting *Before the Start* [pl. 173] by the Ukrainian artist, Tatyana Yablonskaya (born 1917), illustrates the actual effects of the campaign. Yablonskaya was widely recognised as a gifted young painter. In the journal, *Culture and Life*, no. 30, 1949, *Before the Start* was criticised for not overcoming the influence of Impressionism. Yablonskaya responded to this reprimand in a letter published in the same journal on 11 February

1950. She admitted that criticism was justified; she had realised, she said, on a visit to a collective farm that a picture must start from a conception of its content, not formal concerns. A new painting, *Corn* [pl. 174], she hoped, corrected the balance.

In a sense it did, being a most emphatic and expressive piece of socialist realism, for which she received a Stalin prize in 1950. But what is at issue is the extent to which the artist was being true to herself in rejecting the free, impressionistic technique of *Before the Start* for the academic finish of *Corn*. We may never know, but after Stalin's death Yablonskaya adopted a style of painting drawing on Ukrainian folk art and even further from 'finished' realism than the manner of *Before the Start*.

174

Tatyana Yablonskaya
Corn, 1949.
Oil on canvas,
201×370 cm
(79×145½ in).
State Tretyakov Gallery.

Attacks on artists

The reproach of 'Impressionism' and related pejorative terms – modernism, formalism, decorativism, stylisation, primitivism – could be a catch-all. Indeed, when one realises that even Aleksandr Gerasimov was interested in conveying fleeting effects of light, it is clear that these criticisms were, in some measure, a blind. They cloaked personal attacks on artists who in the 1930s had become famous and now occupied important posts in the art world. These artists represented a liberal establishment of sorts; they did not

175

Sergei Gerasimov
The Mother of a Partisan
as repainted in 1949–50
(see pl. 98).

paint Stalin or the political leadership if they could help it, nor did they lead great brigade paintings on official themes. It was for this disengagement, as much as for the formal qualities in their work, that they now faced ostracism.

Thus in 1948, after the second session of the Academy of Arts, which was devoted to art education, a number of prominent teachers accused of encouraging impressionism were removed from their posts in Moscow and Leningrad. Among them were the sculptor, Aleksandr Matveev, who, although he joined the party in 1940, had resisted its narrow directives in the arts; the painter Aleksandr Osmyorkin, a convinced *zapadnik*, or devotee of Western culture, who hung above his bed a map of Paris (which he never visited); and Sergei Gerasimov, who was deprived of his post as director of the Moscow State Art Institute, now under the Academy's aegis. He was replaced by Fyodor Modorov.

Subsequently, at the third session of the Academy of Arts in January 1949, Sysoev (the same Sysoev who had recommended Sergei Gerasimov for a red badge of labour a few years earlier) criticised his *The Mother of a Partisan* [pl. 98] for impressionism. Sysoev claimed that defects in the painting precluded it from being

176

Pavel Korin
Departing Rus, 1935–59.
Oil on canvas,
62×115 cm (24¾×46 in).
Korin Museum, Moscow.

177

Aleksandr Deineka
*A Relay Race around the
'B' Ring*, 1947.
Oil on canvas,
198×297 cm
(78×117 in).
State Tretyakov Gallery.

put on permanent museum display. At this time, Sergei Gerasimov was chairman of the *MSSKh* directorate; indeed, the attacks on him and his picture were a covert attack on *MSSKh* itself, which, with its broad-based membership and semi-democratic elections, was now considered insufficiently tractable by the party.

Sergei Gerasimov seems to have given way to these pressures. In 1949, he repainted *The Mother of a Partisan*, making the heroine more conventionally handsome [pl. 175], which suggests that the reproach of impressionism directed at the painting was here a code for 'we want our heroines to be good-looking'. It was an attempt to bowdlerise and make anodyne which was repeated in a multitude of cases. For example, Sysoev once publicly criticised a painting by Plastov, another independent-minded figure, entitled *The Tractor-Driver's Supper* (1951), because of the meagre fare of bread and milk on display. Plastov, listening to this, responded sarcastically that Sysoev had overlooked the bottle of wine.[94]

Several other leading establishment artists came under attack at this time. Korin and Deineka were criticised by Sysoev for 'modernism', but this charge probably cloaked other causes of dissatisfaction. Sysoev cannot have been unaware of Korin's great project, the painting *Departing Rus*, intended as an elegy to the decline of the Orthodox Church. This picture was never executed on the grand scale which was conceived for it, although a huge, specially woven canvas stood in Korin's studio for many years, waiting to accommodate it; all that survives is a detailed sketch [pl. 176]. Nor can he have failed to notice Deineka's persistent avoidance of the more tendentious subjects in favour of those having only a metaphorical relationship with Stalinist striving [pl. 177].

Korin and Deineka, like Sergei Gerasimov and Plastov, were major figures whose independent attitude to dictats which governed other artists was now impermissible. Perhaps Korin never carried out his masterpiece, despite the many, many studies he had made for it, because he was never ready – or perhaps he was intimidated and afraid to paint a canvas representing clerics and *réligieux* condemned as enemies of the people. If the latter explanation is correct, then Stalinist repression claimed a particularly important victim. As far as Deineka was concerned, he was compelled in 1948 to resign his post as director of *MIPIDI*, the Moscow Institute of Industrial and Decorative Art. Deineka found the criticism he faced after two decades of service to Soviet art almost impossible to bear; he was sometimes reduced to tears by the bullying of Aleksandr Gerasimov and ended up trying to curry favour with him.

A sample paragraph from the resolution of the third session of the Academy of Arts, issued in February 1949, runs as follows: 'Formalism and naturalism, primitivism and stylisation find expression in the work of such painters, sculptors and graphic artists as: N. Altman, V. Bekhteev, I. Vilkovir, A. Goncharov, V. Gudiashvili, K. Dorokhov, P. Kuznetsov, B. Korolyov, A. Matveev, A.

Osmyorkin, Roskin, G. Rublyov, T. Sandomirskaya, Z. Tolkachev, G. Traugot, A. Tyshler, N. Udaltsova, B. Uitts, V. Favorski, R. Falk, A. Fonvizin, I. Frikh-Khar, M. Khazanov, D. Tsaplin and others.' This list by no means exhausts the great number of artists subjected to criticism and its consequences: the withdrawal of commissions, of the opportunity to exhibit, even of union membership and access to materials and studio-space.

A pall over the non-Russian republics

The atmosphere of threat darkened even the remote corners of the Soviet Union. Here, too, the official aim was to suppress independent thought and to subjugate the still relatively independent republican artists' unions under more effective central control. Cultural self-determination, once considered an integral part of the Soviet project, was now seen by Stalin – and who would say wrongly? – as a metaphor for other kinds of independence. By imposing a monolithic ideal, a single, Russian, cultural tradition, Stalin hoped to weld the Soviet Union more firmly together under Moscow's control.

Attacks were mounted on a range of artists from the republics. Most notoriously, at the third session of the Academy of Arts Sysoev made a speech entitled 'The Fight for Socialist Realism in Soviet Representational Art' in which he reproached Saryan. Saryan's choice, along with his followers, of a colourful, broad manner was now held by Sysoev to be a misreading of the formula for Soviet art, 'socialist in content, national in form'. In a judgement that emphasised the unashamed dominance of Russian culture in the USSR, Sysoev no longer allowed Saryan's Armenian nationality to justify his non-adherence to the principles of Russian realism. When Sysoev made this attack, Saryan was, no less than Sergei Gerasimov, a powerful man: he was chairman of the Armenian Union of Artists and head of the section for the theory and history of art of the Armenian Academy of Sciences; in 1946 he had been elected a member of the Armenian Supreme Soviet. That he should have been attacked so forcefully demonstrates how secure the Academy felt in such denunciations, all directly endorsed by the party. Saryan, deeply distressed, cut up his famous *Still Life with Masks* (1915) into little pieces.

In the same speech, Sysoev threw a pall over the whole country. He censured artists of the Baltic states for their continuing formalism; and also a clutch of artists from the Ukraine (in Lvov, following its reoccupation after the war, hundreds, perhaps thousands of modernist works were taken from the town's museum and destroyed). In Georgia he picked on David Kakabadze (1889–1952), who was painting abstract pictures; on Gudiashvili, who had retreated from social engagement into a world of fantasy and eroti-

178

Aleksandr Bazhbeuk-
Melikyan
Choosing Models, 1945.
Oil on canvas,
41×49 cm (16×19 in).
Private Collection.

179

Lado Gudiashvili
Face to Face, 1951.
Oil on canvas,
48×31 cm (19×12 in).

cism [pl. 179]; and on Aleksandr Bazhbeuk-Melikyan (1891–1966), an Armenian artist living and working in Tbilisi.

Bazhbeuk-Melikyan's great subject was the female nude. He was a considerable influence on his friend, Gudiashvili, although his voluptuous women display none of the coquetry found in Gudiashvili's work; they exude a sexiness which, perhaps because it is less pretentious, is intenser. It is a sexiness akin to that which Degas conveyed in his drawings of women bathing and combing their hair, of whores lolling about in armchairs: a sexiness inherent in the very state of youth and nudity [pl. 178].

Bazhbeuk-Melikyan's early work is carefully finished, but as he matured his manner became freer, in emulation of his idols, Rembrandt and Titian. In the post-war years, subject to criticism as a formalist, Bazhbeuk-Melikyan lived in poverty. He received virtually no commissions and was enormously reluctant to sell his work; moreover, he actually destroyed most of his paintings because, at some time or other, they would pique him. Out of an oeuvre of more than 1,000 works, scarcely more than 100 remained in existence on his death.

It was the Baltic states, the Soviet Union's most recently acquired republics, which managed best to maintain some cultural autonomy

at this time. In Latvia, for example, painters such as Janis Pauluks (1906–1984) [pl. 180], Rudolfs Pinnis (born 1902), who worked in Paris in the 1930s, and Georgs Senbergs (1902–1988) helped to keep a distinct national artistic identity alive in the dark post-war years.

Russian resistance: Falk

Artists such as Bazhbeuk-Melikyan and Pauluks roundly ignored the canons of Stalinist art. In this respect they differ from those Russian artists, such as Deineka and Sergei Gerasimov, who strove always to find a middle way, to accommodate their art to Stalinist norms. However, in Moscow, too, there were artists who just could not bend the knee to socialist realism. The most famous of these, the man who came most to symbolise opposition to the Academy's regime, was Robert Falk.

Falk's intellectualism and air of high culture, and his ten years in Paris, marked him out. After the brief thaw of 1945–6, when it looked as though he might be accepted into the official art world, he was rudely excommunicated by the publication of the first cultural

180

Janis Pauluks
Woman at a Table, 1945.
Oil on canvas.
80×64 cm (32×25½ in).
Museum of
Latvian Art, Riga.

181

Robert Falk
*In a White Shawl
(Angelina Shchekin-
Krotova)*, 1946–7.
Oil on canvas,
80×65 cm
(31½×25½ in).
State Russian Museum.

decree of 1946. After that he lived an isolated existence, deprived even of the simple comradeship of sympathetic artists, because to associate with Falk was considered dangerous. An exception to this rule was provided by the Leningrad collector, Grigori Blokh, who in 1946 came to buy five paintings from Falk. Blokh's example inspired a few others, and thanks to the support of these rare private collectors, Falk was able to eke out a living.

Falk came, eventually, to personify the endurance of all the cultural values that the state abhorred. Favorski later termed him a mystic; and although Falk was never certain about the extent of his own faith, he loved to visit church services, particularly at Easter, drawn by their ceremonial. His own paintings from the 1940s, such as *In a White Shawl* [pl. 181] (an image of the artist's wife) and its companion *In a Black Shawl*, are imbued with ritual and a sense of the unseen; their reticence is a reflection of Falk's own indrawn life.[95]

From 1947 to 1957 Falk was not allowed to exhibit his work in Moscow. In the post-Stalin era his steadfastness became a moral beacon to those artists struggling against Stalinist norms in art, even though the language of Falk's art in the late 1940s and 1950s – realistic, undeclamatory, indebted to Corot and Rembrandt in their more pensive moods – had little to offer them. His great significance to future generations of Soviet artists was not that of an artistic revolutionary but of a True Believer, whose faith in his art enabled him to bear the cross of a personal culture in the most hostile conditions.

Resistance: Konyonkov

182

Sergei Konyonkov
*The Golden Man
(Liberation)*, 1947.
Plaster,
430×160×140 cm
(169×63×55 in).
Location unknown.

Falk was not the sole symbol of independence. The decision of the sculptor, Sergei Konyonkov, to return to the Soviet Union in 1945, after more than twenty years' self-imposed absence in the United States, was a considerable event. Konyonkov had built a big reputation in pre-revolutionary Russia, and he returned, on the warm uplift of an allied victory, to an enthusiastic reception. Konyonkov had none of Falk's ethical rigidity; to curry favour, he returned with a portfolio of sculpted portraits of the politburo, made from news photographs. However, the work he showed at the 1947 All-Union Exhibition was the antithesis of political subservience. It was received by Soviet artists as a grand liberating gesture. *The Golden Man* [pl. 182] is – despite the fig-leaf – a symbol of liberation itself; its exuberance contrasted strikingly with the rigid ceremonial quality of the works displayed alongside.

Konyonkov received a Stalin prize for portraits such as *Marfinka*, an image of the daughter of Beria, chief of the *NKVD* (she was married to Maksim Gorki's son). But he continued, in private, to make work of unfettered imagination; he constructed figures,

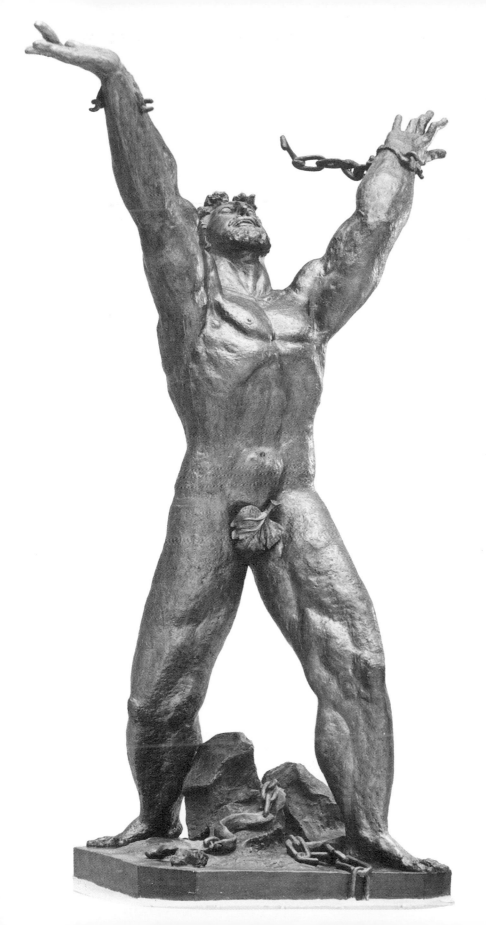

furniture and even musical instruments out of branches and pieces of wood in unpredictable forms of growth; an entire pagan (and subversive) fantasia.

Artists and ethics

We may condemn the art approved under Stalin because it served to put a cheerful gloss on a despotic regime, but we must remember that such a criticism had no real place in the web of ethical discourse at the time. We are face to face with a through-the-looking-glass social order which developed and maintained a system of values which in many cases flatly contradicted those of the West. Crucially, Bolshevik morality negated the Western idea of individual creative responsibility and substituted the party as arbiter of both aesthetics and ethics. The few points of external reference and comparison which existed outside party control, such as the Museum of New Western Art, were progressively removed; Soviet cultural isolation became severe from the late 1920s onwards. Many artists, especially the large numbers drawn, in accordance with Marxist philosophy, from uneducated backgrounds, had no real conception of an alternative to Stalin's scheme of things.

They were encouraged to conform by a system of rewards and privileges, counterbalanced by the sanctions of harassment and repression; but for many artists the artistic programme of the Stalin era did represent a consummation, genuine enough, of their professional ideals. Aleksandr Gerasimov's admiration of Repin and Surikov and his fascination with the picturesque Russian past cannot be doubted; he filled his studio with old military accoutrements – sabres, helmets – and even liked to dress up as Taras Bulba. Similarly, the classical preoccupations of Vuchetich are heart-felt and integral to the artist. The war on 'formalism' in art was waged by people such as these out of conviction – although self-interest might coincide – however misguided it might seem to us today. Their personal passions happened to correspond with at least some of the requirements of their political masters.

The readiness of many artists to put themselves at the service of the state is not easily distinguishable from the privilege claimed earlier by Malevich and Tatlin, Shterenberg and Filonov: they started the ball rolling. Stalin, like many tyrants, inspired profound enthusiasm in a significant portion of the population; and a social role is the birthright of Russian art. To treat the multitude of artists who painted politically tendentious works as mere cynics would be to underestimate the zeal that gripped the country almost in its entirety and only began to wane in the 1950s.

It is true that many artists resisted the requirement to portray the leadership. Mukhina, for example, was petitioned by Stalin after the war to sculpt his portrait. She avoided the commission not by refus-

ing it but by demanding the right to work from life, which Stalin's vanity and insecurity about his appearance would not allow. But to cast Mukhina as a heroine of the anti-Stalin resistance (as has been attempted in the Soviet Union) is absurd: she won five Stalin prizes; and what work did more to enhance the prestige of the Stalin regime abroad than her *Worker and Collective Farm Girl*? Many of the cultural outcasts, even such a figure as Falk, submitted their work to exhibitions and made attempts to participate in the official artistic life of the time. Their courage and endurance are indisputable, but like unsuccessful applicants for membership of some club or society, they did not so much reject the culture of the Stalin era as find themselves rebuffed, or blackballed, by it.

Sergei Gerasimov best embodies all the conflicts felt by Soviet artists at the time. He was a devoted landscape painter and a cultural liberal, dismayed when the debate in *MSSKh* focused on ideology rather than creative matters. Yet he had faith enough in Stalin's cultural policies to take on important posts in the union and to accept big commissions for major shows. During the 1930s he muddled along; after the war this was no longer possible. Criticised for impressionism – a coded assault on the liberal leanings of *MSSKh*, whose chairman he was – he began to participate in the fight against cosmopolitanism. He made the opening speech at a meeting of *MSSKh* in March 1949 devoted to 'the anti-patriotic activity of cosmopolitan critics'. He quoted Stalin's toast to the Russian people, a speech of Zhdanov's, and described cosmopolitanism as 'a striving to cut off national roots, national pride, because people without roots are easier to knock from their position and sell into the slavery of American imperialism.'[96]

It is hard to tell to what extent this speech reflected Sergei Gerasimov's beliefs. He was under enormous pressure and may have judged it better to compromise than resign. His contemporaries have expressed the belief to me that, in his capacity as *MSSKh* chairman, he saved several artists from arrest and perhaps death by his interventions on their behalf. He was an enormously popular figure. On the other hand, there is no reason to believe that he did not share the fiercely patriotic outlook of most Soviet artists. The words quoted above may have been uttered under duress; the rhetoric may be that of the Cold War; but they enshrine a kind of truth: if the Soviet art establishment had not been so rabid in rejection of foreign influence, so intent on the native heritage, socialist realism would not have been the unique phenomenon in twentieth-century art that it is.

Thus although from the vantage point of the Western Liberal Tradition, and with the hindsight provided by history, the conditions of cultural life under Stalin may seem reprehensible, for Soviet artists at the time these conditions merely represented the bald facts of life. They may have been pressured into painting what, and how, they did not want to, but if one speaks today to the artist-

survivors of the period it is clear that for most there was no urgent moral dilemma: to paint Lenin or Stalin, a blithe peasant or construction-site Adonis, was the most ordinary thing in the world, even if it was not always very interesting. The notion that they might have had moral scruples about doing so would have been incomprehensible to nearly all artists.

Insubordination

At the start of the 1950s, when the art of the Cult of Personality and the practice of brigade painting were at their most dominant, a number of prominent artists and critics began to question the order of things. Their protests against the status quo did not touch on the aims of socialist realism; they were based above all on a belief in intrinsic artistic values, which these dissenters reckoned to be in decline. Their protests were the first intimations of a sea-change in Soviet art.

Symptomatic was the new attitude of Bogorodski, who in the 1920s and 1930s had been the very image of communist enthusiasm. In 1945 he had a heart attack and was later dropped from the *MSSKh* party bureau for his lack of involvement; in 1950 he had a kidney removed; perhaps by this time he was in no mood to mince his words. At an election meeting of *MSSKh* in October 1951 he complained about the absurd bowdlerising of paintings by committee; he adduced the examples of a picture by Shegal, *Letter from the Front*, in which a collective-farm girl was shown barefoot: the artist had been told either to give her shoes or to remove the picture from exhibition; and he mentioned how Shurpin, in a picture entitled *Golden Harvest*, had been instructed that to depict a ceramic pot was archaic – it should have been aluminium. Bogorodski went on to complain about the requirement for anonymous academic finish and to make a plea for the old, pre-war values of socialist realism: 'I state categorically that the finishedness of a work of art depends not on whether the paint-marks are fine or broad, but on a clear, communicative solution, fully accessible to the viewer, being the organic expression of the given artist in its plastic and harmonic structure and individual execution.'[97]

Not long afterwards Bogorodski, previewing an exhibition together with Suzlov, was so incensed at an inane comment by the latter that he accused him of having the taste of a hairdresser (causing notably grave offence because hairdressing, it turned out, was a trade that ran in the Suzlov family).[98]

Among the critics, Kostin, although deprived of the opportunity to publish, led an especially energetic guerrilla war, a war of attrition by speeches, directed against the activity of Aleksandr Gerasimov (who once remarked: '. . . maybe I have received the most dirt of all from that little critic, Kostin').[99]

Gerasimov himself was wearying of his role as the mouthpiece of party policy; with an irony that was typical of him (he once quipped, at the funeral of an artist of his acquaintance who had died while making love to his secretary, that 'he wasn't much of a painter, but his death was worthy of Raphael'), he used to compare giving a speech to ascending mount Golgotha, such was the antagonism he was bound to arouse. Uncharacteristically, he began to plead for a sense of comradeship in the art world. He even admitted to shaking Picasso's hand.[100]

Stalin's death and Khrushchev's speech

Stalin died on 5 March 1953, and his straitjacket on the arts began to work loose. Aleksandr Gerasimov, Serov and others were sent in to paint the dead leader in his coffin, but the state did not bother to buy much of their work. Kamenski dates the first stirrings of a metamorphosis in Soviet art back to an exhibition of work by young Moscow artists organised by him in January 1954, less than a year after Stalin's death. 'In contradistinction to some recent exhibitions,' wrote Kamenski, recalling this show, 'there was nothing ceremonial, nothing emotionlessly state-oriented, no cold illustrations of impersonal theses to be met with.'[101]

The example of this exhibition was echoed by a change in party policy. An article in *Pravda* in November 1954 stated that: 'Attempts to express great themes through the huge scale of pseudo-monumental, self-consciously ceremonial compositions; to show the brightness of life by means of a garish diversity of colours; to find *narodnost* by showing a crowd of lifeless figures, have proved barren. For example, in some works by the well-known artists A. Gerasimov and D. Nalbandyan one can find an excessive interest in decorative splendour and false enthusiasm in the representation of ceremonial events and historic personages. At the same time the people is more often than not shown as an inactive mass.'[102]

On 14 February 1956 the 20th Congress of the party opened in Moscow and, behind closed doors, the new leader, Khrushchev, delivered his famous denunciation of Stalin. Although the speech was not published in the Soviet Union, news of it began to circulate among the intelligentsia.

Artists were preparing for their long-awaited first session of a Union of Soviet Artists, at last uniting all the disparate organisations across the country. On 31 October 1956 a delegation from *MSSKh* was invited to the Moscow Committee of the party. The graphic artist, Evgeni Kibrik (1906–1978), spoke at length against Aleksandr Gerasimov, saying that nearly all artistic opinion was against him, that he did not even like artists, and that he had repeatedly said that 150 artists were enough for the country. Shmarinov and Bogorodski confirmed Kibrik's words, the latter making it clear that

at the forthcoming conference of Soviet artists, Aleksandr Gerasimov would not be elected to high office.[103]

Aleksandr Gerasimov himself, after Khrushchev made his speech of denunciation, had an interview with the Soviet leader. He complained bitterly that Khrushchev was denying a whole period in Soviet history. He said that he, and others, had painted Stalin in good faith; their pictures had been an honest response to the times. Khrushchev replied that Gerasimov did not understand the situation; Gerasimov retorted angrily that he, Khrushchev, did not understand, and left, slamming the door behind him. The following day a delegation from the Academy of Arts came and asked Gerasimov to sign a declaration of ill-health and to step down from his post as president. He refused. A day later the delegation, in the persons of Manizer and Sysoev, returned. Gerasimov signed. That night he sat up and drank a bottle of vodka; the next day he suffered a heart attack, and from then until his death produced little work of note.[104]

Conclusion

Socialist realism never achieved the great synthesis of disciplines envisaged in the 1930s and 1940s. This ambition, exemplified by the grandiose plans for the Palace of the Soviets, faded steadily after Stalin's death. The brigade paintings and the pavilions of the Agricultural Exhibition (renamed the Exhibition of the People's Economic Achievements in 1957) give us some idea of what might have gone into the greatest pieces. But the whole socialist realist enterprise under Stalin was by no means a terminological fiction; artists achieved, to a large extent, the goals set for them. They developed, by about 1950, an art whose style was one of uniform, trenchant realism. They developed genres and narratives highly adapted to the preaching of communist ideology. What they made was everything that Lenin, and later Stalin, required: it was charged with ideological content, easily understood by – and often popular with – the public, and carefully attuned to party policy. The most ambitious work of the vast majority of Soviet artists in the Stalin period can be described in these terms – in other words, as socialist realism.

Socialist realism, from its origins in the figurative art of the 1920s to its maturity in the post-war decade, was the creation of artists and politicians working in harness. Artists themselves lobbied passionately for the return to a traditional style; most were glad of a ready patron in the shape of the state. The art they produced was undoubtedly what Aleksandr Sidorov, in the Foreword, terms the 'maidservant of State and party bureaucracy', and for many commentators this has disqualified or dishonoured it as art. But such a judgement, prompted by political or moral considerations, has no

real place in the history of art; it is a relic of the Cold War; indeed, it is a mirror image of the ideologically inspired distortions of Stalin's own art historians. In centuries past, artists have thought it natural to receive commissions from church and state. The nature of a regime, however reprehensible, does not dictate our response to the art produced under its aegis; consider, for example, our admiration for the art produced under the power of the pharaohs. Nor can socialist realism be dismissed as a social or ideological tract. Many artists in the West, and in many disciplines, have engaged in partisan fashion with the great issues of their time; art and propaganda are separate but not mutually exclusive categories. How many people looking at the Bayeux Tapestry today realise it is full of Norman lies; how many are *au fait* with all the Tudor polemic in Shakespeare's *Richard III*?

A more debatable argument suggests that talented artists went into decline under Stalin. This was perhaps a natural view to hold at a time when modernist theory held sway in the West; under its premises, the graduation of Soviet artists to a realist style could be termed a regression and the work they produced as inferior by definition. Such thinking is now anachronistic; there can be no easy equation of stylistic avant-gardism and artistic quality.

This is not to imply that under Stalin it was the best artists who were most highly rewarded; official judgement (which this work has been at pains to elucidate) was coloured by many extraneous factors, most of which can be broadly characterised as political self-interest. The fact that generally mediocre artists, such as Nalbandyan, achieved the pinnacles of communist esteem is often used to justify a view of socialist realism as a pseudo-artistic phenomenon. But we need not employ the artistic criteria of the Soviet communist party as a basis for our own aesthetic judgements. Stalin's art establishment was full of good artists: Deineka, Plastov, Konchalovski, Vasili Yakovlev, even the oft-vilified Aleksandr Gerasimov.

A complete assessment of these artists and their colleagues will have to wait until the Tretyakov Gallery and the Russian Museum dig out the thousands of paintings and sculptures lying in their stores, restore them where necessary, and mount proper survey exhibitions of the art of the 1930s, 1940s and 1950s. There is evidence that this is now beginning to happen; the first such show, displaying the art of the 1930s, was installed in the Tretyakov Gallery in 1990, after this book had been effectively written. It is difficult to predict the conclusions of such a review; but I believe that the art of Stalin's time, full of purpose – always ready, as it were, to die with its boots on – will prove compelling.

Art after Stalin 1956–90

The thaw: the Severe Style

One outstanding artistic response to Khrushchev's speech was the emergence of the Severe Style, a movement which represented, within the confines of socialist realism, a revolution of content and style. Artists rejected the rhetorical, adulatory images of Stalin's last years, and their unwavering optimism. They made heroes of ordinary people, often in difficult circumstances, although these protagonists did not cease to be the moral exemplars required in the art of Stalin's time. The Severe Style did not represent a revolt against the communist ethic, but a revision of it which closely reflected Khrushchev's own reforms, designed to give communism a caring face, such as his crash programme in residential building.

Post-war Italian culture was an inspiration to these artists. The painting of the communist, Renato Guttuso, and the bitter neo-realist cinema of de Sica and Rossellini moved them because this, too, was the expression of a people emerging from a national ordeal precipitated by a despot. This new perspective beyond the Soviet borders implied, apart from anything else, a rejection of the jingoistic norms of the Stalin era. And, indeed, Khrushchev's policies in the arts were less restrictive than before. In the mid-1950s exhibitions were held in Moscow of work by Picasso and Léger, and in 1957 an international youth festival permitted the display of Western abstract painting for the first time since the 1920s.

The Severe Style also represented a stylistic development away from academicism. This followed reappraisals of the work of many Soviet artists. An exhibition in 1957 of work by Deineka, who had been vilified in Stalin's last years, aroused enormous enthusiasm. (Recognition perhaps came too late for Deineka himself; he produ-

183

Arkadi Plastov
Spring, 1954.
Oil on canvas,
210×123 cm (83×50 in).
State Tretyakov Gallery.

ced little of note in the last ten years of his life and died of cirrhosis of the liver.) His laconic, monumental style was of paramount importance to the young Azerbaijani painter, Tair Salakhov (born 1928) [pl. 184]. Nikolai Andronov (born 1929), sought out and found particular inspiration in the work of Shchipitsyn, shot as an enemy of the people in 1943. Pavel Nikonov (born 1930) was influenced by old Russian religious art, which had stimulated artists in the 1920s but thereafter been officially ignored. Aleksandr Kamenski, critical doyen of the new movement and originator, in retrospect, of its title, dates the period of its flowering to 1957–62. However, its influence can be perceived in the work of many Soviet artists throughout the 1960s and it seems logical to regard it as the characteristic style of socialist realism during this decade.

The thaw: unofficial art

The Khrushchev era also saw the birth of the non-conformist, or unofficial, art movement which rejected socialist realism in its entirety and was contemporaneous with the new open political dissidence in Soviet life. Indeed, many non-conformist artists were persecuted as though they were dissident activists. Their art was perceived, both by party-oriented opponents and by radical supporters, to imply the rejection of communist social and political norms. In this respect it was an art no less ethically charged than socialist realism itself.

Non-conforming artists often had little artistically in common with one another. 'All that unites us is our lack of freedom', quoth one artist. This confirms the idea that the motive force of the movement as a whole was not so much an artistic as a social ideal. One favourite mode of expression was surrealist; other artists who began to work independently at the end of the 1950s or in the early 1960s practised geometric abstraction or kinetic art, or imitated the examples of cubism and expressionism. In turning so comprehensively to foreign movements they expressed a radical dissatisfaction with Soviet culture.

Even so, they, like their Severe Style contemporaries, carried out a reappraisal of the Soviet cultural heritage. They attached great importance to the avant-garde of the time of the revolution. The work of Malevich and his peers was not displayed in Soviet museums, but private collections, notably that put together by the Greek, George Costakis (1912–1990), a long-time Moscow resident, were available for study. They also made heroes out of some of the survivors of the Stalin era. One guru to non-conformist artists, until his death in 1964, was Vladimir Favorski. The widow of Robert Falk, who died in 1958, began to organise weekly views of Falk's work in his old studio, and these were attended by many artists fired by Falk's example, among them young lions of the new

movement such as Ilya Kabakov (born 1933) and Erik Bulatov (born 1933).

In Moscow and Leningrad non-conformist artists emerged more or less simultaneously and independently of one another. One group centred on Eli Belyutin, who ran an informal studio in Moscow's Arbat which was perhaps tolerated by the KGB only because it conveniently assembled under one roof artists who otherwise would have required individual surveillance. Maverick individuals such as the sculptor, Ernst Neizvestny (born 1926) [pl. 185] threw down a gauntlet to the union by organising exhibitions of their work outside its auspices. In the Baltic states an art apolitical in content and unrealistic in style was covertly sanctioned by the artists' unions themselves, which contrived to shield members working in an unorthodox way from harassment and expulsion.

1962 and its aftermath

An exhibition held in Moscow's Manezh gallery in 1962 to mark the thirty-year jubilee celebrations of the Moscow Artists' Union was a watershed in the development of Soviet art. This exhibition gathered together not only major examples of the socialist realism of the Stalin era, but also works by practitioners in the Severe Style, by Neizvestny and members of Belyutin's studio, and by artists proscribed under Stalin such as Robert Falk. Khrushchev visited the exhibition and was not pleased with all that he saw. Although there

184

Tair Salakhov
The End of the Shift,
1957.
Oil on canvas,
165×368 cm (65×147 in).
Academic Research
Institute of the USSR
Academy of Arts,
Leningrad.

are many theories to explain Khrushchev's behaviour, there is a consensus that he was deliberately provoked by being confronted with art (and attendant artists) which perplexed and, perhaps, offended him: he threw a notorious tantrum which signalled the end of the cultural thaw.

As a result of the furore raised at this show, cultural policy changed direction sharply. Exponents of the Severe Style were criticised in *Pravda* and, in some cases, prevailed upon to write letters of recantation; Belyutin's venture went into hibernation; and over the next fifteen years or so many non-conformist artists emigrated to the West. The view from the end of the 1980s, however, suggests that the scandal of 1962 was as a temporary setback in the disenthralment of Soviet culture which had begun after Stalin's death. The limited stylistic and ethical freedom claimed by artists of the Severe Style was not lost but consolidated in the 1960s by artists such as Gelli Korzhev (born 1925). In the 1970s official art broadened further as figures such as Nataliya Nesterova (born 1944) and Arkadi Petrov (born 1940) began to take an interest in traditions of folk, primitive and naïve art which had been buried in Stalin's drive towards an academic style. In the work of artists such as these, officially countenanced though it was, the ideal of socialist realism is entirely absent. Non-conformist artists also asserted themselves in the face of vicious opposition. In 1974 an outdoor exhibition of their work in Moscow was wrecked by bulldozers. This caused an international outcry which induced Brezhnev to put brakes on the policy of harassment. In 1976 a city-wide network of exhibitions by non-conformist artists was successfully held in private apartments across Moscow; in 1977 a gallery was established in Malaya Gruzinskaya Street which gave official exhibition space to unofficial artists.

Under Gorbachev in the 1980s the old distinction between official and unofficial art has become virtually redundant. A few isolated figures, such as Nalbandyan, continue to survive by painting pictures of Lenin for dwindling remuneration by the state, but their practice is anachronistic and is likely to perish with the artists themselves, if not sooner. The most effective forays into the area of the grand social *kartina* have echoed Gorbachev's own revisionist line: pictures such as *The Year 1937* by Dmitri Zhilinski (born 1927), depicting the artist's father's arrest by the *NKVD*, and *All Power to the Soviets* by Sergei Prisekin (born 1958), portraying an array of politicians liquidated under Stalin, have received much attention from the public and the press. Following the lead given by the youth section of the Moscow artists' union at its exhibition of November–December 1986, union-sponsored exhibitions have opened up to a plethora of styles and subjects. Unofficial art has, in its turn, gained quasi-official auspices, beginning with a large survey-exhibition in Moscow in April 1987. Nowadays in the Soviet Union, every artist works as he pleases.

The art of Stalin's time has largely vanished from sight. Thousands of paintings and sculptures, trophies of a chimeric triumph, are decaying in the repositories of museums and of the Ministry of Culture and face an uncertain future. The crumbling edifice of Stalinist ideology is exemplified by the state of the Exhibition of the People's Economic Achievements (formerly the Agricultural Exhibition). Many of its extravagant pavilions and fountains are now dilapidated and the multitude of murals and mosaics which once decorated it have been concealed or removed. Although we can still tremble a little before the Stalin era, its art is in a sense already passing from us. We can wonder at the bizarre conditions of life, and the passionate concentration of energy, which gave it rise; but the key to it, the ideal it served, time and change have put beyond our reach.

185

Ernst Neizvestny.
Atomic Explosion, 1957.
Bronze, 40×56 cm
(15¾×22 in).
Private Collection.

Notes

1. A Collections of Lenin's opinions on art were first published in book form in the USSR in the 1930s. The exposition of Lenin's views here is based on the material in V. I. Lenin, *O Literature i Iskusstve*, Moscow, 1960.
2. , Ibid. p.470
3. N. Punin, *Proletarsakoe Iskusstvo/Iskusstvo Kommuny*, 13.iv.1919.
4. Punin's fears were not misplaced. He was arrested by the Petrograd *Cheka* in August 1921, and only released after Lunacharski's intervention.
5. This and much other information about Gerasimov was given to me by the artist's son-in-law, Vladilen Shabelnikov, in a number of interviews during 1989.
6. Nina Tumarkin, *Lenin Lives!*, Cambridge, Mass, and London, Harvard University Press, 1983, pp. 174–5.
7. Ibid., p. 190. Tumarkin reveals that Shchusev viewed the cube in a similar semi-mystical fashion. She also quotes Malevich from the Malevich archive in the Stedelijk Museum: 'The cube is no longer a geometrical body. It is a new object with which we try to portray eternity, to create a new set of circumstances, with which we can maintain Lenin's eternal life, defeating death.'
8. When once the artist's wife, Flora Syrkin, asked him what he liked doing best, Tyshler answered: 1. Listening to music 2. Sweeping the floor 3. Washing dishes 4. Going shopping (told to me by Flora Syrkin).
9. Stalin's visit is referred to in many printed sources, e.g. V. A. Shkvarikov and P. M. Sysoev (eds), *Masters of Soviet Visual Art*, Moscow, 1951, p. 164.
10. Nina Tumarkin, *Lenin Lives!*, p. 237.
11. The concluding thought in Benjamin's essay 'Moscow'; see W. Benjamin, *One-Way Street*, London, New Left Books, 1979, pp. 207–8.
12. From the personal archive of Vladimir Kostin, dossier on Falk. Kostin transcribed the letter from the original in *TsGALI*. The letter is quoted in full except for the last, telling sentence concerning *AKhRR* in Dmitri Sarabyanov, *Robert Falk*, Dresden, VEB Verlag der Kunst, 1974.
13. M. M. Babanazarova et al., *Avangard, Ostanovlennyi na Begu*, Leningrad, Aurora, 1989, introduction (pages not numbered).
14. The full text of the degree, headed 'On the reorganisation of literary and artistic organisations' and issued by the Central Committee on 23. iv. 32, runs as follows:

 The *TsK* states that in recent years, on the basis of the significant successes of socialist construction, both the quality and quantity of literature and art have grown considerably.

 A few years ago, when in literature the significant influence of alien elements was still evident, being especially active during the first years of NEP and when proletarian cadres in literature were still weak, the party aided in every way the creation and consolidation of special proletarian organisations in the fields of literature and art with the aim of consolidating the position of proletarian writers and art workers.

 At the present time, when the cadres of proletarian literature and art are no longer in their infancy and new writers and artists have emerged from plants, factories and collective farms, the frames of reference of existing proletarian literary-artistic organisations (*VOAPP, RAPP, RAPM* and others) are already becoming narrow and limiting the proper scope of artistic creativity. This circumstance creates the danger that these organisations will change from being a means for the maximum mobilisation of Soviet writers and artists around the tasks of socialist construction into a means for the cultivation in the cultural field of a fortress mentality among groups which will lead to estrangement from the political tasks of the present day and from significant groups of writers and artists who support socialist construction.

 From this stems the necessity for a corresponding reorganisation of literary-artistic organisations and for a broadening of the base of their activities.

 For these reasons the *TsK* VKP (b) decrees:
 i. The liquidation of the association of proletarian writers (*VOAPP, RAPP*).
 ii. The unification of all writers who support the platform of Soviet power and who are striving to take part in socialist construction in a single union of Soviet writers with a communist fraction within it.
 iii. The execution of analogous changes in the other arts.
 iv. That an organising bureau should be given the task of working out practical measures for carrying out this decision.

15. Davies's activities are described in Robert C. Williams, *Russian Art and American Money*, Cambridge, Mass., and London, Harvard University Press, 1980. He also bought socialist realist paintings. Interestingly, considering the readiness to sell off original old masters, some of these turn out to have been copies.
16. Shchusev said this at the first conference of Soviet architects, *TsGALI* 674/2/31, p. 12; quoted from V. Paperny, *Kultura Dva*, Ann Arbor, Ardis, 1985, p. 37.
17. Manizer mentioned Stalin's visit to the station and his repeated use of the phrase 'kak zhivye', 'as if alive', to describe the sculptures at a meeting of the Moscow artists' union in 1948, *TsGALI* 2943/1/508, p. 74. Brodski said the highest praise a picture could receive from Stalin was that it contained 'living people'; see *Iskusstvo*, 3/1952, p. 5.

18. G. Nedoshivin, 'Monumentalnoe Iskusstvo v Strane Sotsializma', *Tvorchestvo*, 11/1938, p. 22.
19. 'Iskusstvo Khudozhestvennogo Oformleniya', *Tvorchestvo*, 3/1938, inside front cover.
20. V. Paperny, *Kultura Dva*, p. 160.
21. Ryazhski's role was mentioned by Volter at a meeting of *MOSSKh* in 1937; see *TsGALI* 962/6/200, pp. 17–18.
22. Kogan's advice to artist party members is included in the stenogram of a meeting held by *MOSSKh* to discuss *Pravda*'s articles attacking formalism; see *TsGALI* 2943/1/78, p. 27.
23. See Elizabeth Valkenier, *Russian Realist Art*, New York, Columbia University Press, 1989, p. 167.
24. 'Khudozhnik Grazhdanin', *Tvorchestvo*, 11/1939, pp. 2–3.
25. The minutes of the writers' conference were published as I. Luppol et al. (eds), *Pervyi Vsesoyuznyi Sezd Sovetskikh Pisatelei 1934*, Moscow, 1934.
26. Confirmation that the 1933 meeting took place and that Stalin wanted realists to take a grip on Soviet art can be found in a letter from Katsman to Brodski dated 3.viii.34, partially quoted in V. Manin, 'Istoriya iz Istorii', *Tvorchestvo*, 7/1989, p. 12.
27. Ibid.
28. A. Fyodorov-Davydov, 'Svyazi Russkogo Peizazha s Frantsuzskim', *Tvorchestvo*, 7/1939, p. 16.
29. A breakdown of the initial membership of *MOSSKh* by groups is in *TsGALI* 962/6/200, p. 18.
30. The subject-plan for the exhibition, '20 Years of the *RKKA*', is in *TsGALI* 962/6/9.
31. 'Godovoi Otchet Vsesoyuznoi Khudozhestvennoi Vystavki "Industriya Sotsializma" za 1938', *TsGALI* 962/513/6.
32. Merkurov described his figure of Stalin at the 1939 Agricultural Exhibition in just these terms.
33. A. A. Fyodorov-Davydov, *A. A. Rylov*, Moscow, Sovetski Khudozhnik, 1959, p. 157.
34. It opened in the Tretyakov Gallery on 14 November 1937.
35. See 'Stenogramma soveshchaniya v izoupravlenii komiteta iskusstv po voprosu organizatsii yubileinoi vystavki posvyashchennoy vosmidesyatiletiyu tovarishcha Stalina ot 15 sentyabrya 1939', *TsGALI* 962/6/548.
37. Gerasimov used this phrase in more than one essay from the 1930s onwards, e.g. P. M. Sysoev, V. A. Shkvarikov (eds), *Mastera Sovetskogo Izobrazitelnogo Iskusstva, Zhivopis*, p. 18.
38. See Roy Medvedev, 'O Staline i Stalinizme', *Znamya*, 3/1989, p. 156.
39. Stalin's visit is recorded in Fyodor Bogorodski, *Avtomonografiya*, Moscow, 1937, and in Bogorodski's autobiographical sketch in P. M. Sysoev and V. A. Shkvarikov (eds), *Mastera Sovetskogo Izobrazitelnogo Iskusstva, Zhivopis*, p. 166.
40. See *Tvorchestvo*, 1/1940, back cover.
41. The subject-plan for From the Glorious Past of Our Motherland is in *TsGALI* 962/6/899.
42. Osip Beskin, Formalizm V Zhivopisi, Moscow, *VseKoKhudozhnik*, 1933, p. 85.
43. Interview with Nalbandyan, 'Nikto Menya Ne Mozhet Upreknut', *Ogonyok*, no. 12, March 1989.
44. Grigori Ulko (born 1925), a Russian artist living in Samarcand who knew Benkov in the 1940s, told me that Benkov made an abortive attempt to emigrate in the late 1920s.
45. Gerasimov's son-in-law told me that Voroshilov made this comment on a visit to Gerasimov's studio.
46. Printed under pl. 101 in V. Sysoev (intro.), *Alexander Deineka*, Leningrad, Aurora, 1982, quoted from Aleksandr Deineka, *Iz Moei Rabochei Praktiki*, Moscow, Aurora, 1961.
47. *Tvorchestvo*, 11/1940, p. 4.
48. This story was told me by Angelina Shchekin-Krotova, the woman concerned.
49. *TsGALI* 962/6/200, p. 107.
50. *TsGALI* 2943/1/5.
51. V. Manin, 'Istoriya iz Istorii', p. 12.
52. Romadin's article criticising *VKhuTeIn* is in *Tvorchestvo*, 7/1936, p. 22. His wife, Nina, has stressed to me his real appreciation of the education he received there.
53. My belief that Shevchenko accepted and approved socialist realism despite the criticism he received is based on a conversation with the artist's daughter, the painter Tatyana Shevchenko, on 7.i.89, in which she expressed this view.
54. For the discussion of Shterenberg's candidature, see *TsGALI* 2943/1/122.
55. Told to me by Nikolai Tryaskin.
56. M. M. Babanazarova et al., *Avangard, Ostanovlennyi na Begu*, introduction (pages not numbered).
57. T. N. Glebova, 'Vospominaniya o Pavle Nikolaeviche Filonove' in *Panorama Iskusstv 11*, Moscow, Sovetski Khudozhnik, 1988, p. 108.
58. In the archive of the Committee for Art Affairs there are two files on the Miturich affair, on which this account is based: *TsGALI* 962/13/119 and *TsGALI* 962/6/298.
59. V. Manin, 'Istoriya iz Istorii', p. 13.
60. Details of Sokolov's personality and demeanour were given to me by Irina Evstafeva, daughter of Antonina Sofronova, his close friend (and perhaps his lover for a brief period in the 1920s).

Sokolov's career is doubly interesting because he continued to work in confinement. He maintained a remarkable correspondence with friends such as Sofronova, accompanied by drawings scrawled with a blunt pencil on tiny scraps of yellowed paper. When assembled and displayed in large numbers, these scrappy tokens create a moving monument to spiritual endurance in the most inhuman conditions.
61. V. Manin, 'Istoriya iz Istorii', p. 14.
62. *TsGALI* 962/6/200, p. 56.
63. V. E. Tsigal, *Ne Perestavaya Udivlyatsya . . . Zapiski Skulptora*, Moscow, Sovetski Khudozhnik, 1986, p. 208.
64. This anecdote I have from a conversation with Mukhina's granddaughter, Marfa.
65. See the essay on Molotov in Roy Medvedev, *All Stalin's Men*, Oxford, Basil Blackwell, 1983.
66. Details of Slavinski's interview at *VseKoKhudozhnik* may be found in V. Manin, 'Istoriya iz Istorii', p. 13. That he attended Tomski's funeral and played the piano was told me by Vladimir Kostin, whom Slavinski employed at *VseKoKhudozhnik* in the 1930s.

67. All the quotations and anecdotes that follow are taken from the stenogram of the *MOSSKh* meeting, 5–19 May 1937. Evidence that the party attached great importance to this meeting is provided by the fact that its stenogram is not in the archive of the Moscow union but in that of the Committee for Art Affairs. It is to be found in *TsGALI* 962/6/200–5.

68. Rostislav Gorelov's account of this affair in the form of an unpublished manuscript has been deposited in the library of the Moscow artists' union.

69. Details of the prices paid for works at The Industry of Socialism can be found in the exhibition's yearly accounts, *TsGALI* 962/513/6.

70. *TsGALI* 962/6/645.

71. *TsGALI* 962/513/6.

72. *Sbornik Zakonov SSSR i Ukazov Prezidiuma Verkhovnogo Soveta SSSR (1938 – Noyabr 1958g)*, Moscow, Gosudarstvennoe Izdatelstvo Yuridicheskoi Literatury, 1959, p. 475.

73. Cited in G. A. Nedoshivin (ed.), *Istoriya Russkogo Iskusstva*, XIII, Moscow, Nauka, 1964, pp. 306–7.

74. Cited in ibid., p. 305.

75. L. S. Zinger, *Sovetskaya Portretnaya Zhivopis 1930–kh–kontsa 1950–kh godov*, Moscow, Izobrazitelnoe Iskusstvo, 1989, p. 114.

76. A. Fyodorov-Davydov, 'Risunki Khudozhnika D. Shmarinova "Ne Zabudem, Ne Prostim"', *Pravda*, 16. iv. 43.

77. This detail was given me by the artist's son, the artist Mai Miturich.

78. This anecdote was told me by Vladimir Kostin.

79. This anecdote was told me by Vladimir Kostin.

80. Correspondence concerning the plan to create a Museum of World Art is in *TsGALI* 962/6/1217.

81. Emoluments intended for members and employees of the Academy are given in the archive of the Committee for Art Affairs, 'Proekt Ustava Akademii Khudozhestv i Shtatskoe Raspisanie', *TsGALI* 962/6/1364.

82. Gerasimov's speech is printed in P. M. Sysoev et al., *Akademiya Khudozhestv SSSR, Pervaya i Vtoraya Sessii*, Moscow, Akademiya Khudozhestv SSSR, 1949.

83. Zhdanov's speech and the musicians' replies are reproduced in A. Werth, *Musical Uproar in Moscow*, London, Turnstile Press, 1949, pp. 47–86.

84. Translated from the Russian in *Ogonyok*, 9 February 1989.

85. The family of the painter Leonid Tanklevski (1906–1984) related to me how a brigade of artists (of which Tanklevski was a member), working in 1952–3 on a picture of Stalin greeting Oriental dignitaries, was put under pressure to depict Stalin raised above the other figures in the painting. The brigade resisted and portrayed an unfashionably 'democratic' Stalin, on a level with his guests, shaking hands – a *mise-en-scène* reminiscent of *An Unforgettable Meeting*. The work was completed a month after Stalin's death, exhibited once, and its present whereabouts is unknown.

86. Vladimir Kostin told me an anecdote about Orlov which reveals the autocratic workings of Stalin's arts establishment. When, in 1946, the American ambassador, Harriman, was recalled, it was decided to give him a present. A ceramic sculpture by Orlov was removed at short notice from an exhibition and presented to Harriman without the artist being told. Orlov first heard of this when an emissary of the American embassy arrived at his suburban studio to thank him. After consulting Kostin and others, he decided to try and turn the situation to his advantage. He complained; and his boldness was rewarded. He received 50,000 roubles from the Committee for Art Affairs and a prestigious studio on Gorki Street, opposite the Moscow Council building and right next to Soviet Square, where the monument to Dolgoruki stands.

87. A. Gerasimov, 'Eshche o kritike', *Sovetskoe Iskusstvo*, 12. v. 46.

88. M. G. Manizer (ed.), *Akademiya Khudozhestv SSSR, Tretyaya Sessiya*, Moscow, Akademia Khudozhestv SSSR, 1949, p. 8.

89. Beskin uttered these words at a conference in the Tretyakov Gallery in 1946; they were quoted from the stenogram by Sysoev in his speech, 'The fight for socialist realism in soviet visual art', at the third session of the Academy of Arts, see M. G. Manizer (ed.), *Akademiya Khudozhestv SSSR*, ibid.

90. 'O Zadachakh Khudozhestvennoi Kritiki', *Iskusstvo*, 5/1948.

91. The protocol of the meeting which discussed the work of Kostin, and his speech in his own defence, are in *TsGALI* 2943/1/547. Kostin himself told me that Sergei Gerasimov advised him to stress his Russian nationality and roots.

92. From the personal archive of Vladimir Kostin, manuscript entitled 'I Snova Boi . . .', crossed out and omitted from the published version. Kostin writes that a meeting of the MSSKh directorate on 14.i.55 decided to call on Nalbandyan for an explanation of his remark, made at a meeting of the Academy of Arts.

93. Committee for Art Affairs, 'Protokoly Gosudarstvennoi Ekspertno-Zakupochnoi Komissii 8.ii – 28.xii.39', *TsGALI* 962/6/561, p. 38.

94. I have this anecdote from Vladimir Kostin, who witnessed the exchange.

95. Details of Falk's post-war life were given me by his wife, Angelina Shchekin-Krotova, in interviews in 1988–9.

96. Sergei Gerasimov's speech is to be found in the 'Stenogramma Zasedaniya Pravleniya MOSSKh s Aktivom po Obsuzhdeniyu Antipatrioticheskoi Deyatelnosti Kritikov Kosmopolitov, 25.iii.49', *TsGALI* 2943/1/541, pp. 2–27.

97. Bogorodski's speech can be found in *TsGALI* 2943/1/604, pp. 29–34.

98. This anecdote was told to me by Bogorodski's wife, Sofiya Razumovskaya.

99. *TsGALI* 2943/1/541, p. 68.

100. Aleksandr Gerasimov related how he met Picasso at the Warsaw Peace Congress, and pleaded for a new comradeship in the arts, at a meeting of *MSSKh* on 24. x. 1951, see *TsGALI* 2943/1/605, p. 47. His cynical humour has become legend among Moscow artists; these two examples of it were given me by his son-in-law, Vladilen Shabelnikov. The artist who died in flagrante was Pyotr Kotov (1889–1953), an

academician.
101. See Kamenski's essay, 'Surovyi Stil: k Istorii Napravleniya' in Aleksandr Kamenski, *Romanticheskii Montazh*, Moscow, Sovetski Khudozhnik, 1989, pp. 189–90.
102. Unsigned article in *Pravda*, 22. xi. 54.

103. The visit by a delegation of Moscow artists is described in Kostin's article, 'I Snova Boi . . .', seen in manuscript form (archive of V. Kostin).
104. The tale of Aleksandr Gerasimov's interview with Khrushchev and his forced resignation from the Academy was told me by his son-in-law, Vladilen Shabelnikov.

Glossary

Academy of Architecture – see USSR Academy of Architecture.

Academy of Arts An Imperial Academy of Arts was founded in St Petersburg in 1757; it was dissolved in 1918 and its premises given over to *GSKhUM* (q.v.). The All-Russian Academy of Arts was the name given to the art school formed in Leningrad in 1933, on the base of *InPII* (q.v.); it was also known as *InZhSA* (q.v.) and was housed in the building of the Imperial Academy. The All-Russian Academy of Arts was in reality little more than an art institute. The name became defunct in 1947 when the USSR Academy of Arts was created. The new Academy was an organisation with a wide remit and powers, described in the text; it took responsibility for the *MGKhI* (q.v.) and *InZhSA*; the latter art institute is known today as the Repin Institute or sometimes, confusingly, as the Academy because of its historic premises.

AKhR Association of Artists of the Revolution. Existed 1928–32. Previously known as *AKhRR* (q.v.)

AKhRR Association of Artists of Revolutionary Russia. Existed 1922–8. Renamed *AKhR* (q.v.) in 1928.

AKhR/R Denotes in this book *AKhRR* and *AKhR* collectively.

All-Russian Academy of Arts – *see* Academy of Arts.

ARMU Association of Revolutionary Art of the Ukraine. Existed 1925–9.

AsNovA Association of New Architects. Existed 1923–32.

Bolshevik The Bolsheviks were initially a faction of the Russian Social Democratic and Labour Party. The RSDLP was formed in 1898; Lenin formed the Bolshevik (majority) group after a split vote at its second congress in 1903. The RSDLP adopted the name RSDLP (Bolshevik) at its seventh conference in April 1917. In March 1918, after control had been gained of the country, another name change was made and the party became the Russian Communist Party (Bolshevik). In 1925 it became the All-Union Communist Party (of Bolsheviks); and in 1952, the Communist Party of the Soviet Union.

Committee for Art Affairs – see KPDI.

communism A term in broad use in Europe from the 1840s; see Bolshevik.

FOSKh Federation of Associations of Soviet Artists. Existed 1931–2.

GSKhM State Free Artistic Studios. Existed in Moscow 1918–20 on the premises of *MUZhVZ* (q.v.) and the Stroganov college, and in other cities. Renamed *VKhuTeMas* (q.v.) in 1922.

GSKhUM State Free Artistic-Educational Studios. Existed in Petrograd 1918–21 on the premises of the old Academy of Arts (q.v.). Renamed *VKhuTeMas* (q.v.) in 1921.

GTsKhNRM State Central Artistic-Scientific Restoration Studios.

Imperial Academy of Arts – see Academy of Arts.

InKhuK Institute of Artistic Culture. Founded in Moscow in 1920. A State *InKhuK* (*GInKhuK*) existed in Petrograd/Leningrad 1923–6.

InPII *Institute of Proletarian Visual Arts.* Existed in Leningrad 1930–2, successor to *VKhuTeIn* (q.v.); reorganised and renamed *InZhSA* (q.v.) in 1932.

InZhSA Institute of Painting, Sculpture and Architecture. Has existed in Leningrad from 1932 to the present day. Known as Leningrad *InZhSA* (*LInZhSA*) 1932–3; as *InZhSA* of the All-Russian Academy of Arts 1933–44; as Repin *InZhSA* of the All-Russian Academy of Arts 1944–7; as Repin

InZhSA of the USSR Academy of Arts (Repin Institute) 1947–present day. Successor to *InPII* (q.v.).

IzoGIz State publishing house for the visual arts, formed 1930.

Izo NarKomPros The art department of the People's Commissariat for Education, set up in 1918. The Commissariat (*NarKomPros*) existed 1917–46.

Kollegiya The executive committee of *Izo NarkomPros* (q.v.).

KPDI Committee for Art Affairs, existed 1936–53, when its duties were taken over by a newly formed Ministry of Culture. Under the auspices of the Council of Peoples' Commissariats (*SovNarKom*) to 1946; of the Council of Ministers 1946–53.

LOSSKh Leningrad Section of the Union of Soviet Artists. Formed 1932.

MArkhI Moscow Architectural Institute.

MGKhI Moscow State Art Institute. Has existed from 1940 to the present day. Known as *MGKhI* 1940–7; as *MGKhI* of the USSR Academy of Arts 1947–8; Surikov *MGKhI* of the USSR Academy of Arts (Surikov Institute) 1948– present day. Successor to *MIII* (q.v.)

MGPI Moscow State Pedagogical Institute.

MGU Moscow State University.

MIFLI Chernyshevski Moscow Institute of the History of Philosophy and Literature.

MIII Moscow Institute of Visual Art. Existed 1935–9. Renamed *MGKhI* (q.v.)

Ministry of Culture – Founded in 1953; see KPDI.

MIPIDI Moscow Institute of Applied and Decorative Art. Existed early 1940s– 1952.

MKhPU Moscow Artistic-Technical College.

MOSKh Moscow Organisation of the *RSFSR* (q.v.) Union of Artists. See *MOSSKh*.

MOSSKh Moscow Section of the Union of Soviet Artists. Formed 1932. Renamed in 1938 *MSSKh*, Moscow Union of Soviet Artists. Renamed *MOSKh* (q.v.) in 1957.

MSSKh see *MOSSKh*.

MTI Moscow Textile Institute.

MUZhVZ Moscow College of Painting, Sculpture and Architecture.

MVKhPU Moscow Higher Artistic and Technical College, has existed from 1945 to the present day; also known as Stroganov college, in honour of pre-revolutionary institution.

NarKomPros People's Commissariat for Education.

NEP New Economic Policy. Devised by Lenin in 1921; became defunct with the advent of the first 5-year plan.

NKVD People's Commissariat for Internal Affairs. The secret police 1934–54; previously *Cheka* (1917–22), GPU (1922–3), OGPU (1923–34); after-

afterwards KGB.

NOZh New Society of Painters.

OKhR Society of Russian Artists.

OMAKhR The youth section of *AKhR* (q.v.).

OMKh Society of Moscow Artists.

OMKhU Society of Young Ukrainian Artists.

OPKh Society for the Encouragement of Artists (1821–75); renamed Society for Encouragement of the Arts (1875– *c.* 1917). Based in St Petersburg. Drawing school founded in 1906.

Orgkomitet Organising Committee. The term *orgkomitet* used in the text is short for *Orgkomitet SSKh* – Organising Committee of the Union of Soviet Artists – a body which existed 1939–57 and was headed for most of its life by Aleksandr Gerasimov. Also found in other contexts, e.g. *Orgkomitet SKh RSFSR* – Organising Committee of the Russian Union of Artists which existed 1957– 60, see *SKh RSFSR*

ORS Society of Russian Sculptors.

OSt Society of Easel Painters.

proletkult Proletarian culturo-educational organisation. Existed 1917–32.

RANION Russian Association of Academic Research Institutes in the Social Sciences.

RAPKh Russian Association of Proletarian Artists. Existed 1931–2.

RAPM Russian Association of Proletarian Musicians. Existed 1923–32.

RAPP Russian Association of Proletarian Writers. Existed 1925–32.

RKKA Workers' and Peasants' Red Army.

RSFSR Russian Soviet Federation of Socialist Republics: in short, Russia.

SARMA Association of Revolutionary Artists of Georgia.

SKh Union of artists.

SKh RSFSR Russian Union of Artists. Formed in 1960. Subordinate to *SKh SSSR* (q.v.).

SKh SSSR USSR Union of Artists. Formed in 1957.

SRKh Union of Russian Artists.

SSKh Union of Soviet Artists.

TsGALI Central State Archive of Literature and Art.

TsK Central Committee of the communist party.

Union of A term with shades of meaning. It may
artists refer to a local union, such as *MOSSKh* (q.v.), or to a larger, umbrella union, such as the USSR Union of Artists (*SKh SSSR*, q.v.).

UNovIs The Affirmers of New Art. Avant-garde grouping of early 1920s, led by Malevich.

USSR Union of Soviet Socialist Republics. Formed in 1922.

USSR Academy of Architecture – Functioned in Moscow 1934–56; statutes and staff confirmed in 1939. Contained six research insti-

tutes, a museum, library, laboratory and workshops. In 1956 renamed USSR Academy of Construction and Architecture.

USSR Academy of Arts – see Academy of Arts.

VDNKh Exhibition of the Achievements of the People's Economy; name given in 1958 to *VSKhV* (q.v.).

VGIK All-Union State Institute of Cinematography.

VKhuTeIn Higher Artistic-Technical Institute. Successor to *VKhuTeMas* (q.v.). Existed in Moscow 1926–30, in Petrograd/Leningrad 1922–30. No successor in Moscow; succeeded by *InPII* (q.v.) in Leningrad.

VKhuTeMas Higher Artistic-Technical Studios. Successor to *GSKhM/GSKhUM* (q.v.). Existed in Moscow 1921–6, in Petrograd 1921–2. Succeeded by *VKhuTeIn* (q.v.).

VOAPP All-Union Association of Proletarian Writers. Grew out of *VAPP* (All-Russian Association of Proletarian Writers, formed 1920) in 1920s and after 1928 was dominated by *RAPP* (q.v.).

VOKS All-Union Society for Foreign Cultural Links.

VOPrA All-Russian Association of Proletarian Architects. Existed 1929–32.

VseKoKhudozhnik All-Russian Union of Co-operative Comradeships of Workers in the Visual Arts. Founded in 1929.

VSKhV All-Union Agricultural Exhibition (opened 1939; re-opened 1954). Renamed *VDNKh* (q.v.) in 1958.

Windows of *RosTA* Name given to posters displayed in the windows of the Russian Telegraph Agency in Moscow, early 1920s.

Artists' Biographies

ALABYAN, Karo Semyonovich, 1897–1959. Architect. Born in Elizavetpol (subsequently renamed Kirovabad; now Ganja). Graduated from the *VKhuTeMas/VKhuTeIn* in 1929 (architecture dept.). Member of *VOPrA* in 1929. First secretary of Union of Soviet Architects in 1933. Member of the communist party from 1917. Main work: Red Army Theatre 1934–40 (with Vasili Simbirtsev); Armenian pavilion at *VSKhV* 1939/1954 (with S. A. Safaryan); project for reconstruction of Stalingrad 1943.

ALTMAN, Natan Isaevich, 1889–1970. Painter, sculptor, theatre designer. Born in Vinnitsa. Graduated from Odessa Art College in 1907; studied at the Free Russian Academy in Paris 1910–11. Taught at M. Bernshtein's private school, Petrograd 1915–17; at *GSKhM*, Petrograd 1918–20. In 1920 did a sculpture and series of drawings of Lenin from life. Lived in Paris 1928–35; on his return worked mainly in the theatre.

ANDERSON, Voldemar Petrovich, 1891–1938. Painter. Born in Riga. Studied at Riga School of Painters and Decorators 1910–14; at Riga Art School 1914–15; at Moscow *VKhuTeMas* 1922–4. Joined *AKhRR* 1925. 1917–*c.* 1922 member of 7th Latvian Rifle Regiment.

ANDREEV, Nikolai Andreevich, 1873–1932. Sculptor, theatre designer. Born in Moscow. Studied at Stroganov College, Moscow 1885–91, at *MUZhVZ* 1892–1901, in private studios in Paris 1900. Member of Itinerants from 1904, of *ORS* from 1916. Taught at Stroganov College

1892–1918. Worked in Moscow Art Theatre 1910–27. Worked assiduously on images of Lenin from *c.* 1920.

ANTONOV, Fyodor Vasilevich, born 1904. Painter. Born in Tambov. Graduated from the Moscow *VKhuTeIn* (textile department) in 1929. Member of *OSt* in 1930.

ASLAMAZYAN, Mariam Arshakovna, born 1907. Painter, ceramicist. Born in Bash-Shirak. Studied at Yerevan Art Tekhnikum 1926–9; at Moscow *VKhuTeIn* from 1929; graduated from *InPII* 1932; post-grad at *InPII/InZhSA* 1932–4. Member of *OMAKhR* 1929–30. Taught at Artistic-Pedagogical Tekhnikum, Leningrad, 1934–41; at Yerevan Artistic-Technical College 1941–4. Member of communist party from 1946.

AVILOV, Mikhail Ivanovich, 1882–1953. Painter. Born in St Petersburg. Graduated from the Academy of Arts in 1913 (battle painting class under F. A. Rubo and N. S. Samokish). Member of Leningrad *AKhR/R* 1923–9, of *SSKh* 1929 onwards. Taught in Tyumen 1918–21, Leningrad *VKhuTeMas/VKhuTeIn* 1922–30, *InZhSA* 1947–54. Member of USSR Academy of Arts. Awarded Stalin prize in 1946 for *The Joust of Peresvet with Chelubei* (1943).

AZGUR, Zair Isaakovich, born 1908. Sculptor. Born in Molchany, village in the Vitebsk region. Graduated from Vitebsk Artistic Technicum 1925; from Leningrad *VKhuTeIn* 1928. Member of the USSR Academy of Arts. Member of the communist party from 1943. Awarded

Stalin prizes in 1946 for portraits of Heroes of the Soviet Union and in 1948 for portrait of F. E. Dzerzhinski (1947).

BAKSHEEV, Vasili Nikolaevich, 1862–1958. Painter. Born in Moscow. Graduated from the *MUZhVZ* in 1888. Member of Itinerants from 1896. Made an Academician in 1913. Member of *AKhRR* 1925–7, *OKhR* 1927–31. Taught at the *MUZhVZ* 1894–1918, Institute for Raising Artists' Qualifications, Moscow, 1933–40, Moscow College 'In Memory of 1905' 1940–58, Kalinin *MKhPU* 1945–51. Member of the USSR Academy of Arts. Awarded Stalin prize in 1943 for services to art.

BAZHBEUK-MELIKYAN, Aleksandr Aleksandrovich, 1891–1966. Painter. Born in Tiflis (now Tbilisi). Studied at Tiflis Art College 1906–10; at Academy of Arts, St Petersburg, from 1911. Taught in the studio of M. I. Toidze 1922–9, at Tbilisi Academy of Arts 1929–38.

BAZHENOVA, Zinaida Vasilevna, 1905–1988. Sculptor. Studied at Sverdlovsk Artistic-Technical Technikum 1924–8; at Moscow *VKhuTeIn* 1928–30; at *InPII* 1930–2.

BELASHOVA-ALEKSEEVA (BELASHOVA), Ekaterina Fyodorovna, 1906–1971. Sculptor. Graduated from Leningrad *VKhuTeIn* 1930; post-grad at *InPII* 1930–2. Taught at *MIPIDI* 1947–52; at *MVKhPU* 1952–65. Chairman *SKh SSSR* 1968–71. Member of Academy of Arts. Member of communist party from 1946.

BELOUSOV, Pyotr Petrovich, 1912–1989. Painter, printmaker. Born in Berdyansk. Studied at *InZhSA* 1933–9. Lived with Brodski in 1930s, virtually as an adopted son. Taught at *InZhSA* 1939–41, 1942–87. During siege of Leningrad worked for newspaper *Smena*. Member of USSR Academy of Arts.

BENKOV, Pavel Petrovich, 1879–1949. Painter. Born in Kazan. Studied at Kazan Art School 1896–1901; at Academy of Arts 1901–9. Lived in Kazan 1909–30, thereafter in Samarcand. Member of *AKhRR* from 1922. Taught at Kazan Art College 1909–29; at Samarcand Art College 1930–49.

BESKIN, Osip Martynovich, 1892–1969. Critic. Editor of *Tvorchestvo* 1933–40; of *Iskusstvo* 1933–6. Head of critics' section in *MOSSKh* 1930s. Author of *Formalism in Painting*, 1933. Expelled from Moscow artists' union 1948 for 'cosmopolitan' views, i.e. support for French impressionism.

BIRSHTEIN, Maks Avadevich, born 1914. Painter. Born in Kiev. Studied at *MIII/MGKhI* 1935–42. Worked in Falk's studio after war.

BOGORODSKI, Fyodor Semenovich, 1895–1959. Painter. Born in Nizhni-Novgorod. During revolution member of *VChK* (Cheka) and revolutionary tribunal in Nizhni-Novgorod and Orenburg. Graduated from the Moscow *VKhuTeMas* in 1924. Member of *Bytie* 1921–4, *AKhRR* from 1924. Lived in Germany and Italy 1928–30. Taught at *VGIK* 1938–59. Chairman of *MSSKh/MOSKh* directorate 1955–8. Member of the USSR Academy of Arts. Awarded Stalin prize 1946 for *Glory to the Fallen Hero*. Member of the communist party from 1917.

BOICHUK, Mikhail Lvovich, 1882–1939. Painter, monumental artist. Studied at art studios in Lvov in 1898,

graduated from Academy of Arts in Cracow in 1905, thereafter studied in Munich and Vienna. Lived in Paris 1908–11, Lvov 1911–17, thereafter in Kiev. Member of *ARMU* from 1925. Taught at Kiev Art College 1917–19, at the Ukrainian Academy of Arts 1919–22, at the Kiev Art Institute 1924–36. Led the school of Boichukists, mural painters inspired by Italian primitives and Ukrainian folk and religious art. Arrested in 1938 and executed as a nationalist in 1939.

BRODSKI, Isaak Izraelevich, 1884–1939. Painter. One of the originators of the Lenin genre. Born in Sofievka (Ekaterinoslav region). Graduated from Odessa Art College 1902, from Academy of Arts 1908. Travelled in Germany, France and Italy in 1909–11. Member of *SRKh* from 1910, *AKhRR* 1923–8; chairman of Kuindzhi Association 1930. Taught at *InPII/INZhSA* 1932–9 (director 1934–9). First artist to be awarded Order of Lenin (1930s).

BRUNI, Lev Aleksandrovich, 1894–1948. Graphic artist, monumental artist. Studied at Academy of Arts 1909–12; at Académie Julien, Paris, 1912. Member of The 4 Arts from 1925. Taught at Moscow *VKhuTeMas/VKhuTeIn* from 1923; at *MTI* from 1930; at *MArkhI*/Academy of Architecture (monumental art studio) from 1935.

BUBNOV, Aleksandr Pavlovich, 1908–1964. Painter, book illustrator, wartime poster artist. Born in Tbilisi. Graduated from Moscow *VKhuTeIn* in 1930. Member of *OMAKhR*, *AKhR* 1928–32. Member of USSR Academy of Arts. Awarded Stalin prize in 1948 for *Morning on Kulikov Field*.

BULAKOVSKI, Sergei Fyodorovich, 1880–1937. Sculptor. Born in Odessa. Studied in B. V. Eduards's studio, Odessa, 1893–1902; in marble products studio, Odessa, 1902–5; in Milan Academy of Arts 1906–9; in Paris 1909. Member of *ORS*. Taught at Moscow *VKhuTeMas/VKhuTeIn* 1922, 1924–30; at *InPII* 1930.

BYALYNITSKI-BIRULYA, Vitold Kaetanovich, 1872–1957. Painter. Landscapes. Born in Krynka, village near Byalinichi, Belorussia. Graduated from *MUZhVZ* in 1897. Member of Itinerants from 1904, of *Izograf* in 1917, of *OKhR* in 1928, of *SSKh* from 1929. Member of USSR Academy of Arts.

CHUIKOV, Semyon Afanasevich, 1902–1980. Painter. Born in Pishpek (now Frunze). Studied at Turkestan Art School 1920–1, graduated from Moscow *VKhuTeIn* in 1930. Taught at *InPII* 1931–2, *MGKhI* 1947–8. Chairman of organising committee of Kirgizian artists' union 1933–4, chairman of Kirgizian artists' union 1934–7, 1941–8. Member of USSR Academy of Arts. Awarded Stalin prizes in 1949 for *Kirgizian Collective-Farm Suite*, in 1951 for series of landscapes. Married to MALEINA, E. A., q.v.

DEINEKA, Aleksandr Aleksandrovich, 1899–1969. Painter, graphic artist, monumental artist, sculptor. Born in Kursk. Studied at Kharkov Art College 1915–17; at *GSKhM/VKhuTeMas* 1920–5. Member of *OSt* 1925–7, of October 1928–30, of *RAPKh* 1931–2. Taught at Moscow *VKhuTeIn* 1928–30, at Moscow Polygraphic Institute 1928–34, at *MIII/MGKhI* 1935–46, 1957–63, at *MIPIDI* 1945–52 (director 1945–8), at *MArkhI* 1953–7.

Member of USSR Academy of Arts. Member of communist party from 1960.

DREVIN, Aleksandr Davidovich, 1889–1938. Painter. Born in Venden, Latvia. Studied at Riga Art School 1908–13. Member of Jack of Diamonds 1915–17; of Moscow Painters 1924–5; of *AKhRR* 1926; of *OMKh* 1927–32. Taught at Moscow *VKhuTeMas/VKhuTeIn* 1920–30. Joined Latvian Rifles at time of revolution; part of Lenin's personal guard. Arrested and shot 1938. Married to UDALTSOVA, N. A., q.v.

EFANOV, Vasili Prokofevich, 1900–1978. Painter. Born in Samar (now Kuibyshev). Studied at Samar Artistic-Industrial Technikum 1917–19, in private studio of D. N. Kardovski, Moscow, 1920–6. Taught at *MGKhI* 1948–57, at Lenin *MGPI* 1959–78. Awarded Stalin prizes in 1941 for *An Unforgettable Meeting*, in 1946 for *At Sick Gorki's Bedside*, in 1948 for a portrait of Molotov, in 1950 for *Leading People of Moscow in the Kremlin* (brigade painting), in 1952 for *A Meeting of the Presidium of the Academy of Sciences* (brigade painting). Member of the communist party from 1952.

ELKONIN, Viktor Borisovich, born 1910. Monumental artist and painter. Born in Malaya Pereshchepina (Poltava region). Studied in studio of M. Leblan, Moscow, 1923–7; at Moscow *VKhuTeIn* 1927–30. Member of The 4 Arts in 1930. Worked as art critic 'Viktorov' in *Literary Gazette* 1933–5; in studio of monumental art run by Lev Bruni, attached first to *MArkhI*, then to Academy of Architecture, 1935–41, 1946–8. During war evacuated to Tashkent and in 1943 called up to Polish front.

FALK, Robert Rafailovich, 1886–1958. Painter. Born in Moscow. Studied at K. Yuon's and V. Meshkov's art school 1903–4, at *MUZhVZ* 1905–10. Founder member of Jack of Diamonds in 1910; member of The World of Art from 1916, of *OMKh* 1925–8, of *AKhRR* 1926–8. Member of the *Kollegiya* in 1918. Taught at Moscow *GSKhM/VKhuTeMas/VKhuTeIn*. Lived in Paris 1928–38, thereafter in USSR, when he was ostracised by the art establishment.

FAVORSKI, Vladimir Andreevich, 1886–1964. Graphic artist, book illustrator, theatre artist, painter, theoretician. Born in Moscow. Studied at school-studio of K. Yuon and I. Dudin, Moscow 1903–4; graduated from art school in Munich 1907; graduated from historical-philological faculty of Moscow University 1913. Taught at Moscow *GSKhM/VKhuTeMas/VKhuTeIn* 1918–19, 1923–30 (rector 1923–5); at Polygraphic Institute, Moscow 1923–5; at *MIII* 1935–8; at *InZhSA* 1936–41; at *MIPIDI* 1942–8. A widely respected teacher with a whole school of followers, he was nevertheless criticised and branded a formalist in the 1930s. Member of USSR Academy of Arts after Stalin's death.

FILONOV, Pavel Nikolaevich, 1883–1941. Painter. Originator of theory of Analytical Art. Born in Moscow. Studied in painting studios in St Petersburg 1897–1901; in the private studio of L. Dmitriev-Kavkazski 1903–8; at Academy of Arts 1908–10. Member of Union of Youth 1910–13; leader of collective Masters of Analytical Art from 1925. Ran dept. of general ideology at Leningrad *InKhuK* 1923; during 1930s worked in Leningrad in

isolation from official art world. Died of hunger in siege of Leningrad.

FYODOROV-DAVYDOV, Aleksei Aleksandrovich, 1900–1969. Art historian and critic. Born in Moscow. Graduated from Kazan University 1923, post-graduate at Institute of Archaeology and Art Study of *RANION* until 1928. Taught at Moscow Conservatory 1925–6, at *MGU* 1927–56, at *MTI* 1937–41, at *MIPIDI* 1944–8, at Central Committee's Academy of Social Sciences 1948–56. Worked in Tretyakov Gallery 1929–34, Academic Research Institute of Academy of Arts 1949–69. Member of USSR Academy of Arts. Member of the communist party from 1946.

GAPONENKO, Taras Gurevich, born 1906. Painter. Born in Zavoron, village in the Smolensk region. Studied at Moscow *VKhuTeMas/VKhuTeIn* 1924–30. Member of *AKhR* 1929–30, of *RAPKh* 1931–2. Ran *VseKoKhudozhnik* 1948–53, was chairman of *Orgkomitet SKh SSSR* in 1954. Awarded Stalin prize in 1947 for *After the Expulsion of the Fascist Occupiers*.

GELFREIKH, Vladimir Georgevich, 1885–1967. Architect. Born in St Petersburg. Studied at the Higher Art College of the Academy of Arts 1906–14 (class of L. Benois). Main works: colonnade at Smolny (with V. Shchuko) 1923–5, Monument to Lenin at Finland Station (with V. Shchuko) 1925, Lenin Library 1928–52 (at first with V. Shchuko), Gorki Theatre, Rostov-on-Don 1930–7 (with V. Shchuko). Helped to develop Iofan's design for the Palace of the Soviets, 1930s.

GERASIMOV, Aleksandr Mikhailovich, 1881–1963. Painter. Portraits, thematic pictures, still-lifes, landscapes. Born in Kozlov (now Michurinsk). Graduated from *MUZhVZ* painting faculty in 1910; from architectural faculty in 1915. Member of *AKhR/R* 1927–32. Chairman of *MOSSKh* 1937–9, of *Orgkomitet SSKh* 1939–54. President of USSR Academy of Arts 1947–57. Member of the communist party from 1950. Awarded Stalin prizes in 1941 for *Stalin and Voroshilov in the Kremlin*; in 1943 for *A Hymn to October*; in 1945 for *Group Portrait of the Oldest Artists*; in 1948 for a number of works.

GERASIMOV, Sergei Vasilevich (1885–1964). Painter. Landscapes, thematic pictures. Book illustrator. Born in Mozhaisk. Graduated from *MUZhVZ* in 1912. Member of *Makovets* 1922–5, *OMKh* 1926–9, *AKhR* 1931–2. Taught at the Moscow *GSKhM/VKhuTeMas/VKhuTeIn* 1920–9, Moscow Polygraphic Institute 1930–6, *MIII/MGKhI* 1936–50 (director 1946–8), *MVKhPu* 1950–64. Chairman of *MSSKh* 1939–52. First Secretary of *SKh SSSR* 1958–64. Member of USSR Academy of Arts.

GOLTS, Georgi Ivanovich, 1893–1946. Architect. Born in Bolshevo, nr. Moscow. Studied at *MUZhVZ* 1913–15, at Moscow *VKhuTeMas* in 1920s. Member of *MAO* from 1926. Taught in and led *Kafedra Proektivaniya* of *MArkhI* from 1934. Main work: Bolshoi Ustinski Bridge, Moscow, 1936–8.

GRABAR, Igor Emmanuilovich, 1871–1960. Painter, writer on art, museum worker, restorer. Born in Budapest. Graduated from the St Petersburg University juridical faculty in 1893. Studied in higher art college attached to the Academy of Arts in 1894–6; at A. Azhbe's school 1896–1901; at architectural polytechnic in Munich in

1901. Member of The World of Art and *SRKh*, of *OMKh* and the Repin Association of Artists in the 1920s. Taught at *MGU* 1920–7, *MIII/MGKhI* 1937–42 (director), *InZhSA* 1942–6 (director), Institute of the History of Art of the USSR Academy of Sciences 1944–60 (director). Worked at the Tretyakov Gallery 1913–25 (some time spent as director), and as artistic director of *GTsKhNRM* 1944–60. Member of USSR Academy of Arts. Awarded a Stalin prize in 1941 for two-volume monograph on Repin.

GREKOV, Mitrofan Borisovich, 1882–1934. Painter. Born in Sharpaevka (Rostov region). Studied at Odessa Art College 1899–1903; Academy of Arts 1903–11. Red Army volunteer 1920–c. 1925. Member of *AKhRR* from 1925. Author of first Soviet diorama, *The Taking of Rostov*, exhibited 1929, now destroyed.

GRIGOREV, Sergei Alekseevich, 1910–1988. Painter. Born in Lugansk. Studied at Moscow *VKhuTeIn* 1926–7, at Kiev Art Institute 1928–32. Member of *OMKhU* 1929. Taught at Kharkov Art Institute 1933–4, Kiev Art Institute 1934–60 (director 1951–5). Member of USSR Academy of Arts. Awarded Stalin prizes in 1950 for *The Goalkeeper* and *Acceptance into the Komsomol*, in 1951 for *Discussion of a Low Mark*. Member of the communist party from 1941.

GRITSAI, Aleksandr Mikhailovich, born 1914. Painter. Landscapes. Born in Petrograd. Studied in private studio of S. M. Zaidenberg *c*. 1931, at *InPII/InZhSA*, Leningrad, 1932–9. Called up 1940, demobilised 1946. Taught at *MGKhI* 1948–74. Awarded Stalin prizes in 1951 for *A Stormy Day in Zhiguli*, in 1952 for *A Meeting of the Presidium of the Academy of Sciences* (brigade work).

GUDIASHVILI, Vladimir (Lado) Davidovich, 1896–1980. Born in Tiflis (now Tbilisi). Studied at School of Painting and Sculpture, Tiflis, 1910–14; at Académie Paul Rançon, Paris, and lived in France 1919–25. Member of Society of Georgian Artists from 1916, of *SARMA* 1929–32. Worked as an artist on archaeological expeditions 1916–17, made copies of frescoes. Taught at Tiflis Academy of Arts 1927–34.

GUREVICH, Mikhail Lvovich, 1904–1943. Painter. Born in Smolensk. Studied at Moscow *VKhuTeMas/VKhuTeIn* 1925–30. Member of the communist party from 1942. Died at the front.

GUTNOV, Elbrut Aleksandrovich, born 1906. Graphic artist. Born in Dzhivgis. Studied at Berlin Academy of Arts 1922–7. Joined October *c*. 1928. Arrested 1937, later released.

IOFAN, Boris Mikhailovich, 1891–1976. Architect. Born in Odessa. Studied at Odessa Art College 1903–11; in Rome 1914–19. Major works: houses in Roman suburbs and chapel in San Lorenzo cemetery, Rome, 1916–22; houses in Rusakovskaya Street, Moscow, 1925; dwelling complex in Serafimovich Street, Moscow, 1928–31; winning project for the Palace of the Soviets, 1931–3.

IOGANSON, Boris Vladimirovich, 1893–1973. Painter. Born in Moscow. Studied in studio of P. I. Kelin 1912–13, at *MUZhVZ* 1913–18. Member of *AKhR/R* 1923–31, of *RAPKh* 1931–2. Taught at Moscow Polygraphic Institute 1932–5, at *MIII* 1935–9, at *InZhSA* 1939–60, at *MGKhI* 1964–7. Led painting studio of Academy of Arts

in Leningrad and Moscow 1949–60. Director of State Tretyakov Gallery 1941–4. Chairman of *Orgkomitet SKh SSSR* 1954–7. First Secretary of *SKh SSSR* 1965–8. Awarded Stalin prizes in 1941 for *In an Old Urals Factory*; in 1951 for *Lenin's Speech to the Third Congress of the Komsomol* (brigade work). Member of USSR Academy of Arts from 1947. Member of the communist party from 1943.

IORDANSKI, Boris Vyacheslavovich, 1903–1987. Monumental artist. Born in Kovrov. Studied at Moscow *VKhuTeMas/VKhuTeIn* 1922–30. Member of *AKhR* 1928–31; of *RAPKh* 1931–2. Taught at *MIPIDI* 1950–2; at *MVKhPU* from 1952. Member of communist party from 1947.

KAKABADZE, David Nesterovich, 1889–1952. Painter, also worked in theatre and cinema. Born in Kukhi, village nr. Kutaisi. Studied in private schools of Paevski and V. Krotkov, St Petersburg, 1910–15, at St Petersburg University 1910–16. 1919–27 lived in Paris. Taught at Tiflis Academy of Arts from 1928.

KAMENSKI, Aleksandr Abramovich, born 1922. Art critic. Attacked for 'cosmopolitanism' late 1940s. Coined term Severe Style to describe innovative socialist realism of Khrushchev period.

KATSMAN, Evgeni Aleksandrovich, 1890–1976. Painter, specialist in coloured pastel drawing. Born in Kharkov. Graduated from *MUZhVZ* 1916. Member of *AKhR/R* 1923–32 (founder member). Member of USSR Academy of Arts from 1947.

KAZANTSEV, Anatoli Alekseevich, 1908–1973. Painter, wartime poster artist. Born in Khabarovsk. Studied in K. Yuon's studio, Petrograd, 1920s. Member of *OMAKhR* from 1928.

KHMELKO, Mikhail Ivanovich, born 1919. Painter. Born in Kiev. Graduated from Odessa Art Tekhnikum 1940, Kiev Art Institute 1946. Awarded Stalin prizes in 1948 for *To the Great Russian People*; in 1950 for *The Triumph of the Conquering People*.

KLUTSIS, Gustav Gustavovich, 1885–1938. Avantgardist, graphic designer. Born in Latvia. Studied at Riga municipal art school 1912; at *OPKh* drawing school, Petrograd, 1915–17; in V. Meshkov's school and I. Mashkov's studio, Moscow, 1918; at Moscow *GSKhM/VKhuTeMas* 1918–21. Member of *InKhuK* 1921–5. Member of October from *c*. 1928. Taught at Moscow *VKhuTeMas/VKhuTeIn* 1924–30. Member of the communist party from 1920. Arrested and perhaps executed *c*. 1938.

KONCHALOVSKI, Pyotr Petrovich, 1876–1956. Painter. Born in Slavyansk. Studied at drawing school in Kharkov; at Stroganov College, Moscow, mid-1890s; at Académie Julien, Paris 1897–8; at higher art school of Academy of Arts 1898–1905. Member of Jack of Diamonds from 1910; exhibited with Union of Youth 1911–12, The World of Art 1917/1921–2, *Bytie* 1926–7, *AKhRR* 1928, *OMKh* from 1927. Taught at Moscow *GSKhM/VKhuTeMas/VKhuTeIn* 1918–21, 1926–9. Awarded Stalin prize 1943 for services to art. Member of USSR Academy of Arts (1947).

KONYONKOV, Sergei Timofeevich, 1874–1971. Sculptor. Born in Karakovichi (Smolensk region). Graduated from *MUZhVZ* 1896; studied at higher art college of Academy of Arts and in studio of P. Trubetskoi 1899–1902. Member of *SRKh* 1909; of The World of Art 1917. Made an Academician in 1916. Taught at *GSKhM/VKhuTeMas* 1918–22. Lived in USA 1923–45, thereafter in USSR. Awarded Stalin prize in 1951 for sculptures *Marfinka* and *Ninochka*. Member of USSR Academy of Arts.

KORIN, Pavel Dmitrievich, 1892–1967. Painter and monumental artist. Historical and religious subjects, portraits. Born in Palekh. Worked in icon-painting studios at Donski monastery, Moscow, 1908–11; studied at *MUZhVZ* 1912–16 (class of K. A. Korovin, S. V. Malyutin). Taught at Moscow *GSKhM* 1918–19; worked in anatomy theatre of 1st Moscow University 1919–22, making anatomical drawings; ran restoration studios at Pushkin Museum 1932–59; taught at *MGKhI* 1950. Member of USSR Academy of Arts. Awarded Stalin prize in 1952 for mosaics in the Komsomolskaya–Koltsevaya metro station.

KOSTIN, Vladimir Ivanovich, born 1905. Art critic. Studied at art school, Moscow, 1920s. Worked for *Komsomolskaya Pravda* as critic and in *VseKoKhudozhnik* 1930s. Author of *Young Soviet Painters* (1935); *Young Artists and Problems of Soviet Painting* (1940). Expelled from Moscow artists' union in 1948 for liberal views on art.

KOVALEVSKAYA, Zinaida Mikhailovna, 1902–1972. Painter. Pictures of Uzbek life, esp. women; portraits. Born in Volsk. Graduated from Kazan Art-Technical Institute 1927. Moved to Samarcand 1930, continuing her close association with Benkov, who had painted her portrait as a young girl and subsequently been her teacher. Worked in ethnographic dept. of Uzbek State Scientific Research Institute from 1930, later in Samarcand Art Institute. Received diploma as external student of *InZhSA*, then in evacuation in Samarcand, 1943.

KRYLOV, Porfiri Nikitich, born 1902. Painter, graphic artist, illustrator. Born in Shchelkunovo (Tula region). Graduated from Moscow *VKhuTeIn* 1927, where he met M. V. Kupriyanov and N. A. Sokolov and formed the KUKRYNIKSY, q.v. Member of USSR Academy of Arts from 1947.

KRYMOV, Nikolai Petrovich, 1884–1958. Painter, also worked in the theatre. Landscapes. Born in Moscow. Studied at *MUZhVZ* 1904–11. Member of Bluc Rose in 1907; of *SRKh* 1910–18; of OMKh 1928–31. Taught at Moscow *VKhuTeMas* 1920–2, at Moscow Art Tekhnikum 'In Memory of 1905' 1934–9. Member of USSR Academy of Arts from 1949. Practised theatre design in 1920s–30s.

KUKRYNIKSY. The collective name adopted by three artists working together (see KRYLOV P. N., KUPRIYANOV M. V., SOKOLOV N. A.). The Kukryniksy contributed drawings to *Pravda* from 1932. The were awarded Stalin prizes in 1942 for political posters and caricatures; in 1947 for illustrations to tales by Chekhov; in 1949 for *The End*; in 1950 for illustrations to Gorki's *Foma Gordeev* and political caricatures; in 1951 for illustrations to Gorki's *Mother* and other works.

KUPRIN, Aleksandr Vasilevich, 1880–1960. Painter. Landscapes. Born in Borisoglebsk. Studied in studio of L. Dmitriev-Kavkazski, St Petersburg, 1902–4; in studio of K. Yuon, Moscow, 1904–6; at *MUZhVZ* 1906–10. Member of Jack of Diamonds from 1910, of Moscow Painters and *Bytie* in 1920s. Travelled to France and Italy 1913–14. Taught at Moscow *GSKhM* 1918–20; at Nizhny-Novgorod *GSKhM* 1920–2; at Moscow *VKhuTeMas/VKhuTeIn* 1922–30; at *MTI* 1931–9; at *MVKhPU* 1946–52. Member of USSR Academy of Arts from 1949.

KUPRIYANOV, Mikhail Vasilevich, born 1903. Painter, graphic artist, illustrator. Born in Tetyushi (Kazan region). Graduated from Moscow *VKhuTeIn* in 1929, where he met P. N. Krylov and N. A. Sokolov and formed the KUKRYNIKSY, q.v. Member of USSR Academy of Arts from 1947.

KUZNETSOV, Pavel Barfolomeevich, 1878–1968. Painter. Born in Saratov. Studied in studio of painting and drawing in Saratov 1891–6; at *MUZhVZ* 1897–1904. Member of The World of Art and *SRKh* from 1902; chairman of The 4 Arts 1924–31. Head of painting section of *Kollegiya* 1919–24. Taught at Moscow *GSKhM/VKhuTeMas/ VKhuTeIn* 1918–30; at *MIII*; at *MVKhPU* 1945–8. Criticised for formalism and lack of socialist subject-matter in 1930s.

LABAS, Aleksandr Arkadevich, 1900–1988. Painter. Born in Smolensk. Studied at Stroganov College, Moscow, and in private studios of I. Mashkov and F. Rerberg 1912–17; at Moscow *GSKhM* 1918–19; at Moscow *VKhuTeMas* 1921–4. Member of *OSt* from 1925. Taught at Ekaterinburg Art Institute 1920–1; at Moscow *VKhuTeMas* 1922–4. Branded formalist in 1930s.

LAKTIONOV, Aleksandr Ivanovich, 1910–1972. Painter. Born in Rostov-on-Don. Studied at Rostov Art School 1926–9; at *InZhSA* 1932–8, and post-grad. at same place 1938–44. Taught at *InZhSA* 1936–44. Awarded Stalin prize in 1948 for *A Letter from the Front*. Member of USSR Academy of Arts.

LANSERE, Evgeni Evgenevich, 1875–1946. Monumental artist, painter. Born in Pavlovsk, nr. St Petersburg. Studied at *OPKh* drawing school, St Petersburg, 1892–6; in Paris 1896–9. Made an Academician in 1912. Member of The World of Art from 1907. Travelled to Europe 1896–9, 1907, 1927; to Japan 1920; to Turkey 1923. Lived in St Petersburg to 1917, Dagestan 1917–20, Tiflis 1920–34, thereafter Moscow. Taught at Tiflis Academy of Arts from 1922.

LEBEDEV, Andrei Konstantinovich, born 1908. Art historian and critic. Born in Vyazniki (Vladimir region). Graduated from Lenin *MGPI* in 1930; post-grad. at *MIFLI* to 1934. Worked in State Tretyakov Gallery 1933–4; in KPDI 1937–41 and 1944–9; as art editor for *Great Soviet Encyclopaedia* 1949–54; in Min, of Culture 1956–63; in Academic Research Institute of USSR Academy of Arts 1948–9 and from 1963. Member of USSR Academy of Arts. Member of the communist party from 1942.

LEBEDEV, Polikarp Ivanovich, 1904–1981. Art historian. Born in Malaya Serdoba (Saratov region). Graduated from party school in 1925; from *MGU* in 1930; from Institute of Red Professorship in 1934. Taught at *MGU* 1937–61. Worked in *IzoGIz* 1934–9; as head of art dept.

in Central Committee directorate of propaganda and agitation 1945–8; as chairman of KPDI 1948–51; in State Tretyakov Gallery 1939–41, 1953–4 and, as director, 1954–79. Member of USSR Academy of Arts. Member of communist party from 1924.

LEBEDEV, Vladimir Vasilevich, 1891–1967. Painter, graphic artist, illustrator. Born in St Petersburg. Studied in F. Rubo's battle-painting studio at Higher Art College of Academy of Arts 1910–11; in studio of M. D. Bernshtein, St Petersburg, 1912–14; at Higher Art College of Academy of Arts 1912–16. Member of Union of Youth from 1918; of The 4 Arts from 1928. Taught at Petrograd *GSKhUM* 1918–21; ran Petrograd Windows of *RosTA* 1920–2; art editor of *Detizdat* (children's book publishers), Leningrad, 1924–33; collaborated with S. Ya. Marshak on many books in 1920s–30s. Made an example of as a formalist in *Pravda* in 1936. Married to LEBEDEVA, S. D., q. v.

LEBEDEVA, Sarra Dmitrievna, 1892–1967. Sculptor. Born in St Petersburg. Studied at art school of M. D. Bernshtein and L. V. Shervud, St Petersburg, 1910–14. 1910s visited Paris, Berlin, Italy. Taught at Petrograd *GSKhUM* 1919–20. Lived in Moscow from 1925. Visited London 1925, Berlin and Paris 1928. Member of *ORS* from 1926. Member of USSR Academy of Arts. Married to LEBEDEV V. V., q.v.

LENTULOV, Aristarkh Vasilevich, 1882–1943. Painter. Born in Nizhnee Lomovo (Penza region). Studied at Penza Seliverstov Art College 1898–1900, 1905; at Kiev Art College 1900–4; in D. Kardovski's studio, St Petersburg, 1907–8; in Le Fauconnier's studio, Paris, 1911. Member of Jack of Diamonds from 1910; of *AKhRR* from 1926; of *OMKh* from 1928. Visited France, Italy 1911. Taught at Moscow *GSKhM/VKhuTeMas* from 1919.

LEVITIN, Anatoli Pavlovich, born 1922. Painter. Born in Moscow. Graduated from *InZhSA* 1951. Member of USSR Academy of Arts. Member of communist party from 1954.

LISHEV, Vsevolod Vsevolodovich, 1877–1960. Sculptor. Born in St Petersburg. Studied at higher art college of Academy of Arts 1906–13. Taught at higher art college of Academy of Arts/Petrograd *GSKhUM/VKhuTeMas/VKhuTeIn* 1918–29; at Leningrad Artistic-Industrial Tekhnikum 1921–30; at *InZhSA* 1934–5, 1947–60. Ran sculpture studio of USSR Academy of Arts 1952–60. Member of USSR Academy of Arts from 1949. Awarded Stalin prize 1942 for sculpture of Chernyshevski.

LISSITSKI, Lazar Markovich (EL LISSITSKI), 1890–1941. Designer, illustrator, visionary architect. Born in Pochinok (Smolensk region). Studied architecture in Darmstadt, Germany 1909–14; at Riga Polytechnic Institute, evacuated to Moscow, 1915–16. Member of *InKhuK* 1921, of *AsNovA* 1926; of October 1928. Taught at Vitebsk Art-Practical Institute 1919–20, at Moscow *VKhuTeMas* 1921. Lived in Germany and Switzerland 1921–5. Founded journal *Veshch* with I. Ehrenburg, Berlin 1920; journal *ABC* with M. Stam, Switzerland 1925. In 1930s worked as photographer and typographic designer, esp. for journal *USSR In Construction*.

LUCHISHKIN, Sergei Alekseevich, 1902–1990. Painter. Born in Moscow. Studied at Moscow *GSKhM/VKhuTeMas* 1919–24. Member of *OSt* from 1925. Member of *MOSSKh* directorate 1930s. Worked as artist on major film, *Tsirk*, in mid-1930s. Post-war concentrated on sports subjects.

LUKOMSKI, Ilya Abelevich, 1906–1954. Painter. Born in Polotsk. Studied at *VKhuTeMas/VKhuTeIn*. Member of *AKhR*.

LUNACHARSKI, Anatoli Vasilevich, 1875–1933. Art administrator, critic, revolutionary, playwright. Born in Poltava. Entered Zurich University 1892. Returned to Russia 1898. People's Commissar for Enlightenment 1917–29, responsible for arts policy. Made ambassador to Spain 1933, died on the journey to his post.

MAKSIMOV, Konstantin Mefodevich, born 1913. Painter. Born in Shatrovo, nr. Sereda (today Furmanov). Studied at Ivanovo-Voznesensk Artistic–Pedagogical Tekhnikum from 1930; at *MGKhI* 1937–42. Awarded Stalin prize in 1950 for *Leading People of Moscow in the Kremlin* (brigade work); in 1952 for *A Meeting of the Presidium of the USSR Academy of Sciences* (brigade work). Taught at Peking Academy of Arts 1956–8; at *MGKhI* 1940s–present day.

MALAEV, Fyodor Petrovich, born 1902. Painter. Studied at Moscow *VKhuTeMas/VKhuTeIn* 1920s. Member of *RAPKh* 1931–2. Arrested and incarcerated 1938; released during war.

MALEINA, Evgeniya Alekseevna, 1903–1984. Painter. Still-lifes, landscapes, children, women. Born in Tashkent. Studied at Tashkent Art School from 1919; at Moscow *VKhuTeMas/VKhuTeIn* 1921–30. Member of *OMKh* 1928–30. Married to CHUIKOV, S. A., q.v.

MALEVICH, Kazimir Severinovich, 1878–1935. Painter, designer, theoretician. Originator of suprematism. Born in the Kiev region. Studied at the Kiev drawing school 1895–6, *MUZhVZ* 1904–5, F. Rerberg's studio 1905–10. Member of the Petrograd *Kollegiya* in 1918. Director of Vitebsk Art-Practical Institute 1919–21, where he founded *UNovIs*, the 'Affirmers of New Art', in 1920. Director of Petrograd *InKhuK* 1923–6. Travelled to Berlin with exhibition 1927; arrested and imprisoned for 3 months after his return.

MANIZER, Matvei Genrikhovich, 1891–1966. Sculptor. Born in St Petersburg. Graduated from Academy of Arts in 1916. Made work for Lenin's plan for monumental propaganda 1918–20. Member of *AKhR/R* from 1926. Taught at Leningrad *VKhuTeMas/VKhuTeIn* 1921–9; at All-Russian Academy of Arts 1935–41, 1945–7; at *MIPIDI* 1946–52; in sculpture studio of USSR Academy of Arts, Leningrad, 1948–52; at *MGKhI* 1952–66. Chairman of *LOSSKh* 1937–41; vice-president USSR Academy of Arts 1947–66. Awarded Stalin prizes in 1941 for monument to Lenin in Ulyanovsk; in 1943 for *Zoya Kosmodemyanskaya*; in 1950 for monument to Pavlov in Ryazan. Member of communist party from 1941. Member of USSR Academy of Arts from 1947.

MASHKOV, Ilya Ivanovich, 1881–1944. Painter. Born in Mikhailovskaya-on-Don. Studied at *MUZhVZ* 1900–9. Member of Jack of Diamonds from 1910; *AKhRR* 1924; *OMKh* 1927–8. Taught in own private studio in Moscow

1902–17; at Moscow *GSKhM/VKhuTeMas/VKhuTeIn* 1918–30.

MATVEEV, Aleksandr Terentevich, 1878–1960. Sculptor. Born in Saratov. Studied at Bogolyubov Drawing School in Saratov; at *MUZhVZ* 1899–1902; worked at Abramtsevo pottery studios 1901–5. Member of The World of Art 1910–24; of *ORS* from 1926. Taught at Leningrad All-Russian Academy of Arts 1932–48 (director 1932–4); at *MGKhI* 1940–8. Member of communist party from 1940.

MAYAKOVSKI, Vladimir Vladimirovich, 1893–1930. Poet, playwright, graphic artist. Leading propagandist of Futurism. Studied at *MUZhVZ*. Worked on Windows of *RosTA* 1919–21; on posters with Rodchenko 1923–5. Shot himself in 1930.

MELIKHOV, Georgi Stepanovich, 1908–1985. Painter. Historical and contemporary Ukrainian subjects, the life of Taras Shevchenko. Born in Kharkov. Studied at Kharkov Art Institute 1933–4; Kiev Art Institute 1935–41. Taught at Kiev Art Institute 1945–66. Awarded Stalin prize in 1948 for *The Young Taras Shevchenko Visiting the Artist K. P. Bryullov*.

MELNIKOV, Konstantin Stepanovich, 1890–1974. Architect. Born in Moscow. Studied at *MUZhVZ* 1905–17. Worked in studio of Moscow Council 1918–20s. Member of *AsNovA*. Taught at Moscow *VKhuTeMas/VKhuTeIn*, *MArkhI* from 1921. Major works: Rusakov club, Kauchuk factory club, Gorki Palace of Culture, Storm Herald factory club, bus garage and own house, all in Moscow, 1927–31. Thrown out of Architects' Union in 1930s because of the formalist character of his work.

MERKUROV, Sergei Dmitrievich, 1881–1952. Sculptor. Born in Aleksandropol (today Leninakan). Studied in Zurich early 1900s; graduated from Munich Academy of Arts 1905. Member of *AKhR/R* from 1925. Director of Pushkin Museum 1945–50. Member of communist party from 1945. Member of USSR Academy of Arts. Awarded Stalin prizes in 1939 for figure of Stalin at *VSKhV*; in 1951 for monument to Stalin in Yerevan.

MITURICH, Pyotr Vasilevich, 1887–1956. Draftsman and inventor. Influenced by mystical theories of Velimir Khlebnikov. Inventor of *volnoviks*, prototypes for new kinds of land and underwater vehicles. Born in Moscow. Studied at Kiev art college 1906–9; at Academy of Arts 1909–16. Exhibited with The World of Art 1915. Served in tsarist and Red armies 1916–21. Member of The 4 Arts 1925–9. Taught at Moscow *VKhuTeMas/VKhuTeIn* 1923–30; at Institute for Raising Artists' Qualifications, Moscow, 1930s, until sacked for disseminating his own theory of art.

MOCHALSKI, Dmitri Konstantinovich, 1908–1988. Painter. Born in St Petersburg. Graduated from *InZhSA* 1936. Taught at *MIII/MGKhI* 1937–1980s. Chairman of *MOSKh* 1961–3. Member of USSR Academy of Arts.

MODOROV, Fyodor Aleksandrovich, 1890–1967. Painter. Portraits, historical and revolutionary subjects, Belorussian partisans. Born in Mstera. Studied at Kazan Art School 1910–14; at Higher Art College of Academy of Arts 1914–18. Member of *AKhR/R* from 1923. Organised Mstera Art-Technical College and Art School-

Commune 1918–21. Taught at *VGIK* 1939–41; rector of *MGKhI* 1948–62. Member of USSR Academy of Arts. Member of communist party from 1946.

MORDVINOV, Arkadi Georgevich, 1896–1964. Architect. Born in Zhuravlika (Gorki region). Graduated from architectural-construction institute, Moscow, 1930. Founder member of *VOPrA*. Taught at *MArkhI* 1930–3. Later headed Committee for Architectural Affairs.

MOTOVILOV, Georgi Ivanovich, 1884–1963. Sculptor. Born in Kostroma. Studied in F. Rorberg's studio 1910s; at Moscow *GSKhM/VKhuTeMas* 1918–21. Member of *Bytie*, *AKhRR*. Taught at *MVKhPU* 1945–63. Awarded Stalin prize 1950.

MUKHINA, Vera Ignatevna, 1889–1953. Sculptor. Born in Riga. Studied in studios of K. Yuon 1909–11, N. Sinitsina 1911, and I. Mashkov 1911–12, in Moscow; in Paris 1912–14, including study under Bourdelle. Visited Italy 1914, France 1928. Made work for Lenin's plan for monumental propaganda. Joined *ORS* in 1926; member of The 4 Arts. Taught at Moscow *VKhuTeIn* 1926–30. Awarded Stalin prizes in 1941 for *Worker and Collective Farm Girl*; in 1943 for portraits of Khizhnyak and Yusupov; in 1946 for portrait of Krylov; in 1951 for *We Demand Peace* (brigade work); in 1952 for monument to Gorki in Moscow (brigade work based on Shadr's project). Member of USSR Academy of Arts from 1947.

MYLNIKOV, Andrei Andreevich, born 1919. Painter, monumental artist. Born in Pokrovsk. Studied at *INZhSA* 1940–6, then as post-grad. at same place 1946–8. Taught at *INZhSA* 1947–present day. Awarded Stalin prize in 1951 for *In Peaceful Fields*. Member of USSR Academy of Arts.

NALBANDYAN, Dmitri Arkadevich, born 1906. Painter. Political leaders, landscapes, portraits, still-lifes. Born in Tiflis (now Tbilisi). Graduated from Tiflis Academy of Arts 1929. Moved to Moscow 1931. Worked in animated film studio *MezhRabPomFilm* 1931–4. Awarded Stalin prizes in 1946 for portrait of Stalin; in 1951 for *Power to the Soviets – Peace to the People* (brigade work). Member of USSR Academy of Arts from 1947. Member of communist party from 1948.

NEIZVESTNY, Ernst Iosifovich, born 1926. Sculptor. Born in Sverdlovsk. Rowed with Khrushchev at 1962 Manezh exhibition. Emigrated to Zurich 1976; now lives and works in USA.

NEPRINTSEV, Yuri Mikhailovich, born 1909. Painter, illustrator. Born in Tbilisi. Graduated from *InZhSA* 1938; then post-grad. at same place to 1941. Taught at *InZhSA* 1938–present day. Awarded Stalin prize in 1951 for *A Rest After Battle*. Member of USSR Academy of Arts.

NESTEROV, Mikhail Vasilevich, 1862–1942. Painter and monumental artist. Studied at *MUZhVZ* 1877–81, 1884–6; at Academy of Arts 1881–4. Worked in Kiev 1890–1910, otherwise in Moscow. Visited Italy, France, Austria, Germany, Greece, Turkey. Joined Itinerants 1896; founder-member of *SRKh* 1903.

NIKICH-KRILICHEVSKI (NIKICH), Anatoli Yurevich, born 1918. Painter. Born in Petrograd. Studied at *MIII/MGKhI* 1935–42.

NIKOGASYAN, Nikogos (Nikolai) Bagratovich, born 1918. Sculptor. Born in village of Nalbandyan, Armenia. Studied at Yerevan ballet school 1933–7; at art school attached to *InZhSA* 1933–7; at *InZhSA* 1940–1; at *MGKhI* 1944–7.

NISSKI, Georgi Grigorevich, 1903–1987. Painter. Graduated from Moscow *VKhuTeIn* in 1930. Awarded Stalin prize in 1951 for landscapes executed in 1950. Member of USSR Academy of Arts.

OLTARZHEVSKI, Vyacheslav Konstantinovich, 1883–1966. Architect. Born in St Petersburg. Studied at *MUZhVZ* 1902–8; at Vienna Academy of Arts 1905. Studied architecture and construction techniques and graduated from university in New York 1924–34. Chief architect of 1939 *VSKhV* until his arrest in 1938.

ORESHNIKOV, Viktor Mikhailovich, 1904–1987. Painter. Graduated from Leningrad *VKhuTeIn* 1927; as postgrad. from *InZhSA* 1936. Taught at *InPII* 1930–2, thereafter at *InZhSA* (rector 1953–77). Ran painting studio of USSR Academy of Arts from 1959. Awarded Stalin prizes in 1948 for *V. I. Lenin Taking an Exam in Petersburg University*; in 1950 for *In the Petrograd Defence Headquarters in 1917*. Member of USSR Academy of Arts.

ORLOV, Sergei Mikhailovich, 1911–1971. Sculptor. Studied at Vologda Art Tekhnikum in 1925. Worked for Kalinin Konakov faience factory and, from 1936, for State Dmitrov porcelain factory. Member of USSR Academy of Arts from 1954. Awarded Stalin prize in 1946 for a number of wartime works.

OSMYORKIN, Aleksandr Aleksandrovich, 1892–1953. Painter. Born in Elizavetgrad (today Kirovograd) Kherson region. Studied at Kiev Art College 1911–13; I. Mashkov's studio 1913–15. Member of Jack of Diamonds from 1914; World of Art 1920–2; Moscow Painters 1925; *Bytie* 1926; *OMKh* from 1927. Taught at Moscow *GSKhM/ VKhuTeMas/VKhuTeIn* 1918–30; at *InZhSA* 1932–47; at *MIII/MGKhI* 1937–48. Sacked from teaching in 1948 for 'formalist' sympathies.

PAKHOMOV, Aleksei Fyodorovich, 1900–1973. Painter and illustrator. Born in Varlamovo (Vologda region). Studied at Baron Shtiglits's Central College of Technical Drawing, Petrograd, 1915–17, 1920–2; at Petrograd *VKhuTeIn* 1920–5. Member of The Circle 1928–31. Member of USSR Academy of Arts. Awarded Stalin prize in 1946 for series of lithographs *Leningrad in the Days of the War and Blockade*.

PERELMAN, Viktor Nikolaevich, 1892–1967. Painter, art activist. Born in Lipetsk. Studied at Bogolyubov Drawing College, Saratov, 1910–12; in studio of I. P. Kelin, Moscow, 1914–15; at *MUZhVZ* 1915–19. Member of *AKhR/R* 1923–32.

PETROV-VODKIN, Kuzma Sergeevich, 1878–1939. Painter, theoretician. Born in Khvalynsk (Saratov region). Studied at Baron Shtiglits's Central College of Technical Drawing, St Petersburg, 1895–7; at *MUZhVZ* 1897–1905; in Munich 1901; in Paris 1905–8. Member of The World of Art 1911–24; The 4 Arts from 1924. Taught at Petrograd *GSKhUM/VKhuTeMas/VKhuTeIn/InPII/ InZhSA* 1918–33. First chairman of *LOSSKh* 1932.

PIMENOV, Yuri Ivanovich, 1903–1977. Painter, theatre artist. Born in Moscow. Studied at Moscow *VKhuTeMas* 1920–5. Member of *OSt* from 1925; of *Izobrigada* 1931. Taught at *VGIK* 1945–72. Member of USSR Academy of Arts. Awarded Stalin prizes in 1947 for designs for B. Lavrenev's play *For Those at Sea*; in 1950 for designs for N. Vinnikov's play *The Wide Steppe*.

PLASTOV, Arkadi Aleksandrovich, 1893–1972. Painter. Born in Prislonikha. Studied at Stroganov Central Artistic-Industrial College, Moscow, 1912–14; at *MUZhVZ* (in sculpture dept.) 1914–17. Member of USSR Academy of Arts. Awarded Stalin prize in 1946 for *Haymaking* and *Harvest*.

PUNIN, Nikolai Nikolaevich, 1888–1953, Art historian, critic. Born in St Petersburg. Entered University of St Petersburg 1907. Joined *Kollegiya* of *Izo NarKomPros* 1918, became head of Petrograd section. Commissar of Hermitage and State Russian Museum during civil war. Taught history of art at *InZhSA* from 1932; made head of art history at Leningrad University 1946. Arrested and freed on a number of occasions in 1920s–30s; finally arrested and incarcerated 1948; died in camp. Common-law husband of Anna Akhmatova in 1930s.

PUZYRKOV, Viktor Grigorevich, born 1918. Painter. Born in Dnepropetrovsk. Studied at Dnepropetrovsk Art College 1936–8; at Kiev Art Institute 1938–41, 1944–6; at MGKhI in Samarcand 1942–4. Taught at Kiev Art Institute 1948–present day. Awarded Stalin prizes in 1948 for *Black Sea Sailors* and in 1950 for *Stalin on the Cruiser 'Molotov'*. Member of the communist party from 1954.

RADIMOV, Pavel Aleksandrovich, 1887–1967. Painter, art activist. Born in Khodyainovo (Ryazan region). Graduated from Kazan University in 1911 and began to teach history of art and literature in Kazan Art School. Joined Itinerants 1914; founder member and first chairman of *AKhRR* 1922.

RESHETNIKOV, Fyodor Pavlovich, 1906–1988. Painter, graphic artist, sculptor. Born in Sursko-Litovskoe (Ekaterinoslav region). Graduated from *MIII* 1935. Taught at *MGKhI* 1953–7; at Lenin *MGPI* 1959–62. Member of USSR Academy of Arts. Awarded Stalin prizes in 1949 for *Home for the Holidays*; in 1951 for *For Peace*. Member of communist party from 1945.

RODCHENKO, Aleksandr Mikhailovich, 1891–1956. Painter, sculptor, designer, photographer, theatre artist, theoretician, art activist. One of the originators of constructivism. Born in St Petersburg. Studied at Kazan Art School 1910–14; at Stroganov College 1914–16. Member of *Kollegiya* in 1918; of *InKhuk* in 1920 (chairman from 1921). Organiser of production faculty at Moscow *VKhuTeMas/VKhuTeIn* 1920–30. Worked mainly as a photographer in 1930s, helped wife with book illustration and design 1930s–40s.

ROMADIN, Nikolai Mikhailovich, 1903–1988. Painter. Born in Samar. Studied at Moscow *VKhuTeMas/ VKhuTeIn* 1923–30. Member of USSR Academy of Arts. Awarded Stalin prize in 1946 for series of landscapes *Volga – Russian River*.

RUBLYOV, Georgi Iosifovfich, 1902–1975. Painter, monu-

mental artist. Born in Lipetsk. Studied at Moscow *VKhuTeMas/VKhuTeIn* 1923–9. Worked on public decorations with Tatlin and others 1930s. Deputy chairman of *MSSKh* late 1940s; sacked after allowing 'cosmopolitan' views to be expressed during a discussion of naturalism.

RYANGINA, Serafima Vasilevna, 1891–1955. Painter. Born in St. Petersburg. Studied in studio of Ya. F. Tsionglinsk: 1910–2; at Academy of Arts 1912. In 1912 left to live in Orenburg with husband, painter S. M. Karpov. Returned to Petrograd 1922; graduated from VkhuTeIn 1923. Visited Germany and Italy 1927.

RYAZHSKI, Georgi Georgievich, 1895–1952. Painter, art activist. Born in Ignatevo (Moscow region). Studied in studio of M. Leblan, R. Baklanov and M. Severov, Moscow, 1912–14; in studio of A. Golubkina, Moscow, 1917; in Moscow *GSKhM* 1918–20. Joined *NOZh* 1922; member of *AKhR/R* 1924–30, of *RAPKh* 1931–2. Visited Italy and Germany 1929. Taught at Moscow *VKhuTeIn* 1929–31; at *MIII/MGKhI* 1935–52. Member of USSR Academy of Arts. Member of communist party from 1924. Married to YANOVSKAYA O. D., q.v.

RYLOV, Arkadi Aleksandrovich, 1870–1939. Painter. Landscapes. Born in Istobenskoe. Studied at Baron Shtiglits's Central College of Technical Drawing 1888–91; graduated from St Petersburg Academy of Arts 1897. Made an Academician 1915. Joined *SRKh* 1903; member of The World of Art, of the Kuindzhi Association 1925–30, of *AKhRR* 1925–6, of *SSKh* 1929–32. Taught at *OPKh* drawing school, St Petersburg, 1902–18; at Petrograd *GSKhUM/VKhuTeMas/VKhuTeIn* 1918–29.

RYNDZYUNSKAYA, Marina Davydovna, 1877–1946. Sculptor. Born in Petrozavodsk. Studied in P. A. Vlasov's studio, Astrakhan, 1890s; at Stroganov College, Moscow, 1898–1901. Attended *MUZhVZ* as an external student 1901–15; worked in E. N. Zvantseva's studio, Moscow, 1900s. Member of *ORS*; of the Free Art association. Helped carry out Lenin's plan for monumental art. Worked in Museum of the Peoples of the USSR, Moscow, 1931–3.

RZHEZNIKOV, Aron Iosifovich, 1906–1943. Painter. Born in Chernigov. Entered MUZhVZ 1917, studied 2 months; studied Moscow VKhuTeMas/VKhuTeIn 1923–7. Died at the front.

SALAKHOV, Tair Taimurovich, born 1928. Painter. Born in Baku. Graduated from *MGKhI* 1957. Currently First Secretary of USSR Artists' Union.

SAMOKHVALOV, Aleksandr Nikolaevich, 1894–1971. Painter. Born in Bezhetsk. Studied at higher art college of Academy of Arts 1914–17 (architectural faculty); at Petrograd *GSKhUM/VKhuTeMas* from 1920. Member of The Circle 1927–9; joined October in 1930.

SARYAN, Martiros Sergeevich, 1880–1972. Painter, illustrator, theatre artist. Born in Nakhichevani-on-Don. Graduated from *MUZhVZ* 1904. Joined The Blue Rose 1907; member of The World of Art 1910–16, *SRKh* 1910–11, The 4 Arts 1925–6. Lived in Paris 1926–8, thereafter basically in Erevan. Taught at Erevan Theatrical-Artistic Institute 1946–52; ran sector of theory and history of art of Armenian Academy of

Sciences 1947–52. Chairman of Armenian artists' union 1947–51. Member of USSR Academy of Arts. Awarded Stalin prize in 1941 for designs for A. Spendiarov's opera *Almast*.

SEREBRYANY, Iosif Aleksandrovich, 1907–1979. Painter. Born in Gorodnya. Studied at Leningrad *VKhuTeIn/InPII* 1927–31. Taught at *InZhSA* 1948–79. Chairman of *LOSKh* 1957–63. Member of USSR Academy of Arts. Member of communist party from 1943.

SEROV, Vladimir Aleksandrovich, 1910–1968. Painter, illustrator, poster artist. Born in Emmaus (Tver region). Graduated from *InPII* 1931; as post-grad from *InZhSA* 1933. Taught at *InZhSA* 1932–1960s. Chairman of *LOSKh* 1941–8; of *Orgkomitet SKh RSFSR* 1957–60. 1st Secretary *SKh RSFSR* 1960–8. Member of USSR Academy of Arts from 1947; vice-president 1958–62; president 1962–8. Awarded Stalin prizes in 1948 for *Lenin Declares Soviet Power*, in 1951 for *On Foot To V. I. Lenin*. Member of communist party from 1942; deputy of Supreme Soviet *RSFSR* 1958–68; member of communist party revisionary committee 1961–8.

SHADR, Ivan Dmitrievich, 1887–1941. Sculptor. Born in Taktashinskoe, nr. Shadrinsko. Studied at First Artistic-Technical School, Ekaterinburg, 1903–7; at *OPKh* drawing school, St Petersburg, 1907–8; at Institute of Fine Arts, Rome, 1911–12. Took advice from Bourdelle and Rodin 1910–11. Lived in Moscow from 1914. Member of *ORS* from 1926.

SHCHIPITSYN, Aleksandr Vasilevich, 1896–1943. Painter. Born in Nizhny-Novgorod. Studied at Nizhny-Novgorod Art Tekhnikum; at Moscow *VKhuTeMas/VKhuTeIn* 1924–c. 1929. 1929–32 lived in Tatlin's studio in tower of Novodevichi monastery working on *Letatlin*. From 1933 made regular visits to village of Vzvoz, Kerzhenets region, life in and around which became the focus of his work. Paintings on war subjects 1941–2. Arrested and executed 1943.

SHCHUKO, Vladimir Alekseevich, 1878–1939. Architect and theatre artist. Born in Tambov. Graduated from higher art college of Academy of Arts, St Petersburg, 1904. Made an Academician of architecture 1911. Taught at Petrograd *GSKhUM/VKhuTeMas/VKhuTeIn* 1920–9. Most major projects carried out with GELFREIKH, V. G., q. v.

SHCHUSEV, Aleksei Viktorovich, 1873–1949. Architect. Born in Kishinev. Studied at higher art college of Academy of Arts 1891–7. Member of Academy from 1908, architect Academician from 1910. Taught at *OPKh* drawing school, St Petersburg 1908–11; at Stroganov College, Moscow, 1913–18; at *GSKhM/VKhuTeMas* 1918–24; at *MArkhI* 1948–9. Worked on first plan for reconstruction of Moscow 1918–25. Chairman of Moscow Architectural Association 1919–29; director of Tretyakov Gallery 1926–9; chief architect of 2nd Architectural-Project Studio of the Moscow Council 1932–7; director Museum of Russian Architecture, Moscow, 1946–9. Member of USSR Academy of Architecture from 1939. Awarded Stalin prizes 1941 for project for Institute of Marx-Engels-Lenin-Stalin in Tbilisi; in 1946 for project for interior of Lenin's mausoleum; in 1948 for project for theatre of opera and ballet in

Tashkent; in 1952 (posthumous) for project for Komsomolskaya-Koltsevaya metro station in Moscow.

SHEGAL, Grigori Mikhailovich, 1889–1956. Painter. Historical and revolutionary subjects, contemporary life, portraits, landscapes. Born in Kozelsk. Graduated from Moscow *VKhuTeMas* 1925. Taught at *MGKhI* 1937–41; at *VGIK* 1947–56. Member of USSR Academy of Arts. Member of communist party from 1943.

SHEVCHENKO, Aleksandr Vasilevich, 1883–1948. Painter. Born in Kharkov. Studied at Stroganov College, Moscow, 1899–1905, 1907; at the Académies Carrera and Julien in Paris 1905–6; at *MUZhVZ* 1907–10. Member of *InKhuK* 1920, of *Makovets* 1922–5; of *OMKh* 1928–9. Taught at Moscow *VKhuTeMas/VKhuTeIn* 1920–8. Estranged from art establishment in 1930s because of his work's 'formalism'.

SHERVUD, Leonid Vladimirovich, 1871–1954. Sculptor. Born in Moscow. Studied at *MUZhVZ* 1886–91; at higher art school of Academy of Arts 1893–8; in Italy and France as an Academy stipendiary 1899–1900; at Académie Julien, Paris, 1899–1900 (with Bourdelle and Rodin). Taught at Petrograd *GSKhUM/VKhuTeMas/VKhuTeIn/InPII/InZhSA* 1918–37; at Kiev Art Institute 1937–9; at *MGKhI* 1939–41.

SHMARINOV, Dementi Alekseevich, born 1907. Illustrator and painter. Born in Moscow. Studied in studio of N. Prakhov, Kiev, 1919–21; studio of D. Kardovski, Moscow, 1923–8. Chairman of *MOSKh* 1958–61, 1966–8. Member of USSR Academy of Arts. Awarded Stalin prize in 1943 for series of drawings *We Shan't Forget, We Shan't Forgive*.

SHTERENBERG, David Petrovich, 1881–1948. Painter, art administrator. Born in Zhitomir. Studied in Paris 1906–12. Returned to Russia in 1917. Commissar of Art Affairs 1917–18, director of *Izo NarKomPros* 1918–20. Professor at Moscow *VKhuTeMas/VKhuTeIn* 1920–30. Member of *OSt* 1925–30. Estranged from art establishment in 1930s because of earlier friendship with avant-garde.

SHUKHAEV, Vasili Ivanovich, 1887–1973. Painter and graphic artist, also worked in theatre. Born in Moscow. Studied at Stroganov College, Moscow, 1897–1905; at higher art college of Academy of Arts, St Petersburg, 1906–12; as Academy stipendiary in Italy 1913–14. Taught at Petrograd *GSKhUM* 1917–19. Lived in Finland 1920–1, in France 1921–35. Taught at *InZhSA* 1935–6. Arrested 1937, worked in Magadan early 1940s. Moved to Tbilisi 1947. Taught at Tbilisi Academy of Arts 1947–73.

SHURPIN, Fyodor Savvich, 1904–1972. Painter. Images of mother and child. Born in Kuryakino (Smolensk region). Joined *RabFak*, 'Workers' Faculty', of Moscow *VKhuTe-Mas* 1923; studied at Moscow *VKhuTeMas/VKhuTeIn* 1925–31. Awarded Stalin prize in 1949 for *The Morning of Our Motherland*.

SIMBIRTSEV, Vasili Nikolaevich, 1901–1985. Architect. Born in St Petersburg. Graduated from Moscow *VKhu-TeIn* 1928. Joined *VOPrA* 1928. Taught at *MArkhI* 1928–31. Major works: Red Army Theatre, Moscow, 1934–40 (with K. Alabyan); project for reconstruction of Stalingrad 1940s (with K. Alabyan).

SLAVINSKI, Yuvenal, ?–1936. Arts administrator. Head of Union of Art-Workers 1919. Chairman of *VseKoKhu-dozhnik* from 1929. Arrested and executed *c.* 1936.

SOFRONOVA, Antonina Fyodorovna, 1892–1966. Painter, illustrator. Born in Droskovo (Orlov region). Studied in F. Rerberg's school, Moscow, 1910–13; in I. Mashkov's studio 1913–17. Took part in exhibitions of Jack of Diamonds 1914, The World of Art 1917, The Group of 13 1931. Taught in *GSKhM*, Tver, 1920–1; thereafter lived in Moscow.

SOKOLOV, Mikhail Ksenofontovich, 1885–1947. Graphic artist, painter. Born in Yaroslavl. Studied at Stroganov College 1904–7. Military service in Baltic fleet 1907–9. Lived in Yaroslavl from start of 1910s. Called up again 1914; on his return worked as an art teacher. Arrested and sent to Siberian camp 1938. Freed 1943 and lived thereafter in Ryabinsk.

SOKOLOV, Nikolai Aleksandrovich, born 1903. Painter, graphic artist, illustrator. Born in Moscow. Graduated from Moscow *VKhuTeIn* in 1929, where he met P. N. Krylov and M. V. Kupriyanov and formed the KUKRY-NIKSY, q.v. Member of USSR Academy of Arts from 1947.

SOKOLOV-SKALYA, Pavel Petrovich, 1889–1961. Painter. Born in Strelna, nr. St Petersburg. Studied in I. Mashkov's studio, Moscow, 1914–18; graduated from Moscow *VKhuTeMas* 1922. Founder-member of *Bytie* 1921; member of *AKhR/R* 1925–31, of *RAPKh* 1931–2. Taught from 1922: on Central Courses of *AKhR* 1929–30; in the studio of artist-borderguards 1942–7; at *MIPIDI* 1948–52; at Potemkin Pedagogical Institute 1952–3; at *MGKhI* 1953–61. Member of USSR Academy of Arts. Awarded Stalin prizes in 1942 for political posters and caricatures, in 1949 for *Those From Krasnodon*. Member of communist party from 1952.

SOTNIKOV, Aleksei Grigorevich, 1904–1989. Studied at Krasnodar Art School 1925–8; at Moscow *VKhuTeIn* from 1928. Assisted Tatlin with *Letatlin*. Worked with Dulevski porcelain factory from 1934.

SYSOEV, Pyotr Matveevich, born 1906. Art historian. Born in Roslavets (Smolensk region). Studied in party school, Leningrad, 1920s; graduated from State Tretyakov Gallery/*MIFLI* 1934. Worked in *GTG* 1933–4; for journal *Novy Mir* 1935–8; as editor of journal *Iskusstvo* 1940–1, 1946–51; as chief editor and director of publishers Iskusstvo 1942–4; as member of KPDI 1946–53; as member of *Kollegiya* of Ministry of Culture from 1953. Member of USSR Academy of Arts. Member of communist party from 1927.

TATLIN, Vladimir Evgrafovich, 1885–1953. Sculptor, visionary architect and designer, painter. One of the originators of constructivism. Studied at *MUZhVZ* 1902–3 and 1909–10; at Penza Art College 1904–10. Travelled to Berlin and Paris in 1913. Leader of Moscow *Kollegiya* 1918–19. Taught in Moscow *GSKhM* 1918–20; at Petrograd *GSKhUM/VKhuTeMas* 1920–4; at Kiev Art Institute 1925–7, where he developed prototype of *Letatlin* with assistance of Nikolai Tryaskin; at Moscow *VKhuTeIn* 1927–30, where he developed *Letatlin* with assistance of A. SOTNIKOV q.v., A. SHCHIPITSYN q.v., M.

Akselrod and A. Zelenski. In 1930s–40s worked in *MTI*; on designing public decorations; in theatre.

TOMSKI, Nikolai Vasilevich, 1900–1984. Sculptor. Born in Ramushovo (Novgorod region). Graduated from Leningrad *VKhuTeIn* 1927. Taught at *MGKhI* 1948–82 (rector 1964–70). Chairman of *MSSKh* 1952–3. Member of USSR Academy of Arts, president 1968–83. Awarded Stalin prizes in 1941 for monument to Kirov; in 1947 for bust of Chernyakhovski; in 1949 for a number of portraits; in 1950 for portraits and cycle of bas-reliefs devoted to Lenin and Stalin (brigade work); in 1952 for portrait of Gogol. Member of communist party from 1950.

TSAPLIN, Dmitri Fyodorovich, 1890–1967. Sculptor. Lived in France, Spain 1927–35.

TSIGAL, Vladimir Efimovich, born 1917. Sculptor. Born in Odessa. Graduated from *MGKhI* 1948. Worked as artist for Chief Political Directorate of Black Sea Fleet, 1942–4. Member of USSR Academy of Arts. Awarded Stalin prize in 1950 for *V. I. Lenin, High-School Student* and cycle of bas-reliefs devoted to Lenin and Stalin (brigade work). Member of communist party from 1952.

TSIRELSON, Yakov Isaakovich, 1900–1938. Painter, monumental artist, art polemicist. Born in Velizh (Smolensk region). Studied at Moscow *VKhuTeMas/VKhuTeIn* 1923–30. Editor of *Red October*, *VKhuTeIn* journal, late 1920s. Member of *AKhR* 1928–30, *RAPKh* 1931–2. Chairman of *MOSSKh* revisionary committee 1930s. Member of communist party from 1921. Arrested and executed 1938.

TSYPLAKOV, Viktor Grigorevich, 1915–1988. Painter. Born in Burminka (Ryazan region). Graduated from *MGKhI* 1942. Taught at *MGKhI* 1948–1980s. Awarded Stalin prize in 1950 for *Leading People of Moscow in the Kremlin* (brigade work).

TULIN, Yuri Nikolaevich, 1921–1988. Painter.

TYSHLER, Aleksandr Grigorevich, 1898–1980. Painter, theatre artist. Born in Melitopol. Studied at Kiev Art College 1912–17; visited studio of A. Ekster, Kiev 1917–19; attended Moscow *VKhuTeMas* 1921. Member of *OSt* from 1925. Branded formalist in 1930s and worked mainly in theatre; chief artist of State Jewish Theatre 1941–9. Awarded Stalin prize in 1945 for E. Shneer's *Freikhels*. Gave up theatre work 1961 to concentrate on painting and sculpture.

UDALTSOVA, Nadezhda Andreevna, 1886–1961. Painter. Born in Orel. Studied in K. Yuon's school, Moscow, 1906–7; at I. Kim's private school 1909; in Paris 1912–13. Returned to Moscow 1913, worked in Tatlin's studio. Member of *Kollegiya* of *Izo NarKomPros* from 1918. Taught at Moscow *GSKhM/VKhuTeMas/VKhuTeIn* 1918–30. Member of *InKhuK* 1921. Branded formalist in 1930s. Married to DREVIN A. D., q.v.

UITTS, Bela Fridrikh, 1887–1972. Monumental artist. Born Temeshvava, Hungary. Entered Budapest Academy of Arts 1908; studied in Italy 1914. Emigrated from Hungary to USSR in 1920s. Taught at Moscow *VKhuTeIn* late 1920s. Ran monumental art studio of the Palace of the Soviets 1930s–40s. Communist. Arrested briefly in 1930s.

VEIDEMAN, Karl Yanovich, 1897–1944. Painter, theatre artist. Graduated from Riga school for painters and decorators 1915; studied at *OPKh* drawing school, St Petersburg, 1915–17, and at Moscow *GSKhM/VKhuTeMas* 1919–22. Member of *Bytie* 1924–8; of *AKhR* from 1928. Served in Red Guard at Smolny and the Kremlin during revolution. Lived in Germany 1923–4. Arrested 1938, subsequently executed.

VILYAMS, Pyotr Vladimirovich, 1902–1947. Painter, theatre designer. Born in Moscow. Graduated from Moscow *VKhuTeMas* in 1923. Member of *OSt* 1925–31, of *Izobrigada* 1931–2. Visited Germany and Italy in 1928. Chief artist of Bolshoi Theatre from 1941. Taught at *MIPIDI* 1946–7. Awarded Stalin prizes for theatre work in 1942, 1945 and 1946.

VOGELER, Heinrich, 1872–1942. Painter. Born in Bremen. Leading figure in artists' commune at Worpswede 1894–c. 1920. Disillusioned by First World War and harrassed for his communist convictions; emigrated to USSR in 1927. Arrested in 1930s and sent to Kazakhstan; believed to have died working on a railroad in Siberia.

VOLKOV, Aleksandr Nikolaevich, 1886–1957. Painter. Pictures of national and folk subjects. Born in Fergana, Turkestan. Graduated from Kiev Art College in 1916. Taught at Tashkent Art College 1916–46.

VOLTER, Aleksei Alcksandrovich, 1889–1974. Painter, arts administrator. Born in Nizhny-Novgorod. Studied in A. O. Karelin's studio, Nizhny-Novgorod, 1900–8; *OPKh* drawing school, St Petersburg, 1913; V. A. Zverev's studio, St Petersburg, 1913–15. Member of *AKhR/R* 1923–32. First chairman of *MOSSKh*, 1932–7. Member of the communist party from 1920.

VUCHETICH, Evgeni Viktorovich, 1908–1974. Sculptor. Monumental work, portraits. Born in Ekaterinoslavl (today Dnepropetrovsk). Studied at art school in Rostov-on-Don 1926–30; at *InPII/InZhSA* 1931–3. Member of Grekov Studio 1943–62. Member of USSR Academy of Arts from 1947. Awarded Stalin prizes in 1946 for portrait of Chernyakhovski; in 1947 for monument to General Efremov; in 1948 for portrait of Chuikov; in 1949 for portraits of Khryukin and Niyazov; in 1950 for *Warrior-Liberator*. Member of communist party from 1943.

VYAZMENSKI, Lev Peisakhovich, 1901–1938. Painter, monumental artist. Born in Vemyasa (Vitebsk region). Studied at Moscow *VKhuTeMas/VKhuTeIn* 1923–30, after leaving Red Army. Member of *AKhR* 1928–30; of *RAPKh* 1931–2. Communist. Arrested and executed 1938.

YABLONSKAYA, Tatyana Nilovna, born 1917. Painter. Born in Smolensk. Graduated from Kiev Art Institute in 1941. Taught at Kiev Art Institute 1944–52, 1966–73. Member of USSR Academy of Arts. Awarded Stalin prizes in 1950 for *Corn*; in 1951 for *Spring*. Member of communist party from 1952.

YAKOVLEV, Vasili Nikolaevich, 1893–1953. Painter. Born in Moscow. Graduated from *MUZhVZ* 1917. Member of *AKhR/R* from 1922; of *SSKh* 1929–32. Taught at Moscow *GSKhM/VKhuTeMas* 1918–22; at *InZhSA* 1933–7; at *MArkhI* 1934–6; at *MGKhI* 1948–51. Chief restorer, Pushkin Museum, 1926–32. Chief artist,

VSKhV, 1938–9, 1949–50. Member of USSR Academy of Arts. Awarded Stalin prizes in 1943 for portrait of General I. V. Panfilov; in 1949 for *A Collective-Farm Herd*.

YANOVSKAYA, Olga Dmitrievna, born 1900. Painter. Born in Ostrogo. Studied in studio of Shor brothers, Moscow, which soon became base for Central Courses of *AKhR/R*, 1923–9. Joined *AKhR* 1929. Taught at *MIII* 1935–6.

ZERNOVA, Ekaterina Sergeevna, born 1900. Painter, monumental artist, graphic artist. Studied in F. Rerberg's studio, Moscow, 1915–18; at Moscow *GSKhM/VKhuTeMas* 1919–24. Member of *OSt* from 1928, then of *Izobrigada*. Taught at *MIPIDI* from 1945; at *MTI* 1953–71.

ZHOLTOVSKI, Ivan Vladislavovich, 1867–1959. Architect. Born in Pinsk. Graduated from higher art college of Academy of Arts, St Petersburg, 1898. Made an architect Academician 1909. Member of USSR Academy of Architecture 1939–56; of USSR Academy of Building and Architecture 1956–9. Taught at Stroganov College from 1899; at Moscow *VKhuTeMas/VKhuTeIn* 1920–30; at USSR Academy of Architecture 1934–7. Major works: participation in general plan for reconstruction of Moscow, 1918–23; general plan of agricultural exhibition, Moscow, 1923; house on Mokhavaya Street 1932; dwelling house on Bolshaya Kaluzhskaya Street (today Lenin Prospect) 1950. Awarded Stalin prize in 1950 for last-mentioned work.

Bibliography

Abolina, R. Ya. et al., *Sovetskoe Izobrazitelnoe Iskusstvo 1917–41*, Moscow, Iskusstvo, 1977

——, *Sovetskoe Izobrazitelnoe Iskusstvo 1941–60*, Moscow, Iskusstvo, 1979

Afanasev, K. N. (ed.), *Iz Istorii Sovetskoi Arkhitektury 1926–32*, Moscow, Nauka, 1984.

Astafeva, E. I. (ed.), *Arkhitektura SSSR 1917–87*, Moscow, Stroizdat, 1987

Babanazarova, M. M., Gazieva, E. D., and Kovtun, E. F., *Avangard, Ostanovlennyi na Begu*, Leningrad, Aurora, 1989

Bernshtein, B. M., and Gens, L. Yu., *Izobrazitelnoe Iskusstvo Estonskoi SSR*, Moscow, Sovetski Khudozhnik, 1957

Beskin, O., *Formalizm v Zhivopisi*, Moscow, VseKoKhudozhnik, 1933

Bogdanov, A. A., *Iskusstvo i Rabochii Klass*, Moscow, 1918

Bogorodski, F., *Avtomonografiya*, Moscow, Iskusstvo, 1938.

Bowlt, J. E. (ed.), *Russian Art of the Avant-Garde, Theory and Criticism*, New York, Viking Press, 1986

Brodski, I. A. et al., *Izobrazitelnoe Iskusstvo RSFSR*, Vol. 1, Moscow, Sovetski Khudozhnik, 1957

Brodski, V., *Sovetskaya Batalnaya Zhivopis*, Moscow and Leningrad, Iskusstvo, 1950

Bush, M., and Zamoshkin, A., *Put Sovetskoi Zhivopisi*, Moscow, Iskusstvo, 1933

Chegodaev, M., 'Khudozhestvennaya Kultura Poslevoennogo Desyatiletiya', *Iskusstvo*, 6/1988, pp. 30–36

Counts, G. S., and Lodges, N., *The Soviet System of Mind Control*, Boston, Houghton Mifflin, 1949

Dolgonosova, E. A., *Izobrazitelnoe Iskusstvo Tadzhikskoi SSR*, Moscow, Sovetski Khudozhnik, 1957

Elliott, D., *New Worlds, Russian Art and Society 1900–37*, London, Thames and Hudson, 1986

Fingert, L. (ed.), *Grafika-Zhivopis-Skulptura, Leningradskie Khudozhniki*, Moscow and Leningrad, Iskusstvo, 1947

Fyodorov-Davydov, A., *Marksistskaya Istoriya Iskusstva*, Ivanovo-Voznesensk, 1925

——, *Sovetskii Peizazh*, Moscow, Iskusstvo, 1958

Gerasimov, A. M., *Za Sotsialisticheskii Realizm*, Moscow, Akademiya Khudozhestv, 1952

Gerasimovich, P. N., and Nikiforov, P. P., *Izobrazitelnoe Iskusstvo Belorusskoi SSR*, Moscow, Sovetski Khudozhnik, 1957

Gordeziani, B. P., and Urushadze, I. A., *Izobrazitelnoe Iskusstvo Gruzinskoi SSR*, Moscow, Sovetski Khudozhnik, 1957

Gorki, A. M., *Gorki ob Iskusstve*, Moscow, Iskusstvo, 1940

Gorki, M., 'O Sotsialisticheskom Realizme', in *M. Gorki*, Vol. 27, Gosudarstvennoe Izdatelstvo Khudozhestvennoi Literatury, 1953, pp. 5–13

Gosudarstvennaya Tretyakovskaya Galereya, Sovetskaya Skulptura 1917–52, Moscow, Iskusstvo, 1953

Gosudarstvennaya Tretyakovskaya Galereya, Sovetskaya Zhivopis 1917–52, Moscow, Iskusstvo, 1953

Ikonnikov, A. V. et al., *Arkhitektura Sovetskoi Rossii*, Moscow, Stroizdat, 1987

Ioganson, B. V., *Za Masterstvo v Zhivopisi*, Moscow, Akademiya Khudozhestv, 1952

Ivanov, M., *Izobrazitelnoe Iskusstvo Latviiskoi SSR*, Moscow, Sovetski Khudozhnik, 1957

James, C. V., *Soviet Socialist Realism: Origins and Theory*, London, Macmillan, 1973

Jelagin, J., *Taming of the Arts*, trans. N. Wreden, New

York, Dutton, 1951.

Johnson, P., and Labedz, L., *Khrushchev and the Arts*, Cambridge Mass. MIT, 1965.

Kalomin, F. I., *Soderzhanie i Forma v Proizvedeniyakh Iskusstva*, Moscow, Gosudarstvennoe Izdatelstvo Politicheskoi Literatury, 1953

Kaufman, R. S., *Sovetskaya Tematicheskaya Kartina 1917–41*, Moscow, Akademiya Nauk, 1954

Kornfeld, Ya. A., *Laureaty Stalinskikh Premii v Arkhitekture 1941–50*, Moscow, Gosudarstvennoe Izdatelstvo Literatury po Stroitelstvu i Arkhitekture, 1953

Kosarev, A. (ed.), *Kak My Stroili Metro*, Moscow, Istoriya Fabrik i Zavodov, 1935

Kostin, V., *OST*, Leningrad, Khudozhnik RSFSR, 1976

——, *Molodye Khudozhniki i Problemy Sovetskoi Zhivopisi*, Moscow, Iskusstvo, 1940

——, *Molodye Sovetskie Zhivopistsy*, Moscow, Iskusstvo, 1935

Krestovski, I. V., *Monumentalno-Dekorativnaya Skulptura*, Moscow and Leningrad, Iskusstvo, 1949

Kuchis, I. Kh., et al., *Izobrazitelnoe Iskusstvo Kazakhskoi SSR*, Moscow, Sovetski Khudozhnik, 1957

Kuriltseva, V., and Yavorskaya, N., *Iskusstvo Sovetskoi Ukrainy*, Moscow, Iskusstvo, 1957

Kuznetsova, A., et al., *Oformlenie Goroda v Dni Revolyutsionnykh Prazdnestv*, Moscow and Leningrad, OGIz-IzoGIz, 1932

Lebedev, P. I., *Sovetskoe Iskusstvo v Period Inostrannoi Voennoi Interventsii i Grazhdanskoi Voiny*, Moscow and Leningrad, Iskusstvo, 1949

Lenin, V. I., *Lenin O Kulture i Iskusstve*, Moscow, Iskusstvo, 1938

——, *O Literature i Isskusstve*, Moscow, 1960

Leonov, A. I. (ed), *Russkoe Sovetskoe Iskusstvo*, Moscow, Iskusstvo, 1954

Lifshits, M. A., and Mansurova, A. M., *Izobrazitelnoe Iskusstvo Moldavskoi SSR*, Moscow, Sovetski Khudozhnik, 1957

——, (ed.), *Marks K. i Engels F. ob Iskusstve*, Moscow and Leningrad, 1938

London, K., *The Seven Soviet Arts*, London, Faber and Faber, 1937

Lunacharski, A. V., *Iskusstvo i Revolyutsiya*, Moscow, 1924

——, *Stati ob Iskusstve*, Moscow, Iskusstvo, 1940

Luppol, I., et al. (eds), *Pervyi Vsesoyuznyi Sezd Sovetskikh Pisatelei 1934*, Moscow, Stenografischeskii Otchet, 1934

Manizer, M. G. (ed.), *Akademiya Khudozhestv SSSR, Tretyaya Sessiya*, Moscow, Akademiya Khudozhestv SSSR, 1949

Martikyan, E. A., and Parsamyan, R. O., *Izobrazitelnoe Iskusstvo Armyanskoi SSR*, Moscow, Sovetski Khudozhnik, 1957

Matsa, I. (ed.), *Sovetskoe Iskusstvo sa 15 Let*, Moscow, 1933

Medvedev, R, *All Stalin's Men*, Oxford, Basil Blackwell, 1983

Mikhailov, A. A., *Gruppirovki Sovetskoi Arkhitektury*, Moscow and Leningrad, 1932

Myunts, M. V., and Rempel, L. I., *Izobrazitelnoe Iskusstvo Uzbekskoi SSR*, Moscow, Sovetski Khudozhnik, 1957

Nalbandyan, D. A. (interview), 'Nikto Menya ne Mozhet Upreknut', *Ogonek*, No. 12, 3/1989, pp. 15–17

Nedoshivin, G. A. (ed.), *Istoriya Russkogo Iskusstva*, Vol. XIII, *Russkoe Sovetskoe Iskusstvo V Gody Velikoi Otechest-vennoi Voiny*, Moscow, Nauka, 1964

Nikonov, I. I. (ed.), *Stanovlenie Sotsialisticheskogo Realizma v Sovetskom Izobrazitelnom Iskusstve*, Moscow, Iskusstvo, 1961

Novitski, P. (ed.), *Izofront, Klassovaya Borba na Fronte Prostranstvennikh Iskusstv*, Moscow and Leningrad, Oktyabr, 1931

Paperny, V., *Kultura Dva*, Ann Arbor, Ardis, 1985

Polikarov, V., 'Zhivopis Poslevoennogo Desyatiletiya', *Iskusstvo*, 11/1987, pp. 43–50

Portnov, G. S., and Vladich, L. V., *Izobrazitelnoe Iskusstvo Ukrainskoi SSR*, Moscow, Sovetski Khudozhnik, 1957

Revyakin, A., 'Stalin o Voprosakh Iskusstva i Kultury', *Iskusstvo*, 6/1939, pp. 20–53

Sarabyanov, D. A., and Smirnova, E. A. (eds), *1920–1930 Zhivopis*, Moscow, Sovetski Khudozhnik, 1988

Schwarz, B., *Music and Musical Life in Soviet Russia 1917–70*, London, Barrie and Jenkins, 1972

Sokolnikov, M. P., *A. M. Gerasimov*, Moscow, Iskusstvo, 1954

——, *Izobrazitelnoe Iskusstvo RSFSR*, Vol. II, Moscow, Sovetski Khudozhnik, 1957

Sokolova, N. I. (ed.), *Sovetskaya Zhivopis Poslevoennykh Let*, Moscow, Sovetski Khudozhnik, 1956

Sopotsinski, O. I., et al., *Sovetskoe Iskusstvo 1917–57*, Moscow, Iskusstvo, 1957

Sosnovski, L. S. (ed.), *Voina Voine*, Moscow, AKhRR, 1925

Struve, G., *Russian Literature under Lenin and Stalin, 1917–53*, University of Oklahoma Press, 1971

Sysoev, P. M., and Kuznetsov, A. M. (eds), *Akademiya Khudozhestv SSSR, Pervaya i Vtoraya Sessii*, Moscow, Akademiya Khudozhestv SSSR, 1949

Sysoev, P. M., and Zotov, A. I. (eds), *Vsesoyuznaya Khudozhestvennaya Vystavka 'Industriya Sotsializma'*, Moscow and Leningrad, Iskusstvo, 1940

Tarlanov, M. A., and Efendiev, R. S., *Izobrazitelnoe Iskusstvo Azerbaidzhanskoi SSR*, Moscow, Sovetski Khudozhnik, 1957

Tikhomirov, A., *Krasnaya Armiya i Voenno-Morskaya Flot v Sovetskoi Zhivopisi*, Moscow and Leningrad, Iskusstvo, 1938

Tsapenko, M., *O Realistichiskikh Osnovakh Sovetskoi Arkhitektury*, Moscow, 1952

Tumarkin, N., *Lenin Lives!* Cambridge, Mass. and London, Harvard University Press, 1983

Ulam, A. B., *Stalin, The Man and His Era*, London, Allen Lane, 1973

Ulosa, V. A., *Izobrazitelnoe Iskusstvo Litovskoi SSR*, Moscow, Sovetski Khudozhnik, 1957

Vasilevich, P. P., and Yakovlevich, E. L., *Izobrazitelnoe Iskusstvo Turkmenskoi SSR*, Moscow, Sovetski Khudozhnik 1957

Volosovich, S. B., *Izobrazitelnoe Iskusstvo Kirgizskoi SSR*, Moscow, Sovetski, Khudozhnik, 1957

Zimenko, V. M., *Sovetskaya Portretnaya Zhivopis*, Moscow, Iskusstvo, 1951

Zinger, L. S., *Sovetskaya Portretnaya Zhivopis 1917 – Nachala 1930–kh Godov*, Moscow, Izobrazitelnoe Iskusstvo, 1978

——, *Sovetskaya Portretnaya Zhivopis 1930–kh – Kontsa 1950–kh Godov*, Moscow, Izobrazitelnoe Iskusstvo, 1989

Index

Italic numbers refer to plate numbers